CHINE

LATTICE

DESIGNS

Daniel Sheets Dye

Sometime Professor in
West China Union University
Chengtu, China

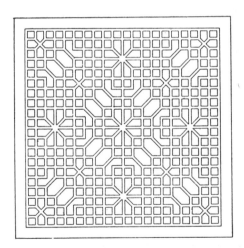

DOVER PUBLICATIONS, INC

New York

Published in Canada by General Publishing Company, Ltd., 30 Lesmill Road, Don Mills, Toronto, Ontario.

Published in the United Kingdom by Constable and Company, Ltd.

This Dover edition, first published in 1974, is an unabridged and unaltered republication of the second (1949) edition of the work originally published in 1937 by Harvard University Press under the title *A Grammar of Chinese Lattice*. The original and second editions constituted Volumes V and VI of the Harvard-Yenching Institute Monograph Series.

DOVER *Pictorial Archive* SERIES

International Standard Book Number: 0-486-23096-1
Library of Congress Catalog Card Number: 74-82205

Manufactured in the United States of America
Dover Publications, Inc., 31 East 2nd Street, Mineola, N.Y. 11501

TABLE OF CONTENTS

CONTENTS

Because of the omission of certain plates originally contemplated, the numbering of the sections of the Supplement is not consecutive.

INDEX OF DESIGNS BY GROUPS

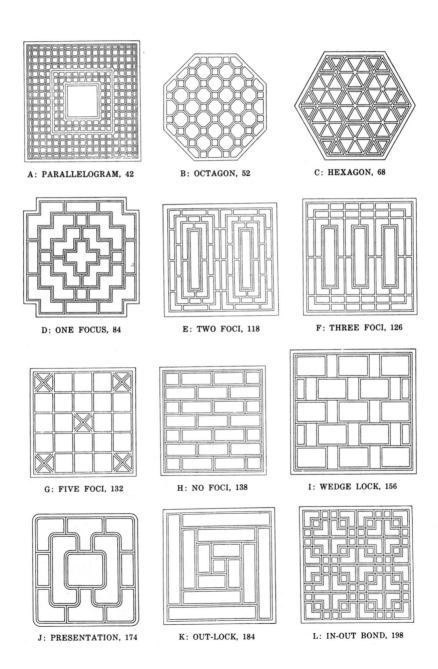

A: PARALLELOGRAM, 42

B: OCTAGON, 52

C: HEXAGON, 68

D: ONE FOCUS, 84

E: TWO FOCI, 118

F: THREE FOCI, 126

G: FIVE FOCI, 132

H: NO FOCI, 138

I: WEDGE LOCK, 156

J: PRESENTATION, 174

K: OUT-LOCK, 184

L: IN-OUT BOND, 198

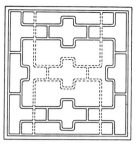

M: HAN LINE, 206

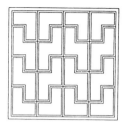

N: PARALLEL WAVE, 214

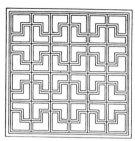

O: OPPOSED WAVE, 222

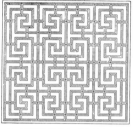

P: RECURVATE WAVE, 232

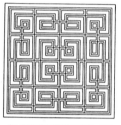

Q: LOOP-CONTINUE, 240

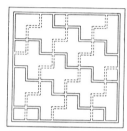

R: LIKE SUASTICAE, 250

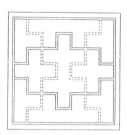

S: UNLIKE SUASTICAE, 260

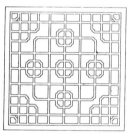

T: CENTRAL "JU I," 276

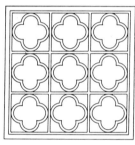

U: ALLOVER "JU I," 282

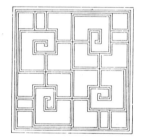

V: S-SCROLL, 286

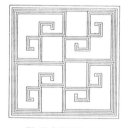

W: U-SCROLL, 292

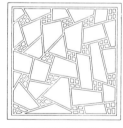

X: RUSTIC ICE-RAY, 298

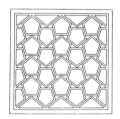

Y: SYMMETRY ICE-RAY, 306

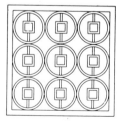

Z: SQUARE-ROUND, 318

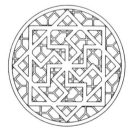

&: SUPPLEMENT, 330

THE PREFACE

A Grammar of Chinese Lattice by reason of its *Plates* is essentially a source book. The plates present windows and grille as constructed by Chinese workmen between 1000 B.C., say, and 1900 A.D. Most of the originals, their ancient counterparts in bronze or brick or their more recent copies in stone or porcelain, have been found *in situ* either in Chengtu, in other parts of Szechwan province, or in the remaining provinces of China. A few have been located in distant places — in museums in various countries, in magazines, books, etchings, prints, and photographs of various dates and provenance. Most of the plates are copied from wooden grille, constructed between 1700 A.D. and 1900 A.D., still extant in 1920. The book is based upon these monuments. Other examples doubtless exist: the collector has gathered some three hundred other plates (collected since August 17, 1933) which could suitably be included in this collection, but has unearthed no basic variants. The collection is as representative as possible. He has endeavored on the one hand to avoid artificial and biased judgments, and has striven on the other to maintain true standards of selection. These plates do not constitute a corpus or an anthology of lattice, but they do aim to be a grammar of systematic Chinese lattice. These window patterns, plate by plate, line by line, bar by bar, are not *sub judice*, for with but few exceptions they have long been subjected to the critical scrutiny of the race which produced them.

The letterpress presents accessory data, classification, correlation, interpretation, and generalizations. Few questions can be raised, we trust, by anyone in a position to know, as to the data presented, but some queries may be put concerning the absent background against which some of the conclusions must be judged. Readers may fill this in by studying available books which are numerous.[1]

The designs are presented for use. The work is a copybook for the student, an art book for the mature scholar, a collection of blueprints for the architect and designer in sundry fields.

The letterpress forms a commentary, so that the user may understand and appreciate the plates. It points out that there is method and reason in lattice design. It seeks to indicate the historical connection between peoples, places, and patterns.

This is probably the first book on Chinese lattice since 1631 A.D.,

[1] Cf., for example, K. S. Latourette, *The Chinese, Their History and Culture*, Macmillan, New York, 1934.

when Chi Ch'êng of Sung-ling 計成, 松陵, near Soochow, prepared a work of 232 cuts with a limited commentary. The master-carpenters have laboriously compiled pattern books for themselves and their clientèle by the use of the carpenter's rule and split-bamboo pen. The writer knows of one such book that is upwards of fifty years old, but he has good reason to believe that more of these were used by the carpenters when lattice was in greater vogue. These lattice scrap books were essentially "sampler pattern books."

Many reasons exist why printed books on this subject are lacking. Chinese literati have not concerned themselves with this work of the artisan. They are interested in objects of porcelain and bronze, which are periodically unearthed and reveal the life and culture of the remote past. Wood grill is so ephemeral that it cannot properly figure in archaeology, in their opinion, and they pass it by. Westerners have not written about it, as so few of them could observe it at its best and in its rich variety. Many Chinese books contain woodblock illustrations containing lattice, but these perforce are of the simplest designs. Thus Chinese illustrated books, even those dealing with architecture, give but few hints as to the wealth and range of patterns. The lattice looks its best around the Chinese New Year when the frayed paper is replaced and broken bars are sometimes repaired, but for ten months of the year lattice is not, as a rule, in best condition. Photographing is difficult in most cases. Sketching and drafting form the only practicable method of study.

The writer did not intentionally select this hobby. On Chinese New Year's Day, 1916, while visiting with a few of his students the famous Ts'ao T'ang Ssǔ 草堂寺, erected in honor of the T'ang dynasty poet Tu Fu 杜甫, some striking lattice seen there led him to collect twenty specimens. He sought types and did not plan to pursue the study beyond this modest goal. He little dreamed how far this would lead him.

The author has been enabled to carry on this study to such lengths through the co-operation of Mr. Yang Chi-shang 楊季常 until the latter's death on January 16, 1936. From 1916 the writer has been collecting patterns and data, while his collaborator, until his last illness, was preparing the drawings in his spare time. The draughtsman-artist did most of his drawing in Chengtu City and had never been more than one hundred and fifty miles from his birthplace; the writer on the other hand has travelled up and down Szechwan province, across China along the Yangtse River route several times, once from north to south along the coast, and has been twice around the world.

For the first half-year the collecting was local; Chengtu proved to be an ideal place in which to begin this study. That summer the

writer travelled to the Buddhist-templed Mount Omei in Szechwan. This visit netted patterns, the drawing of which occupied the spare time of the personal teacher for the remainder of the year. The writer at that time erroneously believed that this distinctive lattice had arisen through Buddhism, and he then began hesitatingly to trace the influence of religion on lattice.

Early in the course of his collecting the writer began to gather information about lattice as well as to collect the actual window patterns. The name of the town, estimated age of the building (whenever the definite date of the building was not ascertainable), use of the building, and local name of the window have all been noted when possible, for every design. The actual year of construction or of restoration could be found in only a few cases. Familiarity with woods and weather and exposure and weathering and wood-eating insects, as well as the styles of various times and places, aided in fixing dates.

The writer himself has collected over ninety-five per cent of these plates. The work has been done under varied conditions. In some cases he has been able to use steel tape and to measure deliberately and carefully, but often a curious crowd has militated against this. Only a few times, however, has he been forbidden to draw the patterns. In some instances the whole window had to be sketched, but more often a drawing of one quadrant has sufficed. After much experience, it became a fairly simple matter, in most cases, to see at a glance and to record in brief notes and sketches the essential features and proportions of the whole, or better still to take a rubbing with crayon and paper.

It has been difficult to preserve the relative proportions in the drawings, as the draughtsman found decided difficulty in using reducing scales. In actual manufacture, however, the proportions vary somewhat, in order to fit the opening or the whim of the carpenter. Those drawings which exceeded the degree of tolerance permitted have either been corrected before inking in or have been discarded. The writer has deemed it unnecessary to encumber the book with absolute dimensions, as few imitators would be guided by them. The windows for the most part are constructed to be viewed at different distances, and the one to be seen at a distance of fifty to one hundred feet exhibits one proportion, while the one to be viewed at another distance must have another proportion. The great majority of windows measure about thirty-two inches in width.

During the early years of collecting the writer began to discover places yielding rare and fine lattice, which appeared to be unique. Then after a lapse of five or ten years he would find another isolated instance of the same design, one, two, or even three days away (walking stages). He has interpreted these old windows as inheritances

from a time when they were in general vogue. Then he made a trip
up the Min 汶 Valley on the old trade route which led to Kansu. Here
unique combinations of lattice elements appeared which he had ex-
pected to find sometime and somewhere. Here he began to integrate
period with lattice. The West China University Museum was
founded by the writer during the early period of this study, and this
contributed to its development.

During the first stage of collecting he obtained the major portion
of the extensive collection of swastikas. He began to connect these
with Buddhism, but Buddhism alone can hardly fully explain the
intensive use of the motif in the Chengtu region. Contacts with the
immediate and with the more remote northwest account for part of
them.

During these early days of the University Museum the writer came
in touch with the Rev. Thomas Torrance, who took him to Han
dynasty grave-tombs, called by the Chinese "Mantse (or aboriginal)
Caves" 蠻子洞, in the hills along the lower Min River. These had
been rifled so many years ago that the people did not recognize
what they were. The discovery of "fossil lattice" of the tide pattern
潮水 and the ice ray 冰紋 types two thousand years old in clay and
stone, opened new horizons for study and collecting. Mr. Torrance,
who has not been especially interested in lattice, has helped the
writer in this study by his wide knowledge of porcelain and things
Chinese. A collection of pattern bricks of the Han dynasty per-
mitted certain deductions to be made as to wood grille patterns,
but most of this material remains in the supplementary collection
not included in this volume.

The writer then went on furlough via Shanghai and Peking,
Mukden, Seoul, and Japan. He noted differences between Peking
and Chengtu lattice, and similarities between Seoul and Chengtu
lattice. Lattice areas and changing contacts began to integrate as
the writer sorted out data and patterns and chronology. Japanese
lattice seemed to have developed quite differently, as he then
thought. In the New York Public Library he found a carpenter's
pattern book. This opened up still another horizon, as these speci-
mens differed from most lattice that he had observed up to that time.

After return from furlough, the writer made a trip one summer
along the Imperial Highway into Shensi from Chengtu. Then he
began to tie together loose threads and to weave the history of
Chinese lattice. The relation of lattice to trade, religion, official life,
migrations, and wars began to take on real significance.

It was over fourteen years ago that the writer began to observe
the patterns of woven belts of tribesmen and tribeswomen of the
Tibetan marches, but it took several years to grasp the relation of

these to the lattice which is almost peculiar to Szechwan. Only during the last five years has he found lattice that seemed to spell Nestorian influence in its patterns.

Meanwhile the writer designed lattice for buildings and special places: for church, chapel, museum, dormitory, furniture, carved-wood book-covers, and the special features of this book. He persistently refused to copy anything, but designed in accordance with definite principles, and sought to prove that the principles which he had formulated were soundly based, and that he could design in the Chinese style.

Once again he went on furlough, and found in Japan lattice which showed earlier contacts and later divergences; in America he found earlier borrowings; and in Europe he found traces of Chinese lattice influence.

And so this study has continued over twenty-one years. Much travel, enforced and otherwise, has made this intensive study possible. Had the writer been stationed on the coast of China, he would have missed much of this material. Repeated journeys over some of the routes have favored intensive collecting and have helped to check data, evaluate theories anew, and validate conclusions.

The writer has not travelled in northern Shensi, Kansu, Kweichou, Yünnan, so that these provinces have not yielded their full share. He has visited Fukien by proxy in the person of (Mrs.) Elizabeth T. Gowdy, long a resident in Foochow. Many cities could add materials to this collection. Bronzes, bricks, monuments, jades, and porcelains may yet contribute valuable data, but many of these are still undiscovered or else in inaccessible private collections in China and elsewhere.

It may never be possible to reconstruct a complete picture of Chinese lattice history during the last three thousand years. However, had not this collection been started when it was, even the present outline would be impossible. The originals of many of these plates have been destroyed by successive disturbances since the revolution of 1911.

Life, study, and teaching for twenty-seven years in Szechwan have influenced the writer more than he himself can fairly estimate, while he sought to reconstruct the story and significance of lattice and while he has surveyed, reviewed, and considered climate, topography, and materials; layout and construction of buildings; burial customs and living practices; cultural life as well as habitual and changing categories of the thought and art of the Chinese over the centuries. Imponderables (part and parcel of the plates, however,) have obtruded themselves into the letterpress and the general reader will question them. The observations and conclusions in this study are

presented with a keen sense of their limitations as to penetration and perspicacity. They evaluate in an intimate way the creative spirit, the spiritual entities, the philosophical attitudes, the artistic-cultural qualities of the Chinese. These desiderata, however, are the imponderables, the intangibles that are shadowed forth in the lattice grille, that are illumined through the light spots of the lattice pattern.

The writer has hardly been able to follow out all lines to their ultimate conclusions. He has endeavored to maintain an open mind with a minimum of preconceived opinions and a maximum of scientific inquiry. He has not been totally free from prejudice in this study and selection. He would frankly put himself on record here as preferring the simple, the dignified, the consistent, the lawful, that which is according to principle and rule, but not obtrusively so. Lawless, meaningless lattice has been excluded from this selection. The reader and the user of these plates should take cognizance of this predilection. The collector has doubtless discarded many examples which others would have preserved. He has had to discover, select and set up standards and criteria of selection for this work, and the validity of the criteria must be judged by the plates selected.

This work cannot be supported by quotations from books or by the conclusions of others, since Chinese lattice as a systematic art is a field in which practically no work has been done, not even by the Chinese themselves. The letterpress must be viewed through the lattice windows.

The writer confesses that it has been the gripping appeal of line and design of the windows that has impelled him to assume the unwonted role of writer, to persevere in writing, rewriting, revamping, and overhauling the material that is herewith presented. He also has confidence that both these designs and these principles will find gradually a place and an appreciation not only in the Occident but once more in the Orient, and be reincorporated, in a new manifestation, in a new "wheel-of-life" in the arts and in the materials of the twentieth century.

Deep gratitude is due to Jane Balderston Dye, who joined the writer after this study was undertaken. She has made more than one pilgrimage with the writer, including among other things the study and collecting of lattice. She gave her last weeks of furlough to deleting, combining, and rewording the manuscript as he copied it. Without her care the letterpress would have been cumbersome and needlessly extensive.

The writer also gratefully acknowledges the courtesies, aid and encouragement given by various curators and directors of museums, librarians, collectors, and others. Their assistance has been of dis-

tinct value. Although they are too numerous to be listed in full, the following must be mentioned.

R. F. Bach, Metropolitan Museum of Art, New York City
P. W. Cobb, Department of Ophthalmology, School of Medicine, St. Louis
Co-Workers, Chengtu, West China
Curator, Ōkura Museum, Tōkyō
George Eumorfopoulos, London
Helen Fernald, Museum of the University of Pennsylvania, Philadelphia
D. J. Fleming, Union Theological Seminary, New York City
Mrs. Elizabeth T. Gowdy, Foochow, China
Miss Chie Hirano, Museum of Fine Arts, Boston
R. L. Hobson, British Museum, London
Y. P. Hsieh, Councillor and Attorney-at-Law, Canton
A. W. Hummel, Library of Congress, Washington
The late B. Laufer, Field Museum, Chicago
Edna St. Vincent Millay
B. A. Stubbs, Freer Art Gallery, Washington
T. Torrance, Chengtu, West China
R. W. Wedderburn, Kelly and Walsh Book Co., Shanghai
L. Wieger, S. J., Hsien-hsien, China

The book, which is published by the Harvard-Yenching Institute, is herewith submitted to the reader.

LITERARY SOURCES

Almost no books on lattice exist. The writer has succeded in finding less than a dozen works affording trustworthy data for this collection. The content of the several volumes scarcely concerns itself with lattice, but has led to inference, deduction, and induction as the writer examined the plates and drawings. The authors of these works are not responsible for the conclusions and generalizations reached through their data and illustrations, which have been considered in their relation to Chinese lattice in general.

Ch'ang-yüan Ch'uang-pan 長源窗办, 10 *t'ao* in boards, a Chinese carpenter's pattern book, was done by carpenter's bamboo brush, end of Ming Dynasty (?), Wu-Han Area (?), deposited in the Public Library, New York City, shelf marked $\frac{*\text{OVL}}{+}$. When the writer located this book in 1923, the librarian could give no idea of its date, origin, contents, or use. She had no idea as to when or how it came to the library, but knew it had been there for years. She allowed the writer to take tracings of doors, windows, and screens, and some of these have been reproduced. They are marked "Ch'ang-yüan." There is no text to these plates. The writer has had to rely upon other data to localize and date the work. Anyone who cares to make a further study of Chinese lattice should study these crude drawings and cartoons, after he has perused the present work. The writer is more indebted, directly and indirectly, to this work than to any other, for it stimulated him to study dynastic lattice, and has had correspondingly an indirect influence upon the discussion of the history of lattice.

Yüan-yeh 園冶, Soochow, Kiangsu, 1635 A.D. The writer examined a MS. copy deposited in the Museum of Fine Arts, Boston, where the librarian allowed him to use celluloid and tracing paper in making copies. The results are listed under *Yüan-yeh*. This now forms part of a collective work in forty volumes published by T'ao Hsiang 陶湘 of Wu-chin 武進 (*i.e.*, Ch'ang-chou 常州), Kiangsu, in the years 1923–1931. The following description of the three volumes having to do with lattice patterns was supplied by Dr. A. W. Hummel of the Congressional Library, Washington:

"*Yüan-yeh*, 3 *chüan*, containing 232 engravings showing examples of Chinese lattice-work for windows, doors, and balustrades with text of the construction of rock gardens and other features of landscape architecture. Preface by the author — Chi Ch'êng 計成, *Tzŭ* Wu-fou 無否 of Sung-ling 松陵, near Soo-chow — is dated

1631. It was printed in 1635. A preface by the recalcitrant Ming general, Juan Ta-ch'êng 阮大鋮 (died 1646) was written in 1634. This work was originally called *Yüan-mu* 園牧."

This work is not so important as the preceding, but it was exceedingly interesting to visit a ducal palace in Soochow that was erected about the time it was compiled. The designs in the book and those in the palace are closely akin, but very little lattice is identical. The comment leaves much to be desired, but the general sequence of plates is intelligently arranged. The collector of the *Yüan-yeh* was limited in his sources.

The Society for Research in Chinese Architecture, Chung-shan Kung-yüan, Peiping, has granted the privilege of using certain designs found in the *Yüan-yeh*. This work is noted under each of the plates so used.

Ying Tsao Fa Shih 營造法式, 1103 A.D. Reprinted by The Commercial Press, Ltd., Shanghai, 1927. This work is primarily concerned with Chinese architecture, not with windows; however, the writer gleaned much indirect evidence from the details in the plates, and its data have been combined with other facts in summarizing the history of lattice by dynasties. Those who do not have access to the Chinese work may find a reference and a few plates in the *Encyclopaedia Britannica*, Fourteenth Edition, Article "Chinese Architecture," Vol. 5, pp. 556–565.

The Commercial Press, Shanghai, has kindly given permission for the insertion of several plates which have been redrawn from the *Ying Tsao Fa Shih*. The chapter and number refer to the numeration in that work.

&j1	...Chap. 31, No. 11.	&y1*j*	...Chap. 33, No. 23.
&v1*e*	...Chap. 29, No. 2.	&y1*k*	...Chap. 33, No. 22.
&v1*e*	...Chap. 29, No. 2.	&y1*l*	...Chap. 32, No. 6.

Hsi-ch'ing Ku-chien 西清古鑑 1750 A.D. The writer consulted an incomplete set which belonged to an ex-viceroy of Kweichou province. Some of the Old Graphies 古文 are copied from this. The general proportions and the framing of the pages are suggested by this superb block-printed book. The writer was told at the British Museum that it had been reprinted in a small edition, but has not located a copy.

Chinese Characters,[2] Dr. L. Wieger, S.J., Hsien-hsien, Catholic Mission Press, 1927; this has furnished some characters which are acknowledged in the appropriate places. Some of these as well as the old graphies from the *Hsi-ch'ing Ku-chien* have contributed contemporary evidence of ancestor worship in antiquity.

The Director,[2] 1755, Thomas Chippendale, London. The writer finally located this volume in the Philadelphia Art Museum. It

furnished no really new lattice, but the small cuts of Chinese furniture (which never seem to be reproduced) showed striking resemblance to furniture available at Chengtu in 1909. This afforded evidence of the contributions of Cantonese to Szechwanese lattice during the early years of the Manchu dynasty (see below, pp. 36–37).

Kenchiku-shashin-ruishu [10,12] 建築寫眞類聚, by the Kōyōsha 洪洋社, 4 vols., Tōkyō, 1931. These photographs help if, after a survey of Chinese historic lattice, they are used as a guide-book when visiting Nara, Kyōto, Tōkyō, Mito, and the Japanese countryside. But even for those who cannot visit Japan, they will prove of interest. The resemblances and contrasts are revealing to the specialist, but most disconcerting to the uninitiated.

The writer has also utilized material from three of his own articles, the first two of which were published in the *Journal of the West China Border Research Society*, Chengtu, West China:

"Some Elements of Chinese Architecture," 3, 162–181 (1929). This gives a background for lattice as presented in Chinese construction. This phase of the subject is practically disregarded in this book.

"A Study of Chinese Lattice," 4, 57–78 (1931). Most of the points in this article are either quoted or employed herein.

"The English Alphabet in a Chinese Setting," *The China Journal*, November 1934, 207–217, Shanghai. The alphabet is almost the same as the one used as division headings for the plates in the present book, but there are some different backgrounds, and the descriptions vary somewhat.

TECHNIQUE OF CONSTRUCTION

This section is based on the practice in Chengtu, Szechwan; but it holds true for all parts of China before 1900 A.D. Although the writer has had experience in directing Chinese carpenters in making foreign furniture, designing Chinese furniture, repairing Chinese buildings, erecting other buildings, and incorporating lattice of his own design both in Chinese buildings and in quasi-Chinese ones, he believes it more profitable to describe the procedure followed in erecting a building opposite his own door almost twenty years ago. This story forms a necessary background for understanding the technique of lattice construction.

The foreign architect-builder in this instance drew the plan of the building with Chinese features. He then purchased materials of stone, brick, lime, and several kinds of lumber in logs and had them delivered on the site. The materials were surrounded by a wall and watched night and day. He then engaged coolies, stone-cutters, brick masons, carpenters, and sawyers, by inviting in headmen in the several trades — who later called in members of their respective guilds. The artisans came in pairs, a master mechanic and his apprentice, — and their numbers were increased or decreased from week to week, depending upon how well the work was synchronized. The builder each Saturday night settled with the various headmen for the number of days' work of their crews.

While the masons were working on the walls, the sawyers were whipsawing the lumber used in the building, whether for the roof, joists, frames, doors, windows, or lattice grilles. The materials may be dry or they may be green, hardwood or soft wood, but these sawyers must whipsaw them all. West China sawyers whipsaw the timber sidewise, but in other provinces it is done vertically.

The carpenters put up the framing for the roof, the joists, the partitions, and the frames of the doors and windows. Before much lumber was spoiled they were told that Chinese V-joining was not desired, in framing or in doors. They proceeded to lath, as well as to design door patterns, to put down flooring, and then to plane the floor flat after the plastering had been finished. Then the windows with their frames to fit the openings were made on the site. After a glazier had cut the glass to fit the openings, the panes were set with wood-oil and lime well pounded together.

Towards the end of the long-drawn-out process of finishing the building, lattice windows were inserted where needed. The head

carpenter called in an especially skillful craftsman to lay out the work. He came with his birdcage, which he hung up in one corner of an unfinished room in the new building, where he proceeded to arrange a "draughting board" which he planed from rough lumber. He next measured the window openings and laid out a full-size window on this work table. This design was his combined blueprint and working drawing. He used India ink (which the Chinese have employed with the hair-brush pen for centuries) and a peculiar bamboo pen. This is a thin splint of bamboo ten inches long, a half-inch wide, and an eighth of an inch thick. It is split lengthwise at one end into slivers smaller than toothpicks, which are left attached to the splint. These are so beveled that the slivers hold the ink by capillary attraction and leave a clean-cut mark close to the carpenter's square (used as a straight-edge or drawing guide). The pen is inked from a bamboo cup filled with ink-soaked rags.

The artisan is now ready for the window bar material which had been prepared by a master carpenter and his apprentice. They rip these out of the whipsawed boards and plane them down to the proper dimensions. The designer then marks out lengths and joints by measurement and by contact with the "working drawing" on the board. He then passes the window material back to the master-carpenter, piece by piece, marked for the final work of fashioning mortise and tenon, and of fitting and gluing. He continues this process for each window of this size and pattern until he has as many teams of master carpenter and apprentice working as there are windows of this particular size. Next he planes off the working drawing and lays out the next size of window pattern, continuing thus until the work is finished. Meanwhile the canary in its cage sings now and again to the roomful of men in general and to the artisan in particular as he lays out the work.

The carpenters, as they finished cutting, mortising, and fitting the bars, joined them together. In the case of the elephant-trunk (end) or lozenge pattern, one set of parallel bars were cut out half depth at the intersections with the other set of parallels, which were also cut half through (but on the opposite side) so as to join with the first set. These were then skillfully joined so that the intersections were tight and snug. Both front and back were slightly planed to make flat surfaces. The carpenter then marked out the outer rough ends of the bars with an ink line (similar to a chalk line, but fine as a thread) and made tenons, the frame being mortised to fit them. The parts were fitted together, taken apart, glued together, clamped by an improvised vise of notched boards and wedges, and set aside to dry. The next day the whole was smoothed and planed to fit the window casing and then "sandpapered" with an equisetum or scouring rush that

comes from the marches of Eastern Tibet. Thus each lattice window is an individual affair.

In the case of certain triangular patterns the three sets of parallel bar systems must each be cut two-thirds through at the intersections. Thus the horizontal bars have notches one-third of the thickness of the bar in depth taken out of both front and back of the bar. Then the diagonal bars at the back must have two-thirds of their front edges cut away at the intersections. The other set of diagonals at the front must have two-thirds of the back cut away. Yet the three sets of bars are so joined as to have structural strength and to withstand thrust. The joints are so snug that the entire three sets of bars combine to withstand thrust at any one point, and *all bars are in the same plane.*[1]

Some windows are so joined by mere wedging of thick frames that there is strength to withstand thrust. Separated square frames are sometimes wedged together, but they must have excessive depth of bar for rigidity. Some patterns have toggles mortised in to give greater strength. In a few cases a half bar is allowed to extend between full thickness bars, but this is hardly effective. It neither gives great strength nor does it fade out of view — especially at night when all obstructions to light stand out in contrast.

The draughtsman in laying out a window divides the sides by means of a ruler into equal spaces either of an odd or an even number and then puts in the bars and portions the area off into equal spaces. He seldom measures off the whole directly into quadrants, but this is usually the final result. In the case of the ice-ray pattern he divides the whole area into large and equal light spots, and then subdivides until he reaches the size desired; he seldom uses dividers in this work. When making hexagons he employs a peculiar rule-of-thumb method of approximating the hexagon where he allows for a little; his geometry is certainly not Euclidian. He adopts cut-and-try methods for angles and curves, but his skill exceeds mere theory. The making of Chinese curves is an art, and it has never been reduced to rule.

The lattice designer seldom has as many as ten fundamental groups at his command; in fact he is hardly aware of definite groups. Very few of these skilled craftsmen have as many as fifty different patterns in their repertoire. To be sure they can produce variations on twenty distinct patterns, but they are totally unaware that as many different patterns exist as are included within this work. Many of the carpenters have never been three hundred miles from their homes; most of them have never had access to some of the finest

[1] The writer has found only three instances in China where this rule is violated, all dating from 1650 A.D.

residences in their own cities, even for repair work. The majority of them would hardly understand many concepts in the present volume, yet they know how to obtain surpassing results.

A painter was engaged to paint and lacquer the completed building inside and out. He used paints and the local wood-oil (桐油), much used abroad today as a basis of paints, on the floors. On the outside of the building he put either foreign or native paints; on the grille inside he rubbed native varnish or lacquer. In painting lattice, however, dark black or red paint is generally put on the outside, and then decorated with flowers and ornaments in gilt; the inside of lattice is left severely plain since it must be papered anyway and color can scarcely be visible against the daylight. At night, from the exterior, the whole pattern in black-and-white stands out clearly with the dim colza-oil light.

In this particular building the lattice spaces were filled with glass. In regular Chinese buildings the windows would be papered by a man who excels in this work. Usually the paper would be plain white, sometimes it would be flowered. Sometimes it would have special writings or pictures for the center of the window. Before the Chinese New Year all this must be replaced anew.

Thus the making of lattice calls for many skills, which combine to make it a successful feature and a tasteful element in the building.

CLASSIFICATION

A perfected system of classification in botany or zoology is difficult to evolve. Like organic life and growth, lattice baffles the systematist; he must finally come back to structure as the basis for his scheme. Even then there are crosses and hybrids, mules and sports, which may, with almost equal propriety, find places on several twigs, branches, limbs, or even stems of the lattice tree of life. Moreover there are gaps or partly vacant spaces where types have almost vanished, or have never come to flower.

The lattice tree has not grown symmetrically. Some groups are hampered by geometric and mechanical considerations; others are enhanced because of symbolic connotations, cheapness, or mechanical strength; others enlarged out of all proportion to their artistic merit because of structural strength and cheapness; still others evince many more examples than mechanical strength justifies, due to a predisposition for representations, for example, of the Heaven Deity and Sovereign Earth. Loose toggles are introduced for artistic reasons and purposes of good-omen, as in the Five-Bats-of-Happiness rebus, even at the expense of light and air. People desire to possess a novelty, something their neighbor does not have, thus perpetrating many oddities and aberrants. Keeping up with the Lis and Wangs accounts for much.

Classification forms an essential step in the study of lattice, and is next in importance to collection. Whole new groups have been found since 1929, for until then the collector had been discarding examples which he regarded as accidents. Fresh analysis and new grouping made new discovery and fresh observation possible.

The nomenclature of designs and of groups has not been a simple matter. Some individual patterns bear Chinese names, but there are only a few group designations generally used by the Chinese. Where individual or group names do exist, they are often employed only in a limited area; the same is true of some of the patterns themselves. The following are names that are used more or less generally: Han Line 漢紋; Windwheel 風車; Ju-i Scepter 如意; Thunder Scroll 雷紋; Cloud Band 雲板; Ice-Ray 冰紋; Buddhist Priest Head 和尙頭; Turtle Scute 龜紋; Elephant's Trunk (Tip) 象鼻; Bean Curd Square 豆腐方; Fish Entrail 魚腸; Pepper Eye 胡椒眼; Swastika 卍字; and Gold-Coin 金錢. Most of the other names used were originated by the writer. Several of the plates have been designed by the writer and are so marked in the accompanying texts.

The classification has been difficult, but interesting. For the most

part there is only one position in the natural order in which an individual design may belong. Even where doubt may obtain, the position was assigned after mature deliberation. The classifier has been embarrassed also by the wealth of material. The reader may visualize the problem if he can imagine fifteen hundred unclassified plates laid end to end.

In this system of classification, in so far as possible, all features have been taken into consideration, and the major ones are allowed to determine where to locate the designs within the scheme. In some cases a lattice window appears to belong in another group because of several equally prominent features; but for the most part the grouping is relatively simple and the broad outlines have been determined. There are five major emphases:

I. Division of the light field (Family of Field Division).
II. Locking of frames and of bars (Family of Locking Systems).
III. Line variations (Family of Line-Flow, or Harmonic Line).
IV. Line-ending (Family of Line Ending).
V. Line broken by short bars and other devices (Family of Broken Line, or Family of No-Line).

These primary emphases, or solutions, are the bases of the lattice art.

I. FIELD DIVISION

1. *Allover.* The first problem in the artistic design of Chinese lattice windows is the pleasing and regular division of the field. The earliest windows extant in bronze and clay fall into this classification. The simple vertical bar and the cross hatch or cancellation type come down from the clay houses and mortuary brick of early Han times and before. Simplicity was their characteristic. Further ingenuity and better tools and more careful workmanship in joining conditioned the development of this type, and probably woven and plaited work influenced lattice. The square, the triangle and its hexagon variations, and the octagon-square cover the possibilities in simple allover. Once one goes beyond these, overlapping, superposition, and complexity set in.

2. *Frame.* Another division of the field is that into similar, stepped, and nested frames, or divisions running from large to small which control and cover the entire field, step by step, until the whole is thus divided and controlled. This is an extension of the multiple border idea.

II. LOCKING SYSTEMS

3. *Knuckle.* While it is not insisted that the next problem and its solution grew out of the preceding, the principle of wedging separate

units together into a strong structure seems subsequent to the development and the exploitation of the allover, and probably of the frame. At all events the invention of the knuckle-wedge, for structural strength, deserves special recognition as a new genus. This device may be used between small and equal and evenly distributed units, and also between nested and graduated frames.

4. *Interlock.* The interlocking of frames, large and small, by other frames, whether single or in series, is a variant of the allover and the nested frame. This leads into the field of superimposed design, where the repeated, superimposed design is sidestepped by one half-step vertically and one half-step horizontally. Partial interlock by groups and entire interlock by stepped repeat superimposed once, twice or thrice, are devices much exploited by the Chinese.

III. LINE FLOW

5. *Wave* 潮水. The woven splint or osier may be superimposed upon a crossbar background, but the sine wave is not easily wrought in wood lattice. It is more feasible in right-angled and joined bars. When the pulsation and stepped motif once finds entrance, a whole new series of windows instantly arises. Where a second wave is opposed, and paired with the first, a wave of a different order is introduced. The eye follows waves thus paired and opposed at quite a different rate from when waves are completely parallel.

6. *Swastika* 卍字花. The simple device of crossing waves at right angles produces more than fifty variations in swastikas. The line-flow is neither so graceful nor so evident as in the simple wave, but there is more nucleation and delay, more emphasis upon the swastika pattern which results at the intersection of the crossed waves.

IV. LINE ENDING

7. *Ju I Scepter* 如意. As an offset to line-flow the ending-of-line was introduced. Herein the eye recoils upon itself, and again follows the line but in the reverse direction. By paired line-endings the attention is brought back to the center of interest. Thus a definite solution of the problem of focus is reached. Its effect is not unlike the centering brought about by the converging of concentered and nested frames. This superposition of unsupported ends upon the supporting structure decreases structural strength, but increases the artistic perfection of the whole.

8. *Thunder Scroll* 雷紋. The rectangularization of the scroll, by graded steps, with short bars alternately vertical and horizontal, all supported by harmonious and suitable devices, gives fine line-endings with centrality, and brings into wood lattice the motifs worked out with such splendid effect in bronze during the Chou and Han

periods. Wood lattice here takes over from bronze the so-called Thunder Scroll and the Cloud Band designs.

V. Broken Line

9. *Ice-Ray* 冰紋. The Ice-Ray recoils from line-flow, from line-ending, from the self-evident locking system, and from the repeat all-over and regimented frame. It may go back to primitive motifs, but its development shows a high degree of artistic progress. It is the most careful of lattice designs, a genus that is distinct and distinctive.

10. *Square-Round, or Circle-and-Square* 方圓. Where the field is broken up into circles with or without squares, and the units are not too large, the effect of broken or modulated line is produced, though there is virtually no line. This pattern, seemingly so distinct from the Ice-Ray, in common with it shows absence-of-line.

ILLUSTRATED CLASSIFICATION INDEX

"Ten hearings are not equal to one seeing" (十聞不如一見).

A classification-index of Chinese lattice set forth in words alone is no more informing than a botanical key written in a dead language. Easy use of such an index demands an intimate knowledge of the types involved and the symbols connected therewith. In Kew Gardens near London, typical forms of flowering plants are grown and displayed. As one wanders in and out along the rows, Latin names, otherwise meaningless, assume significance. This book, with typical diagrams replacing letters or numbers, may serve in some similar manner for the study of lattice.

Typical forms incorporate characteristics forming the bases of the classification. Some of the illustrations have several traits in common; all have some traits in common. But there are certain features which distinguish the several groups. These are indicated by dotted lines.

Some of the small illustrations may be misleading because many of the light spots are framed as though they were meant to illustrate the Wedge-Lock of the I Group, as well as the design in question. This is particularly true of illustrations A, C, D, H, J, K, L, N, O, P, Q, V, and W. The attractiveness of the illustrations is enhanced; but some intention of the illustrations vanishes.

A. Parallelogram, or Square-and-Rectangle Allover.

This rectangular design is known as the bean-curd 豆腐方 design, for the squares are about the size and shape of cakes of that nourishing viand. The several frames are picked out to emphasize the Square of Earth. This is patterned after an original window in Kiating 嘉定, Szechwan. The half-squares around the border are not customary. The simple allover square without variation is one of the most common windows, inasmuch as it is cheap and strong.

B. Octagon, or Octagon-and-Square Allover.

This design is composed of compressed octagons with voids between them. In practise the single bar serves as a frame for two white spaces. All bars are of the same thickness in orthodox lattice. This design in not one of the most beautiful, but it occurs in India, Persia, Turkey and Europe. The Chinese use it frequently in brocades, lattice and brick. The border design of this plaque is frequently found in metal mirrors.

C. Hexagon, or Hexagon-and-Triangle Allover.

This plate, framed like some metal mirrors, contains seven hexagons and forty-two small triangles within them, as well as twelve small triangles between the external hexagonal frame and the seven internal hexagons.

D. One Focus, or One-Focus Frame.

The odd-numbered and concentered frames, besides illustrating the group, show a method of turning a corner. The bars on the sides of the frames suggest four V's converging toward the central Greek cross shape, which is the character for ten and the symbol for the "Five Directions" of East, West, South, North, and Center.

E. Two Foci, or Two-Foci Frame.

The two double-framed frames within the major frame are often found alone, but they are sometimes repeated and stand four in a row. Peking has more windows of this type than most cities.

F. Three Foci, or Three-Foci Frame.

This triple frame, with the surrounding frame arrangement, is not common. There are usually many butterflies, bats, or other toggles in the corners.

G. Five Foci, or Five-Foci Frame.

These twenty-five squares are formed from Group A when crosses are added to the "Five Corners." They only emphasize centrality. This is a very prolific group.

H. No-Foci, or Distributed Frames.

This lattice merely imitates the outlines of brick in the running bond of brick work. The whole surface is divided into framed spots of light; but there is no distinct focus, or foci, in spite of the central frame. This type is rarely executed in wood.

I. Wedge-Lock, or Wedge.

This is the same general design as the preceding, save that the dimensions of the brick are changed. The frames are spread apart on the horizontal, but on the vertical they are compressed in a wedge-lock. This is a slightly modified specimen of a grille of 1800 A.D. at the foot of Mount Omei, near Kiating, Szechwan.

J. Presentation, or Two-Hand Presentation.

Here we have a central, round-cornered frame supported by the formal two handed presentation device. This is a favorite form at Paoning 保寧, Szechwan.

K. Out-Lock, or External Engagement.

This windwheel 風車 or pinwheel design is a frame where a side or part projects beyond its exterior to engage with the other bar for support. This extension of the side is somewhat disguised by framing for each spot of light.

L. In-Out Bond, or External-Internal Bond.

The interlocking of squares as exhibited here is a common device during the last three centuries. The interlocking is somewhat disguised by the median line of the bars. This design also exhibits the five cardinal points, but they are not particularly prominent.

M. Han Line 漢紋 or Cross Embrace.

Two sets of frames are cross-mortised in a unique way as though two sets of connected frames had been interwoven. The peculiar bulbous shapes seem related to the lines of Han Dynasty bronzes, and this may be responsible for the name. This Han Line is peculiar to Szechwan Province, and especially to its capital city, Chengtu.

N. Parallel Wave or Like Wave.

These right-angled waves in parallel series are suggested by a Shensi design. It shows the tendency to convert sloping lines and curved lines into vertical and horizontal bars and lines.

O. Opposed Wave or Paired Wave.

This is a simple variation of the parallel wave, with every other wave reversed, so that crest and trough are opposite.

P. Recurvate Wave or Broken Wave.

This is really the so-called Wall of Troy design, but it is a wave where the crest bends back upon the wave. The central, endless line which is often used as a border is compressed to its lowest limits so as to serve as a central ornament.

Q. Loop-Continue 萬不斷 or Endless Loop.

This is a variation of the preceding plate; instead of a continued broken-wave line, it is looped. The resulting effects are distinctive.

R. Like Swastika.

The swastikas of this group are all of one orientation in any particular window. The bars are parallel waves *en échelon*. The white spots have the shape of the Red Cross symbol, or the Greek cross, while the swastika itself symbolizes the sacred heart of Buddha. The tread-and-rise of the dotted waves are as 1 to 2; but the ratio for the cross waves is as 2 to 1.

S. Unlike Swastika.

The adjacent swastikas of this group are opposed. The bars are arranged in pairs and opposed: they are usually horizontal and vertical. The white spots are in the shape of Lorraine crosses. The type of white spot crosses gives the cue to the grouping.

T. Central "Ju I" or Central "Ju I Sceptre".

The central square with its indented corners is considered to be composed of four Ju I sceptres. The extreme corners are filled with two half Ju I sceptres joined. This sceptre is used in Taoist symbolism, though it did not originate there. It signifies "As you like it."

U. Allover "Ju I," or Allover "Ju I Sceptre".

In this design the sceptre is used as an allover pattern rather than as a special ornament. These are more rounded than usual.

V. S-Scroll, or Thunder Line.

This plate is composed of two Thunder Scroll designs, wedged together to give rigidity. They are so placed that each scroll-ending may be read with each of the other endings in turn and still be recognized as an S-scroll. This shape is found on Chou dynasty bronzes dating from 1000 B.C.

W. U-Scroll, or Cloud Band.

The Cloud Band is an in-curl somewhat like the letter U. These several U-scrolls are fitted together in such a way that they are rigid. In both the S-scroll and the U-Scroll the two ends are frequently of different sizes and of irregular forms. The U-scroll also dates back to the Chou period.

X. Rustic Ice-Ray, or Asymmetrical Ice-Ray.

The quadrilateral and irregular Ice-Ray is carefully placed so that lines are neither parallel, vertical, nor horizontal, and have no rectangular light spot. This particular plate is patterned in general on rustic ice-ray generalized, and is adapted from a K'ang-hsi ginger jar in the British Museum.

Y. Symmetry Ice-Ray.

The regular pentagons are stepped. These partake both of the regular and the irregular, but they are so distinctive that they cannot be placed elsewhere than in the Ice-Ray.

Z. Square-Round or Detail in Square-and-Round.

These cash patterns embody the Square of Earth and the Circle of Heaven. This is a fitting norm for this whole group where the representatives run the gamut from square to circle.

&. Supplement.

It seems fitting that a ligature be used for the depository of accessories of lattice. This is a circular reinforced window of Chengtu, Szechwan. The Circle of Heaven frame contains two equal and crossed Squares of Earth, each containing a swastika. The smaller pattern in the back is a single swastika also. Swastikas joined by small Greek crosses need some reinforcement to give structural strength. Such a complex of symbolism suitably characterizes the art of Chinese lattice.

THE MASTERPIECE OF THE TYPE

"My advice to you would be to confine yourself to the supreme . . .
in whatever literature." — *James Russell Lowell.*

It is well to recognize and distinguish the type, but it is better to
select, analyze, and appreciate the masterpiece of the type. The
Chinese compliment "Your eye is superior" 眼高 implies the ability
to recognize the genuine and the superlative. The man of discern-
ment selects *objets d'art* with an eye for beauty in the type. The time
stamp is interesting and the dynastic characteristic of value, but the
article of superior merit is timeless and invaluable. The scholar-
critic writes or brushes, in his best calligraphy, his careful apprecia-
tion, which he chops in red with his jade or ivory personal seal,
and this is appended as part of that scroll or picture which meets
his approval. Sometimes a half dozen such appreciations, appended
through several generations of purchase or inheritance, enhance the
value of a painting.

It is proper, therefore, that the writer should indicate those de-
signs which he considers best. He has drawn up a list of those one
hundred and fifty which, in his judgment, come into the class of
masterpieces. From some groups more than one has been chosen.
The masterpieces are arranged in alphabetical order, as no discrimi-
nation is made here between groups. Within groups, however, the
serial order is not followed, but the masterpieces are arranged in de-
scending order of merit. There is a certain point in comparing and
contrasting groups, but there is more value in distinguishing the
features and characteristics of the masterpieces in each group.

It would be well for the reader to remember that the lattice de-
signs which were extant in China in 1900 A.D. were for the most part
the selections of millions of people, who preserved them by repeated
use. The best of these have been chosen for inclusion in this an-
thology of lattice, so that practically all are replicas of masterpieces.
By a further more rigorous selection, however, these one hundred and
fifty have been set apart as a preferred list. In one sense they repre-
sent the choice of one person, which can scarcely be without bias, but
in another sense this list (see page 29) represents the judgment of
millions as revised by one.

THE MASTERPIECE OF THE TYPE

A 10*b*	G 5*b*	L 5*a*	T 5	Y 9*c*	&a 1*a*	&a 2*a*
B 12*b*	H 16*b*	M 2*b*	T 2*b*	Y 3*a*	&a 8*a*	&1 2
B 17*b*	H 4	M 6*b*	T 6	Y 3*b*	&b 1*a*	&l 2
B 11*a*	H 3*c*	M 4*b*	U 5	Y 6*a*	&c 2*a*	&m 1*a*
C 11	H 8*a*	N 6*a*	U 4	Y 13	&d 1*b*	&m 1*f*
C 16*a*	H 7*a*	N 7*b*	U 2*a*	Y 11*a*	&e 4*a*	&m 2*a*
C 14*b*	H 12*b*	N 5*a*	V 2*a*	Y 4*c*	&e 3*a*	&o 1*a*
C 9*b*	I 2*a*	O 3*a*	V 5	Z 14*a*	&e 6*a*	&r 1*a*
C 9*a*	I 2*b*	P 6*b*	V 4*a*	Z 7*b*	&f 3*b*	&r 4*b*
D 12*b*	I 3*a*	P 6*a*	V 3	Z 7*a*	&f 8*c*	&r 4*d*
D 2*a*	I 3*b*	P 4*a*	W 4*a*	Z 3*a*	&f 11*d*	&s 1*a*
D 13	I 4*b*	Q 11	W 2*b*	Z 5*b*	&f 17*a*	&y 1*f*
D 11	I 9*b*	Q 2*b*	W 3*b*	Z 2*a*	&f 17*c*	
D 10*a*	I 7*a*	Q 7*a*	W 4*c*	Z 2*b*	&f 18*d*	
D 3*a*	I 18	R 2*a*	W 5*b*	Z 4*a*	&f 24*b*	
D 20*a*	J 8	R 14*a*	X 8*b*	&a 12*a*	&f 28*d*	
D 19	J 4*a*	R 2*b*	X 3*a*	&a 19*b*	&f 29*b*	
E 8*c*	K 2*b*	R 3*b*	X 4*b*	&a 18*b*	&f 37*a*	
F 6*a*	K 10*b*	R 4*b*	X 5*a*	&a 12*d*	&f 38*a*	
F 6*b*	K 8*c*	S 2*b*	X 5*b*	&a 13	&f 40*c*	
F 5*a*	K 5*a*	S 6*a*	Y 10*b*	&a 16*b*	&k 2*d*	
F 4*b*	L 9*d*	S 13*b*	Y 10*a*	&a 20*a*	&k 4*d*	
G 5*a*	L 10*a*	S 10*b*	Y 9*b*	&a 8*b*	&l 1*b*	

HISTORY OF CHINESE LATTICE

The history of lattice *per se* has not been the primary interest of the collector. He has rather sought to present in a systematic way the finest Chinese lattice from all times and places. To comprehend it, however, some inkling of its historical development is necessary.

Primary data on the lattice used during the last three thousand years are scanty. Lattice has been constructed largely of wood in wooden architecture, and few of these buildings, even from the Ming dynasty, have survived. Consequently we are forced to rely upon secondary and tertiary evidence. In spite of the bulk of the material here presented, it is not safe for the reader to conclude that all of the major forms have been unearthed, that all of the minor groups developed in historic times have been located, or that all of the finest specimens of late lattice have been found. Although the writer has followed every lead he has been able to discover, no one is more aware than he that important lattice, past and present, has not been exhausted. The collector has gathered twenty per cent more plates than are included in this work, and he still maintains an expectant attitude. A number of points, however, may be stated with assurance about the history of lattice.

Study of Chinese archaeology reveals that Chinese lattice has seen a history of at least three thousand years, with periods both of growth and of retrogression. Belief in the Heavenly Ruler and in the Sovereign Earth and in the ancestral spirits was widespread, and runs through the generations. Commercial contacts, cultural borrowings, and religious accretions have had their influence, but the prevailing threefold belief has tended to conserve and elaborate the old fundamental forms and patterns. Again, the creative spirit has tended to produce new forms and variations on old themes.

Geometric and genetic relations determine, in general, the ordering and numeration of the lattice examples, especially within the group. The A-B-C groups do not necessarily follow in chronological order of origin. The reader must not be misled by the dating of the plates. The date is an approximation of the date of construction of the particular window drawn, which must not be taken to mean the date of the prototype whence the example came, or of the earliest window of which it may be a facsimile. Thus a plate dated 1700 A.D. may follow lattice dated 1900 A.D., and in turn may be followed by an example dated 200 B.C. or 1800 A.D. Many of these have scarcely varied from their ancient dynastic prototypes, so that genetically

these late forms rightfully precede examples centuries old. In general the plates within the group begin with the simple and proceed to the complex, but it is not safe to assume that this necessarily was always the order in which the patterns were developed. Lattice history is more complex than the order would suggest.

Lattice of 1800 A.D. is abundant, lattice of 1700 A.D. is reasonably common, while lattice in wood of 1600 A.D. is unusual in China. Some few books containing lattice have come down to us. Other books containing indirect evidence survive. But pictures on silk, designs on porcelains, patterns on brick and stone in tombs, in memorial arches, in caves — all these add to the fragmentary evidence of antique lattice designs. Few of these can be dated earlier than 200 B.C. Information on older lattice depends largely upon bronze and pottery which has been preserved in caves or graves, or by accidental or intentional burial when flood, fire, robbery, or war threatened. Ancient sacrificial vessels of bronze, offerings of money, imitation houses of clay, pattern brick and the like bear eloquent testimony to the life and practice of times remote. Bronze vessels for oblations, libations, or sacrifices, when prepared by the largess of the ruling house or by the family itself, were often covered with geometric patterns and dated by moulded inscriptions in old characters or graphies. Still other information is afforded by a few Chinese characters which still retain features revealing their lattice origin. Other corroborative data come from forms introduced into Japan during the T'ang dynasty.

The first clear-cut suggestion of lattice grille comes from the old graphies or pictographs found on ancient sacrificial bronzes of the Chou dynasty, which are probably no earlier or but little earlier than 1000 B.C. They simulate vertically barred gates in connection with temples and ancestral halls, although some would explain them as stands or cases for the family register or books made of bamboo or of wood. These are taken from Ch'ien-lung's *Catalogue of Bronzes* (cf. &u1*g* and &u2*u-v*).

For the Han dynasty, more trustworthy evidence of lattice practice is found in pictures on grave-bricks, and in house models in clay placed in graves, and from iron-tooled patterns on tomb walls. From the second century B.C. to the present time more or less trustworthy data exist on lattice design and practice. From the T'ang dynasty to the present, pottery, clay houses, painting, printing, and brick and wooden buildings have combined to make the story of lattice more connected.

Notwithstanding the fact that pages here and there have been lost, the story of Chinese lattice can be told with some assurance. For Pre-Chou lattice, or lattice of the second millenium B.C., we have

little evidence, but the skill shown in bronze design and manufacture presupposes houses and possibly the forerunners of later windows. The string or wire saws that sawed so truly hard stone ceremonial instruments of those days may have been used to shape grille-scroll to the intriguing designs affected on contemporary bronze vessels. Surviving implements and primitive characters give but little hint of patterns used in the earliest Chinese lattice. This much can be said with assurance, however: the rare ornaments with their line-ended designs which captured the imaginations of workers in bronze of those days are forebears of types used, dynasty after dynasty in China, in various media, and during the Ming and early Manchu dynasties in lattice grille carvings. It is also probable that woven and straight-bar grille came to assume regular forms before the close of Pre-Chou times.

Even Chou dynasty lattice (of approximately the first eight centuries of the first millenium B.C.) is somewhat nebulous. Waves, thunder-scrolls and cloud banks were known. Indented corners were employed in designs on Chou and Pre-Chou bronzes. All of these ideas appeared some hundreds of years later in lattice, but the writer has not found conclusive proof that they were incorporated in the lattice grille of Chou days. However, the evidence is largely negative. Yet it seems natural that only the simplest grille should be depicted on the bronzes, just as the simplest of window designs are depicted upon porcelains of later times. Windows were undoubtedly few, and transparent or translucent materials on them were used by the wealthy only. Silk cloth may have been employed to obstruct vision and to admit light into the houses of the wealthy and the palaces of the rulers. Thus about all that can be positively affirmed is that prior to the Han dynasty vertical and equally spaced bars in grille were used, and that smoke was allowed to find its way through bars as early as 1000 B.C. Early Chinese characters and pictographs testify to these points. But the advanced state of bronze work should have been paralleled by an equally advanced state of window fabrication.

Passing now to the Han dynasty (206 B.C. to 220 A.D.) it seems reasonable to suppose that window coverings did not vary much from those of the Chou, although the use of paper for this purpose may date from the first century A.D. Han tombs bear evidence of an acquaintance with mica, but we have no proof that it was used in windows as in Hangchow today.

The Han dynasty used coarse and heavy grille, especially in balustrades, although thin bars were not unknown. The spaces were larger than those of the Ming and the Ch'ing dynasties. The Han used the lozenge, the square, the circle, the oval, the wave, the ice-

ray, and the thunder-scroll; these were often interlocked or superimposed. Grille windows seem to have been fewer than they are today. Two mortuary houses are shown in the *Encyclopaedia Britannica*[14] (Vol. 18, Plate XXIV, No. 7, facing p. 359 and Plate XXVI, No. 4, facing p. 361). The first illustration is from the Han and the second is from the Pre-T'ang period. The grille designs are identical, viz., a lozenge supported on X-crossbars from corner to corner of the rectangular window. The first, from Han, uses the single bar, and the second, from Pre-T'ang, uses the multiple bar. China has continued the pattern with the Han single bar, while Japan has borrowed the pattern and the Pre-T'ang double or triple bar. The writer has found but one Manchu dynasty grille which uses this principle (in Canton), and he suspects the design may have come from Japan.

During the T'ang dynasty (618 A.D. to 907 A.D.) and immediately before, large open spaces obtained, especially in balustrade grille. Window bars equally spaced, vertical, and near together, and then crossed by parallel and horizontal bars at the top, at the bottom, and at the middle, were also used. The rare andiron pattern was employed immediately preceding the T'ang and was transmitted to Japan,[1] where it still thrives in modern lattice, but it has long since disappeared from use in China.

The writer believes that this andiron pattern, as well as crossed frames akin to the so-called Han line (Group M), were evolved in China during the Han days, but he has no direct evidence for this. He bases the supposition upon the fact that they are very closely related to the Han bracket, which arose during the Han dynasty, is common in Japan and is still used somewhat in China. In design, these are all closely related to the full-bellied round so characteristic of Han bronzes.

Funerary bronze and pottery which show lattice are not so abundant from T'ang as from Han times. Although primary data for T'ang lattice are so few, secondary and tertiary evidence points toward a refinement and an increase in the use of lattice during this age when China achieved such a high level in art and literature and made her political prestige felt throughout the Far East and northern India. It may safely be assumed that by this time paper and other materials were certainly utilized in windows much as they are today, but the writer has not been able to discover documentary

[1] This may be seen in an illustration to an article by René Grousset in *Asia*, September, 1934, p. 530. The building is one of the famous Hōryūji group of Buddhistic temples of the Chinese type built by Korean workmen in 607 A.D. near Nara, when Chinese influence was strong; it can be seen to better effect in the ancient pagoda nearby. In Kyōto the same pattern has been recently used in stair-well balustrade in the fine Commercial Museum.

proof. The present-day connotation of the word "window" in China implies the use of paper covering, even as the same word in the Occident involves glass. The writer believes that paper was used during the Han dynasty and onward. The shift from lattice to glass windows in the Occident led to enlarging of the open spaces. Shifting from guard to screen lattice (without translucent covering) necessitates making the bars small and placing them close together, as found in the Near East today. But the addition of a translucent covering like paper enlarges the small open spaces. The interpretation of the grille of more or less crude funeral furniture in clay is not easy. The patterns presented may be simplified, owing to the tools of the maker; it may represent a guard lattice; it may represent a screen lattice with or without translucent coverings.

With the Sung dynasty (960 A.D. to 1279 A.D.) the student of lattice is on firmer ground. Sung dynasty cloth and its patterns survive to the present. The well-known book on Chinese architecture, the *Ying Tsao Fa Shih* of 1103 A.D., has been preserved, and has been reprinted by The Commercial Press of Shanghai (1927). It contains drawings which give a few lattices of that day, while other points throw light on the designs employed. The circle and the square and their combinations were still used. The gold coin motif was used, both in rectangular and in hexagonal interlock. Much experimentation was being done with superimposed patterns, with the octagon-square allover, with the superimposed honeycomb, and with multiple beading. Not a little of the Ming dynasty lattice was an exploitation of ideas that emerged during the Sung dynasty and earlier. Multiple borders and the use of flowers in toggles were becoming common. Degeneration from strong bold designs set in, and over-ornamentation was under way, before the end of this era.

The Ming period (1368 A.D. to 1644 A.D.) continued to use the octagon-square, the octagon especially being exploited to the limit. One is inclined to term this the Ming pattern. Interlocking was much employed, and design became much more complicated and even fussy. The allover gold coin pattern was common. Some simple and very open lattice of delicate bars is found; yet in railings of balustrades there were some very heavy bars with characteristic corners which suggest the curves and corners of Ming vases. A few one-footed dragons carved on doors or temple balustrades are superbly done. They are more graceful than the archaic prototypes derived from ancient and classic bronzes. Some of the lattice, especially the octagon-square work, seems to have been taken from the brocade of golds and blues which went from Chengtu to the Chinese capital in the days of the Mings. The delicacy and complexity of the work seem to defy the carpenter's skill; the carver and the joiner cooperated in

perfecting the masterpieces of lattice. Depth was produced by front surface carving, but the inside of the window was kept flat for the pasting on of paper. Japanese and Chinese lattice diverge more and more during the Ming period. Little ornament and surface carving on lattice appears before the Sung dynasty. From the Ming dynasty onward, China applied ornament on bars and even carved small window grille out of single boards; a few examples of these are still *in situ* in Szechwan. In Japan the wonderfully carved *ramma* above the moveable partitions between rooms of Japanese houses challenged the carver's skill, yet the lattice of these partitions remained simple.

The Ch'ing dynasty (1644 A.D. to 1911 A.D.) saw a great multiplication of lattice forms. Fashions vary by place and by ruler. The major portion of these plates date from this period, but for the most part they are derived from earlier models. We shall discuss them from the regional standpoint.

During the Ch'ing dynasty, lattice as shown in these volumes reached its climax in variety and quantity. All of the twenty-six families were used during this period, though it is not always easy to ascertain when some of them were transferred from paintings and porcelain to lattice, or in which place they were first employed. The too heavy rectangular scroll ends were used before this time, but they were more affected in later lattice. The knuckled frames were commoner a century ago than they are today, while elaborate curved ends were more in vogue three centuries ago than at present. At the end of the nineteenth century lattice was too elaborate; tricks, devices, and ornaments had been multiplied, and finished work was cheapened in many respects.

Five centers stand out during the last century as offering more or less distinctive and characteristic designs. A few types are common to a majority of the five centers, but a majority are found in scarcely more than two. A typical lattice window will almost locate the province, and possibly the town, where the photograph has been taken. In Szechwan there are several distinct country centers of lattice.

Peking, or Peiping, during its ascendancy as the capital of China, was a center of characteristic lattice. A few simple types prevailed, rather staid patterns, like K9*b*. Peking stands fifth in order of importance; its influence extends to the north and to the northeast, and to the southwest along the dry roads. Mongolia, Manchuria, and even Korea have many windows in common. Mukden has had a few fine types, and from it has spread real lattice superior, though akin, to that of Peking of later days.

Soochow, Nanking, and Hangchow rank fourth in richness of

windows. These three cities are closely connected by waterways and canals, and may be classed as one art center. Usage varied in these cities, but much was common to all and successful designs spread quickly. Soochow was probably the leader of the three before the Taiping Rebellion of 1850–1864 A.D. Windows like C9*b*, E2*a*, L10*a*–*b*, and &a2*e*, were characteristic of the region. This section is in advance over Peking; more imagination and more delicacy in line and design are shown.

Wu-Han, the so-called Chicago of China, was the third center during the past century. Wuchang, Hanyang, and Hankow are the three cities which grew up around the junction of the Han with the Yangtse River. Hither came the scholars for the tripos in the days of the general examinations. Here was the center of art and culture for Central China. Here had been the meeting place of official life for centuries. Hitherward floated the commerce, by junks and rafts, from vast and populous regions. From here comes such lattice as W4*c*.

Canton is the second ranking center. Hard woods were available and were brought in by sea and river; for centuries fruitful contacts brought in ideas with goods from far and from near: from Central China, North China, Japan, and even as far as Arabia. Daring carving and joining in patterns were possible and feasible more than at any other point. Canton lattice has changed much since the earliest days of the East India Company, but much remains that is patterned after the old. Old forms in the furniture are retained here. Such rare patterns as B2*a*, *c*, *d*, *e*, *f*, *h*, and &a12*c* are extant today in Canton and its environs. This city has been in touch with the outside world during recent centuries and up to the present, yet it has been able to put its stamp on most that was borrowed from without as well as from within.

Chengtu is the foremost lattice center of China. The trade routes of the Chinese radiated with the north, northeast, east, southeast, south, southwest, and west. There was the Chengtu-Yachow-Tachienlu gateway to Tibet; the Chengtu-Songpan-Kansu way; the Chengtu-Kwangyüan-Hanchung gateway to Shensi and Peking; the Chengtu-Chungking-Ichang-Yangtse gorge portal; the Chengtu-Suifu-Yünnan door; and the Chengtu-Yachow-Bahmo route. These were all, in turn or simultaneously, ways of ingress of ideas as well as of goods. Szechwan's medicinal plants and roots, her teas, dyes, white wax, wood oil and varnish, agricultural products, pig bristles, casings, ores, wool, and musk drew traders from many places. The provincial guilds, in which have centered the out-of-province tradesmen and business men, brought of their best, and erected great buildings, that ranked with temples in wealth of detail and execution. These guild halls are fast becoming institutions of the past since the

revolution of 1911. The Yünnan guild halls and the Shensi bankers' places of business introduced into the province good examples of the builder's art. The Shensi bankers have ceased to function in Chengtu; moreover, the old official system insisted that the offices of viceroy, treasurer, and a few others, be filled by out-of-province men, who should be replaced at least every three years. These men were often connoisseurs in art and archeology, and assisted the interchange of ideas in lattice as in other things, not only in Chengtu but in other centers. Such centers were also places for the hangers-on and the candidates for positions.

Outside of the metropolitan cities certain "islands" of culture remain, such as that bounded by the roads between Penghsien, Kwankou, Kwanhsien and Chengtu, where designs centuries old have been retained because they are off the routes of travel. Religions and religious strongholds have also played their part; Mount Omei, one of the sacred spots of Buddhism, with its numerous temples preserving ancient windows and designs through centuries, has had a profound influence on the lattice art of the province (cf. comment under D28a-36b). Besides these contacts with other parts of China proper, Szechwan borders upon, and so has been fertilized by influences from, Tibet and a hinterland occupied by various unassimilated tribes. In their mountain fastnesses they have kept ancient weave-patterns and designs; these are available on the streets of Chengtu. The location of lattice motifs in Szechwan is also distinctly related to destructions and migrations of peoples. In the northeastern part of the province population has shifted several times after famine caused by drought. And after the holocaust of the destroyer Chang Hsien-chung at the end of the Ming dynasty there was an influx of people from Canton, Peking, Hupeh, Yünnan, and Kweichow. Many fine and varied patterns thus found their way to Szechwan. Another factor of importance was the early use in the west of paper and block printing. Szechwan has been famous for paper, and still exports it to Shensi over the old Imperial Highway. Owing to these and other causes, the writer considers Chengtu in 1750 A.D. the supreme focal point of lattice design of all time. Ch'ien-lung, the Builder, an outstanding figure in Chinese history, was at this very time doing his work in Peking; but it did not equal that in Szechwan, if one may assume that what one finds in Peking today is genetically related to the work of that time, as present-day lattice in Szechwan is related to that of days agone.

Shanghai is a new and rising capital, where the ships of the seven seas steam into the Whangpoo and dock. Here some of the best of Chinese and foreign designs are being revamped and re-created, as people work with new materials and methods to meet the exigencies

of modern life. The little fishing village of a century ago is rapidly becoming a cultural and artistic center as it assumes the role of the commercial and manufacturing capital of China. The builders of all nations are putting up structures somewhat after the fashions of their own land; but here and there are buildings which reflect world-wide contributions. No longer are these workers bound by precedent and hindered by lack of materials; they are free to use brick, concrete, tile, porcelain, wood, and iron. Chinese designs, often modified, it is true, are appearing in iron sewer covers, wooden furniture, concrete and tile roofs. Shanghai is rapidly becoming a center for the conservation, translation, and re-creation of forms and designs. In the interior, from the several points previously mentioned, much Chinese art and design has departed, only to reappear in Shanghai.

As for relations between Chinese lattice and the art of other countries, here is copious evidence of contact and influence. In Japan, lattice similar to the vertical horizontal bar type of A10b, which dates from the end of the Ming dynasty, is prevalent. But Japanese and Chinese lattice have diverged for some centuries, and each today has its own marks of distinction. In the United States, furniture which dates from the time of the clipper ships shows a definite trace of Chinese influence. In the second edition of Chippendale's catalogue *The Director*, published in 1755, one finds a definite statement that he is depicting furniture made according to "the Gothic, Chinese, and Modern taste." In Indian architecture such as one finds at the Taj Mahal, one might expect to see a definite relationship, but as a matter of fact the difference in material has produced a real difference in result. Throughout India elaborate patterns have been worked out in stone rather than in wood, and the purpose has been more largely that of ornament than of use. In the Moorish architecture of Granada and elsewhere this has also been true. In general we may say that Chinese lattice is unique.

The lattice art in China has been declining for a number of years, coincident with the influx of Western influence. The Sino-Japanese war of 1895 may be taken as the date of the call to China to awake. The leaders more or less dimly heard the call. The Boxer days stirred every province, so that the date of 1900 A.D. may be said to mark the beginning of the end of Chinese lattice as such. The revolution of 1911 made a break with the past. Then by 1920 steamers and railroads and automobiles began to reach many places, so that glass became cheap and available, and was also manufactured locally. Another factor in the decline of lattice was the increase of taxes, which made temple upkeep difficult, as did the dearness of labor. The introduction of science and of Christianity had their effect in weakening belief in malign spirits, in idols, and in temple

worship. By 1927 many temples were occupied by soldiers so that worshippers greatly declined in numbers. The glamour of Western inventions and innovations has turned men away from the values of China's cultural past. Chinese lattice as well as other art work in China has suffered since the revolution of 1911. The greater number of the window designs selected and presented were executed before 1900, and this is taken as the terminus of this collection, though it would not have been possible then for such a collection of plates to have been made. Freedom of travel, especially in West China, was not so general then as in recent years; the museums and libraries and art collections of the world would not have been able to offer the assistance three decades ago that they do at present. But so far as possible the writer has tried to base his conclusions on the Chengtu, Hankow, Peking, Soochow, and Canton of 1900 A.D. and before.

CLASSIFICATION OUTLINE

"To learn to classify is in itself an education." — Alex. Bain.

I. FIELD DIVISION

1: ALLOVER

A. Parallelogram	A1–	A10*b*
B. Octagon	B1–	B20
C. Hexagon	C1–	C17*b*

2: FRAME

D. One Focus	D1–	D36*b*
E. Two Foci	E1–	E8*c*
F. Three Foci	F1–	F8
G. Five Foci	G1–	G8
H. No Foci	H1–	H16*l*

II. LOCKING SYSTEMS

3: KNUCKLE

I. Wedge-Lock	I1–	I18
J. Presentation	J1–	J12*b*

4: INTERLOCK

K. Out-Lock	K1–	K14*d*
L. In-Out Bond	L1–	L10*b*
M. Han Line	M1–	M8*b*

III. LINE FLOW

5: WAVE

N. Parallel Wave	N1–	N8*b*
O. Opposed Wave	O1–	O9
P. Recurvate Wave	P1–	P6*b*
Q. Looped Continue	Q1–	Q12*b*

6: SWASTIKA

R. Like Swastika	R1–	R14*c*
S. Unlike Swastika	S1–	S16*b*

IV. LINE ENDING

7: JU I SCEPTER

T. Central Ju I	T1–	T8*b*
U. Allover Ju I	U1–	U6

8: THUNDER SCROLL

V. S-scroll	V1–	V8*c*
W. U-scroll	W1–	W7*c*

V. BROKEN LINE

9: ICE RAY

X. Rustic ice-ray	X1–	X8*b*
Y. Symmetry ice-ray	Y1–	Y15

10: CIRCLE-AND-SQUARE

Z. Square-round	Z1–	Z14*b*

&. SUPPLEMENT

Euclid alone has looked on Beauty bare.
Let all who prate of Beauty hold their peace,
And lay them prone upon the earth and cease
To ponder on themselves, the while they stare
At nothing, intricately drawn nowhere
In shapes of shifting lineage; let geese
Gabble and hiss, but heroes seek release
From dusty bondage into luminous air.

O blinding hour, O holy, terrible day,
When first the shaft into his vision shone
Of light anatomized! Euclid alone
Has looked on Beauty bare. Fortunate they
Who, though once only and then but far away,
Have heard her massive sandal set on stone.
 Edna St. Vincent Millay, "The Harp-Weaver."[1]

[1] Quoted by permission of the publisher, Harper and Bros.

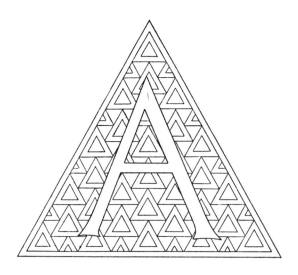

A. PARALLELOGRAM

This group is far more widespread than the number of plates given here suggests. Taking China as a whole, a greater number of lattice windows fall within this section than within any other of the twenty-six groups. In Japan, also, one finds that most lattice windows are of this type. Its simplest form is not presented here, but is merely suggested. The reader may easily envisage it by eliminating all flowers and toggles from 3*b*, and filling in cross-bars until there is a simple allover square pattern. Such a window is used today, and has been extensively used all through China. It is simple, cheap, and strong. Symbolically it represents the deity of earth. It is employed in square windows of eighteen to twenty-five squares on a side for the movable upper section and in four to six rows of equal width in the stationary lower portion.

Variations in this pattern include open centers four or more units square in the upper section, as well as oblong vents in the lower. Again, some windows stand vertically and others horizontally. Some have all bars on the diagonal, such as 3*a*, with no toggles and no voiding. Another pleasing window in the simple square has one or two large reinforced squares within the outer frame, which emphasizes the symbol earth (cf. A: Parallelogram).

2*a–c*. EMPTY SQUARES IN OUTLINE

a. Shop, Chengtu, Szechwan, 1750 A.D. *b, c.* Temple outside Canton, Kwangtung, 1750 A.D.

Although these windows are far separated in location, there seems to be real relationship between them. Such windows are now unusual

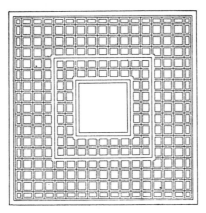

A: PARALLELOGRAM

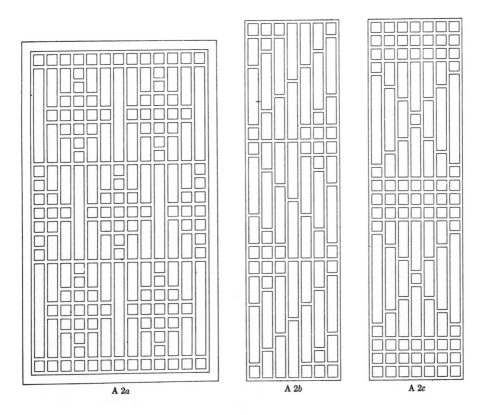

A 2a A 2b A 2c

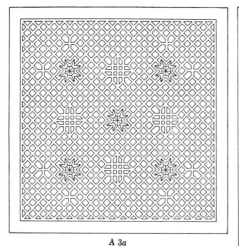

A 3a

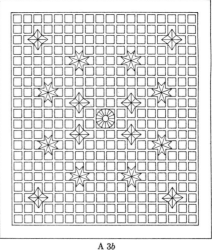

A 3b

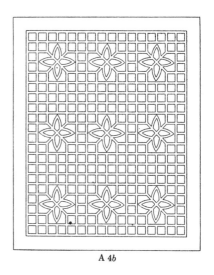

A 4a

A 4b

in these localities. *b* and *c* are completed by mirror-image on the right-hand side, with the center of symmetry in the middle of the light spots on the right. Soochow, Kiangsu, in 1635 had lattice closely related to these specimens.

3*a, b*. Square Lattice with Flowers

Buddhist temple, Mount Omei, Szechwan, 1850 A.D.

a. If one replaces all ornamentation by straight bars on the diagonal a fine window results, made up of two diagonals crossing at the center and surrounded by crossed and concentric frames up to the number seventeen (cf. D12*a*–13). But this plate has spaces and ornamentation which include smaller crossed and concentric frames both in squares and in octagons. There are two oblong octagons which cross each other through the center. These octagons are somewhat unusual in the way each is divided down the center.

b. This variation of a simple design by the mere addition of toggles is a very common device.

3*a*–9*b*. Omei Windows

Buddhist temples, Mount Omei, Szechwan, 1750–1900 A.D.

Mount Omei and the foothill region, especially to the west of the mountain, have windows of one general type. These are classified in several groups, since structure determines classification; but there has been so much uniform development in this region that the classification has been most difficult. The following groups contain most of the Omei windows: A3*a*–9*b*; B9*a*–10*b*; B11*b*–12*a*; B14*a*–*b*; D28*a*–36*b*; G2*a*–4*a*; H10*b*–12*a*; L3*a*–7*b*; O8*a*–9; Z6*a*–*b*. There are a few other single plates scattered through the groups.

There are individual variations, but the general characteristics of these windows are as follows:

 (1) Squares are usually in vertical-horizontal relation.
 (2) Spaces and X-substitutions incorporate the octagon.
 (3) Ornament is applied in such a way as to give five directions or focalizations.
 (4) The endless line is used in some form.
 (5) Units are small, so that windows transmit a relatively small amount of light.
 (6) There is usually an enframing border of small units, or a frame just within the external one (cf. 3b–7b).

A. PARALLELOGRAM (*continued*)

(7) The external surface of most bars is flat, giving a right-angled bead.

It would seem that window-design in this section has been more consistent than has that in many other parts of Szechwan. It suggests types widespread during the Ming dynasty and earlier.

Similar ones are found in distant localities where fashions changed but slowly. Chang Hsien-chung's devastation at the end of the Ming dynasty did not so seriously affect this section. In spite of the comings and goings of pilgrims this area remained in some respects a backwater, and retained the old forms through the Ch'ing dynasty.

It is curious that the Buddhist swastika scarcely found a foothold on Mount Omei, with its numerous Buddhist temples, and its pilgrims coming from afar. The writer attributes this to the fact that the general type of these windows antedates widespread use of the swastika in lattice design. Additional information in regard to Omei windows may be found under D28a–36b.

4a. Note the interlocking squares, the border of unit squares, and the five-direction ornaments.

4b. Note the interlocking oblong octagon-squares. The flowers somewhat conceal the octagons.

5a. The cross-bars in threes are unusual today. The large octagon stands alone, and the window as a whole is not successful.

5b. The central octagon and the external octagon are pleasing.

6a. The octagons seem involved with a maze of lines. The two opposed waves across the center are continued in the neighboring windows in the same bent.

6b. The octagons, the pseudo-octagons, the squares, a few endless looped lines, and the right-angled waves that extend to the other windows of the bent are worth noting.

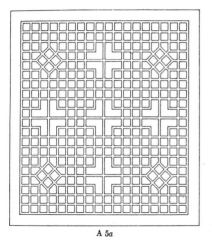

A 5a

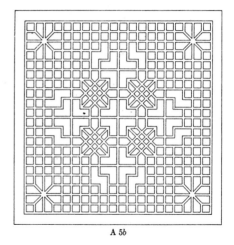

A 5b

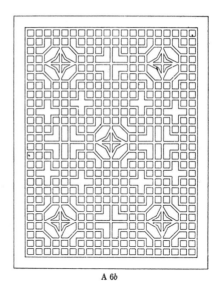

A 6a

A 6b

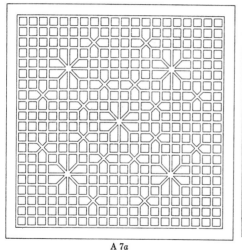

A 7a

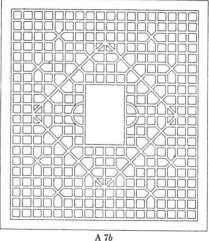

A 7b

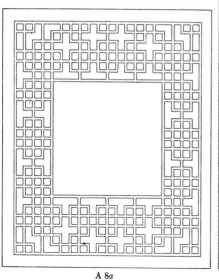

A 8a

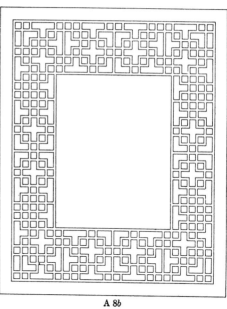

A 8b

A. PARALLELOGRAM (*continued*)

7*a*. This is one of the finer windows which is worth analyzing to show the use of the octagon-square. The oblong crossed octagons at the center, the severed ends of oblong octagons to the right and to the left with reversed and smaller ones inside, and the large outlined octagon enframing the center are effective.

7*b*. This was done by a master of technique like the designer of 7*a*.

8*a–b*. These are not very common at Mount Omei or elsewhere.

A. PARALLELOGRAM (*continued*)

9*a–b*. The triple cross-bars are rare in China today. The peculiar looped squares at the four corners are also unusual.

10*a*. VERTICAL AND HORIZONTAL BARS

Provenance in Szechwan uncertain, 1775 A.D.

This window was probably found in an Omei temple, but specific data are lacking.

10*b*. VERTICAL-HORIZONTAL BAR LATTICE

Chengtu, Szechwan, 1775 A.D.

Windows of this sort are very common throughout China. Single, triple, or quintuple cross-bars at top and bottom and in the middle, with regular vertical bars, make simple and effective windows. The band across the middle may be wider or narrower than that at either end. These windows afford good material for a study of the effect of lines and their number and spacing.

This type of window with the double waist was popular during the Ming dynasty and probably before. A number of patterns are shown in the *Yüan-yeh*, published near Soochow, Kiangsu, in 1635 A.D. Most Japanese lattice windows appear from internal evidence to have been derived from windows such as these.

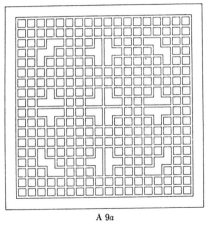

A 9a

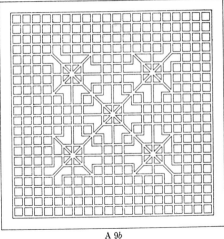

A 9b

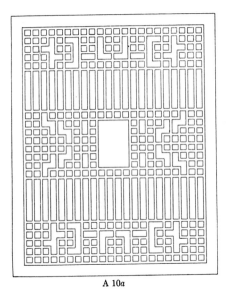

A 10a

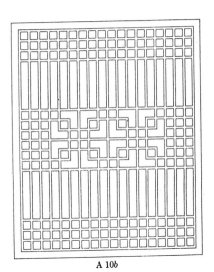

A 10b

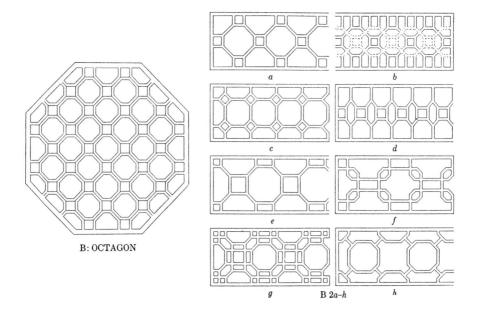

B: OCTAGON

a

b

c

d

e

f

g

B 2*a–h*

h

B 3*a*

B 3*b*

B. OCTAGON, OR OCTAGON-SQUARE

This species comprises those allover designs which utilize the variants in proportion, angles, bars, and spacings of the allover octagon square. Large octagons and small squares between each group of four give one emphasis, equal-sided octagons and squares, another. By changing the angles until the square becomes a lozenge and the octagon conforms, still a third effect is produced. This group was much used during and after the North Sung dynasty.

2*a–h*. VARIANTS OF THE OCTAGON-SQUARE

d, f, h. Canton, before 1753 A.D., in Thomas Chippendale's *The Director. a, c.* Chengtu, 1900 A.D. *b, e, g.* Dye, 1932 A.D.

The octagon series has many variants, but these six plates illustrate some of the basic methods of use.

a. Octagons in diagonal contact with "square" side short.

b. Repetition of *a* with its superposition one half-step to the right, in dotted line. This device is common in Szechwan and in some other parts of the country. It does not often fill a window, owing to structural weakness. Essentially this is the design noted in Finley's *Old Patchwork Quilts*, a "crown of thorns" quilt made in Connecticut in 1830, and a "garden maze" of about the same time which is remarkably like this superimposed octagon-square allover.

c. Octagons in horizontal (and vertical) contact, with "square" corners short.

B. OCTAGON, OR OCTAGON–SQUARE (*continued*)

d. Octagons placed in horizontal contact by the insertion of hexagons between the squares.

e. Octagons in diagonal contact with "square" sides long (cf. *a*).

f. Telescoping the octagons until they interlock is another variant of this device, which Chippendale used in his doors.

g. Alternating large and small octagons in diagonal contact with oblong rectangles arranged vertically and horizontally instead of with squares make this allover system.

h. When *e* is expanded until the octagons no longer touch, and short bars are introduced, this design is obtained. The Chinese character for "work" or "workmanship," 工, (&u *2f'*) is suggested by the short bar and its contacts. Chippendale employed this, but it came from Canton.

3*a*. Equilateral Octagons

Residence, Chengtu, Szechwan, 1725 A.D.

Octagon-square allover in simple form. The elements are of equal length, and the internal angles in the units are equal.

3*b*. Octagon-Square Bats

Shihfang, a foothill town a day and a half northeast of Chengtu, Szechwan, 1825 A.D.

This combination of shapes and symbols is somewhat crowded, but has more unity than might be expected. To be sure, the square and the octagon go together. Probably the character for "happiness" is written on the paper pasted over the window at Chinese New Year, so as to complete the "Five happiness" symbol. Structurally this window is not strong in wood.

4*a*. Single Oblong Octagon-Lozenge Allover.

Chengtu, 1850 A.D.

This sketch is inferior, as it was one of the first made. The lines are unequal, but the window is effective.

4*b*. Oblong Octagon-Lozenge.

Hankow, Hupeh, 1850 A.D.

This window is not so obviously centered as some, but the octagons and lozenges are alike vertical in intent.

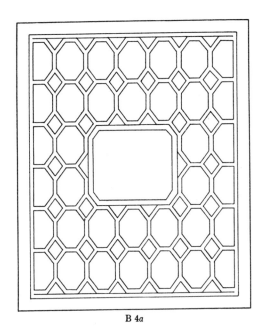

B 4a

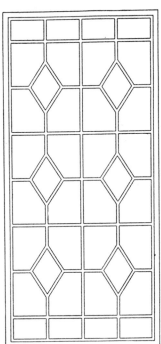

B 4b

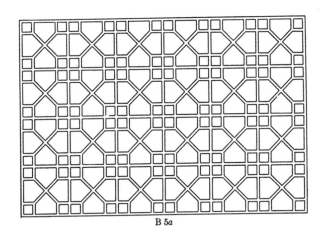

B 5a

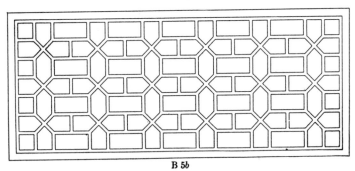

B 5b

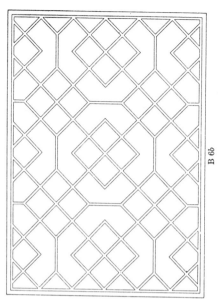

B 6b

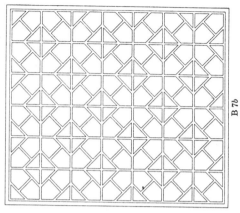

B 7b

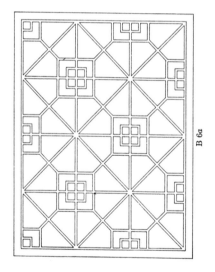

B 6a

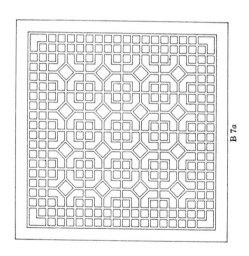

B 7a

B. OCTAGON, OR OCTAGON–SQUARE (*continued*)

5a. OCTAGONAL BROCADE
Street-side, Luchow, Szechwan, 1825 A.D.

When the twelve light spots within the octagons of this pattern were equalized in 1092 A.D., the pattern was called "The Adjusted Twelve."

5b. OBLONG INTERLOCKED OCTAGONS
Ch'ang-yüan, Wuchang, Hupeh(?), 1650 A.D.(?)

This is an excellent variation of octagon-square, hardly suitable for a large window.

6a. OCTAGON, CONCENTERED SQUARES, AND CLOUD-BOARD
Hsinchang, Szechwan, 1850 A.D.

A cloud-board is a square with one quadrant omitted (cf. &s 1*f*). It is done in metal or resonant stone and suspended by one corner so as to hang symmetrically. It serves as a musical instrument. In this window the cloud-board stands on one point, and is outlined by the diagonal lines.

6b. OCTAGON-SQUARE WITH SUPPLEMENTAL SQUARE
Hankow, Hupeh, 1850 A.D.

7a. ENFRAMED OCTAGON AND SQUARE
White Dragon temple, Mount Omei, Szechwan, 1800 A.D.

7b. SQUARES, GREEK CROSSES, AND OCTAGONS
Street-side, Chengtu, Szechwan, 1825 A.D.

The development of the squares, as well as their size, almost masks the octagons.

B. OCTAGON, OR OCTAGON–SQUARE (*continued*)

8a. SEPARATED OCTAGONS AND SQUARES

Hankow, Hupeh, 1825 A.D., and also Shaohing, Chekiang, 1775 A.D.
This design is a simple variation of 3*a*.

8b. OCTAGON-SQUARE SUBDIVIDED BY CROSS-BARS.

Luchow, Szechwan, 1850 A.D. Also found at Paocheng, Shensi, of
the same date or earlier.

9a. OCTAGON-SQUARE IN SPECIAL PATTERN

Buddhist temple, Mount Omei, Szechwan, 1850 A.D.

9b. UPRIGHT RECTANGLES AND OCTAGONS

Buddhist temple, Mount Omei, Szechwan, 1900 A.D.
This window is only a variant of the preceding one.

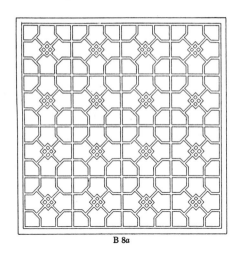

B 8a

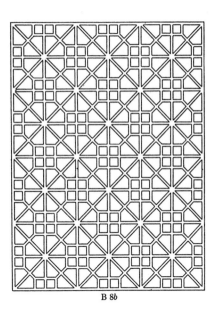

B 8b

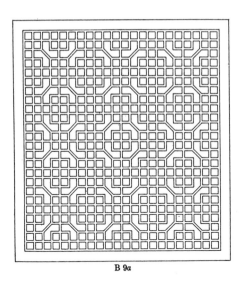

B 9a

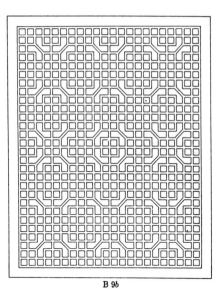

B 9b

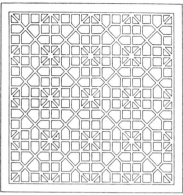

B 10a

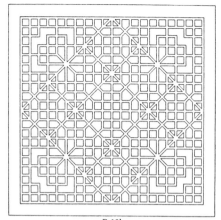

B 10b

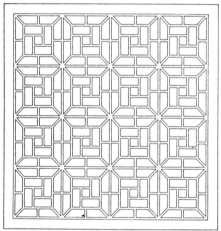

B 11a

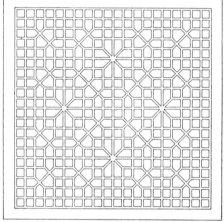

B 11b

B. OCTAGON, OR OCTAGON–SQUARE (*continued*)

10*a*. CROSSED AND CENTERED OCTAGON-SQUARE

Buddhist temple, Mount Omei, Szechwan; 1850 A.D.

This excellently illustrates the combining possibilities of the octagon-square. Two systems of octagon-square, and two systems of rectangular supports unite in this window.

10*b*. COMPLEX OCTAGON SQUARE

Buddhist temple, Mount Omei, Szechwan, 1850 A.D.

This variant of 10*a* exhibits an interesting diagonal checkerboard.

11*a*. INTERLOCKED OCTAGONS WITH CENTERED SQUARES

Chengtu, Szechwan, 1800 A.D.

Squares, octagons, and windwheels hardly seem to be kindred motifs, but the windwheels so disguise the overlapping systems of octagon-square that the design merely appears as a set of octagons in which the windwheels are inscribed within the central squares.

11*b*. IRREGULAR OCTAGON-SQUARE

Buddhist temple, Mount Omei, Szechwan, 1750 A.D.

B. OCTAGON, OR OCTAGON–SQUARE (*continued*)

12*a*. COMPLEX OCTAGON–SQUARE
Buddhist temple, Mount Omei, Szechwan, 1875 A.D.

12*b*. OBLONG OCTAGON–SQUARE SUPERIMPOSED
Minshan, on Yachow-Chengtu road, Szechwan, 1725 A.D.

13*a*. IRREGULAR OCTAGON–SQUARE
Buddhist temple, Mount Omei, Szechwan, 1850 A.D.

Octagons are separated and the squares are replaced by the swastika of R14*c*, with an additional small square.

13*b*. COMPOUND OCTAGON–SQUARE DESIGN
Chengtu, Szechwan, 1825 A.D.

The interlocked squares in this octagon-square design are unique. They were common as a simple pattern during the Ming dynasty and later, but not in combination with the octagon in this manner (cf. H 8*a*).

14*a*. SEPARATED OCTAGON–SQUARE
Buddhist temple, Mount Omei, Szechwan, 1875 A.D.

14*b*. CONCENTERED OCTAGON–SQUARE
Buddhist temple, Mount Omei, Szechwan, 1875 A.D.

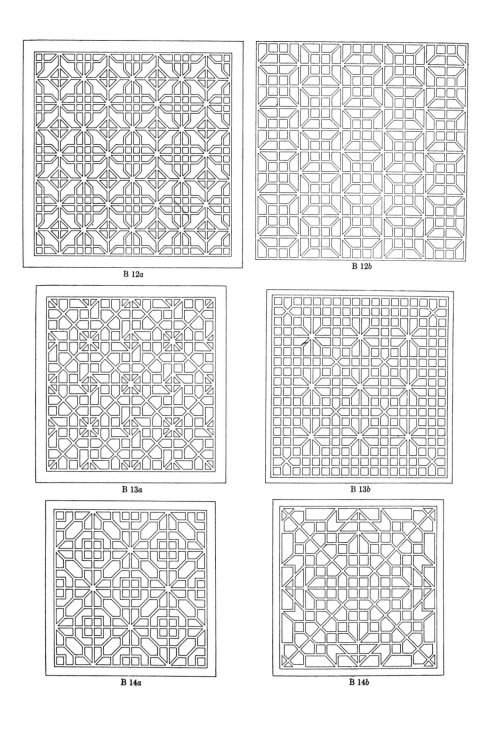

B 12a

B 12b

B 13a

B 13b

B 14a

B 14b

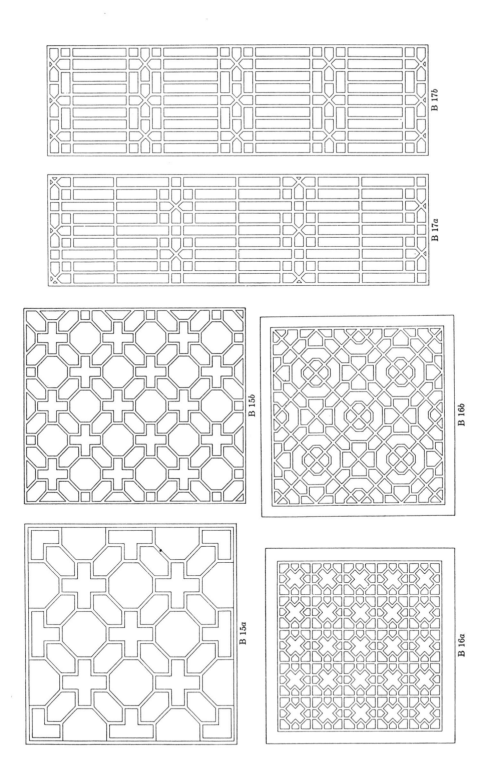

B 17b

B 17a

B 15b

B 16b

B 15a

B 16a

B. OCTAGON, OR OCTAGON–SQUARE (*continued*)

15a, b. OCTAGON, HEXAGON, AND TEN-CHARACTER

Penghsien, one day northwest of Chengtu, Szechwan, 1800 A.D. *b.* The proportion between thickness of bar and light spot is not that favored by the Chinese.

16a. SUPPORTED OCTAGON, HEXAGON, AND TEN-CHARACTER.

Chengtu, Szechwan, 1800 A.D.

The structurally weak design of 15a and 15b is supported by cross-bars.

16b. OCTAGON, HEXAGON, AND TEN–CHARACTER COMPLEX.

Chengtu, Szechwan, 1800 A.D.

A variant of the preceding.

17a, b; 18a, b. INTERLOCKED OBLONG OCTAGON-SQUARES

Yüan-yeh, Soochow, Kiangsu; 1635 A.D.

These are excellent variations of the regular equilateral octagon-square design. The four windows, as far as the writer knows, are of a type not now employed.

B. OCTAGON, OR OCTAGON–SQUARE (*continued*)

19. CONCENTERED OCTAGONS

Chengtu, Szechwan, 1800 A.D.

This is a complicated system of octagon-squares supported upon diagonal cross-bars. The drawing is inferior, as it was one of those first made.

20. CHAIR–BOTTOM WEAVE

Temporary house, Chengtu, Szechwan, 1917 A.D.

After the fire of 1917 when one-fifth of all the houses within the city wall were burned, Chengtu put up many temporary houses. Many windows were made of woven bamboo splints and some were covered with paper. This window conveys a suggestion as to how some of the lattice designs have arisen.

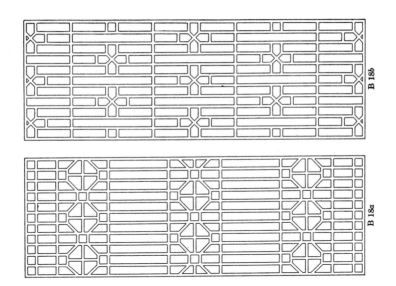

B 18b

B 18a

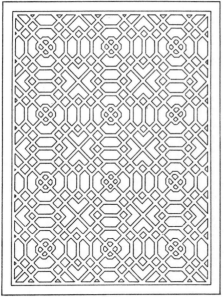

B 19

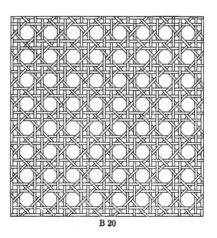

B 20

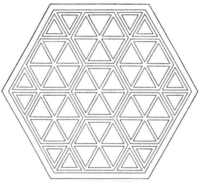

C: HEXAGON

C 2a

C 2b

C. HEXAGON

This might just as well be called the triangle group, as the hexagon is composed of six equilateral triangles. The hexagon (or triangle) holds its important position in single plane design for several reasons. It is structurally strong, enters into many combinations, interweaves, interlocks, and voids with great facility. Pleasing and harmonious permutations and combinations of the triangle and hexagon are legion. This group contains some of the finest and richest window patterns.

2a, b. SOME POSSIBILITIES OF THE TRIANGLE

Dye, 1931 A.D.

These two plates show a few of the many patterns which can be developed if one starts with a background composed of an allover of equal and regular triangles.

C. HEXAGON (*continued*)

3*a, b.* Turtle Back, or Hexagons

Residence, Chengtu, Szechwan, 1800 A.D.

In China the honeycomb is often termed the turtle-back, or turtle markings, or simply hexagon pattern. A century ago this design was used much more commonly than now. Skill, patience, and cheap labor are needed for such windows.

4*a, b.* Begonia Flower.

Yamen, Chengtu, Szechwan, 1700 A.D.

The empty hexagons show in outline the begonia flower, which gives this window its name.

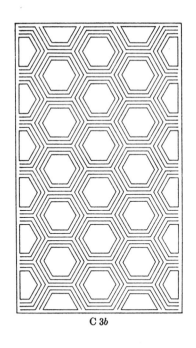

C 3b

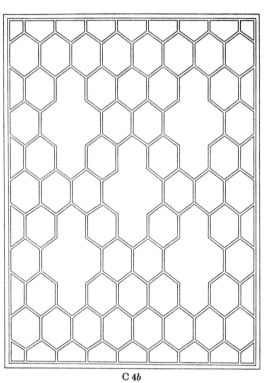

C 4b

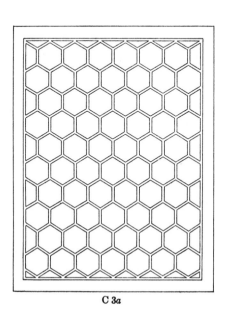

C 3a

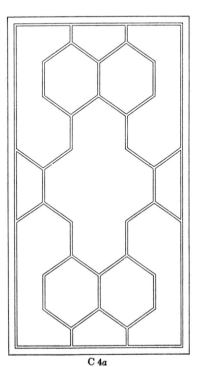

C 4a

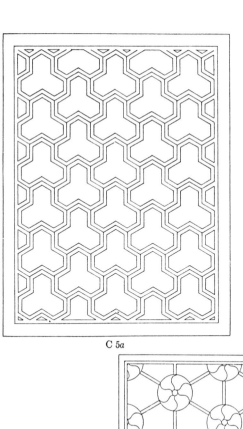

C 5a

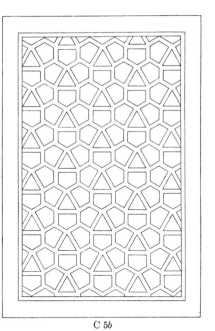

C 5b

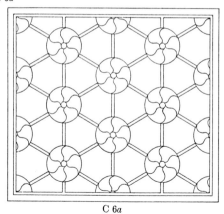

C 6a

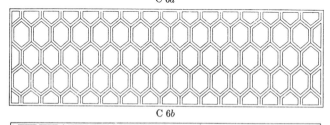

C 6b

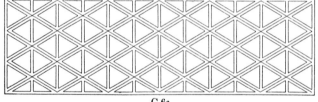

C 6c

C. HEXAGON (*continued*)

5*a*, *b*. COAT–OF–MAIL FOR DOOR GODS

Chengtu, Szechwan, 1800 A.D.

These designs were more often found as armor on the door gods than they were in window grilles, but they, together with the gods, have almost disappeared from the streets of Chengtu.

6*a*. HEXAGON–TRIANGLE AND FLOWER

Chengtu, Szechwan, 1800 A.D.

6*b*, *c*. TRIANGLES, QUADRILATERALS, AND HEXAGONS

Manchu city, Chengtu, Szechwan, 1800 A.D.

These two examples come from different streets in the same section. The narrow vertical bars are thinner than the diagonals, which is unusual in Chinese lattice.

C. HEXAGON (*continued*)

7*a, b*. FOURFOLD INTERLOCKED HEXAGON

a. Chengtu, Szechwan, 1875 A.D. *b*. Canton, Kwangtung, 1750 A.D.

This optical illusion design is actually made up of four allover hexagon patterns. It is frequently seen on brick walls at the sides of entrance gates.

8*a, b*. COMPOUND TURTLE–BACK AND CIRCLES

Wên-shu Yüan, Chengtu, Szechwan, 1825 A.D.

In the original window the centers were at one time touched with gold.

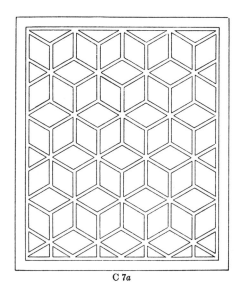

C 7a

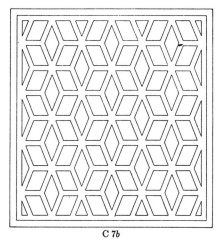

C 7b

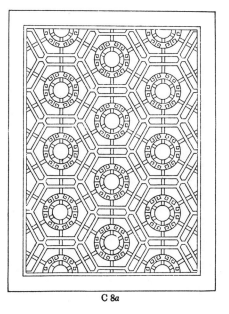

C 8a

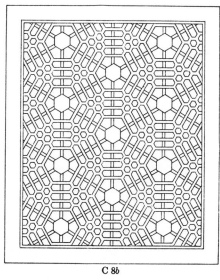

C 8b

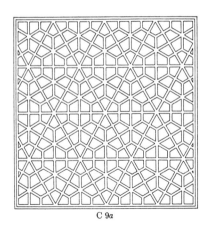

C 9a

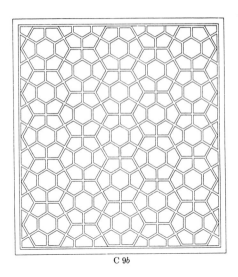

C 9b

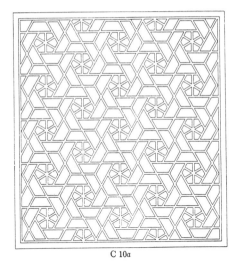

C 10a

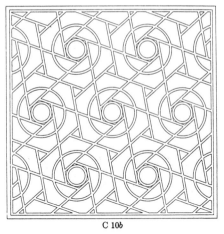

C 10b

C. HEXAGON (*continued*)

9a. COMPOUND HEXAGONS

Location and date, same as 8a, b.

This design is closely akin to the Ming pattern of C11. There is a plate like this one among the *Ch'ang-yüan* designs, but with a slight modification.

9b. CROSSED HEXAGONS

Shop, Shaohing, Chekiang, 1850 A.D.

The large hexagons are deeper than the bars of the two sets of smaller ones. This practise is unusual in Szechwan. In the original the depressed bars are in black and gold, while the others are in red and gold. In both cases the gold is on the outer face of the bars.

10a. SUPERIMPOSED HEXAGON SYSTEMS

Shop, Shaohing, Chekiang, 1850 A.D.

This is a combination of 3a in deep bars and Y2b in thin and shallow bars. The color combinations are like those of 9b. These types are favorites in this city of canals.

10b. SUPERIMPOSED HEXAGON–TRIANGLE ALLOVER

Shanghai, Kiangsu, 1900 A.D.

This is a rare combination of Y2b and Y3a.

C. HEXAGON (*continued*)

11. CROSSED CONCENTRIC HEXAGONS

Bronze plate, Mount Omei, Szechwan, Ming dynasty, 1603 A.D.

This pattern is taken from an exceedingly fine bronze temple tablet which has survived several fires. The pattern is similar to that of 9*a* if certain supporting bars there are removed. I do not claim that either of these designs was actually used in window lattice when this bronze was cast, but windows of this general type were made at that time.

12*a*. PEPPER–EYE WEAVE

Wu Hou temple, Chengtu, Szechwan, 1900 A.D.

Just why the Chinese give the name of pepper-eye to this pattern I do not know. It looks more like the bamboo splint loose weave in the baskets which hold the cobbles for the Chengtu irrigation canal dikes than any pepper-eye with which I am familiar.

12*b*. MODIFIED PEPPER–EYE WINDOW

Shop front, Chengtu, Szechwan, 1875 A.D.

13. BAMBOO HEXAGON WINDOW

Yünnan guild hall, Suifu, Szechwan, 1900 A.D.

This is the motif of Y2*b* adorned with conventionalized bamboo sections whose nodes and sprouts are picked out in gilt. Both ice-crack and bamboo symbolize winter.

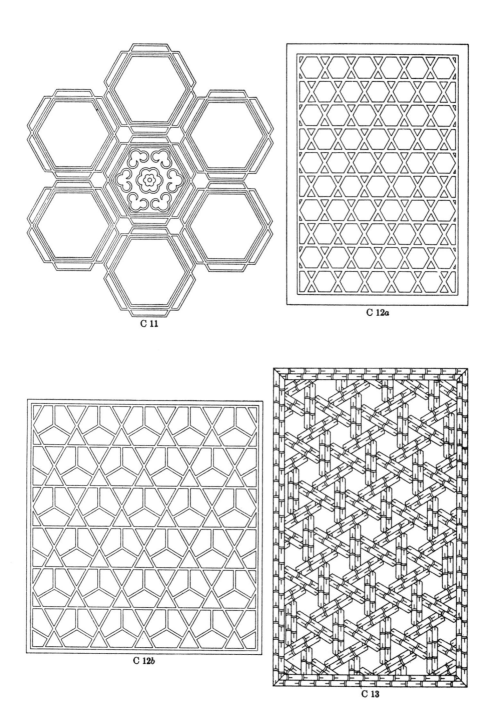

C 11

C 12a

C 12b

C 13

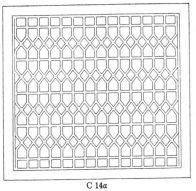

C 14a

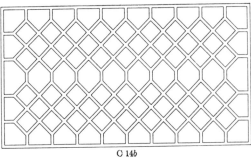

C 14b

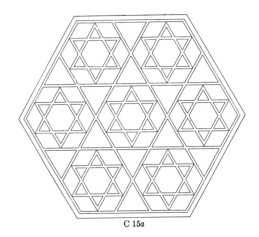

C 15a

C 15b

C. HEXAGON (*continued*)

14a. SUPERIMPOSED TURTLE–MARKINGS

Chengtu, Szechwan, 1900 A.D.

This might have come out of the *Yüan-yeh* of 1635 A.D.

14b. FOUR SUPERIMPOSED HEXAGON ALLOVERS

Chengtu, Szechwan, 1800 A.D.

15a. INTERLOCKED TRIANGLES WITHIN HEXAGON

Provenance and date uncertain.

This is not the Solomon's-seal motif, for the Chinese conceive of this as the triangle of heaven-earth-man.

15b. TRIANGLES

Provenance and date uncertain.

These triangles of heaven-earth-man have their horizontal side upward.

C. HEXAGON (*continued*)

16a–17b. ELONGATED TURTLE–BACK PATTERN.

Yüan-yeh, Soochow, Kiangsu, 1635 A.D.

These elongated hexagons are beautifully done. The collector and commentator mentions "willow twig changed to man-character" (cf. 17a, b) and "man-character changed to hexagons" (cf. 16a, b) in referring to these four plates.

C 16a

C 16b

C 17a

C 17b

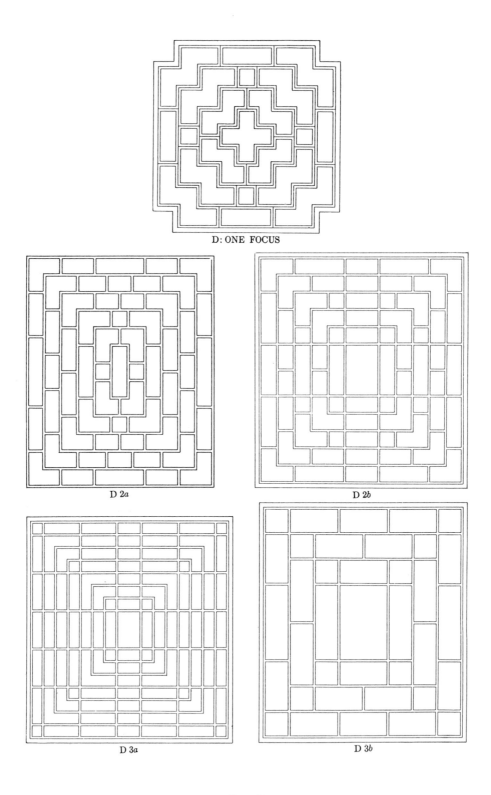

D: ONE FOCUS

D 2a

D 2b

D 3a

D 3b

D. SINGLE FOCUS FRAMES

This large group is characterized by nested, concentered frames with central focus. Often there are accessories like bars and corners and ornaments which point towards and emphasize the center. It is one of the finest, as well as one of the largest, groups of window designs.

2a. CONCENTERED FRAMES

Buddhist temple, Luchow, Szechwan, 1700 A.D.

This sixfold concentered frame is peculiarly Chinese. It is Pekingese in its use of the small, oblong, brick-shaped spots of light, but Szechwanese in its artistry and ensemble. Foochow, below Chungking on the Yangtse, Szechwan, has this window, with an open center for characters or drawing.

2b. CONCENTERED FRAMES AND CROSS–BARS

Dye in Chengtu style, Szechwan of 1800 A.D., 1930 A.D.

These were designed in order to demonstrate the possibilities of their use, and of the development of short bars in V array.

3a. CONCENTERED FRAMES AND CROSS–BARS

Dye in Chengtu style, Szechwan of 1800 A.D., 1930 A.D.

I did not discover concentered frames until late in this study, when I found 2a, and later 11. I then noticed such specimens as 5a, and

D. SINGLE FOCUS FRAMES (*continued*)

generalized from them. Since 1750 A.D. such fundamental structure
has been disguised by toggles and flowers.

3b. Nested Well–Characters Externally Framed

Dye in Chengtu style, Szechwan of 19th century, 1930 A.D.

The device is quite simple, two pairs of parallel lines so crossing as to
allow the ends to project slightly beyond the cross. It was suggested
by 6a, which extends but one bar instead of both at the corners. The
reason for the shape of the well-character is deduced from well-curbs
exhumed in Manchuria and Korea. These are made of four stone
slabs with mortise and tenon. The division of land in classical times
was centered about the well in such a "fox-and-geese" layout.
This character should strictly speaking have been included in the
list of those especially connected with lattice design. The single
frame with projecting ends was used in Canton in 1750 A.D.; it was
copied in Thomas Chippendale's *The Director* in 1753 A.D., and was
used in both America and Chengtu in 1850 A.D. with single or double
cross-bars and sixteen projecting ends. This series of nested well-
characters as an allover centered frame is true to the spirit of certain
Chengtu lattice of 1850 A.D., but I have no data as to its actual use.

4a. Alternated and Concentered Frames

Dye in Chengtu style, Szechwan of 19th century, 1931.

These concentered and nested frames are an extension of principles
used by designers of windows in Chengtu during the 19th century.

4b. Concentered Frames

Kwangyüan-Paoning road, Szechwan, 1800 A.D.

Windows of this type were popular during the 19th century.

5a. Cross and Frame

Chengtu, Szechwan, 1850 A.D.

The triple frames are typical of a host of windows that existed during
the 19th century.

5b. Internal–External Frames

Kwangyüan-Paoning road, Szechwan, 1800 A.D.

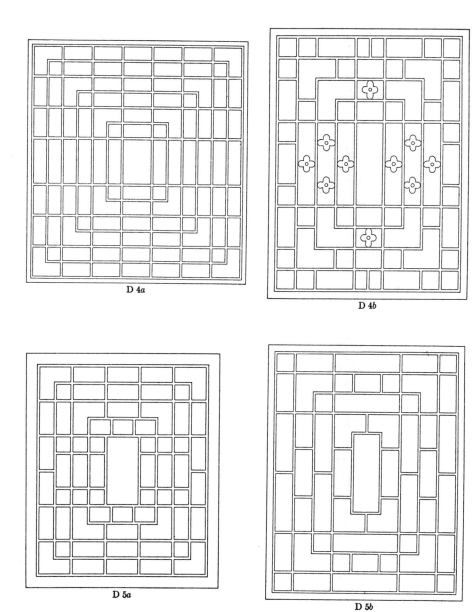

D 4a

D 4b

D 5a

D 5b

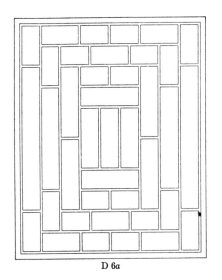

D 6a

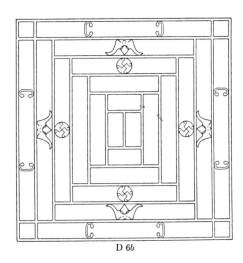

D 6b

D 7a

D 7b

D. SINGLE FOCUS FRAMES (*continued*)

6*a*. CONCENTERED FRAMES WITH EXTENDED ENDS

Canton, Kwangtung, 1750 A.D.

This drawing is taken from an early etching from Canton.

6*b*. NESTED EXTENDED–END FRAMES

Summer palace, Peking, 1872 A.D.

If this plate is cut diagonally from corner to corner, and only the lower section retained, there remains a typical roof truss that is universal in China. It constitutes the intrusive cantilever. The lower cross-timber supports five times as much weight as it could were all the weight at the center, and the sagging is greatly reduced. This general arrangement, without all of the florid toggles, is used in much of China. The pattern is especially common between Chengtu and Yachow, at Sintsing and Kiungchow, as well as at Tungchwan, near Paoning, Szechwan. It is also common in Mukden, Manchuria.

7*a, b*. CONCENTERED FRAMES AND FLOWERS

Anhsien, four days north of Chengtu, Szechwan, 1775 A.D.

In this vicinity one of the earliest dated memorial arches was found by V. H. Donnithorne. This plate is a happy combination of frames and carved flowers as toggles.

D. SINGLE FOCUS FRAMES (*continued*)

8a, b. SUITE OF DOUBLE FRAMES

Residence, Chengtu, Szechwan, 1825 A.D.

a should be visualized with several other windows just like it in one row, where the center is at eye level, and the windows are six inches apart with an upright timber between them. This window is related to *b*.

b is one of five old windows that have come down through the vicissitudes of a century in a large residence block.

9a. THE SQUARE OF EARTH.

Chungking, Szechwan, 1875 A.D.

This window seems weak, but is interesting because of its symbolism and its internal frame.

9b. FRAME WITH EXTENDED CORNERS

Provenance in Szechwan uncertain, in the style of 1700 A.D.

This type of frame seems to have been common in Szechwan up to the middle of the 19th century.

D 8a

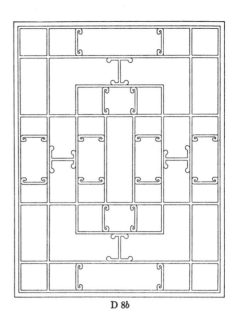

D 8b

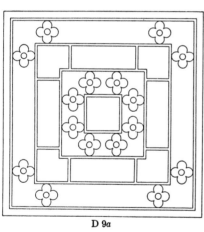

D 9a

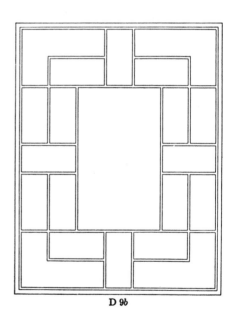

D 9b

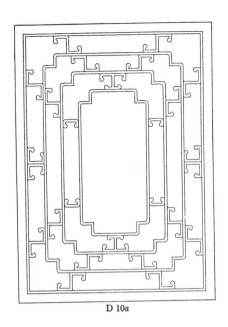

D 10*a*

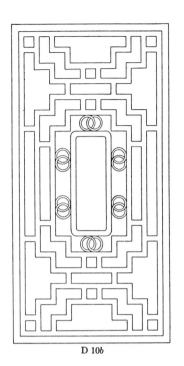

D 10*b*

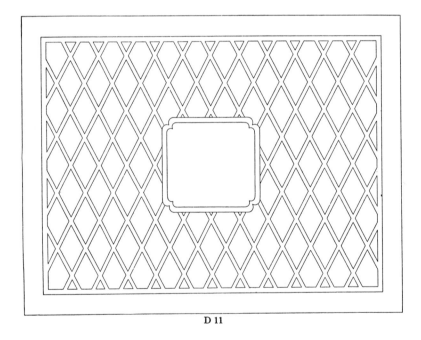

D 11

D. SINGLE FOCUS FRAMES (*continued*)

10*a*. CONCENTERED FRAMES WITH INDENTED CORNERS

Sintsing, on Chengtu-Yachow road, Szechwan, 1775 A.D.

This is a rare window. The concentered frames leave a large center for characters or brush work.

10*b*. NESTED FRAMES WITH INDENTED CORNERS

Ch'ang-yüan, Wuchang, Hupeh(?), 1650 A.D.(?)

A series of windows of this type is to be found in Hankow today.

11. CENTERED ELEPHANT–NOSTRIL WINDOW

Residence, Yachow, Szechwan, 1850 A.D.

This design was much affected in the Yachow area during the 19th century, but was employed as early as the 2nd century B.C. in Szechwan. It was the commonest lattice of those times, if mortuary brick and funerary houses afford sufficient grounds for conclusions. In the 19th century bars were diminutive and spaces small; many examples were even larger than this. The size of present-day lattice of this type lies between these two extremes. One of the fine points of this window is the narrow border of small triangles around the frame. This practice has been out of use for almost a century.

D. SINGLE FOCUS FRAMES (*continued*)

12*a*. Crossed Frames

Chengtu, Szechwan, 1850 A.D.

This pleasing and simple design was perfected over two thousand years ago, but is not used much today. This idea of crossed frames found its way to Japan during the T'ang dynasty.

12*b*. Crossed Lozenge Frames

Residence, Chengtu, Szechwan, 1850 A.D.

13. Complex Compounded Frames

Dye, 1933 A.D.

Unless the reader is interested in Chinese puzzles, or in the various methods of devising crossed frames and the dividing up of space in a systematic and effective way, this plate should be passed over. However, a real mastery of this series must include an understanding of this design. Although the writer drew the cartoon, the essential features and layout have Chinese precedent, especially (1) the endless line, (2) the pseudo-crossed frames, and (3) the unequal steps between bar centers.

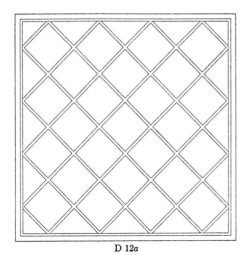

D 12a

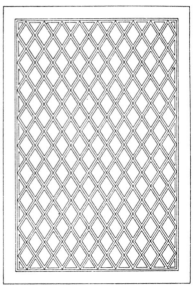

D 12b

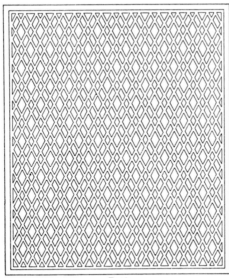

D 13

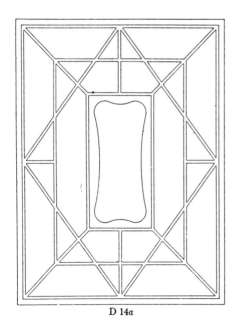

D 14a

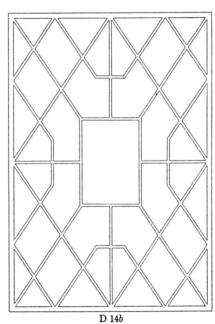

D 14b

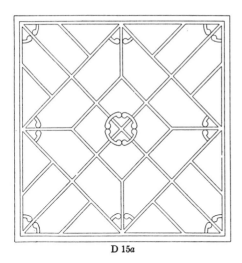

D 15a

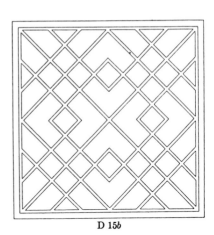

D 15b

D. SINGLE FOCUS FRAMES (*continued*)

14*a*. CROSSED CONCENTERED FRAMES

God of war temple, Shihfang, Szechwan, 1875 A.D.

The motif is that of optical illusion from centered frames. The lozenge crossed frame gives structural strength and centering. The inner frame is the shape of a table-top. Some such design was used in Canton two centuries ago. It is used today in many places in Szechwan, where features older than the actual date of construction are still retained.

14*b*. INTERLOCKED RECTANGLE, CROSS, AND LOZENGE

Screen within front door, residence, Hanchow, Szechwan, 1900 A.D.

This is really a paper screen which blocks the view into the inner court.

15*a*. CROSSED AND CENTERED LATTICE

God of war temple, Shihfang, Szechwan, 1875 A.D.

The motif here is also based on an optical illusion (cf. 14*a*). It is derived from something older than patterns of the same date in Chengtu. In remote centers carpenters are more conservative.

15*b*. CONCENTERED SQUARES

Yünnanfu, Yünnan, 1900 A.D.

D. SINGLE FOCUS FRAMES (*continued*)

16*a*, *b*; 17*a*. KNUCKLED AND CENTERED FRAMES

Hankow, Hupeh, 1850 A.D.

Windows such as these, and older ones found in this area, whose patterns are closely related to the *Ch'ang-yüan* designs, suggest the provenance of that book. There are three of these windows, one above the other, all alike.

b has its center between the fish-entrail or endless knots. This is in a retail tea shop. It is in a wooden panel which forms part of the partition, and is lacquered black.

17*a*. The corner device is noteworthy; it is restricted to this locality. These and other old and characteristic lattice patterns are to be found between the customs house and the Han River in Hankow.

17*b*. KNUCKLED AND CROSS–BAR–SUPPORTED FRAME

Chengtu, Szechwan, 1800 A.D.

The large inner frame is supported by cross-bars. A second inner frame is fastened to the first one and the two supporting bars. This has not been common practise for over a century. The knuckle-bars are not the conventional clouds of the 19th century.

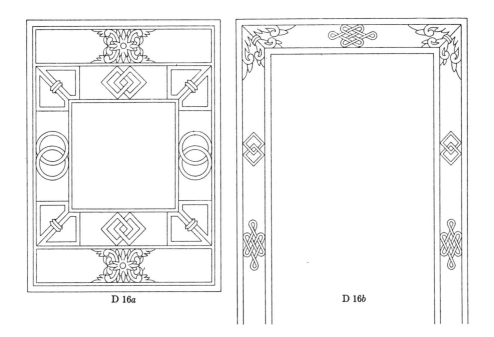

D 16a

D 16b

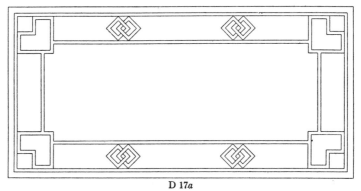

D 17a

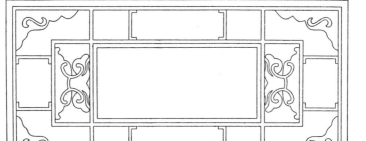

D 17b

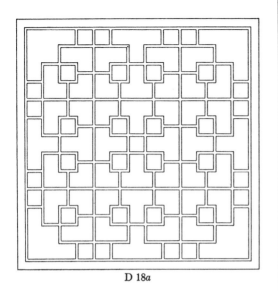

D 18a

D 18b

D 19

D. SINGLE FOCUS FRAMES (*continued*)

18*a*. INCURVED ENDLESS LOOP FRAME

Shanghai, Kiangsu, 1900 A.D.

This is apparently a coiled rope rectangularized for purposes of lattice.

18*b*. MULTIPLE CONCENTERED FRAMES

Two days west of Yachow, Szechwan, 1850 A.D.

This comes from near a center where iron was used during the 2nd century B.C., not far from where an iron vessel of that early date was disclosed when the river shifted its bed. It is not strange to find such a device on this amban route of other days. The four wind-wheels at the corners are uncommon, but occur along the route from Tachienlu through Yachow and Chengtu and as far as Hanchong on the old imperial highway.

19. MIXED CENTRAL FRAMING

Pihsien, one half-day west of Chengtu, Szechwan, 1800 A.D.

This fine lattice comes from a temple in a town famous for its scholars. I know of one other window so planned, and it uses other motifs. It is a full day to the north in an old temple. This window may be three hundred years old.

D. SINGLE FOCUS FRAMES (*continued*)

20*a*. FOURFOLD SQUARE MAN–CHARACTER SCREEN

Residence, Chengtu, Szechwan, 1875 A.D.

This pattern comes from a screen so placed in the front room that it shuts off the view into the house. It is not strictly a window lattice, but fits approximately into this group.

20*b–e*. SMALL ROTATIONALLY SYMMETRICAL WINDOWS

Gate-house, Chengtu, Szechwan, 1900 A.D.

Each window is rotationally symmetrical, and each quadrant may be advanced by 90 or 180 degrees so as to coincide. These are neighboring windows, and were probably constructed by the same carpenter. They have the inner square in common.

21*a–c*. FRAME BORDER GRILLE

Yüan-yeh, Soochow, Kiangsu, 1635 A.D.

a, b. Many of the patterns in this book have elongated designs crossed or framed like these.

c has been employed in west, central, east, and south China since Ming days. When the rectangles become squares, the pattern is known as "interlocked squares" or "iris pattern."

21*d*. OPEN CENTER WINDOW

Chinese Book, 1800 A.D.

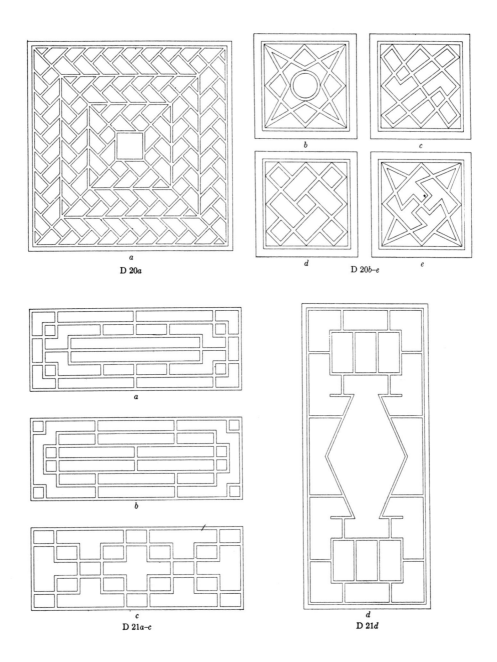

a

D 20a

b

c

d

e

D 20b–e

a

b

c

D 21a–c

d

D 21d

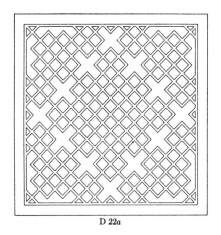

D 22a

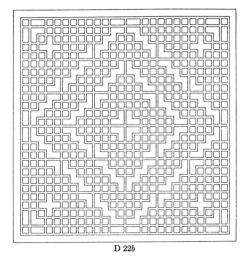

D 22b

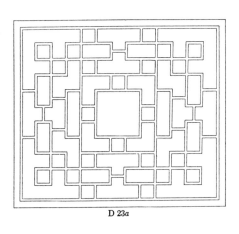

D 23a

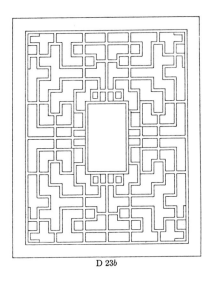

D 23b

D. SINGLE FOCUS FRAMES (*continued*)

22a. CROSSED CENTRAL FRAMES

Mount Omei, Szechwan, 1900 A.D.

22b. INTERLOCKED CONCENTERED FRAMES

Mount Omei, Szechwan, 1900 A.D.

The mutual interlocking of frames is well done here, and this particular device can be extended. This is perhaps the best example found by the author.

23a. CENTERED WINDOW WITH LOOPED CORNERS

Manchuria, 1900 A.D.

This is not a particularly fine design, but is related to those of north China.

23b. MEANDER AND CENTRAL FRAME

Residence, Chengtu, Szechwan, 1850 A.D.

This window is representative of a great number designed throughout Szechwan during the middle of the 19th century.

D. SINGLE FOCUS FRAMES (*continued*)

24*a*. OBLONG CENTERED WINDOW

Chungking, Szechwan, 1875 A.D.

This top-and-bottom Greek fret runs through a series of windows in one or two bents of a building. The series was much used in Szechwan during the 19th century.

24*b*. ENCLOSED TRIPLE FRAMES

Two days from Chungking on Chungking-Chengtu road, Szechwan, 1825 A.D.

25*a*. CENTRAL FRAME EMPHASIZED BY OUTSET CORNER

Chengtu, Szechwan, 1875 A.D.

25*b*. CENTRAL FRAME EMPHASIZED BY BORDERS

Chengtu, Szechwan, 1825 A.D.

This design is somewhat like 24*b*, with the addition of Greek fret sides with dragon-ends to the lines.

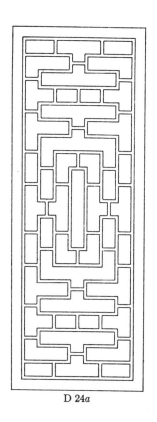

D 24a

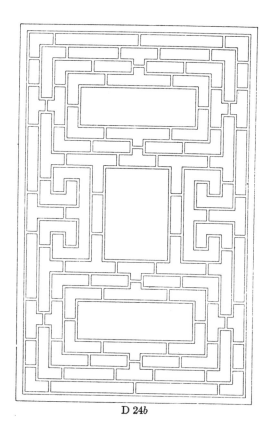

D 24b

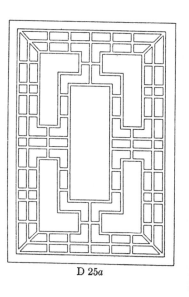

D 25a

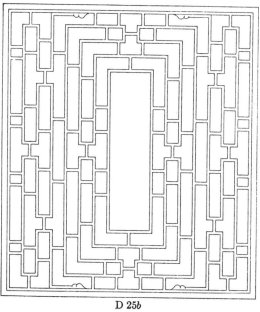

D 25b

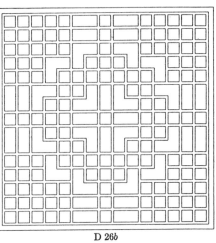

D 26a

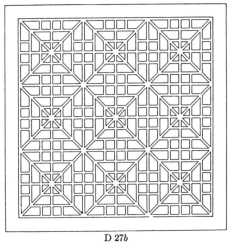

D 26b

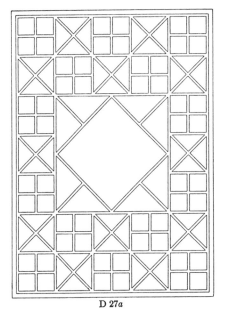

D 27a

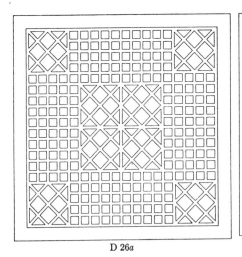

D 27b

D. SINGLE FOCUS FRAMES (*continued*)

26*a*. SQUARE AND CROSSED FRAMES

Dye, 1933 A.D.

This window was designed to illustrate the crossed frames and the five directions so much affected in lattice windows.

26*b*. INTERWOVEN–CENTER WINDOW

Foothill village of Mount Omei, Szechwan, 1800 A.D.

The interwoven center of square and cross is unusual. The devices for structural strength are effective.

27*a*. CROSSES AND SQUARES

Residence, Shihfang, Szechwan, 1850 A.D.

This design is not common today, but it appears to have been used during the first half of the 19th century in central and northern Szechwan. It is sometimes placed on false windows with board backs.

27*b*. DOUBLE FRAMES

Buddhist temple, Mount Omei, Szechwan, 1875 A.D.

D. SINGLE FOCUS FRAMES (*continued*)

28a–36b. UNIFOCAL OCTAGON–SQUARE WINDOWS

Temples, Mount Omei, Szechwan, 1800–1900 A.D.

The fundamental octagon and square is the basis for all these windows. Most of them have several concentric frames. All have four corners, so emphasized as to bring out the unifocal element. The octagons may be small or large with corresponding large or small squares; wide or narrow with the connecting squares narrow or long; octagons and squares may be concentered or overlapped or interlocked; and both octagons and squares may be crossed, in series, or alternating. The pattern is limited to four or five units, and these are so modified at the corners as to focus on the center. Surrounding these several units are small squares which serve as secondary frames to the whole plaque.

The sacred Buddhist Mount Omei, thirty-five miles southwest of Kiating, Szechwan, is the center of the single focus octagon-square window. This type predominates in the shops and residences of the foothill towns, and no religious significance is attached to it. It is not confined to this locality nor this province, but some special elaborations and combinations of it are.

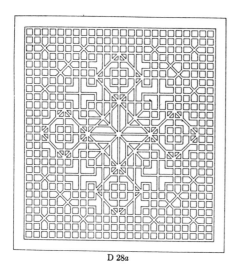

D 28a

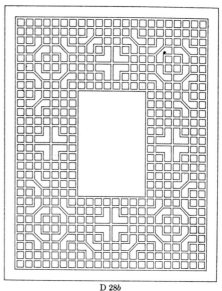

D 28b

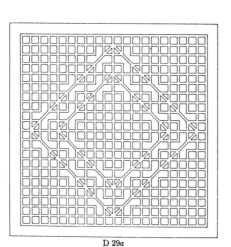

D 29a

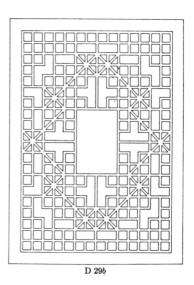

D 29b

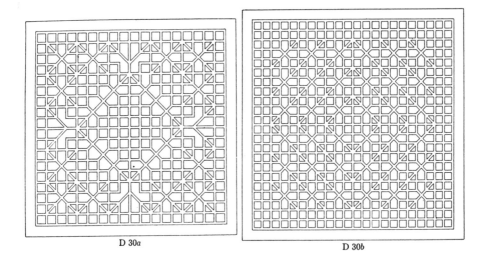

D 30a

D 30b

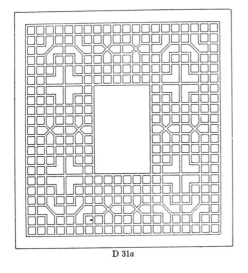

D 31a

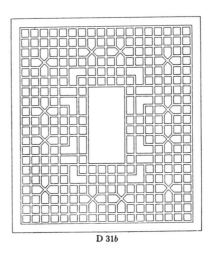

D 31b

D. SINGLE FOCUS FRAMES (*continued*)

This region escaped the worst of the devastation which Chang Hsien-chung inflicted upon many other parts of the province in the 17th century. It lies on no great trade route, nor near an imperial highway, although it is the terminus of religious pilgrimages. It is adjacent to tribesmen on the south, to Chinese mountaineers on the west, and to Chinese plain-dwellers on the east and north. Local carpenters continue the old traditions, and keep up the temple repairs and replacements after fires. These craftsmen carry on, generation after generation, with little or no influx of new blood. Thus, in spite of the religious importance of this place for Buddhists, it is an architectural backwater. At times in the past conditions were otherwise, as remnants of lattice and a few buildings testify. But the priesthood does not infuse many new ideas into temple construction and repair. When temples burn and windows rot, they are rebuilt much as they were before.

Though many fine old types of lattice have died out and those varieties which have persisted have degenerated, a group of quite superior and fairly uniform lattice designs has survived here. Embroidery and cross-stitch patterns on aprons, children's clothes, etc., and shapes and figures on silver and jewelry also contain designs characteristic of this section and not found elsewhere. In many localities a definite relation exists between lattice and embroidery patterns.

D. SINGLE FOCUS FRAMES (*continued*)

I considered placing a large number of windows in a special group called the "five-cornered Omei window." Such a group would include windows that are now assigned to A, B, D, G, and L. It would be interesting to study local history and geography in order to determine the trend of lattice in such a region. The tendency to homologous evolution of windows of different groupings and to elimination of other less congenial patterns is excellently illustrated in this region. These windows indicate that the patterns were better a century or more ago. Today many fail to attain the distinction that they might have. They suggest the brocade design which was woven in gold and blue, red, or green, and sent from Szechwan to the capital in Peking before the fall of the Manchu dynasty.

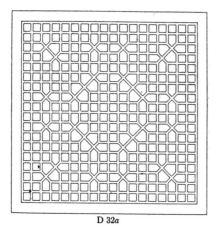

D 32a

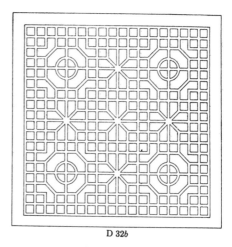

D 32b

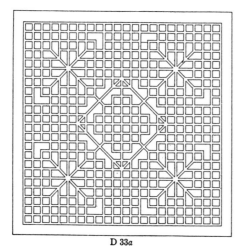

D 33a

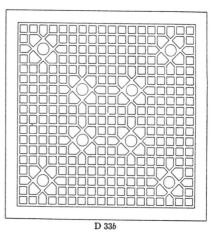

D 33b

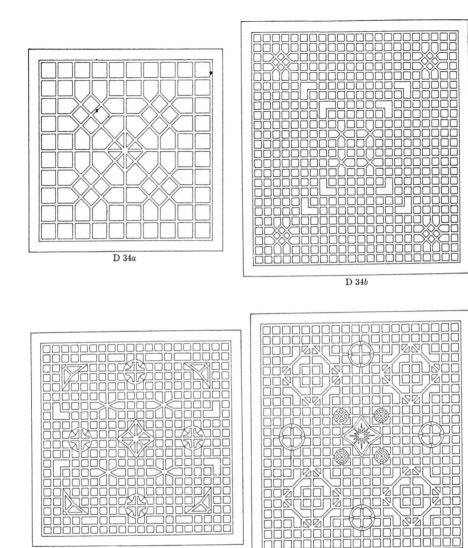

D 34a

D 34b

D 35a

D 35b

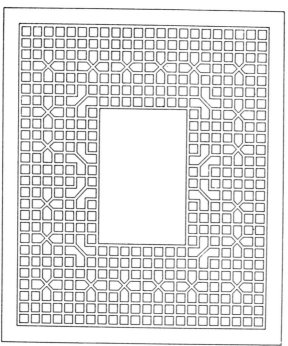

D 36*a*

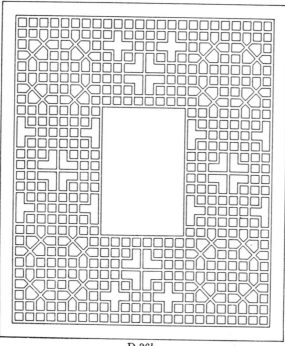

D 36*b*

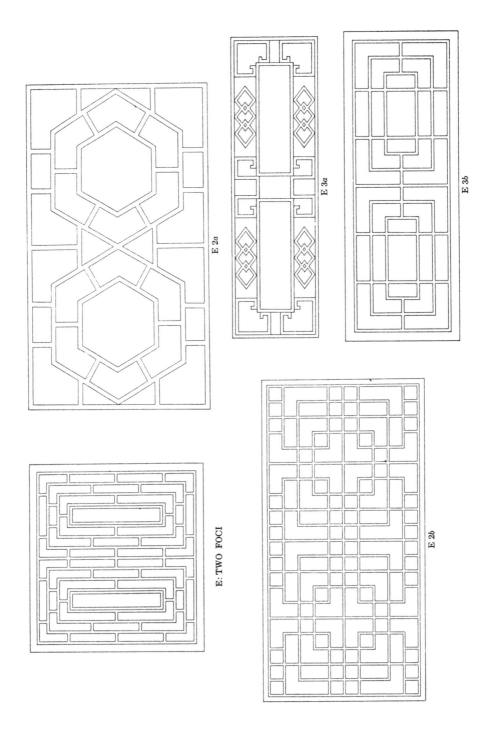

E 2a

E 3a

E 3b

E: TWO FOCI

E 2b

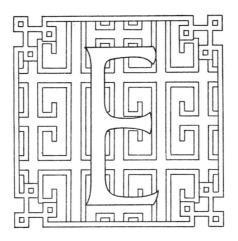

E. DOUBLE FOCUS FRAMES

Centering is common in this group, but doubling less so. Several types appear. The two centers are placed side by side with but little differentiation, save that the one of the east is considered slightly higher than that on the west, according to Chinese views of precedence. The placing of one focus directly above the other is not common. The linking of the two centers is variously achieved, as these plates show. Peking has more windows of this type than most cities.

2a. LINKED BI–FRAMES

Yüan-yeh, Soochow, Kiangsu, 1635 A.D.

The centers are joined by two links. This is a most unusual balustrade frame; its strength depends upon the size of the bar.

2b. TWO DOUBLE FRAMES LINKED

Hangchow, Chekiang, 1875 A.D.

The simple linked square design is modified by a second surrounding rectangle, which is elongated by the insertion of vertical bar supports. The long rectangles which link these, but add to the linear effect, give unity to the whole.

3a. KNUCKLED BI–FRAME

Chengtu, Szechwan, 1750 A.D.

The frames are really wedge-locked or knuckled by the cloud-bands and the three links. The two cloud-bands in the middle are espe-

E. DOUBLE FOCUS FRAMES (*continued*)

cially good. These might be almost considered as conventionalized bats, which have a wide range in shape. The significance of the three links is obscure, although for centuries it has been widely used in Chinese designs.

3b. DOUBLED BI–FRAMES

Sintu, Szechwan, 1800 A.D.

This double- or triple-framed pair of frames is uncommon. It is no mere complex of bars, for it is structurally strong and beautifully integrated. The four cross-bars and the central longitudinal bar are all harmoniously designed. I have found a few old windows in Chengtu which are closely allied to this.

4a. INTERLOCKED BI–FRAMES

Chengtu, Szechwan, 1875 A.D.

This is a temple railing. The big rectangles are interlocked and joined across the vertical bar by smaller oblong rectangular frames. Were the whole enlarged and extended by repetition the pattern would appear to be what it is, cross-woven catenary framing (cf. M).

4b. SINGLE BI–FRAMES

Luchow, Szechwan, 1875 A.D.

The double cartouches, doubly framed, are effective. The double-sided and single-ended frame surrounding the two inner figures is in turn enclosed with the single-sided and double-ended frame just within the exterior border.

5a, b. NESTED FRAMES OF CANTILEVER CONSTRUCTION

Tungchwan, three days northeast of Chengtu, Szechwan, 1900 A.D.

The first illustration comes from a bed-end, the second from a building. This design is common in Kwangyüan, Tungchwan, Chengtu, Kiungchow, Yachow, and other places in Szechwan, and is also frequent around Peking, Chihli. The tops and bottoms of the rectangular frames are extended to obtain support from the frame next in size. Viewed from the side the horizontal effect is emphasized; viewed from the front, the vertical. Note that the construction of this window is similar to that of the typical Chinese bracket and the Chinese roof. If b is placed on end and all but the central lozenge feature is concealed, the lower half is similar to the bracket, and the upper

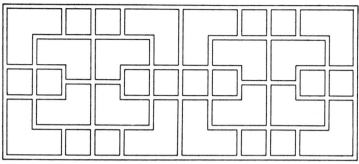

E 4a

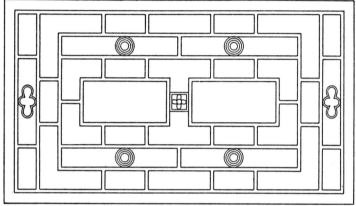

E 4b

E 5a

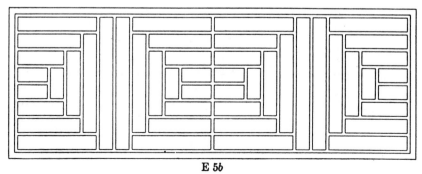

E 5b

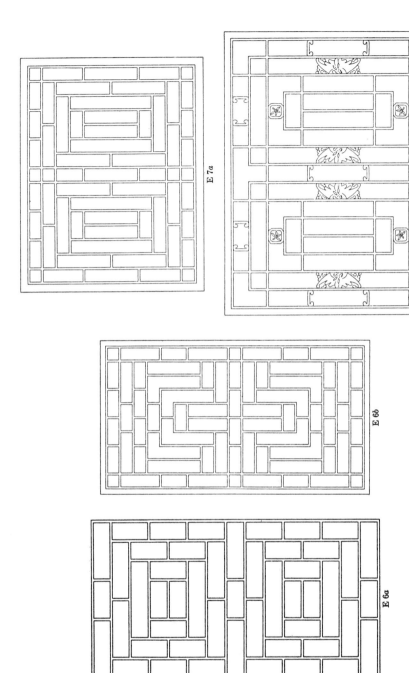

E 7a

E 7b

E 6b

E 6a

E. DOUBLE FOCUS FRAMES (*continued*)

half is like the framing that supports the roof. I do not know which came first, the roof or the bracket, but have discovered no example of the window as early as the Han dynasty, while the bracket is definitely found in caves of that period.

6*a*. PAIRED NESTED FRAMES

Peking, Chihli, 1900 A.D.

This is a typical Peking window. Basically it is similar to 5*a* and *b*, but the structure is disguised by the short bars, which divide the white spots into comparable areas and give a brick-like appearance. This window illustrates the Chinese penchant for double reading of line and design. One may view the design as a double series of nested squares or of oblong rectangles.

6*b*. DIVIDED CENTER

Provenance uncertain, 19th century.

This is a frequent use of the common motif of 5*a*. The nested frames are divided across the center; and the roof and bracket support, as seen in that plate, are cut in two.

7*a*. STEPPED FRAMES

Peking, Chihli, 1900 A.D.

The light space within the large frame is diminished by the single long straight bars along each edge. The field is divided into two large light spots by the two vertical bars through the center. These two sections are divided into nested frames according to the principle of 5*a*.

7*b*. SUMMER PALACE WINDOW

Summer palace, Peking, Chihli, 1872 A.D.

The field is first divided by two pairs of concentered frames. The frames are supported by cross bars in the same manner, so that there is unity in the design. Bats, cloud-bands, and floral blocks serve as toggles for support.

E. DOUBLE FOCUS FRAMES (*continued*)

8a. Cross–Bar–Supported Central Frames

Summer Palace, Peking, Chihli, 1872 A.D.

Structurally this is the same as 7*b*. The central cloud-band toggles do double duty, as they pair with those at each end of the window.

8b, c. Paired Frames

Summer Palace, Peking, Chihli, 1872 A.D.

These plates are given distinction by use of the cloud-band and priest-head toggles, which are not needed for structural support.

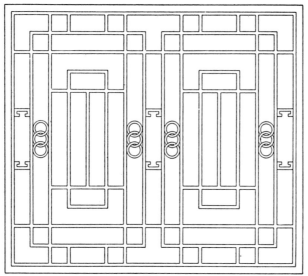

E 8a

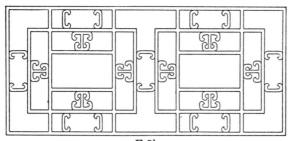

E 8b

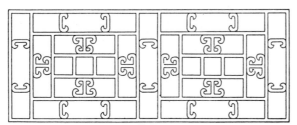

E 8c

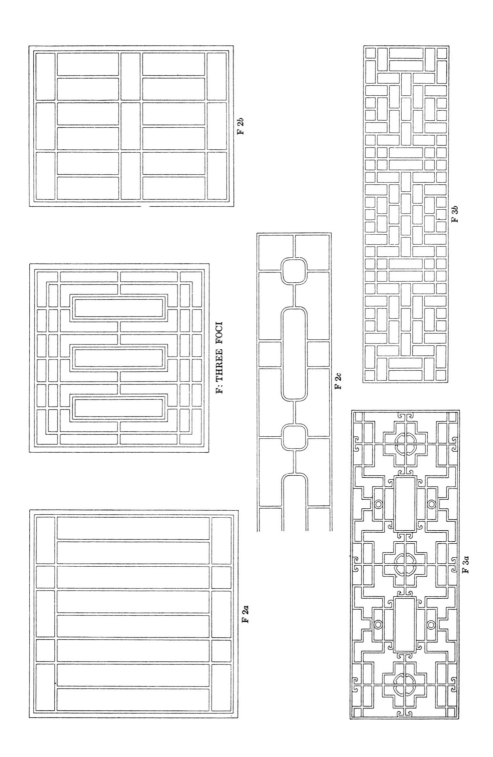

F: THREE FOCI

F 2a

F 2b

F 2c

F 3a

F 3b

F. TRIPLE FOCUS FRAMES

One of the advantages of the Triple Focus group is that centering is combined with symmetrical distribution. Most of the windows and grilles in this group stress the horizontal. Grouping by threes is used in China, but grouping by fives is much more prevalent. Alignment by threes is commonly used for catenary framing over theater stages or in temples, somewhat below the eaves. 6*a* and *b* are good examples.

2*a*, *b*. VERTICAL RAIL WINDOW

Native city, Hankow, Hupeh, 1900 A.D.

The vertical lines stand out when viewed from in front, the horizontal ones when viewed from a distance, owing to the depth of the bars.

2*c*. CATENARY FRAME

Picture, East China, 1875 A.D. or earlier.

Three small frames and two oblong ones are beaded on a string.

3*a*. TEN–CHARACTER FRAMES

Residence, Chengtu, Szechwan, 1875 A.D.

Knuckle-wedging and cross-bar supporting are both used in this window. The Ju I scepter within the ten-characters is usually mortised across the bar instead of being wedged into the corners. The use of cloud-band ends in the three vertical cross-bars is very rare.

F. TRIPLE FOCUS FRAMES (*continued*)

3b. BRICK FRAMES
Peking, Chihli, 1900 A.D.

The cantilever construction of E 5a and b is here isolated and repeated thrice. The effect is not particularly pleasing. Such windows frequently occur in Chihli.

4a. TRIPLE FRAMES
Chengtu, Szechwan, 1875 A.D.

This series is unusual in being asymmetrical on the horizontal axis.

4b. WEDGED TRIPLE FRAMES
Yachow, Szechwan, 1725 A.D.

Two small rectangles and two cloud-bands are wedged between two continuous lines. The double lozenges, the double circles, and both toggle-bars emphasize the triple centers of interest by symmetrical placing.

5a. CLOUD–SUPPORTED TRIPLE FRAMES
Êrh Wang (also called Êrh Lang) temple of the irrigation system, Kwanhsien, Szechwan, 1825 A.D.

This window is extremely good, except for its lack of structural strength. The knuckled frames are emphasized. The cloud-bands and thunder-scrolls are all distinct and separate as seen here by day, but at night every line evokes diverse effects, since the bead is indistinguishable.

5b. TRIPLE FRAMES IN CONTINUOUS LINES AND CLOUDS
Chengtu, Szechwan, 1850 A.D.

The frames are wedged between cloud-bands, continuous lines, and priest-head toggles. The result is not particularly beautiful, and is characteristic of the middle of the 19th century.

F 4a

F 4b

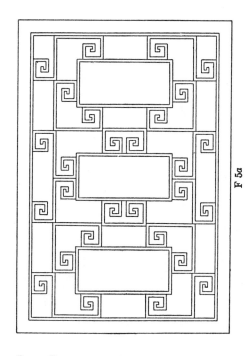

F 5a

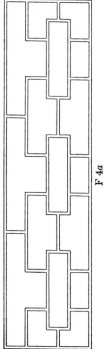

F 5b

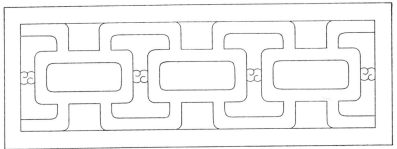

F 6a

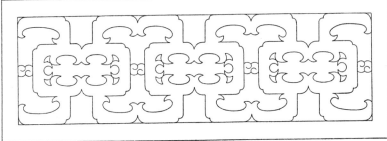

F 6b

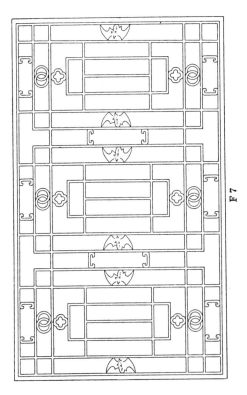

F 7

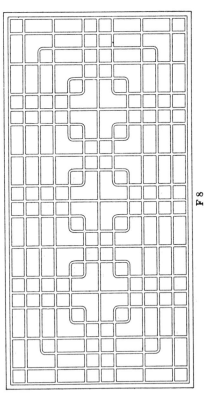

F 8

F. TRIPLE FOCUS FRAMES (*continued*)

6*a*, *b*. PRESENTATION BY TRIPLE FRAMES

Ten Thousand Years Monastery, Mount Omei, Szechwan, 1775 A.D.(?).

These two heavy grilles above the first story under the eaves are exceedingly well executed. The ceremonious presentation motif is used for the supports in *a*, while in *b* even the frames are composed of the same motif. The latter illustrates the Chinese penchant for carrying an idea in design to extremes (cf. J 5*a* and W 4*a*).

7. TRIPLE CONCENTERED FRAMES

Summer palace, Peking, Chihli, 1872 A.D.

These are good examples of Peking windows.

8. TRIPLE ENCLOSED FRAMES

Imperial highway, Shensi-Szechwan, 1875 A.D.

The rounded corners of the squares customary in the iris pattern are good, and the enclosing frame is in keeping. This is an unusual window.

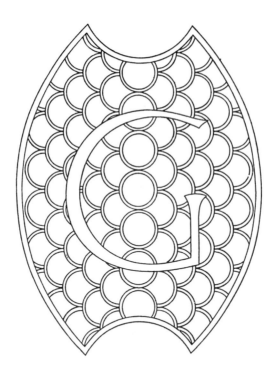

G. QUINTUPLE FOCUS FRAMES

The five focus group fits in with the Chinese tendency to quintuple categories, as is shown by their five relations, five elements, five sacred mountains, five blessings, five directions, etc. The windows can be so arranged as to give horizontal and vertical alignment as well as centering. The group is much larger than the number of plates listed here would indicate. Some representatives of the B group might also be classed here (cf. B13a, 14a, 15a, 16b), and the octagon-square window might be included. Mount Omei, Szechwan, probably has a larger proportion of its windows in the group than has any other place (cf. D 28a–36b). The writer attributes this fact to historical and geographical influences, not to Buddhism *per se*.

2a–4a. Five-Cornered Omei Windows

Buddhist temples, Mount Omei, Szechwan, 1800–1900 A.D.

The fivefold repetition in the dice-five is common to these windows. The borders of small squares just within the large frame are alike. The octagon-square is used in each window, and verticals and crossbars support and emphasize the pattern. The windows greatly resemble those from the same area classified under A, B, and D.

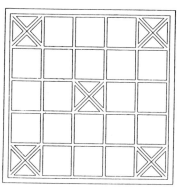

G: FIVE FOCI

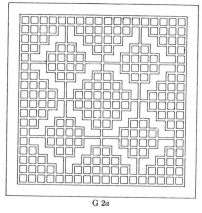

G 2a

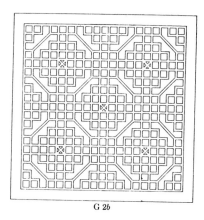

G 2b

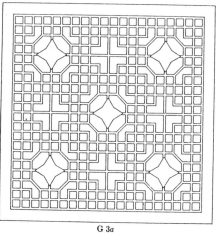

G 3a

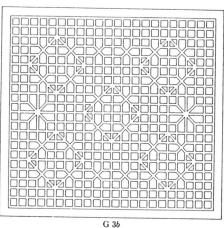

G 3b

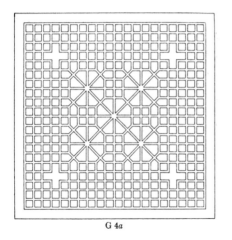

G 4a

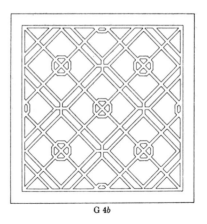

G 4b

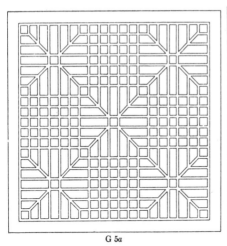

G 5a

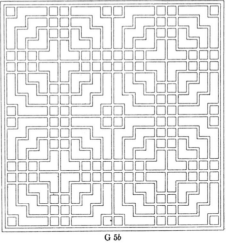

G 5b

G. QUINTUPLE FOCUS FRAMES (*continued*)

2a. The central crossed-frame-interlock includes a square different from the corner designs. The empty areas simulate the bat of happiness clinging to the four sides of the four corners.

The cross of double bars supporting the five corners is unusual. The octagon-square design is single and not superimposed, although merely connecting the corners of the adjacent crossed oblong frames within the octagons would increase their number.

3a. The unique characteristic of this plate is that the five octagons are connected by ten-characters (or Greek crosses) and hexagons. The large squares enclosing each octagon are infrequent in China.

3b. The oblong octagons, modified oblong octagons, and regular octagons converted into diagonal squares are unique.

4a. The compact octagon-square surrounded by an enclosing square and interlocked by a large octagon within gives a good effect.

4b. Octagon–Square Centered by Octagon

Provenance uncertain, 1700 A.D.(?)

In this design, where the square approximates the area of the octagon, the former is centered by a small octagon. The disparity in areas of light spots is reminiscent of the Ming Dynasty.

5a. Interlocked and Nested Squares

Mount Omei temple, 1700 A.D.

This window is unique with its squares and hexagons and a quasi-octagon, the interlocked squares at the center and at the edges being omitted. The diagonals are completed and the double cross-bars are continued into one, — with equal steps, of course, — recalling a design of the Han dynasty.

5b. Five Indented–Corner Square

East gate suburb, Chengtu, Szechwan, 1875 A.D.

Large squares are separated by vertical and horizontal bars. Each square is connected to its neighbor by two short bars across the supporting crosses. The four neighboring squares are connected by two concentric indented-corner squares. Finally, every other square is centered by a small square.

G. QUINTUPLE FOCUS FRAMES (*continued*)

6a. FIVE–CORNERED AND CROSSED FRAMES

God of war temple, Shihfang, Szechwan, 1750 A.D.

The window is centered by a diagonal cross and two diagonal crossed frames. The five Ju I scepters and conventional cloud-bands are exceedingly well executed. These windows come from a backwater off the main routes. Such careful carving is not attempted today.

6b. FIVE–CORNERED JU I

Mienchu, Szechwan, 1704 A.D. (date given in temple inscription).

The short bars connecting the Ju I elements are effective from the standpoint of design, but not from that of structural strength. This is possibly a replacement of the original window made two centuries ago, when this design was apparently more common.

7a. JU I AND SQUARE QUINCUNX

Shihfang, Szechwan, 1800 A.D.

7b. OCTAGONS AND LINKED SQUARES

Canton, Kwangtung, 1775 A.D.

This unusual variation of interlinked octagons is formed by two rows of elongated octagons across the top and bottom of the window, which are interlocked by a third row across the middle. Each octagon is centered by a pair of linked squares, which really connect the interlocked octagons.

8. FIVE–CORNERED BRICK PATTERN

Yünnanfu (?), 1875 A.D.(?)

This comes from a picture probably taken in Yünnanfu, Yünnan. The building is in such disrepair that it doubtless antedates the year assigned. Though not a beautiful window, it suggests possibilities in the use of this design (cf. E 5a, b).

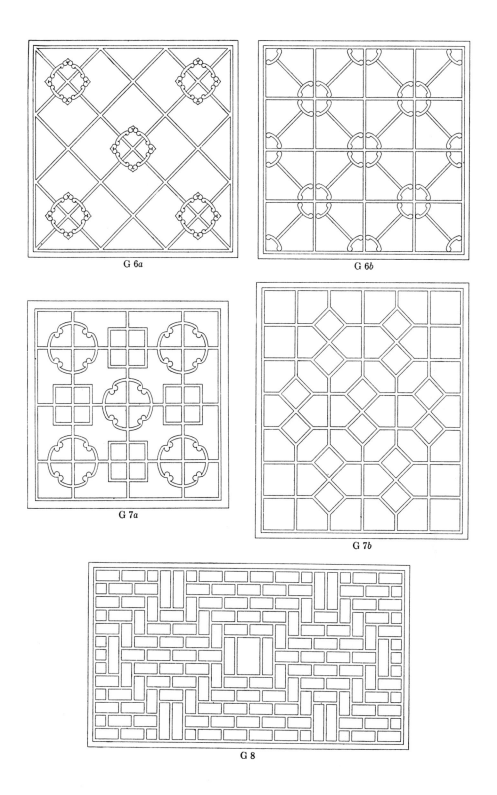

G 6a

G 6b

G 7a

G 7b

G 8

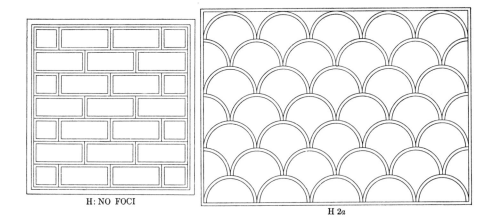

H: NO FOCI

H 2a

H 2b

H 2c

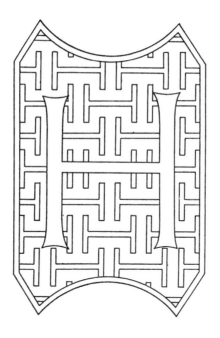

H. NO FOCUS FRAMES

When apparent centers of interest in lattice windows reach or exceed nine in number, they lose their significance. Under these circumstances most of the devices of groups D–G break down and merely attract attention to the window as a whole. It is not always necessary that a window shall have centers of interest in order to be beautiful. D 2a and H 3c show that the Chinese are often successful in carrying a principle out to its ultimate conclusions, positive or negative.

2a. IMBRICATED PATTERN

Yünnan guild hall, Suifu, Szechwan, 1900 A.D.

This pattern is sometimes carried out in wood, but more often in tile. It is common in Peking. Used as wall-top it serves as an alarm, for in scaling the wall an intruder is bound to upset the tiles.

2b. TILE COMBINATION

Yünnan guild hall, Suifu, Szechwan, 1900 A.D.

This is a window in a garden wall; it is made of double tiles fastened together with plaster. Tile patterns are found at their best in Peking,

H. NO FOCUS FRAMES (*continued*)

but are used in other parts of China as well. The old city of Chung-kingcheo (one day southwest of Chengtu) contains more tile flowers than any city of Szechwan.

2c. TILE DESIGN

Peking, Chihli, 1900 A.D.

This arrangement is shakier than that shown in either of the two preceding plates, and so provides a more sensitive alarm.

3a, b. KNUCKLED RECTANGULAR FRAMES

a. Residence, foothill town of Mount Omei, Szechwan, 1750 A.D.
b. Expansion of overhead grille, Kiating, Szechwan, 1750 A.D.

These frames are at the opposite pole from D 2a. They have had to be knuckled together by careful workmanship. Owing to instability and change of styles there has been almost no reproduction of these windows for nearly a century. This is one of the designs that probably found its way into Szechwan through Canton immigrants after the devastation by Chang Hsien-chung at the end of the Ming dynasty. During the 18th century the pattern shown in *b* found its way to America, where it appeared in wall-paper design.

3c. SEPARATED MULTIPLE FRAMES

Ancestral temple, Kienwei, one day below Kiating, Szechwan, 1750 A.D.

This is a variation of 3b, where the frames are held apart by short bars. These catenary frames are beaded on strings, both vertically and horizontally. I have found this general type of window in Kienwei, Yachow and Wenchwan only. It is probable that it was more widely spread in Szechwan some centuries ago.

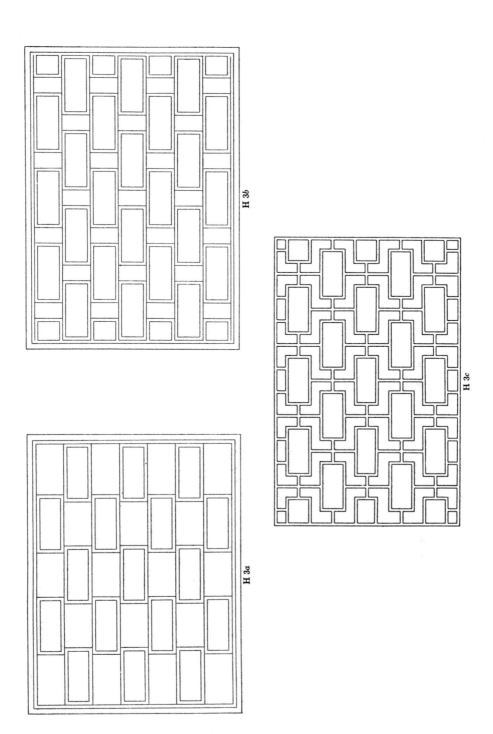

H 3b

H 3c

H 3a

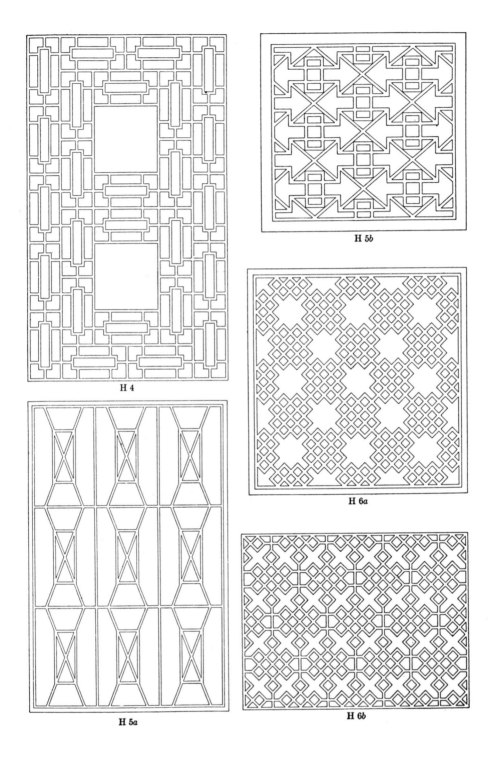

H 4

H 5b

H 5a

H 6a

H 6b

H. NO FOCUS FRAMES (*continued*)

4. FRAMES ENCLOSED BY FRAMES

Residence, Yachow, Szechwan, 1800 A.D.

This is a pleasant variation of 3*c*, with a finer frame as unit. These small frames form two complete ones for the inner open plaques. In case one desires to fill in the two open spaces, he should insert two vertical unit frames in each.

5*a*. OCTAGONS–HEXAGONS–RECTANGLES

Shaohing, Chekiang, 1900 A.D.

5*b*. RECTANGLES AND WAVES

Provenance and period uncertain.

6*a*. COMPOUND CROSSED FRAMES

Sating, Fukien(?), 1900 A.D.

The supporting bars compose three crossed and concentered frames, while the units are composed of two oblong crossed frames.

6*b*. ALLOVER FISH–ENTRAIL DESIGN

Chengtu, Szechwan, 1850 A.D. or earlier.

The fish-entrail design is one which symbolizes good luck, and is common throughout China, especially in Chihli and Manchuria. It is frequently stamped on the red paper in which gifts are wrapped at New Year's.

H. NO FOCUS FRAMES (*continued*)

7a. Iris Pattern of Interlocked Squares

Buddhist Chao Jo monastery, one hour north of Chengtu, Szechwan, 1833 A.D.: repaired and probably copied from a former window.

This type is very common elsewhere in Szechwan, as well as in other parts of China. The same general design is found in the old temple near Shaohing, Chekiang, built in honor of the Great Yü, emperor and canal-builder of prehistoric days. It was used before the Ch'ing dynasty, but became frequent during the last three centuries. A fine specimen, containing prunus blossoms at the centers of the squares, was located on the Shensi-Szechwan border. The Chinese name is due to the interlocking rather than to the tripartite division of the petals of the iris. This pattern was employed in heavy grille for balustrades two and three centuries ago in Szechwan. It has been one of the very common lattices.

7b. Ju I Centered Iris Window

Chengtu, Szechwan, 1800 A.D.

8a, b. Compound Iris Windows

Dye, 1931 A.D.

These were designed to illustrate three things: the use of two sizes of squares in interlocking, the superposition of a second like system sidestepped by one half-step, and the use of an all-enclosing frame and border for the window. The supporting cross-bars are added in *b.* All of the principles employed were common in lattice construction during the 18th century.

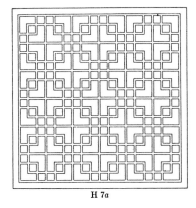

H 7*a*

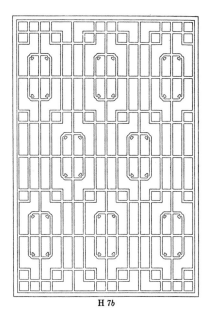

H 7*b*

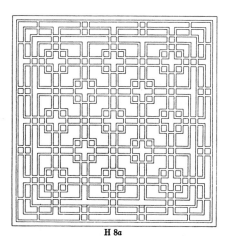

H 8*a*

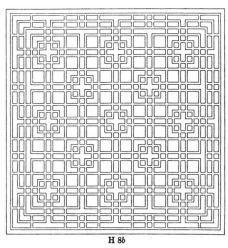

H 8*b*

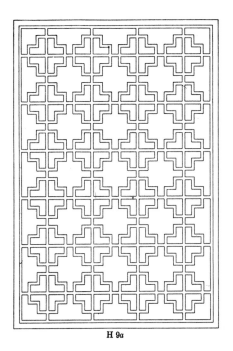

H 9a

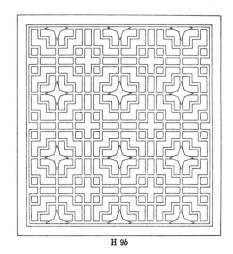

H 9b

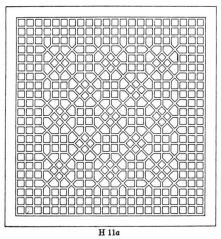

H 11a

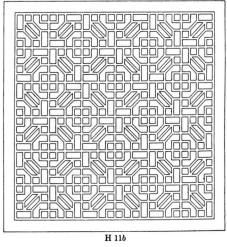

H 11b

H. NO FOCUS FRAMES (*continued*)

9a. TEN–CHARACTER WINDOW

Yüan-yeh, Soochow, Kiangsu, 1635 A.D.

9b. IRIS LOCK AND TEN–CHARACTER

Chengtu, Szechwan, 1800 A.D.

This is a combination of two allover patterns sidestepped by one half-step, i.e. the iris motif and the pattern in 9*a.* The four-petal ornaments at the intersections of cross-bars disguise the presence of the cross-bars. This design is closely related to H 14*a.*

11*a.* These complex octagons are enframed by a border of small squares in the style of the 18th century.

11*b.* Usually when octagons are spread apart the interstices are blocked out into hexagons and ten-characters. But here a short bar is run through the hexagon and a windwheel whorl is substituted for the ten-character.

10*a*. INTERLOCKED OCTAGON–SQUARES

Chengtu, Szechwan, 1850 A.D.

This type is very common in many sections, but is finished in different ways in different places. In southern Shensi, the Ju I scepter is not commonly used to fill the center, but in Szechwan it is frequently utilized in this manner.

10*b*–12*a*. OCTAGON ALLOVERS

Buddhist temples, Mount Omei, Szechwan, 1800–1900 A.D. Cf. plates and comment under D 28*a*–36*b*.

10*b*. The five octagons are almost equilateral, and are separated, necessitating connecting hexagons and ten-characters instead of the usual square. The four corner octagons are centered by squares, which are connected by flattened octagons, whose inner sides form a large square frame for the central octagon.

10*c*. Rectangles join the nine small octagons, the triple cross-bars, and the large squares enframing these crossings.

10*d*. This window has carried the octagon to such an extreme that it is scarcely recognizable as such.

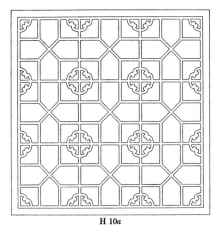

H 10a

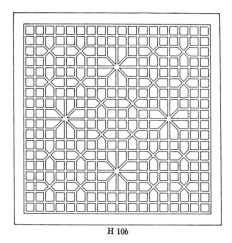

H 10b

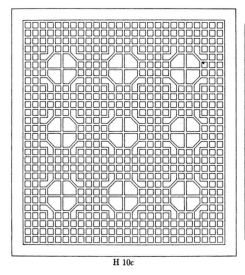

H 10c

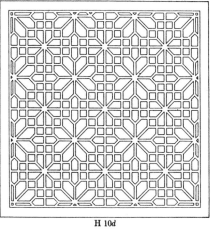

H 10d

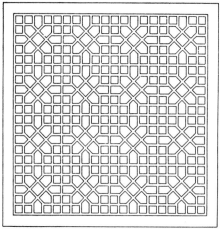

H 12a

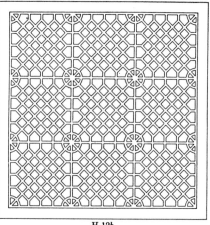

H 12b

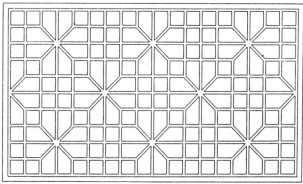

H 13a

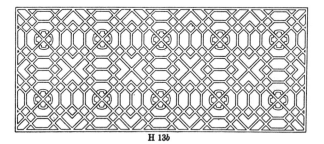

H 13b

H. NO FOCUS FRAMES (*continued*)

12*a*. Double concentered octagons are obtained by joining two systems of crossed oblongs instead of regular squares. Cf. plate and comment under 13*b* for another method.

12*b*. TRIPLE CONCENTERED OCTAGON ALLOVER

Yüeh Lin Ch'ang, Shensi, 1825 A.D.

This is an extension of the principle of 12*a*. Triple concentered octagons are obtained by joining the three systems by three crossed and concentered rectangles. Windows much like this are found in several other places along the Imperial Highway between Paocheng, Shensi and Chengtu, Szechwan.

13*a*. INTERLOCKED SQUARES AND INTERLOCKED OCTAGONS

Shop, Chengtu, Szechwan, 1850 A.D.

Note the interlocked squares of the iris pattern of 7*a* and the interlocked octagons.

13*b*. OCTAGON–SQUARE COMPLEX

Over gateway of residence, Chengtu, Szechwan, 1900 A.D.

This is an alternate to the method in 12*a* of forming double concentered octagons, where the square with an interwoven ten-character alternates with a hexagon as a link between the octagon sides. The examples from Chengtu during the 20th century do not have the dignity of the simpler octagons used earlier.

14*a*. INTERLOCKED SQUARES AND INTERLOCKED OCTAGONS

Residence, Chengtu, Szechwan, 1850 A.D.

The supporting cross-bars give emphasis to the squares in this octagonal window. The double octagon around each crossing completes the plate.

14*b*. COMPLEX WINDWHEEL WITH FLOWERS

Probably from Yünnanfu, Yünnan, 1850 A.D.

The background is a modified cantilever (cf. E 5*a*, *b*), and the design is a modified windwheel.

15*a*. TEN–CHARACTERS AS WHORLS

Buddhist temple, Mount Omei, Szechwan, 1875 A.D.

The large ten-characters modified into whorls give the set to this window. The double cross-bars through these, and the single cross-bars through the small squares, also emphasize the whorls. It is an unusual window. The use of the double bar occurs only occasionally in China, but is frequent in Japan.

15*b*. INTERLOCKED AND BRACED SQUARES

Chengtu, Szechwan, 1850 A.D.

Fundamentally this is an allover of interlocked squares and octagons (cf. 13*a*), but the octagons are disguised by the three types of well designed corner figures.

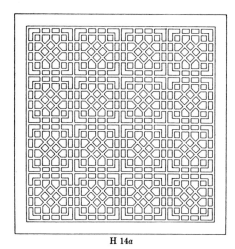

H 14a

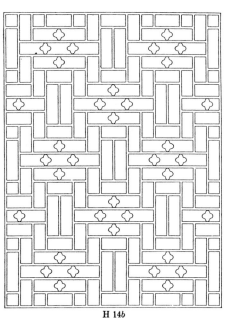

H 14b

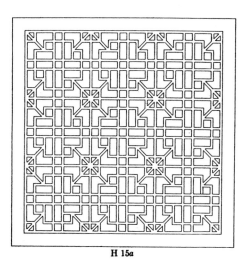

H 15a

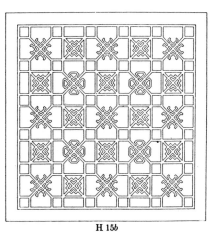

H 15b

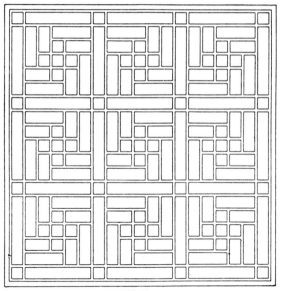

H 16a

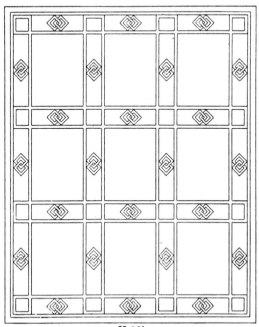

H 16b

H. NO FOCUS FRAMES *(continued)*

16*a*. Crossed Windwheels

Chengtu, Szechwan, 1875 A.D.

This window has double cross-bars like those in 15*a*. They are needed to frame the crossed oblong windwheels. Compare these windwheels with those of K 9*b*; the opposed wheels are not connected here, but are severed by the double cross-bars. These double cross-bars were more common in Szechwan during the Ming dynasty.

16*b*. Non–Concentric Crossed Frames

Residence, Chengtu, Szechwan, 1800 A.D.

Four narrow crossed frames divide the field into nine spots of light. There is also an endless looped line which enframes the whole. This frame, with slight modification, has been used in the Woman's College Building of the West China Union University.

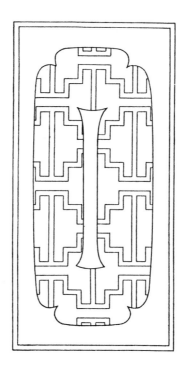

I. WEDGE–LOCK

This group was difficult to classify. Although it has some fine representatives, many are damaged. Isolated individual wedge-lock windows appeared to be aberrant, not falling within the lattice classification. This structural form seems not well founded mechanically. The wedge-lock affords pleasing and effective patterns and gives a change from the other groups of lattice. Some windows combine cross-bars and wedge-lock, but many stand out as pure wedge-lock. In some cases devices such as bars are used at the back for reinforcement, concealed with more or less success. All things considered, the wedge-lock has a real place in the lattice window maker's repertoire.

2a. KNUCKLED JU I FRAMES

Canton, Kwangtung, 1850 A.D.

These nine frames, combined side by side and end to end, do not give the impression of nine foci, but of an allover. They are knuckle-wedged together. Each small frame is composed of four Ju I scepters. This and many similar specimens were extant in Canton in 1932 A.D. The rounded corners of the large frame are in keeping with the detail. The outer frame should fit close to the small panes, and the drawing is in error at this point. This window is suggestive of W 4a.

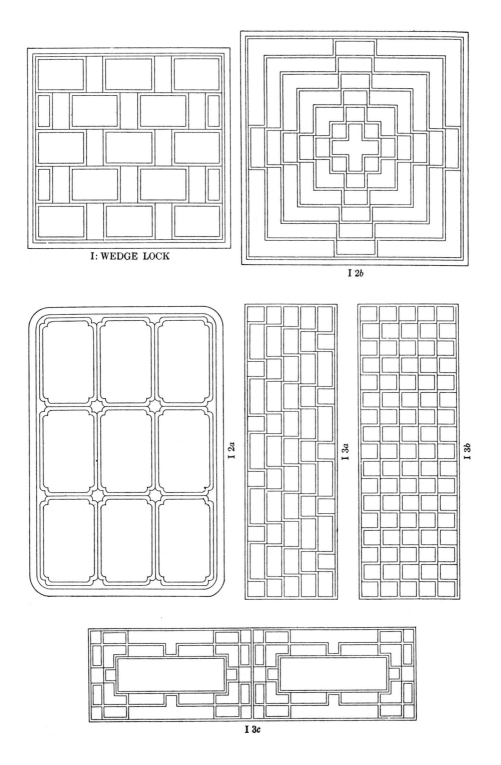

I: WEDGE LOCK

I 2b

I 2a

I 3a

I 3b

I 3c

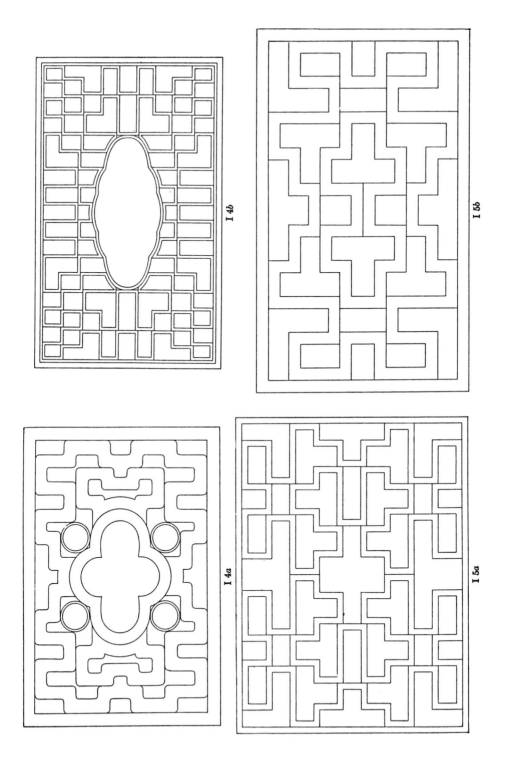

I 4b

I 5b

I 4a

I 5a

I. WEDGE–LOCK (*continued*)

2b. KNUCKLED TEN–CHARACTER

Residence, Chengtu, Szechwan, 1750 A.D.

Had this admirable design been found earlier in this study, it would have been easier to classify the group. The discovery of patterns similar to this one convinced me that the knuckle motif was not aberrant but a genuine design. The draughtsman of these plates, Mr. Yang Chi-shang, found this example in Chengtu about the time the plates were finally classified. It is one of the best, although in structural strength it leaves something to be desired. At night one sees five frames with eight lines of bars between, by day six concentered Greek crosses.

3a, b. KNUCKLED WAVES

a. East suburb woodshop. *b.* City cash shop, Chengtu, Szechwan, 1850 A.D.

These two windows were found towards the end of the investigation. They are closely related to 2b. Moreover, 3a and 2b were found in the same building. This type of window can best be used in narrow frames because of its structural strength.

3c. DOUBLE FRAMES KNUCKLED BY ENDLESS LINES

Shop, Chengtu, Szechwan, 1850 A.D.

Note the internal frames and the external one and the two endless lines that are wedged between, producing a linear effect.

4a. ENDLESS HAN LINE KNUCKLE FRAME

Native city, Shanghai, Kiangsu, 1900 A.D.

This is constructed in heavy wood. Such designs are found serving as balustrades in front of drug shops in the native city of Shanghai. They may be as much as three and one half or four feet high. This pattern presents some of the characteristics of the Han line (cf. M). The tooth-and-socket device at the ends gives greater strength to the knuckle bond. There is no straight line of thrust across the grille, but it is structurally strong because of the thickness of the wood.

4b. ENFRAMING ENDLESS LINE WEDGES

Shop door, Hankow, Hupeh, 1850 A.D.

There are four endless rope meanders, above, below, right, and left of the central frame, which support the center. The pattern is akin

I. WEDGE–LOCK (*continued*)

to the Hangchow rope (cf. 6*a–c*) and Chengtu knuckled-wave (cf. 3*a-b*).

5*a*. ENDLESS LINE KNUCKLE

Hangchow, Chekiang, 1850 A.D.

This device is a favorite one in Hangchow, where it is characterized by curves and rounds rather than rectangles. The number of variations of this endless meander which has been developed, especially in Hangchow, Shanghai, and to a lesser extent in Wu-Han, is remarkable.

5*b*. ENDLESS OPPOSED WAVE FRAME

Hangchow, Chekiang, 1850 A.D.

The central portion of the balustrade grille is set off in two sections, and this dissipates the sense of centrality. The outer endless line surrounds the central endless line like a frame. There are two vertical lines of unbroken thrust for strength.

6*a*. INDENTED RECTANGULAR FRAME

Shanghai, Kiangsu, and Hangchow, Chekiang, 1900 A.D.

This is a heavy grille, suggesting the Han line of M. The short bars take the place of simple adjacent knuckling or wedge-lock.

6*b*, *c*. INFOLDED ENDLESS LINES ENFRAMED

Ch'ien-lung library, West Lake, Hangchow, Chekiang, 1925 A.D.

The two endless rope meanders become plaquelike and suggest the bifocal design (cf. E). The short bars are used as wedges for rigidity as well as to give light spots of the same order of magnitude.

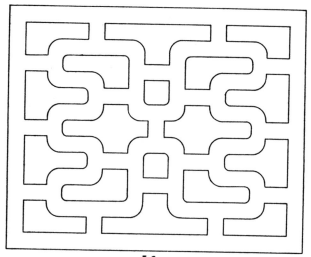

I 6a

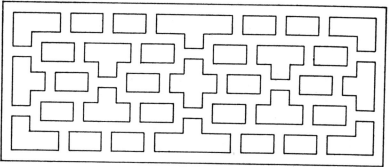

I 6b

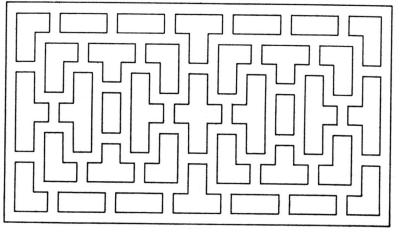

I 6c

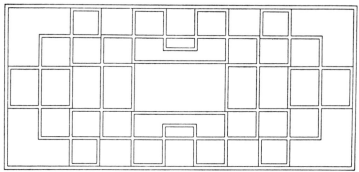

I 7a

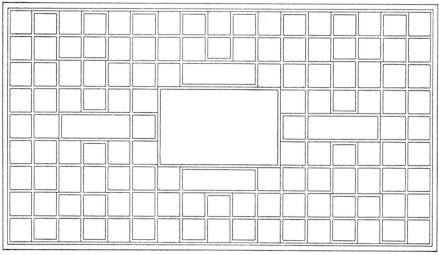

I 7b

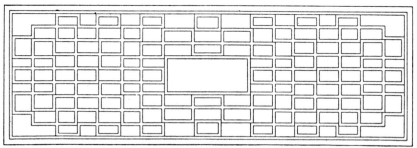

I 7c

I. WEDGE–LOCK (*continued*)

7*a*. THREE FRAMES OF INTERLOCKED WEDGE
Street shop, Chengtu, Szechwan, 1825 A.D.

7*b*. KNUCKLED FRAMES AND LINES
Residence, Chengtu, Szechwan, 1750 A.D.

7*c*. INTERLOCKED AND INTERWEDGED FRAMES
Over central door of ancestral hall, Chengtu, Szechwan, 1750 A.D.

I. WEDGE–LOCK (*continued*)

8*a*, *b*. CENTRAL **F**RAMES **W**EDGED **BY **E**NDLESS **L**INES**

Same residence as 7*b*, Chengtu, Szechwan, 1750 A.D.

Such windows as these, found in older buildings, testify to styles no longer current. The curl-ends are different from the preceding plates of this group.

9*a*. KNUCKLED **S**QUARE **W**INDOW**

Drug shop, Chengtu, Szechwan, 1750 A.D.

The internal and external square frames are emphasized as the prevailing motif by the square formed by knuckled bars just inside the outer frame.

9*b*. KNUCKLED **C**LOUDS **IN **O**CTAGONS**

Buddhist temple, Mount Omei, Szechwan, 1800 A.D.

Interlocked squares in iris pattern usually form an allover pattern; but here it is modified to fit into the octagon-square pattern in the center. The quadrants are filled in with knuckled clouds so as to equalize the light spots.

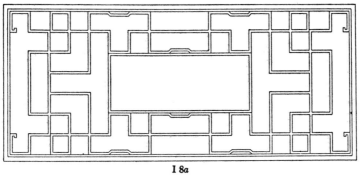

I 8a

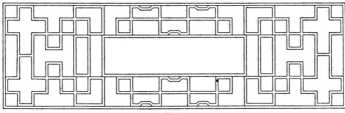

I 8b

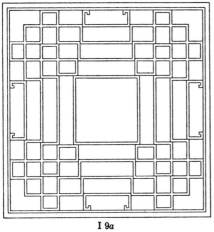

I 9a

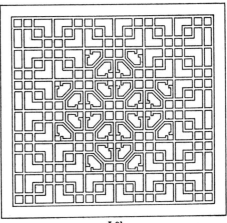

I 9b

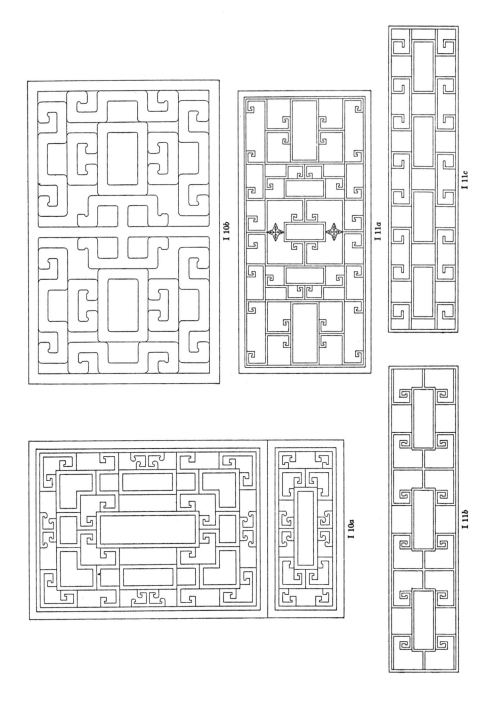

I 10b

I 11a

I 11c

I 10a

I 11b

I. WEDGE–LOCK (*continued*)

10*a*. CENTRAL FRAME AND SATELLITES WEDGED BY CLOUDS

Chengtu, Szechwan, 1850 A.D.

The central frame is supported by two smaller side frames, and magnified by L-frame corners. The several cloud-band and priest-head toggles knuckle-wedge the whole window. The small frame below the main window is typical of much lattice; the lower frame is usually long and horizontal, as is this. It is in harmony with the main window above; if the pattern above is ice-ray, the one below is also. Very few lower fixed windows are presented in this work; they occur in the front of practically every Chinese building. The upper window is pivoted by pin and socket about two-thirds the length of the side-strip from the bottom, swings inward, and is supported on the horizontal by a bracket that swings under the window when in this position. Even when the upper sashes are open along the building the line of small fixed lower sashes gives it a sense of length.

10*b*. CLOUD–SUPPORTED FRAMES

Chengtu, Szechwan, 1850 A.D.

This pattern when executed in heavy wood is particularly pleasing. The frames are really held together by dowels, but wedging is effective in giving strength. The bead is flattened from the half-round.

11*a*. CLOUD–SUPPORTED FRAMES

Sintientsi, on main highway near Yachow, Szechwan, 1800 A.D.

A series of three vertical frames flanked by two horizontal frames, all on the same level, are wedged by classical scroll features.

11*b*, *c*. CATENARY FRAMES WEDGED BY CLOUDS

b. Sintu, one half-day northeast of Chengtu, Szechwan. *c*. Hehohtse, one day and a half northwest of Chengtu in the hills, Szechwan, 1775 A.D.

The location of *b* is closer to main routes than is *c*. It retains proportions heavier than are given in this drawing. These two examples are closely related.

I. WEDGE–LOCK (*continued*)

12a. Ju I Scepter Combination Supporting Rectangular Frame

English etching from Canton, Kwangtung or Foochow, Fukien. Early 18th century A.D.

This is typical of work in several old official buildings in Foochow which were still extant in 1935. In 1932 I ate at an inn in Canton where an overhead grille survived which was a close relative of this. It was out of reach and was not annually papered so that it had retained its form in spite of its fragility. The European etchers did not always meticulously copy the originals, but in this case the copyist did not go far astray.

12b. Knuckled Central Frame

Over front gate of residence, Yachow, Szechwan, 1775 A.D.

This is a delightful old pattern of splendid workmanship, from a place where hard wood of good quality has been available for centuries. It has stood for decades in the protected place over the great front doors of the gatehouse of the compound.

13a. Interlocked and Ambiguous Cloud–Bands

Sintsing, Szechwan, one day southwest of Chengtu, 1775 A.D.

The four priest-head toggles, or T's or I's on the median line, demark the axes, and wedge the bars into rigidity.

13b. Wave and Cloud Wedge–Lock

Sintsing, Szechwan, 1775 A.D.

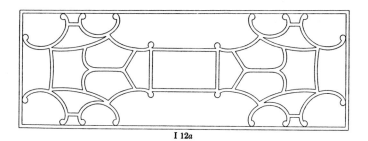

I 12a

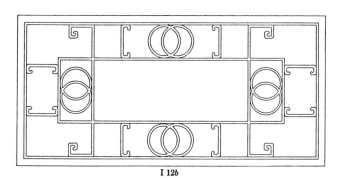

I 12b

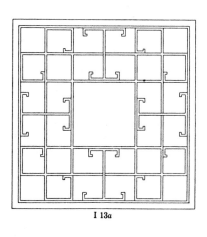

I 13a

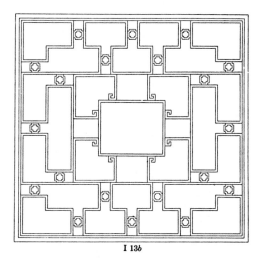

I 13b

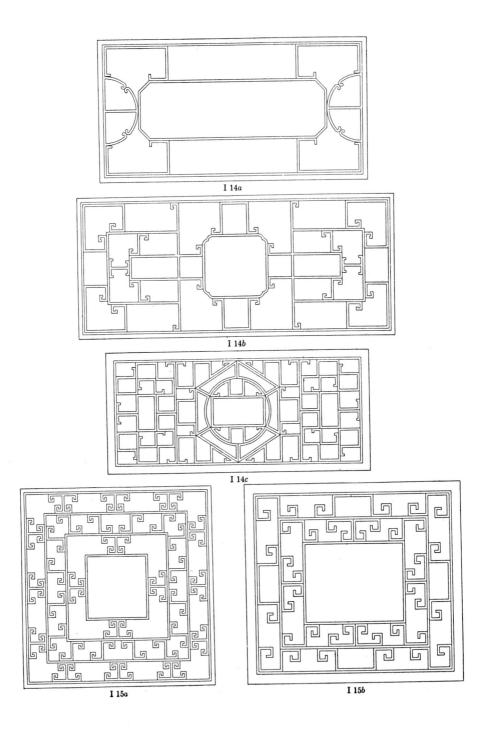

I 14a

I 14b

I 14c

I 15a

I 15b

I. WEDGE–LOCK (*continued*)

14*a*. KNUCKLED OCTAGONAL FRAME

Kin Kiang Ch'ao, Szechwan, 1850 A.D.

This open grille does not suggest strength, but it suffices to support translucent paper. The Ju I elements are rounded, but the other parts are slightly beveled. This reveals the mechanical weakness of the knuckle-wedge when its use is carried too far.

14*b*. FRAME SUPPORTED BY AMBIGUOUS CLOUD–BANDS

Confucian temple, Yachow, Szechwan, on imperial highway to Yünnan and Nepal, 1800 A.D.

This is an unusually fine example of a type of window which was common before and after 1800 A.D. Few new ones have been executed since 1900. This grille is just under the eaves and over a marvellously carved square-and-circle window.

14*c*. CONCENTERED RECTANGLE, CIRCLE, AND OCTAGON, WEDGED BY S– AND U– SCROLL

Temple, Chengtu, Szechwan, 1825 A.D.

The penchant for meander scroll comes down from classical Chou times. Some of the bronzes of that day have still more fantastic designs of this type, but these are quite distinct. They were not used for wedge-bond purposes, but to fill space symmetrically and beautifully. The S– and U– scroll are often much modified.

15*a*. THREEFOLD FRAME WEDGED BY T– AND S– SCROLLS

Residence, Kiungchow, Szechwan, on Chengtu-Yachow road, 1800 A.D.

This square with its three internal and concentered frames presents the appearance of a three-stepped or terraced pyramid. The S–scrolls are symmetrically deployed and balanced in a most pleasing manner.

15*b*. TWOFOLD FRAME WEDGED BY S– AND U– SCROLLS

Sintsing, Szechwan, 1800 A.D.

The T–scrolls or priest-head toggles of the previous plate have given place to two U–scrolls back to back. It is possible that this device has given rise to the priest-head toggle motif.

I. WEDGE–LOCK (*continued*)

16. MEDIAN FRAME SUPPORTED WITHIN AND WITHOUT BY CLOUD–WEDGES

Chengtu, Szechwan, 1925 A.D.

This is one of those designs that appears to have but one internal frame by daylight, but three or more by transmitted light.

17a–c. HORIZONTAL WINDOWS

Yamen, Chengtu, Szechwan, 1775 A.D.

a is one endless line wedged apart by short bars and supported by six cross-bars in pairs. *b* has knuckled cloud-bands simulating catenary framing. *c* is a rare set of wedged frames and an endless looped line. All three are uncommon.

17d. MAGNOLIA FLOWER ENFRAMED

Ch'ang-yüan, Wuchang, Hupeh(?), 1650 A.D.(?)

18. COMPOUND CLOUD–BANDS SUPPORTING CIRCLE–OF–HEAVEN FRAME

Small temple on Szechwan border, on imperial highway between Kwangyüan and Hanchung, 1775–1800 A.D.

This elaborately carved grille was executed by a master of his craft; the drawing does not do it justice. The enclitics with other cloud-bands carved upon them are rare. A specimen analogous to this was found in the native city of Hankow, in which dragon heads simulate the bronze work of the Chou dynasty.

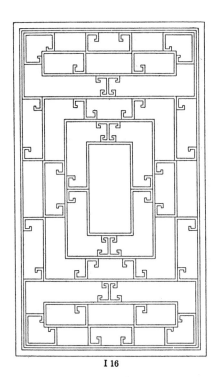

I 16

a

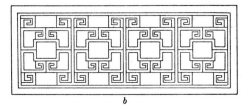

b

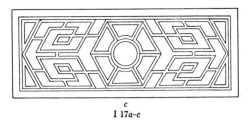

c
I 17a–c

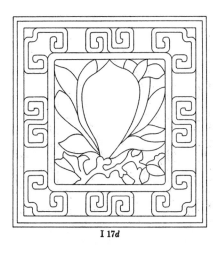

I 17d

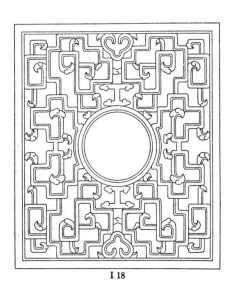

I 18

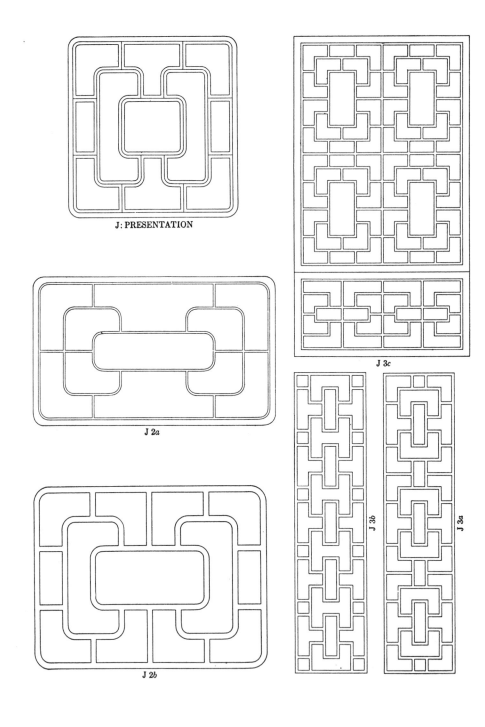

J: PRESENTATION

J 2a

J 2b

J 3c

J 3b

J 3a

J. PRESENTATION

This fine, though small, group of window patterns was first observed at Paoning, Szechwan, but the group has representatives much further afield. These suggest the manner in which gifts were presented with both hands in the ceremonious pre-revolution days. The same design was discovered in old graphies taken from stamps on old bronzes as depicted in Ch'ien-lung's *Catalogue of Ancient Bronzes* (cf. &ulf). This device is also found in some very ancient ideographs in Wieger's *Chinese Characters.*

2*a*. PRESENTATION WINDOW

Dye, 1930 A.D.

This window with light bars lacks structural strength, but is strong enough to support paper.

2*b*. PRESENTATION BALUSTRADE

Railing in temple at Looking-toward-Heaven Gate. Chungking, Szechwan, 1850 A.D.

3*a, b*. PRESENTATION IN CATENARY FRAMING

a. Chinese block-printed book of 1850 A.D. *b.* Pagoda, Shanghai, Kiangsu, 1850 A.D.

J. PRESENTATION (*continued*)

3c. RECTANGULAR PRESENTATION WINDOW

House of Bishop Cassels, Paoning, Szechwan, end of 19th century.

Bishop Cassels built a house in the Chinese style of the 19th century, and used a window design characteristic of that date; this style might be dated 1875 A.D. The lower part of the window is fixed. Compare and contrast H 3c and H 4 with this window.

4a. PRESENTATION IN WINDWHEEL ORIENTATION

Paoning, Szechwan, 1875 A.D.

Each quadrant has a central plaque supported by the presentation method; the central oblong plaques are turned through an angle of 90 degrees with respect to their neighbors.

4b. COMPOUND PRESENTATION MOTIF

From photograph of temple, Chihli, 1875 A.D.

5a. PRESENTATION ALONE

Residence, foothill town of Mount Omei, Szechwan, 1850 A.D.

The writer is not sure which is the top and which the bottom of this window. Turned the other side up it suggests scales.

5b. FRAMED PRESENTATION

Yüan-yeh, Soochow, Kiangsu, 1635 A.D.

The plate should have no median line in the bars. It is a variation of the motif of 5a.

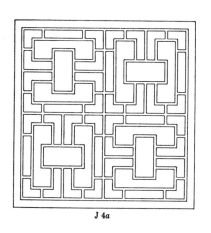

J 4a

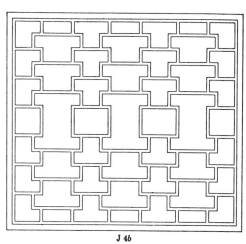

J 4b

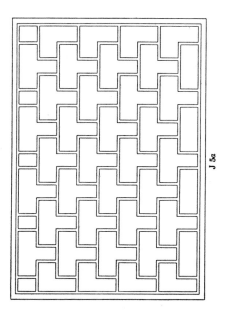

J 5a

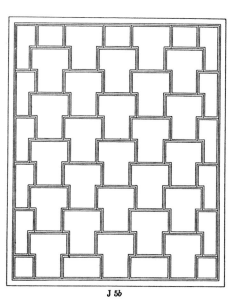

J 5b

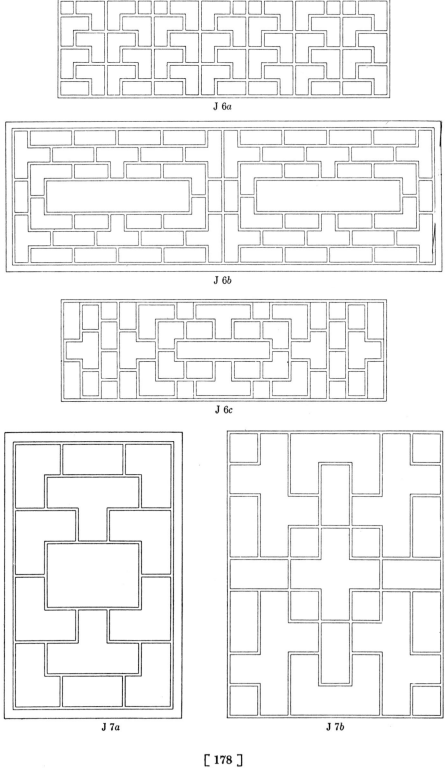

J 6a

J 6b

J 6c

J 7a

J 7b

J. PRESENTATION (*continued*)

6*a–c*. PRESENTATION BORDERS

Shops and residences, Chengtu, Szechwan, 1850–1875 A.D.

7*a, b*. PRESENTATION COMPLEX WINDOWS

a. Railing in temple, Chungking, Szechwan, 1875 A.D. *b*. Provenance and date uncertain.

J. PRESENTATION (*continued*)

8–9*a*. COMPOUND PRESENTATION

8. Mienchow-Kwangyüan, Szechwan, 1850 A.D. 9*a*. One day west of Yachow, Szechwan.

These two windows are similar to E 5*a*, *b* in essential structure, yet they come under presentation as variations.

9*b*. PRESENTATION MOTIF

Shanghai, 1900 A.D.

10*a*, *b*. COMPOUND PRESENTATION

a. Three days west of Yachow, Szechwan, 1875 A.D. *b*. Inn on imperial highway, Shensi-Szechwan border, 1825 A.D.

Certain old windows such as *a* led me to believe that an investigation of the old imperial highway to the northeast of Chengtu might prove fruitful, and my surmise was correct. Along this highway are many forms and types that have almost disappeared from Chengtu.

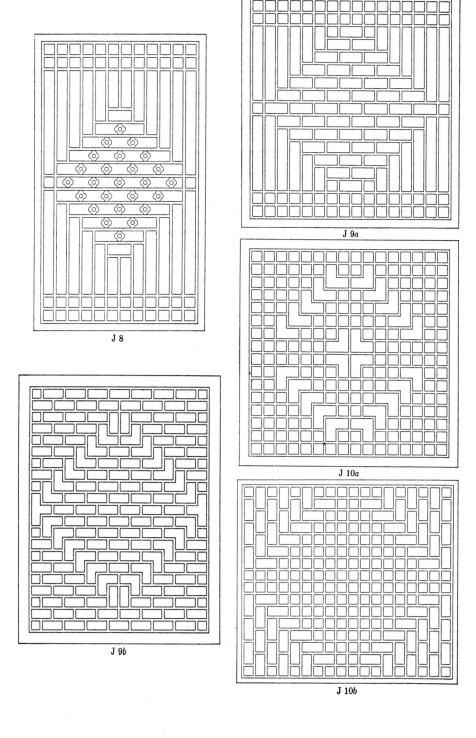

J 8

J 9a

J 9b

J 10a

J 10b

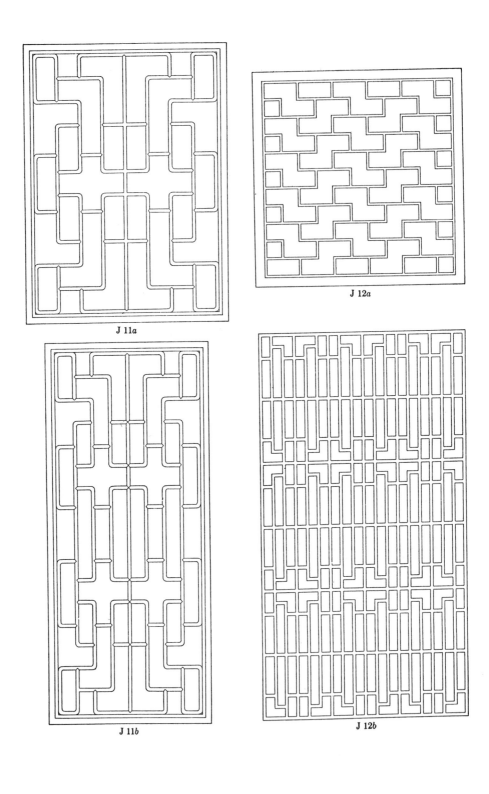

J 11a

J 12a

J 11b

J 12b

J. PRESENTATION (*continued*)

11*a*, *b*. MODIFIED PRESENTATION

Ch'ang-yüan, Wuchang, Hupeh(?), 1650 A.D.(?)

The only window or door of this type with which the writer is acquainted is at Hankow. The half-round bead and the mortise should be noted. There is a suggestion here of the andiron design from the Tun-huang caves discovered by Sir Aurel Stein (cf. &e 3*a*).

12*a*. THE HANDS REVERSED

Shanghai, Kiangsu, 1900 A.D.

This design seems related to the presentation group, though the two ends are reversed.

12*b*. OPPOSED PRESENTATION

Yüan-yeh, Soochow, Kiangsu, 1635 A.D.

The hands, opposed pair by pair, are interesting. The Soochow writer classifies this among "changes in the well-character," but is hazy about these particular plates. The internal evidence in several designs indicates an underlying bond. Compare in this connection the presentation pattern (J4*b*) and the andiron design (&e 3*a*).

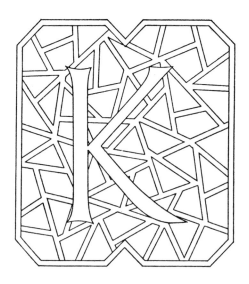

K. OUT–LOCK

The term "out-lock" was coined to express the principle best seen in figures 5a and 12a–c. It involves the external support of the several ends of the windwheel motif. Each side of the central frame is extended at one end (but not both) until the four ends find external support. 12a–c show the division of a surface by the alternate insertion of the characters signifying "man" and "to enter" (cf. &u 2m, h) until the whole surface is covered. The support principle is similar. This type seems to have been fairly popular under the Ming dynasty, but it may have been used earlier to a limited extent.

2a. Brick Pattern Converted into a Swastika

Chengtu, Szechwan, 1850 a.d.

This is not a rare pattern. It is frequently seen framed on the horizontal. This double-arm form of the swastika is not so common in China as the single-arm. The design may have been suggested by bricks or by simple basket-weave.

2b, c. Man–Character or T- Pattern

a. Paocheng, Shensi, 1850 a.d. *b.* Hanchung, Shensi, 1850 a.d.

These two windows vary only in proportions. Similar examples are found in both Shensi and Szechwan. The character for man, or individual, as it appears in its modern form in &u 2g is seen by the

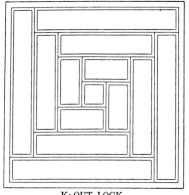

K: OUT-LOCK

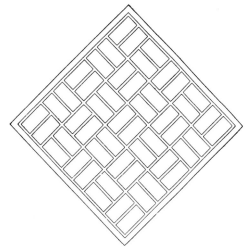

K 2a.

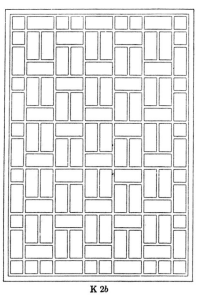

K 2b

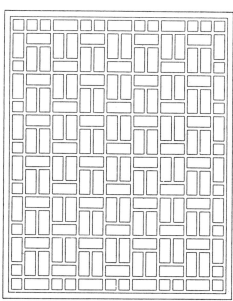

K 2c

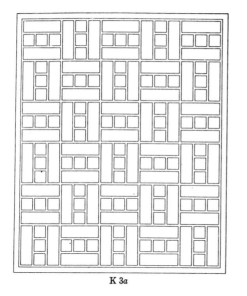

K 3a

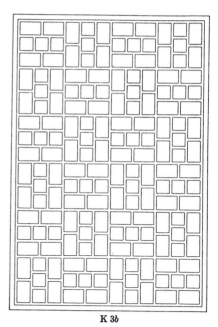

K 3b

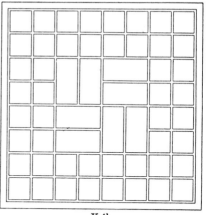

K 4a

K 4b

K. OUT–LOCK (*continued*)

modern Chinese in these windows. The ancient graphies or primitive characters for "above" and "below" (&u 2*e*, *f*) appear in alternate frames, but these are not the meanings which are impressed upon the mind today.

3*a*, *b*. MODIFIED SWASTIKA

a. One day south of Chengtu, 1850 A.D. *b*. East Gate suburb, Chengtu, Szechwan, 1850 A.D.

4*a*, *b*. SWASTIKAS

a. Over door of residence, Chengtu, 1875 A.D. *b*. Near Kwangyüan, Szechwan, 1875 A.D.

a is a variation of 2*a*. The proportions between thickness of bar and size of light spot vary, as do the actual sizes. *b* is interesting for the large light spots and the double border of unit squares.

K. OUT–LOCK (*continued*)

5*a*, *b*. LARGE AND SMALL WINDWHEELS OF OPPOSITE ROTATION

Temple, Chengtu, Szechwan, 1850 A.D.

These contrast with the paired and opposed windwheels of equal size in 9*b*.

6*a*, *b*. COMPOUND AND COMPLEX WINDWHEELS

a. Residence, Chengtu, Szechwan, 1850 A.D. *b*. One day northeast of Kwangyüan, Szechwan, 1850 A.D.

Another case like *a* with two additional windwheels was found on the Shensi-Szechwan border. It is interesting to find these windows so widely separated.

7*a*, *b*. COMPLEX WINDWHEELS

a. Shanghai, Kiangsu, 1900 A.D. *b*. Shop, North Gate suburb, Chengtu, Szechwan, 1875 A.D.

a. This large-embracing-small windwheel is only twofold instead of sevenfold as in 6*a*. Such a design offers a fertile field for variations. Another simplification of this at Shanghai has but one windwheel within a square.

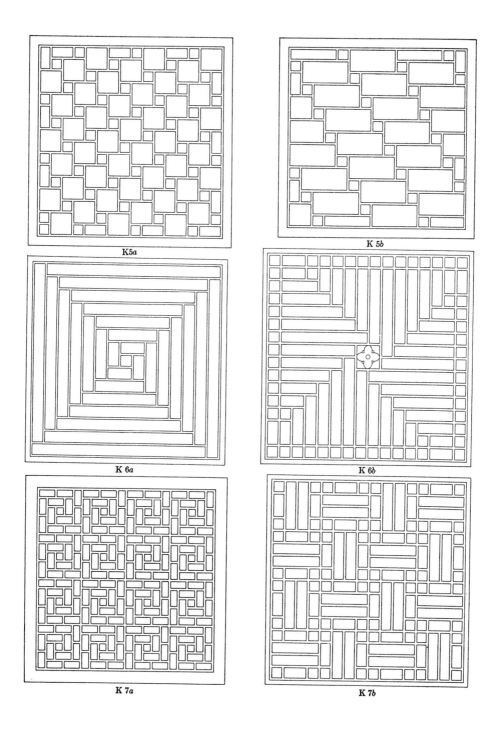

K5*a*

K 5*b*

K 6*a*

K 6*b*

K 7*a*

K 7*b*

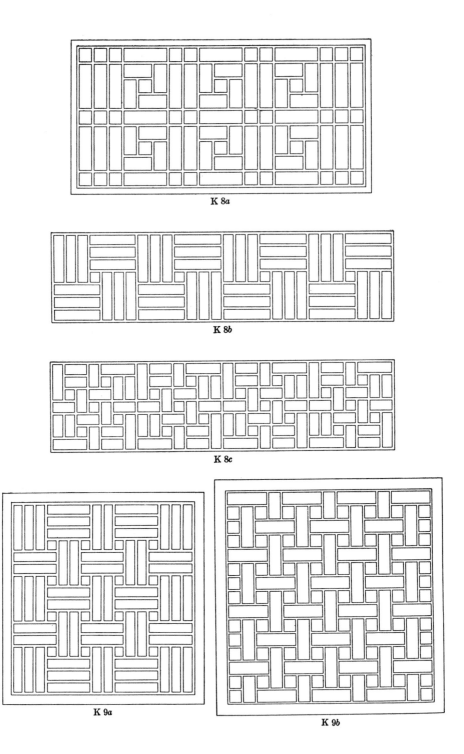

K 8a

K 8b

K 8c

K 9a

K 9b

K. OUT–LOCK (*continued*)

8*a–c*. COMPLEX WINDWHEELS

a. Shanghai, Kiangsu, 1900 A.D. *b.* Chengtu, Szechwan, 1875 A.D. *c.* East Gate suburb, Chengtu, Szechwan, 1850 A.D.

These designs are evolved by separating the units of the windwheel design of 9*b* by bars, or by copying the pattern formed by stacking bricks at the kiln.

9*a, b.* OPPOSED WINDWHEELS

a. Rice shop, Chengtu, Szechwan, 1850 A.D. *b.* Residence, Chengtu, Szechwan, 1875 A.D.

These are evolved from weave of bamboo, either in single ply or two-ply, where the edges of the splints are picked out and emphasized by bars and the light spots represent the visible portions.

K. OUT–LOCK (*continued*)

10*a*–12*a*. OPPOSED WINDWHEELS

10*a*. Chengtu, Szechwan; Peking, Chihli; Shanghai, Kiangsu, 1900 A.D.

10*b* is noteworthy for its raking and its bars crossed through the spaces between the windwheels. The waves are closely akin to some of 1825 A.D. found west of Yachow, Szechwan.

11*a*. Buddhist temple, Ningpo, Chekiang, 1850 A.D. 11*b*. *Ch'ang-yüan*, Wuchang, Hupeh(?), 1650(?). 12*a*. Chengtu, Szechwan, 1875 A.D.

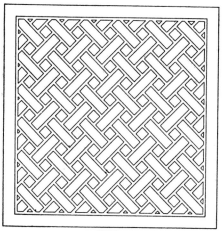

K 10a

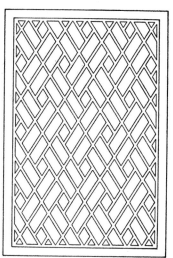

K 10b

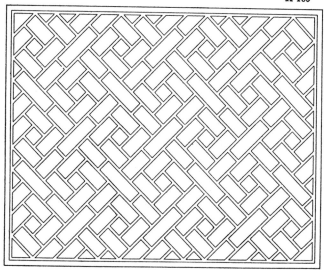

K 11a

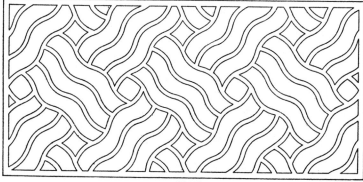

K 11b

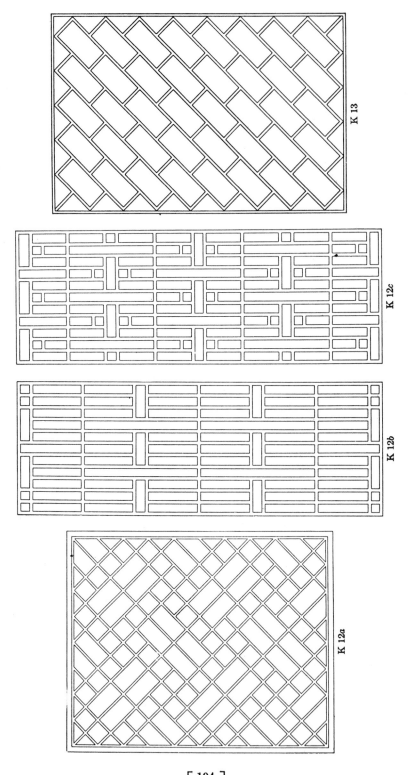

K 13

K 12c

K 12b

K 12a

K. OUT–LOCK (*continued*)

12*b, c.* Concealed Windwheels

Yüan-yeh, Soochow, Kiangsu, 1635 A.D.

These fine old specimens suggest that simple types like 5 and 9 have survived from a more extensive use of the windwheel.

13. Crossed Complex Waves

Luchow, Szechwan, 1875 A.D.

This window does not seem unbalanced. The brick spaces or short bars are so arranged that they appear as waves across the window both horizontally and vertically. The type seems to have been foreshadowed in Han times. In the University of Pennsylvania Museum there is an imprint of a Han brick pattern that is seemingly more raked than is this one.

K. OUT–LOCK (*continued*)

14*a–d*. MAN–CHARACTER PROP

a. Chengtu, Szechwan, 1875 A.D. *b, c. Yüan-yeh*, Soochow, Kiansu, 1635 A.D. *d.* Dye in the Kwangyüan style, Szechwan, 1875 A.D.

The weave pattern of *a*, as well as many others, was more open and longer during the Ming dynasty than during the later years of the Ch'ing dynasty. *d* comes from a bed-foot; it was only one half as high, although as long, as this. All four of these patterns are mere idealizations of simple wave designs.

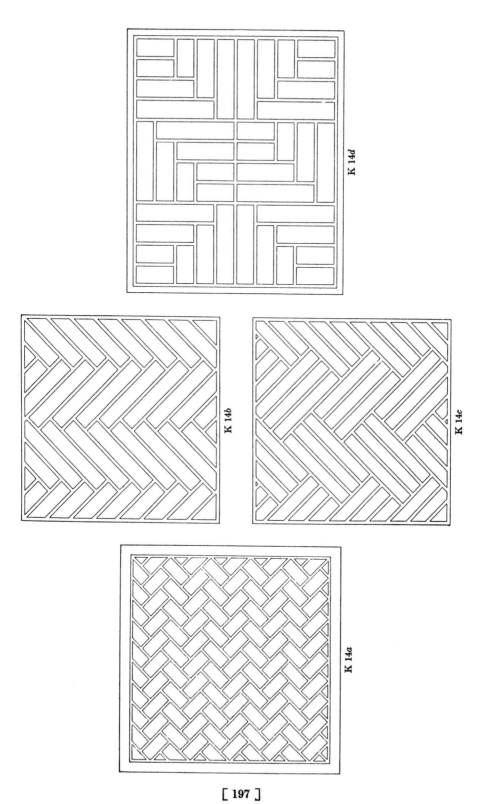

K 14d

K 14b

K 14c

K 14a

L: IN-OUT BOND

L 2a

L 2b

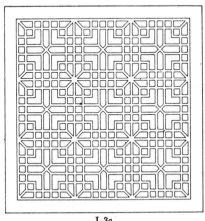

L 3a

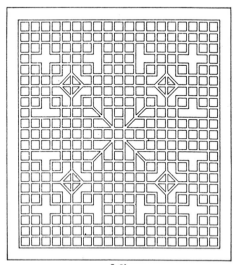

L 3b

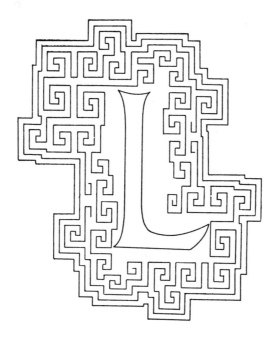

L. IN–OUT BOND

Some windows of this group might equally well be placed elsewhere, and some from other groups might be grouped here. A union of the parallelogram of Group A or the octagon of Group B with the interlocking square of the present group gives pleasing results. The chief feature of this group is elaborate interlocking of corners; furthermore, many of the corners are free, i.e., unconnected with further cross or diagonal bars. I feel sure that this type has been exploited much more than is shown in this book, but cannot produce confirmatory data. The older the form of the interlock, the finer the window. Like many other motifs, it can be so overemphasized that it becomes trite and displeasing; the simpler it is made, the more appealing the window appears.

2*a*, *b*. INTERLOCKED RECTANGLES

a. Hanchow, one day northeast of Chengtu, and Mount Omei, Szechwan, 1875 A.D. *b*. Hanchow, Szechwan, 1875 A.D.

This is a rather extreme form of interlocked rectangles. It is similar to H 7*a*, which shows the commoner iris pattern of interlocked squares which has been so much in vogue for something like three centuries over much of China. The addition of bars through the middle of the squares is not common today.

L. IN–OUT BOND (*continued*)

3*a*–7*b*. INTERLOCKED WINDOWS

Buddhist temples, Mount Omei, Szechwan, 1800–1900 A.D.

3*a*, 4*a*, 4*b*, 5*a* and 5*b* are the best of this group of Mount Omei temple windows. It is noteworthy that they have borders inside the frame of simple squares. These particular windows are not as old as the Ming dynasty but the design goes back to that period. In 4*b* this border device extends along the top and the bottom of a series of windows in one bent.

8*a*. INTERLOCKED FRAMES

Provenance uncertain.

These frames are comparable to opposed swastikas.

8*b*. L–SHAPED INTERLOCK

Chengtu, Szechwan, 1850 A.D.

This window is unusual today, but was common a century ago.

9*a*–*d*. INTERLOCKED NARROW WINDOWS

a–*c*. Chengtu, Szechwan, 1900 A.D. *d*. Provenance uncertain.

All these are old patterns. *b* was more frequent in 1800 A.D., but the others are more often met with today.

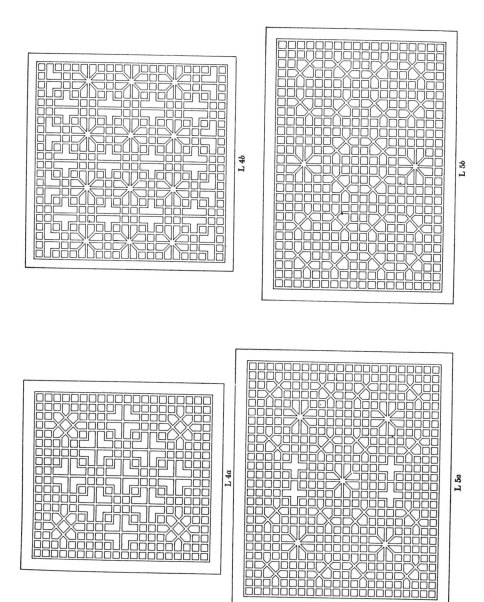

L 4b

L 5b

L 4a

L 5a

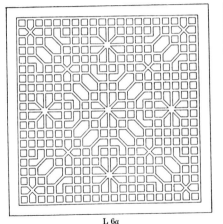

L 6a

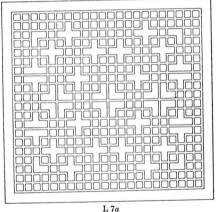

L 7a

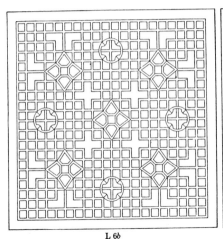

L 6b

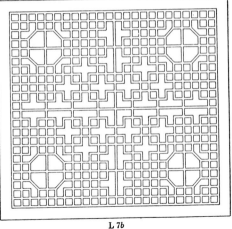

L 7b

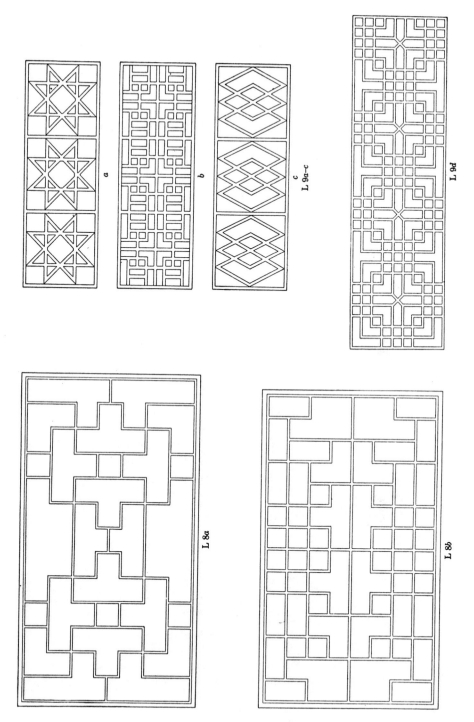

a b c
L 9a–c

L 9d

L 8a

L 8b

L 10*a*

L 10*b*

L. IN–OUT BOND (*continued*)

10*a*, *b*. OBLONG INTERLOCKED RECTANGLES
Yüan-yeh, Soochow, Kiangsu, 1635 A.D.

10*a* is the iris pattern (cf. H 7*a*) stretched from the top and the bottom and four Ming dynasty "waists" interposed. These waists running through a whole series of windows give the sense of horizontality to the long low buildings.

10*b* is H 4 with its allover frames drawn out and supplied with "waists." (H 4 was constructed after 10*b*, but the idea of H 4 came before the theme of 10*b* was incorporated in this particular window.)

M. THE HAN LINE

This special series of designs is limited and local in its distribution, and is used predominantly in balustrades rather than in windows. It is found in Chengtu, in a city one day to the southwest of Chengtu, and in a village one day to the south on the Fu River; all these examples are from Szechwan. There are some examples reminiscent of it in Hangchow, Chekiang, but the patterns there differ in some respects. One window quite similar to the Chengtu type was seen in a city one day to the west of Kwangyüan, Szechwan. 8b is not, strictly speaking, a member of this group. I have seen as many as fifty examples of this pattern, most of them on one narrow Chengtu alley. Some appeared as heavy railings in front of medicine shops. Practically all the examples date from before 1850 A.D., and very few are now extant, since the streets of Chengtu have been widened.

Several features seem to be essential to orthodox Han Wên, or Han line. Each design should have outset corners, like the outline of the large light spots in 7b. Also the curved or full-bellied round appears, which seems to be related to the characteristic curve of bronzes and brackets of the Han dynasty. Again, the frames are joined by one, or preferably two, bars. Finally an allover of frames is crossed and superimposed upon another by careful mortising; glossy black or red lacquer covers all, and conceals the mortising when the balustrade is in good repair.

The Han line in balustrade was well developed in 1684 A.D. in a city a day to the southwest of Chengtu, for an example of that date is still extant in the Confucian temple there. The grille is out of

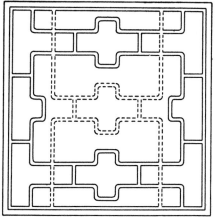

M: HAN LINE

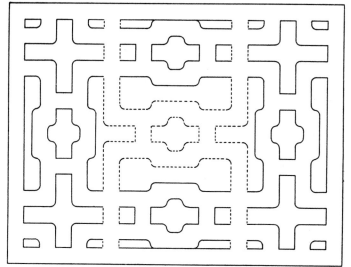

M 2*a*

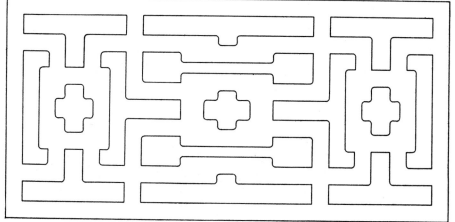

M 2*b*

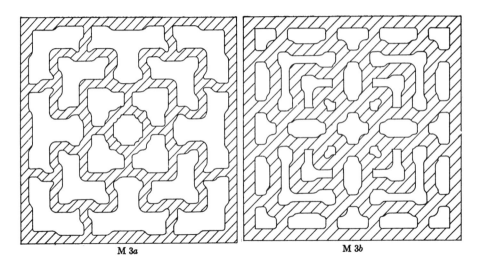

M 3a M 3b

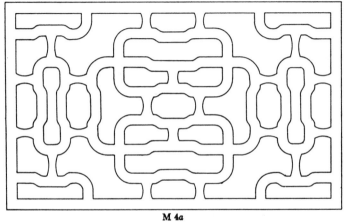

M 4a

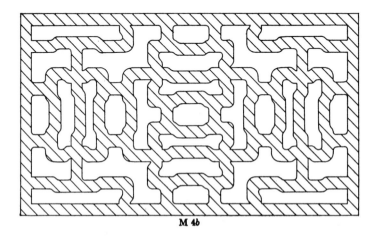

M 4b

repair, but it is clearly related to 4*a* and 6*b*. The Japanese have examples of 8*b* with rounded corners. It is highly probable that this grille reached a high state of perfection by the time of the T'ang dynasty. I know of no grille of this type which has been constructed during this century in Szechwan. It probably reached its highest point during K'ang-hsi's time.

2*a*, 3*a*–6*b*, 8*a*. Chengtu Han Line

Street-side balustrades before silk and medicine shops, Chengtu, Szechwan, 1684–1850 A.D.

3*a*. The wooden bars are hatched in the diagrams so that their heaviness reveals the gradual curve in line.

3*b*. This is on somewhat the same order as 3*a*.

2*b*. Han Line Frames Joined by Frames Instead of Bars

One day south of Chengtu, Szechwan, 1700 A.D.

The short bars between the allover frames are replaced by small rectangular frames with rounded corners, which do not leave space between the large and small frames, so that the bars appear to be thickened.

M. THE HAN LINE (*continued*)

7*a*. HAN LINE TYPE

Provenance and date uncertain.

This is not Han line in every respect.

7*b*. FRAMES AFTER THE HAN LINE

Thunder god temple, East Gate suburb, Chengtu, Szechwan, 1800 A.D.

This is only a single allover of frames, without the Han interlock of a second system. The extrusive corners of the frames were utilized in the desk-tops of Canton which Chippendale copied in *The Director* in 1753 A.D. They were also used in desk tops in Chengtu in 1900 A.D.

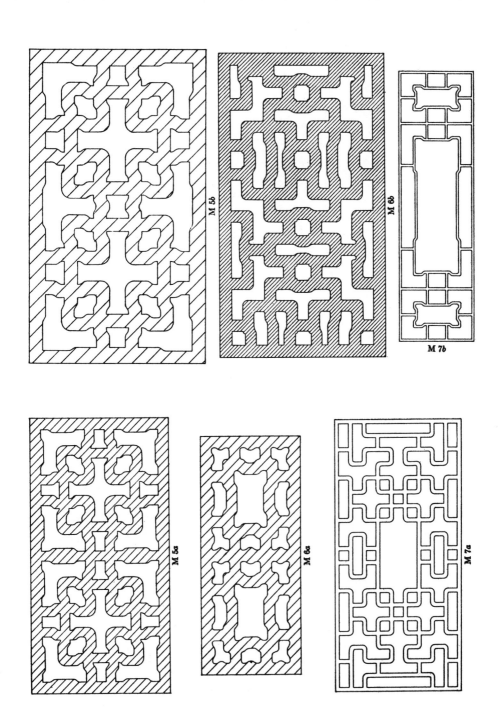

M 5b

M 6b

M 7b

M 5a

M 6a

M 7a

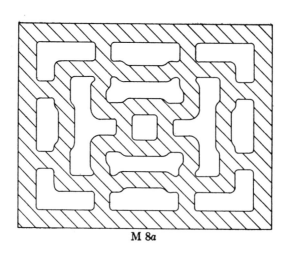

M 8a

M 8b

M. THE HAN LINE (*continued*)

8*b*. ALLOVER RECTANGULAR SUPERIMPOSED FRAMES

Paoning, Szechwan, 1850 A.D.

This design shows well what is meant by "superimposed frames." One frame is outlined in dotted lines for analysis, but all are solid in the original window.

This design differs but little from two designs presented in the *Yüan-yeh*, Soochow, Kiangsu, in 1635.

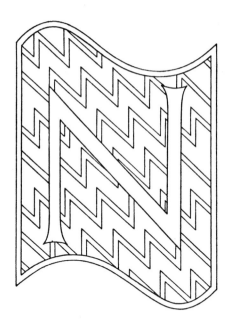

N. PARALLEL WAVES

The wavy line appears early in artistic evolution, but carefully drawn, parallel waves, regular, systematic, and proportioned, are a much later development. The Chinese have experimented with and demonstrated in lattice waves some of the effects in speed of reading and the impression produced by the following factors:

(1) The angle of angular waves.
(2) The height of waves.
(3) The number of parallel waves.
(4) The thickness of bars.
(5) The distance between planes of waves.
(6) The distance of observation.
(7) The vertical bars across waves.
(8) The voiding of waves.
(9) The reinforcing of slopes of single waves.

2a. THE WAVE

Silk shop, Chengtu, Szechwan, 1875 A.D.

This general design is called "The Tide" in Szechwan, but it may be a local name, so I use "The Wave" instead. The design shows parallel and angular waves on a strictly parallel bar background. This dizzying motive is seldom used by the lattice worker today, but

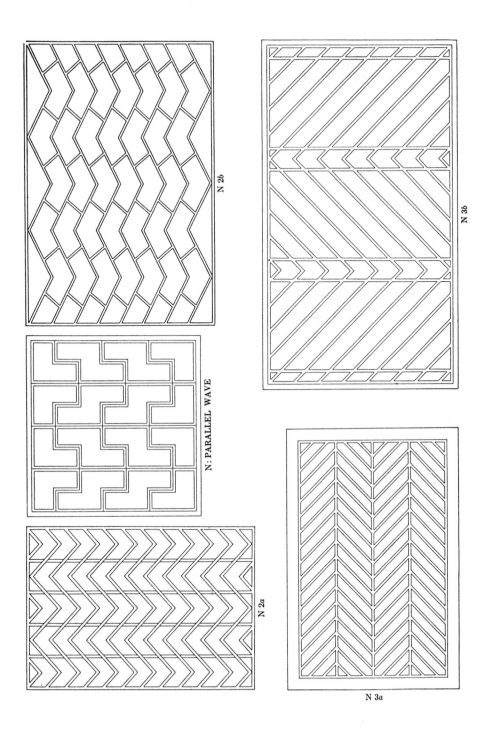

N 2b

N 3b

N : PARALLEL WAVE

N 2a

N 3a

N 4c

N 5b

N 4b

N 4a

N 5a

it lies at the base of the work of the psychologist, the painter of military camouflage, the worker in embroidery, the Chinese carver and worker in porcelains, and the designer of Manchu dynasty gowns. In garment hems the waves are in color, and in these, as in embroidery, the plumb lines are omitted. In thread or in paint the lines are not so stiff, the verticals are not present, the haziness vanishes, and angularity takes on sinusoidal curves. The chevron quality of these patterns, when done in lattice, is almost lost.

2b. FLATTENED WAVES

Shop, Chungking, Szechwan, 1775 A.D.

The modification of the verticals so as to eliminate the optical illusion is interesting. The spots of light approach in shape the metal or jade musical instruments used in Confucian worship. Y 3b is but a slight modification of this plate.

3a. HERRING–BONE WAVES

Residence, Chengtu, Szechwan, 1875 A.D.

This is a bona fide Chinese lattice window. Spacing and proportion of parts, as well as pleasing angularity, make a place for this among artistic window designs.

3b. THREE–SLOPE WAVES

Dye after a Chinese book of 1761 A.D., and shop, Chengtu, Szechwan, of 1875 A.D., 1933.

A Chinese book of unknown provenance gives a woodcut similar to this except that it lacks the outside bars; in Chengtu there is extant a set of three adjoining windows with heavier bars akin to this. I have combined them both.

4a. SEPARATED WAVES

Public building, Chengtu, Szechwan, 1875 A.D.

4b, c. VOIDED WAVES

Chengtu, Szechwan, 1800 A.D.

The elimination of all save three parallel waves in the design of b is unusual in Szechwan today. It reminds one of certain patterns from Soochow, Kiangsu, of 1635 A.D. The voided waves of c are very

different from those of *b*, to which the pattern is related. The light spots here are similar, but they are paired two and two, while those of *b* are the mirror image of the figure either on the right or that on the left.

5*a*, *b*. CHOPPY WAVES

a. Chengtu, Szechwan, 1900 A.D. *b*. Shop, Chungking, Szechwan, 1875 A.D.

The waves in *b* suggest serried cones receding into the distance. The spots of light, like those in 2*b*, are reminiscent of instruments used in Confucian worship (cf. &t 1*f*). There is bilateral balance in this design, absent from 7*a*.

6*a*, *b*. COMPOUND WAVES

Residences, Manchu city, Chengtu, Szechwan, 1850 A.D.

The overhead grilles are paired with their counterparts. I am aware of no parallel save in the drum tower, Hsienyang, Shensi; cf. the *Encyclopaedia Britannica* [11], s.v. "Chinese Architecture," Pl. IX.

6*c*. REINFORCED WAVES

Tooled on stone sarcophagus near Chengtu, Szechwan, 150 B.C.

I have seen much stamped brick of the Han dynasty on the imperial highway between Hanchung and Chengtu, Szechwan, have compared many funerary remains of the same period in museums from Canton to Washington, and have seen many rubbings or photographs of bronzes and of stone of the same time; the patterns are consistently allied to those used in wooden lattice of other days. I am thus confident that this pattern is very like wooden lattice of that time. The Koreans copied it, and used it on a bronze bell during the latter part of the Han dynasty, when they were trading with Szechwan.

7*a*. ECHELON WAVE

Buddhist temple, Sintu, Szechwan, 1850 A.D.

This has its counterpart in Hankow in an asymmetrical single window, but it is unusual to find a stepped wave such as this.

N 6a

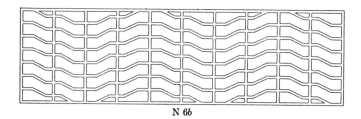

N 6b

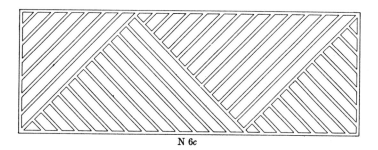

N 6c

N 7a

N 7b

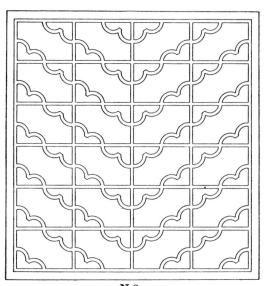

N 8a

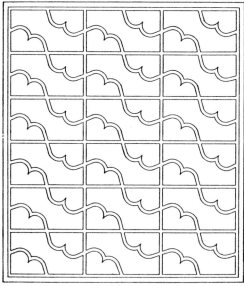

N 8b

N. PARALLEL WAVES (*continued*)

7*b*. KING WAVES

Manchu city, Chengtu, Szechwan, 1875 A.D.

The straight bars are vertically so arranged that the unusual waves and bars cut up the light spots into the character for "prince" or "king," i.e., three horizontal bars — heaven above, man between, and earth below — connected by a vertical — the one who joins heaven–earth-man (&u 2*d*). This character is repeated again and again in the clear spaces, framed. This design comes from a quarter inhabited by Manchu bannermen in the pre-revolutionary days of 1911. It is not a common one; in fact, this window is the only one of the kind that I have seen. Racial or social significance should not be attached to its use in the Manchu city, for the name is a common one among all ranks of Chinese. Manchu city lattice in Chengtu does not seem to differ essentially from that of the government section, known as the imperial city, nor from that of the business section. These three sections were separated by walls before the revolution of 1911, but were all enclosed within a single city wall.

8*a*. JU I WAVES

One day southwest of Chengtu, Szechwan, 1825 A.D.

8*b*. ASYMMETRICAL JU I WAVES

Shop, Hankow, 1875 A.D.

This differs from the preceding plate in the contour of the Ju I waves, which do not change their slope.

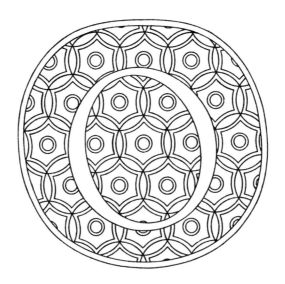

O. OPPOSED WAVES

2a. PAIRED AND KNUCKLED SINE WAVES

Yünnan guild hall, Suifu, Szechwan, 1900 A.D.

The waves approximate the sine curve, and are wedged together with trough to crest. These opposed waves are sometimes done in heavy wood and wedged together, sometimes in scroll work without actual separation. All edges are rounded in bead.

2b. MODIFIED SINE WAVES

Residence, Penghsien, one day northeast of Chengtu, Szechwan, 1900 A.D.

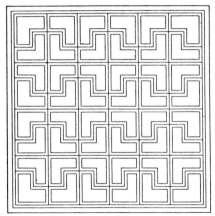

O: OPPOSED WAVE

O 2a

O 2b

O 3a

O 3b

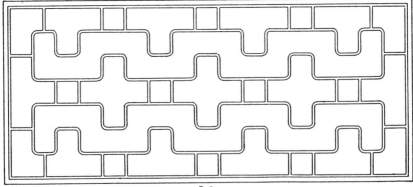

O 3c

O. OPPOSED WAVES (*continued*)

3*a*. PAIRED WAVES IN NARROW GRILLE
Shop, Hankow, Hupeh, 1875 A.D.

3*b*. RECTANGULARIZED OPPOSED WAVES
Yüan-yeh, Soochow, Kiangsu, 1635 A.D. (Original in form of a screen.)

3*c*. COMPLEX OPPOSED WAVES
Tea house balustrade, West Lake, Hangchow, Chekiang, 1900 A.D.

O. OPPOSED WAVES (*continued*)

4a. OPPOSED WAVES ON VERTICAL–HORIZONTALS

Residence, imperial highway from Kwangyüan to Hanchung, within Szechwan, 1800 A.D.

4b. COMPLEX OPPOSED WAVES

Chinese book, 1900 A.D.

This is a simple modification of some such window pattern like that in 4*a*, with the loop rosette made to conform with the wave in slope, crest, and trough.

5a. BEADED CROSSES BETWEEN WAVES

Door paneling in Gothic cathedral, Europe, 16th century A.D.

Chinese lattice has this design with the ten-characters separated, a horizontal bar connecting them, and a vertical bar crossing this bar and so supporting it.

5b. CROSSED WAVES

Sintientsi, one half-day north of Paoning, Szechwan, 1900 A.D. The design is modified in bead to conform to 5*a*.

The light spot in 5*a* is the Christian Cross in Europe; the similar spot in 5*b* is the ten-character of perfection in China. The dark bars of the latter give the swastika of Buddhism.

5c. BAMBOO JOINT WINDOW

Yüan-yeh, Soochow, Kiangsu, 1635 A.D.

This type of design is still found in Shaohing, Chekiang.

5d. TURTLE BACK AND WAVES

Shop, Shaohing, Chekiang, 1875 A.D.

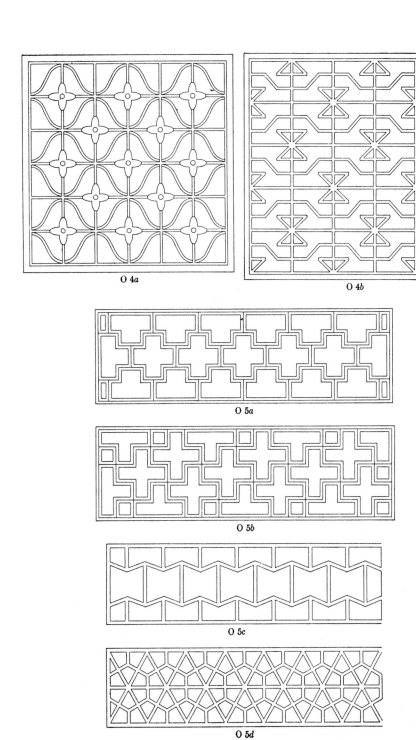

O 4a

O 4b

O 5a

O 5b

O 5c

O 5d

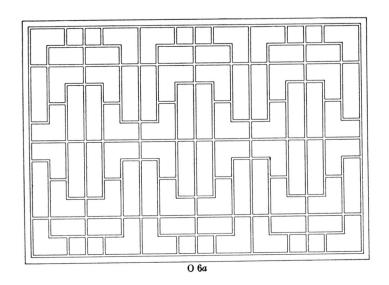

O 6a

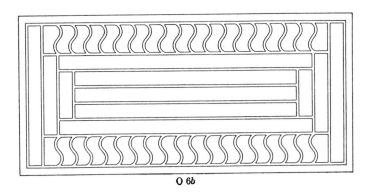

O 6b

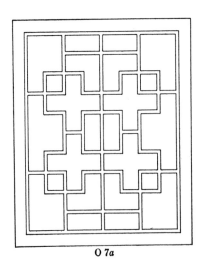

O 7a

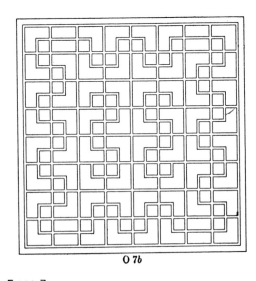

O 7b

O. OPPOSED WAVES (*continued*)

6a. TRIPLE FRAMES BETWEEN OPPOSED WAVES

Over entrance gate, Chengtu, Szechwan, 1850 A.D.

The three frames are connected in a series by the framing between opposed waves.

6b. FRAMES BETWEEN WAVES

Hweisweiho, near Kwangyüan, Szechwan, 1850 A.D.

This type of grille, used just under the eaves without paper, seems frequently to have been employed along the imperial highway from Hanchung, Shensi, to Yachow, Szechwan, and beyond through Kwangyüan and Chengtu. Upon removal of the parallel waves a pattern results which is common on the same road, but is not so frequent in Chengtu (cf. E 5*a, b*).

7a, b. WAVE FRAME

a. Sintu, one half-day northeast of Chengtu, Szechwan, 1900 A.D.

b. Provenance uncertain.

The central ornament in *b* simulates an ancient symbol for Asia.

O. OPPOSED WAVES (*continued*)

8*a*. DOUBLE FRAMING WAVES
Buddhist temple, Mount Omei, Szechwan, 1900 A.D.

8*b*. WAVE . AS CROSS WITHIN CROSSED OCTAGONS
Buddhist temple, Mount Omei, Szechwan, 1850 A.D.

9. ENFRAMING WAVE
Buddhist temple, Mount Omei, Szechwan, 1875 A.D.

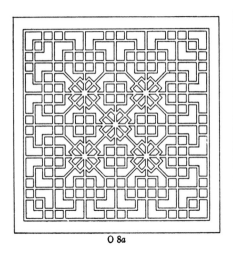

O 8a

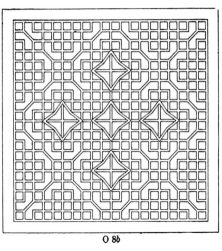

O 8b

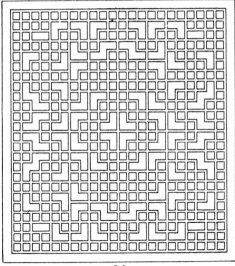

O 9

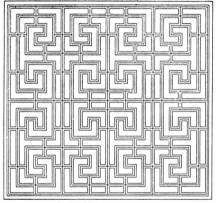

P: RECURVATE WAVE

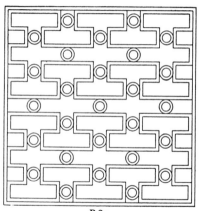

P 2a

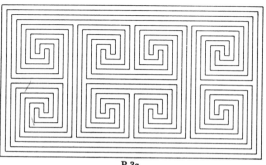

P 3a

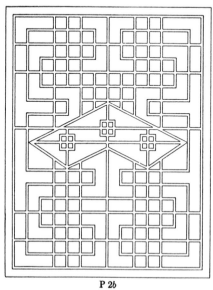

P 2b

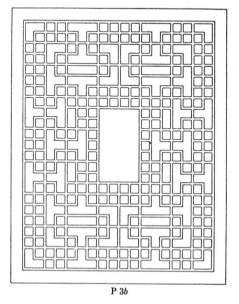

P 3b

P. RECURVING WAVE

The forward movement in line is retarded in various ways, such as increasing the thickness of line, toning down the line to the density of the background, giving it the sine wave curve, the broken line wave, the wave with all parts vertical or horizontal to the line of progress, overtones on wave crests and troughs, and by turning the line back upon itself in what amounts to a broken or recurving wave. The meander (much like that of 2a without the circles) is found on a gold finger-ring taken from a Han dynasty grave of Anhwei Province; even the Chou dynasty bronzes reveal an understanding of it. I can find no evidence that this design was used in early lattice. Some very fine examples of its use during the 18th and 19th centuries are presented here.

2a. DOUBLED RECURVING WAVES

Residence, Chengtu, Szechwan, 1875 A.D.

These two waves double back upon themselves and are endless. The crests and troughs are knuckled apart by circles, and the waves wedge into the external frame in wedge-lock. This window might have been classified under Group I.

P. RECURVING WAVE (*continued*)

2*b*. ENDLESS WAVE IN FRAME

Chengtu, Szechwan, 1850 A.D.

The endless wave is used as a frame for the outline of the jade musical instrument (cf. &t 1*f*). This window is typical of a large group.

3*a*. ENFRAMED ENDLESS MEANDERS

Adapted from a Chou bronze.

This is an idealized pattern from an ancient bronze. It is introduced here to show that the Chinese early explored some possibilities of the recurving wave, even if they did not use the idea in lattice grille at that date.

3*b*. RECURVING WAVE FRAME

Buddhist temple, Mount Omei, Szechwan, 1875 A.D.

4*a*. BALANCED RECURVING WAVES

Dye in style of Hanchow, Szechwan, of 1875, 1933 A.D.

The two balanced recurving waves were not continuous in the original window, and I have connected them across the ends of the window.

4*b*. PAIRED MEANDERS

Residence, village (too small to be shown on the map) one day northeast of Hanchow, Szechwan, 1850 A.D.

4*c, d*. ENDLESS WAVE AND CENTER

Buddhist temple, Mount Omei, Szechwan, 1875 A.D.

These two waves are much like 3*b*–4*b*. This general wave was much affected during Ch'ien-lung's time as a border. This incorporation within the lattice grille is interesting, and this window is probably a copy of one a century older.

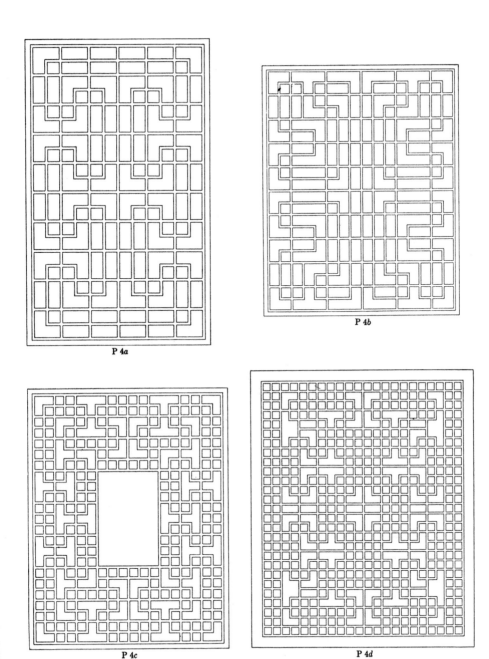

P 4a

P 4b

P 4c

P 4d

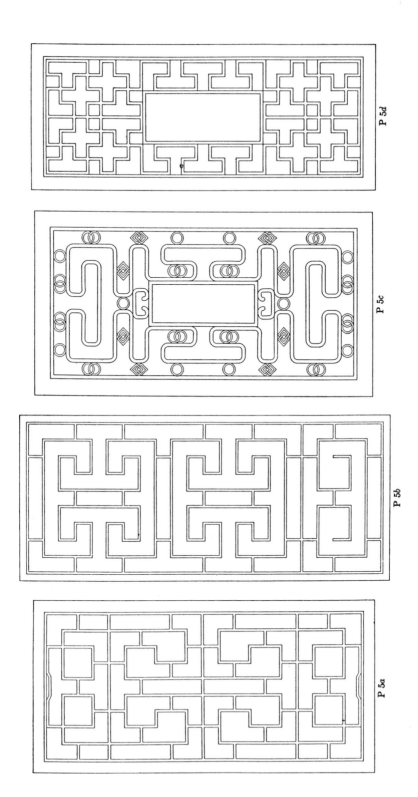

P 5d

P 5c

P 5b

P 5a

P. RECURVING WAVE (*continued*)

5a, b. ENDLESS WAVES EXPRESSED IN UNITS

a. Residence, Chengtu, Szechwan, 1825 A.D. *b.* Coastal China, 1750 A.D.(?)

These two windows appear in squares. *a* is one endless line of loop and recurving wave. *b* is composed of two units of endless recurving wave. The proportions of these are well done. The cloud-band in the bottom panel is usually reversed.

5c, d. NARROW ENDLESS WAVE WINDOWS

c. Yünnan guild hall, Suifu, Szechwan, 1900 A.D. *d.* Temple, Sintu, one half-day northeast of Chengtu, Szechwan, 1900 A.D.

Both these windows have knuckle-lock waves and central frames, the first more skilfully executed than the second. The second is a hybrid, but many similar ones are found in central Szechwan, executed between 1875 and 1925 A.D.

P. RECURVING WAVE (*continued*)

6*a*, *b*. Endless Wave Frames

Residences, goldbeaters' street, Chengtu, Szechwan, 1750 A.D.

These windows present the rare phenomenon of a single wave filling up a window or its unit.

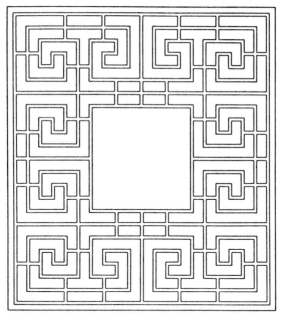

P 6*a*

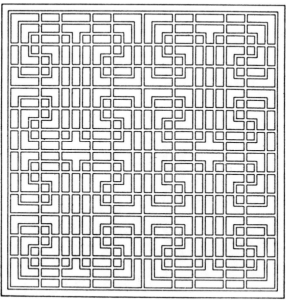

P 6*b*

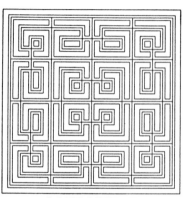

Q: LOOP–CONTINUE

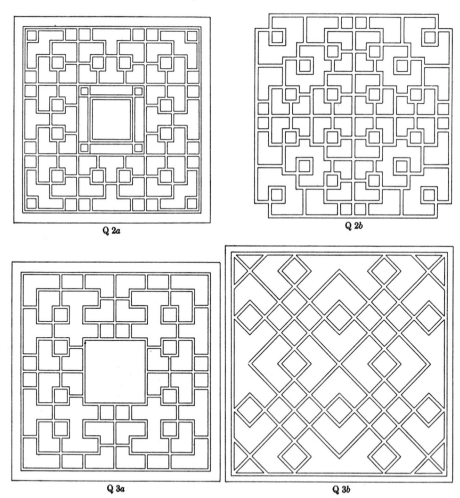

Q 2a

Q 2b

Q 3a

Q 3b

Q. LOOP–CONTINUED

The continuously looped line is one method the Chinese have of calling attention to some point or some thing within the endless line. It is practically an extension of the framing idea. It may vary in many ways, but it always emphasizes centrality or the median area.

2a. ENDLESS IN–LOOP

Tea shop, Chengtu, Szechwan, 1800 A.D.

2b. TRIPLE ENDLESS LINE IN–LOOP AS FRAMES

Tea shop, North Gate, Chengtu, Szechwan, 1800 A.D.

3a. ENDLESS IN–LOOP BETWEEN SQUARES

Chengtu, Szechwan, 1800 A.D.

3b. ENDLESS OUT–LOOP AND DOUBLE SQUARES

Buddhist monastery, Sienyu, a day south of Foochow, Fukien. 1850 A.D. (?)

Q. LOOP–CONTINUED (*continued*)

4a. THREE ENDLESS LINES
Provenance uncertain. Date probably 1800 A.D.

4b, c. OVERHEAD LOOPED GRILLE
b. North Gate suburb, 1850 A.D. c. Shop, Manchu city, Chengtu, Szechwan, 1850 A.D.

5a. ALLOVER OUT–LOOPS CONNECTED BY TEN–CHARACTERS
Manchu city, Chengtu, Szechwan, 1850 A.D.

5b. ENDLESS LOOPS AND CLOUD–BANDS
Canton, Kwangtung, 1750 A.D.

This window should not be reversed, as the cloud-bands in the upper section have their in-loops below. The lower section of the window is centered along the line of the large squares. This arrangement is typical of the period.

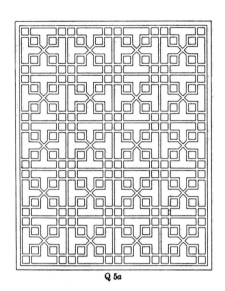

Q 5a

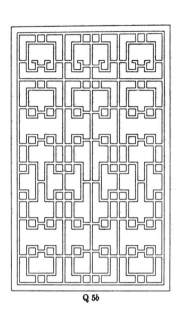

Q 5b

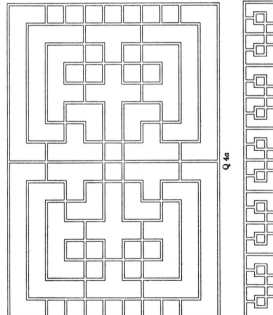

Q 4a

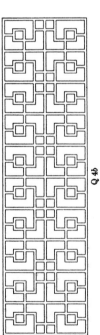

Q 4b

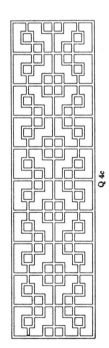

Q 4c

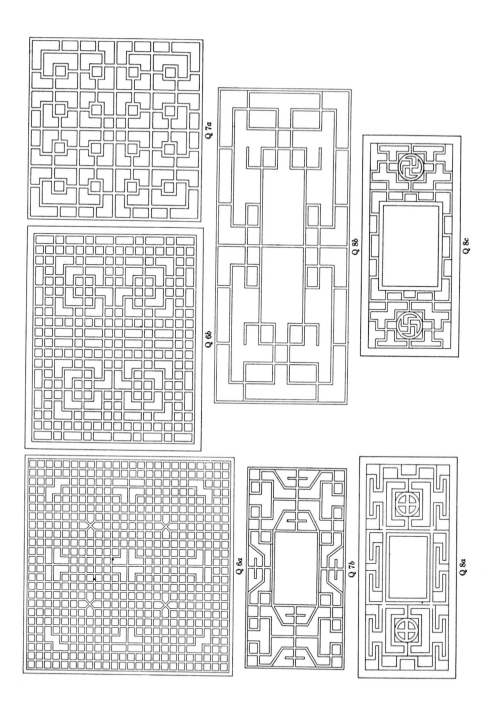

Q 7a

Q 8b

Q 8c

Q 6b

Q 6a

Q 7b

Q 8a

Q. LOOP–CONTINUED (*continued*)

6*a*. Endless In–Loop and Octagon
Buddhist temple, Mount Omei, Szechwan, 1875 A.D.

6*b*. Endless Line and Voiding of Bars and Squares
Location and date, same as 6*a*.

7*a*. In–Loop and Out–Loop
Residence, North Gate suburb, Chengtu, Szechwan, 1800 A.D.
This represents a distinct advance over 2*a*.

7*b*. Endless Loop in Longevity Characters
Shansi guild hall, Chengtu, Szechwan, 1875 A.D.

8*a*. Endless Loop and Fret
Chengtu, Szechwan, 1825 A.D.
The execution of this drawing (one of the first) leaves something to
be desired. This is a decadent specimen of lattice.

8*b*. Loops and Frames
Provenance uncertain. Date probably 1825 A.D.

8*c*. Single In–Looped Line Enclosing Frame
Location and date, same as 8*a*.

Q. LOOP–CONTINUED (*continued*)

9a. Vase Enclosed by Looped Line

Tea shop, Kwanhsien, one day northwest of Chengtu, Szechwan, 1900 A.D.

Windows filled with simulated vases are not common. This is a decadent form of lattice which lacks unity. Its prototype took form something like a century before this particular window was wedged together.

9b, c. Endless Line Looped in Cloud–Band

Wu Hou monastery, Chengtu, Szechwan, 1875 A.D.

These show some of the possibilities of the endless line.

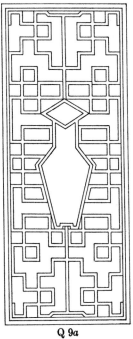

Q 9a

Q 9b

Q 9c

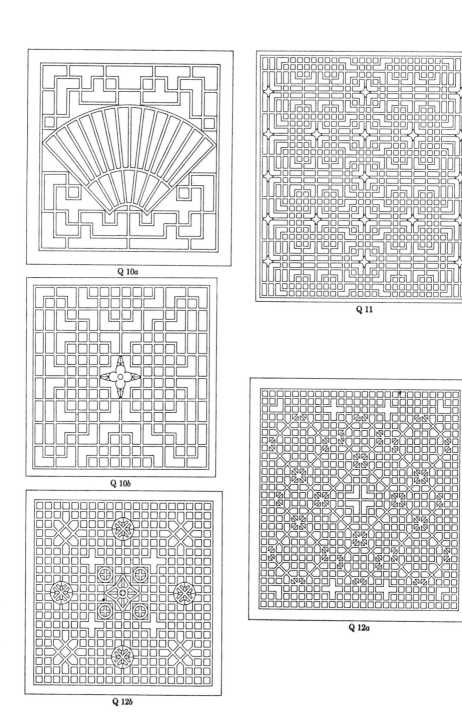

Q 10a

Q 10b

Q 11

Q 12a

Q 12b

Q. LOOP–CONTINUED (*continued*)

10*a*. FAN WEDGED BETWEEN ENDLESS LOOPED LINES

Pao-kuang monastery, Sintu, one half-day northeast of Chengtu, Szechwan, 1875 A.D.

10*b*. FLOWER AND LEAVES FRAMED BETWEEN LOOPED LINES

Provenance uncertain, probably 1800 A.D.

11. LOOP–CONTINUED CONNECTING SQUARES

Residence, Chengtu, Szechwan, 1750 A.D.

12*a, b*. OCTAGON AND LOOP–CONTINUED

Buddhist temples, Mount Omei, Szechwan, 1875 A.D.

These are typical Mount Omei windows (cf. D 28*a*–36*b* and G 2*a*–4*a*). The looping in *a* is neatly done; in *b* the interlocking by the loop method at the four corners around the ten-character light spots is well concealed.

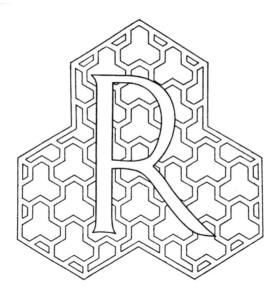

R. LIKE SWASTIKAS

The single swastika seems far removed from the wave, but the regularly and systematically connected swastikas appear to be intimately related to it, whether they are placed parallel or opposed and crossed. The like swastikas are composed of various devices in crossed parallel waves, while the unlike or opposed swastikas are composed of various devices in crossed waves, opposed in pairs. These systems of waves result in the characteristic swastika forms in bars and in the two groups of voids, or light spots. The Greek cross, or the Chinese ten-character, is associated with the like swastika, while the Lorraine cross in light spot is associated with the unlike or opposed swastika in bar outline. Such a device seems limited, yet there are sixty swastika plates in the R and S groups, not counting the less clear examples scattered through this book. I do not insist that the swastika design arose from the wave, but believe that the two must be regarded as inseparable in studying Chinese swastika lattice.

The swastika appears to have been much used in Szechwan during the Ch'ing dynasty, especially during the last two centuries. In fact it became so common that the name swastika flower (or ornament) or swastika pattern was and remains a synonym for lattice in parts of Szechwan. Although the motif is found in almost all parts of China, it is less common elsewhere than in Szechwan.

The writer does not attribute the sudden rise to popularity in Szechwan of the swastika to a rebirth of Buddhism, with which it is

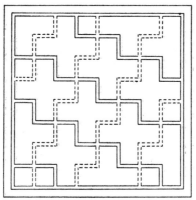

R: LIKE SWASTIKA

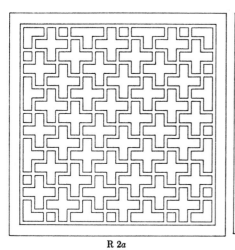

R 2a

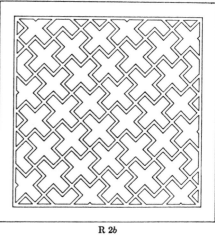

R 2b

R 3a

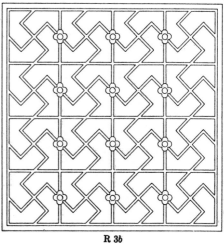

R 3b

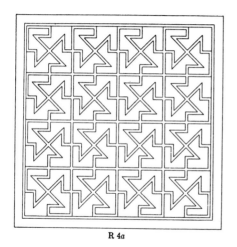

R 4a

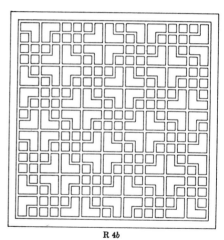

R 4b

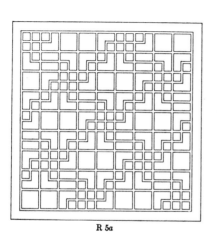

R 5a

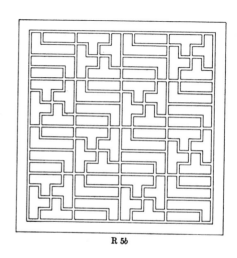

R 5b

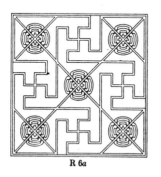

R 6a

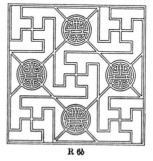

R 6b

not associated in the minds of the population. On the sacred Buddhist Mount Omei only a relatively small proportion of windows employ the device. It is true that during the early years of the 20th century the Buddhist priests in Chengtu issued a circular protesting against its secular use, but their effort was in vain. The popularity of the device seems to have been purely local. Once it had been started, the almost endless possibility of variations caught the imagination of the window-makers. Some of the tribes of West China use the swastika in their woven belts. These may have played a real part in promoting the use of the swastika. Again the proximity of the corridor to and beyond Kansu to the north and west offered contacts with places where even now the swastika still remains in ancient brick.

2a, b. SIMPLE TEN–CHARACTER AND SWASTIKAS

Residence and temple, Chengtu, Szechwan, 1900 A.D.

This is not strong structurally, so that it must either be confined to small spaces or executed with large bars. These two designs are common in Chengtu and in other parts of Szechwan, as well as in other provinces, especially along the Yangtse River.

3a. RAKED SWASTIKAS

Chao-chüeh monastery, beyond North Gate, Chengtu, Szechwan, 1662 A.D.

This X-like rather than ten-character swastika is a pleasing variation.

3b. SWASTIKA BAR AND WINDWHEEL VOID

Suifu, Szechwan, 1850 A.D.

4a. SINGLE LINE SWASTIKAS

Kwanhsien, Szechwan, 1900 A.D.; also in Buddhist temple, Pihsien, between Kwanhsien and Chengtu.

4b–5a. SWASTIKAS WITH DIVIDED TEN–CHARACTER

Shop, Chengtu, Szechwan, 1875 A.D.

b is only 2a varied by the intercalation of cross bars, but a is formed by the addition of a small variation in the crests and troughs in the crossed waves.

R. LIKE SWASTIKAS (*continued*)

5b. CROSSED PARALLEL WAVES IN SWASTIKAS

Temple rail in Pao-kuang Buddhist monastery, at Sintu, one half-day northeast of Chengtu, Szechwan, 1875 A.D.

This is an unusual and clever method of separating swastikas. By stepping one of the crossed waves to the right by one step and down by one step the two waves are made to coincide.

6a, b. LONGEVITY SWASTIKAS

Residence, Chengtu, Szechwan, 1825 A.D.

These two are essentially the same. The ornament in *a* is in the center, while in *b* the swastika is in the center. The ornamentation of *b* is a carved longevity character; that of *a* is formed of Ju I scepters nested in a fine way. *b* virtually says, "Ten thousand years (to you)"; *a* implies, "May things always be as you desire." The Ju I scepter is almost the symbol of Taoism, while the swastika is the symbol of Buddhism; such syncretism is not unusual in China.

7a, b. SWASTIKAS ON CLOTH AND STONE

Chengtu, Szechwan, 1925 A.D.

Woven and stone work allow more variation in swastikas than do lattice windows, as structural strength is not required. *a* is woven in cloth; *b* is carved on stone. In China, as elsewhere, styles have much to do not only with the way in which clothing is made, but also with the designs used on the materials. Silks and satins for gentlemen's gowns may have floral decorations (with or without symbolic meanings) for one season and geometric designs for the next. One can tell the year of certain garments by the style of design affected. Since 1920 A.D. a definite foreign influence has been visible.

8a. SWASTIKAS IN LIGHT AND IN SHADE

Szechwan silk pattern, 1920 A.D. The endless lines were done in dull black, and the background of large swastikas in glossy black.

8b. SWASTIKAS SEPARATED BY OCTAGONS

Chengtu, Szechwan, 1875 A.D.

This is appliqué in wood on a solid back.

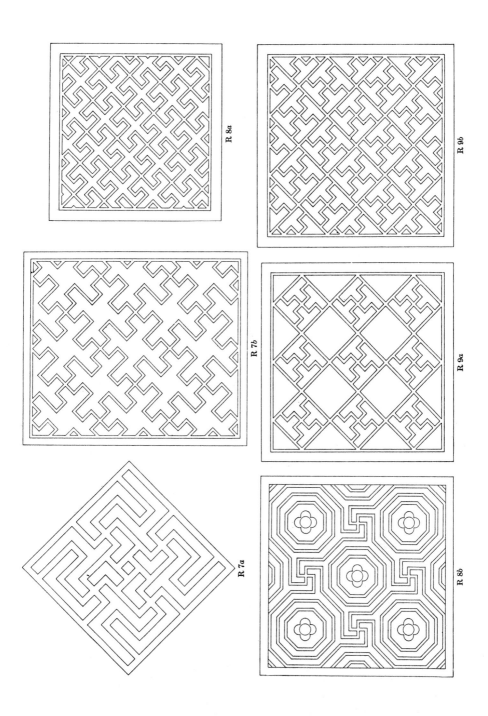

R 8a

R 9b

R 7b

R 9a

R 7a

R 8b

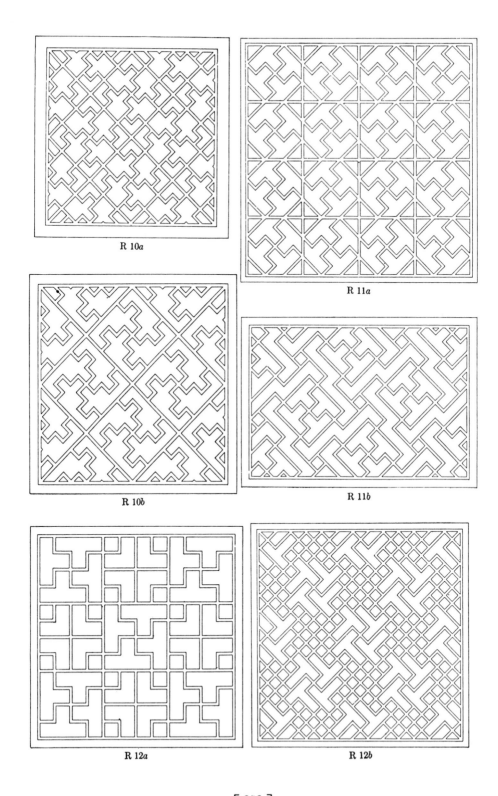

R 10a

R 11a

R 10b

R 11b

R 12a

R 12b

R. LIKE SWASTIKAS (*continued*)

9a, b. SWASTIKAS IN ECHELON

a. Kwanhsien, one day northwest of Chengtu, Szechwan; also at Nine Peaks temple, three days northwest of Chengtu. *b.* Residence, Chengtu, Szechwan. All about 1850 A.D.

10a, b. SWASTIKAS IN ECHELON

a. Residence, Chengtu, Szechwan, 1875 A.D. *b.* Shansi guild hall, Chengtu, Szechwan, 1850 A.D.

11a, b. SWASTIKAS AND WINDWHEELS

a. East Gate suburb, Chengtu, Szechwan, 1875 A.D. *b.* City residence, Chengtu, Szechwan, 1875 A.D.

12a, b. SWASTIKAS IN ECHELON

a. Ts'ao T'ang monastery outside South Gate, Chengtu, Szechwan, 1875 A.D. *b.* Temple outside North Gate, Chengtu, Szechwan, 1875 A.D.

It was in the temple of *a* that I first had my attention attracted to lattice on the Chinese New Year, 1916. "The Grass Hall" recalls the site where the poet Tu Fu wrote during the T'ang dynasty.

R. LIKE SWASTIKAS (*continued*)

13*a*. MODIFIED SWASTIKA

Provenance uncertain, probably 1825 A.D.

13*b*. SWASTIKAS FORMED BY VOIDING

Medicine shop, Hangchow, Chekiang, 1875 A.D.

The plate is not an exact copy of the original; the size and number of the swastikas and the size of the window are not precise. The voiding of the bean curd pattern so as to produce the swastika is very unusual.

14*a*. CROSSED THUNDER–SCROLL SWASTIKAS

Three days southwest of Chengtu, Szechwan, about 1875 A.D.

This fine compound swastika window comes from a region conservative in its lattice. This region retains the old Han brackets and many fine windows, reproduced many years after they had almost disappeared from Chengtu. The date of construction (which is approximate) is misleading in this case, as similar patterns appeared in other places by 1775 or earlier.

14*b*. CROSSED THUNDER–SCROLL SWASTIKAS AND JU I

Ch'ang-yüan, Wuchang, Hupeh(?), 1650 A.D.(?)

14*c*. CROSSED THUNDER–SCROLL SWASTIKAS

Wên-shu monastery, Chengtu, Szechwan, 1836 A.D.

Though this window is not so fine as 14*a* and *b*, all three show that this complex swastika was used at a still earlier date.

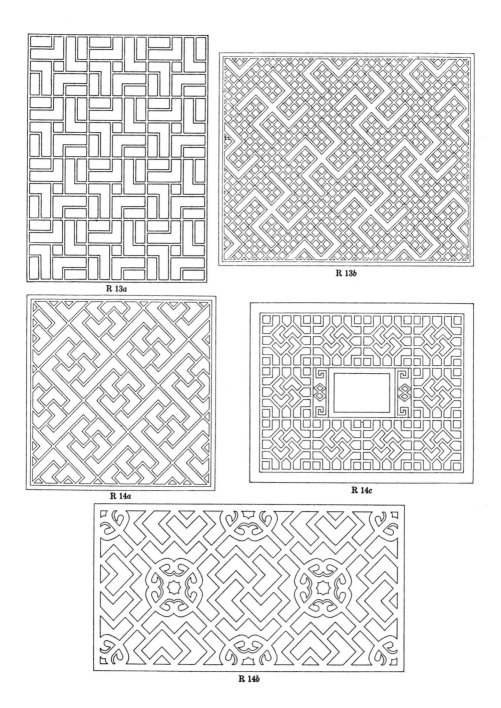

R 13a

R 13b

R 14a

R 14c

R 14b

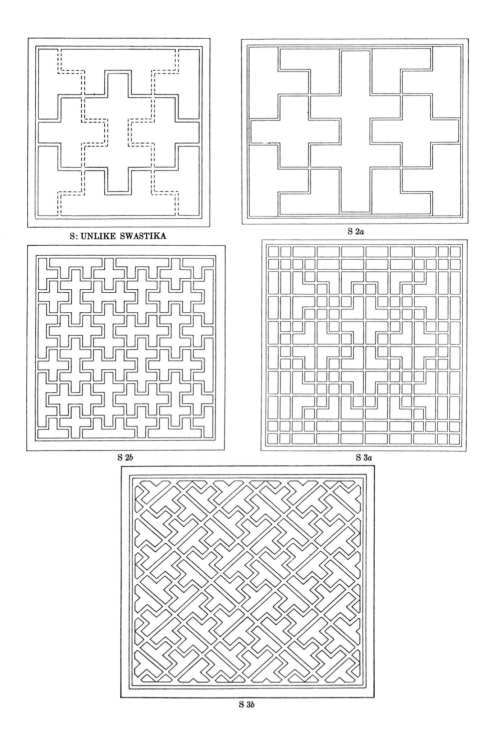

S: UNLIKE SWASTIKA

S 2a

S 2b

S 3a

S 3b

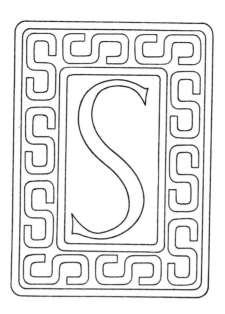

S. UNLIKE SWASTIKAS

The unlike swastika shows the spots of light in the form of the Lorraine cross, whereas the like swastika has interstices in the shape of the Greek cross or the Chinese ten-character. I am convinced that paired balance and not symbolic significance determines rotor direction in China today. Right and left rotors are evidently used without discrimination in symbolism. This is not true in Tibet, however, for in that country the direction of the rotor in the swastika indicates to which sect of Buddhism the temple belongs.

2a. BALANCED SWASTIKAS IN ENDLESS LINES

Chengtu, Szechwan, 1875 A.D.

2b. SIMPLE BALANCED SWASTIKAS

Residence and temple, Chengtu, Szechwan, 1900 A.D.

This is the simplest example of balanced swastika. The window gives us the basic design from which most of this group are derived, just as R 2a is the basic design for that group.

3a, b. PAIRED LATTICE ON CROSS–BAR SUPPORT

Residence and temple, Chengtu, Szechwan, 1900 A.D.

S. UNLIKE SWASTIKAS (*continued*)

4a, b. SUPPORTED AND PAIRED SWASTIKAS

a. Pao-kuang Buddhist monastery, Sintu, one half-day northeast of Chengtu, Szechwan, 1875 A.D. *b.* Small temple, Chengtu, Szechwan, 1875 A.D.

The proportions of bars and light spots in *a* differ from those in *b*. The heavy wave around the frame, combined with three interlocked lozenges, is very unusual, as most Chinese lattice employs but one thickness in the bars.

5a, b. ELONGATED GRILLE OF PAIRED SWASTIKAS

a. Place and date, same as *4a*. *b.* West Lake, Hangchow, Chekiang, 1920 A.D.

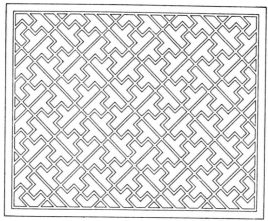

S 4*a*

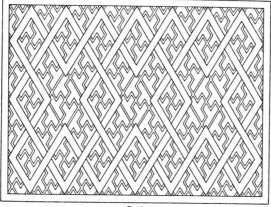

S 4*b*

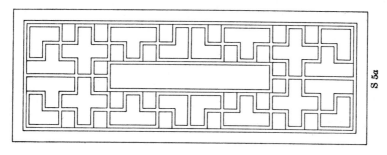

S 5*a*

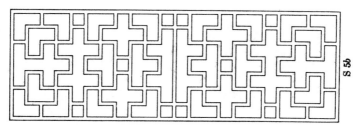

S 5*b*

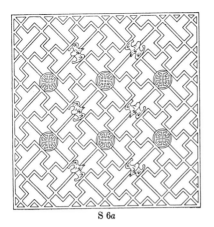

S 6a

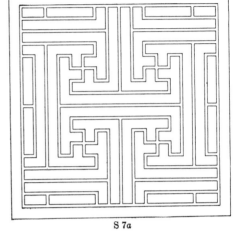

S 7a

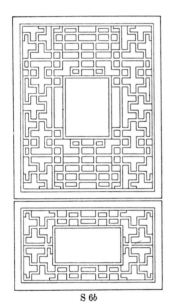

S 6b

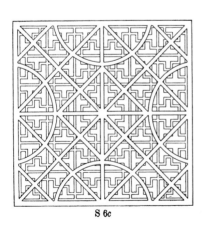

S 6c

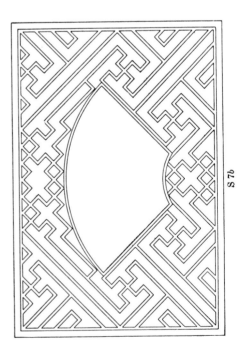

S 7b

S. UNLIKE SWASTIKAS (*continued*)

6a, b. COMPLEX PAIRED SWASTIKAS

Residences, North Gate suburb, Chengtu, Szechwan, 1750 A.D.

6a is the same as 4a with longevity characters and bats applied at the crossings of cross-bars. The combination spells "Ten thousand blessings and ten thousand years." b is one of the many windows of this type, which seems to have become quite general during the whole of the 19th century. The second cross-bar of b should be severed and knuckled by drawing short vertical lines in two places. This would give two endless lines. This also applies to the bottom of the window. This defect in the original plate was discovered after printing.

6c. CIRCLE, SQUARE, AND SWASTIKA

Travelling stall, Chengtu, Szechwan, 1900 A.D.

7a, b. SWASTIKAS OF REENTRANT WAVES

a. Residence, Chengtu, Szechwan, 1900 A.D. b. Buddhist Eastern Sacred Mountain temple, ten miles west of Chengtu, Szechwan, 1900 A.D.

The fan shape is fairly good, but it requires an expert to select length of radii and spread of fan so that the proportions shall be entirely satisfactory. The fan is a favorite motif in art, and is frequently used in architecture. The general design of both plates is termed in some circles the Japanese fret. I have not sufficient data to judge as to priority in the use of this design.

S. UNLIKE SWASTIKAS (*continued*)

8*a, b.* ELABORATED SWASTIKAS

a. Guild hall, Luchow, Szechwan, 1850 A.D. *b.* Three days south-west of Chengtu, Szechwan, 1800 A.D.

These two plates are mere variations of 7*a, b.* The flower-toggles are well carved in the windows. The *b* design is called the harrow swastika, as there is some resemblance to a Chinese harrow or drag such as is used in the rice fields. The latter design is frequently woven in colors into bamboo mats in central Szechwan.

9*a, b.* PAIRED SWASTIKAS OF COMPOUND WAVES

a. Residence, Chengtu, Szechwan, 1875 A.D. *b.* Silk pattern, 1920 A.D.

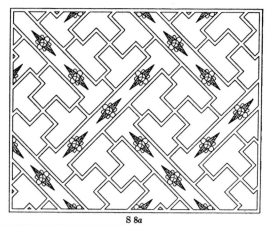

S 8a

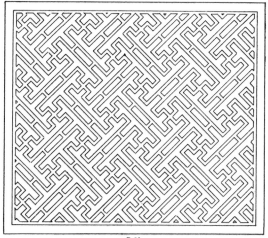

S 8b

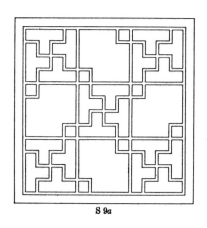

S 9a

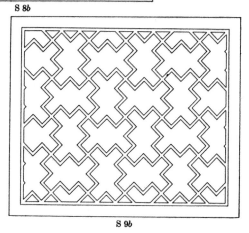

S 9b

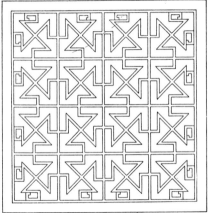

S 10a

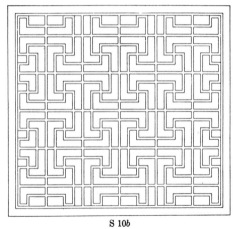

S 10b

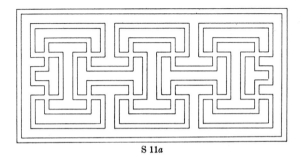

S 11a

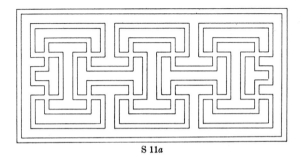

S 11b

S. UNLIKE SWASTIKAS (*continued*)

10*a, b*. Sᴍᴍᴇᴛʀɪᴄᴀʟ Sᴡᴀsᴛɪᴋᴀs

a. City temple, Pihsien, one half-day northwest of Chengtu, Szechwan, 1900 A.D. *b*. Sintu, one-half day northeast of Chengtu, Szechwan, 1850 A.D.

a is found in association with R 4*a*. The lines are not endless as in that plate, but are well terminated.

11*a, b*. Sᴡᴀsᴛɪᴋᴀs ᴏғ Sɪᴍᴘʟᴇ Rᴇᴄᴛᴀɴɢᴜʟᴀʀ Wᴀᴠᴇs

a. Bamboo mat weave, Chengtu, Szechwan, 1920 A.D. *b*. Tea house, Willow Tree Bridge, Shanghai, Kiangsu, 1900 A.D.

S. UNLIKE SWASTIKAS (*continued*)

12*a*, *b*. CONCEALED SWASTIKAS

Residences, Chengtu, Szechwan, 1875 A.D.

These two plates are the same as 9*b*, with short bars introduced in appropriate places. *a* is essentially the design seen in the *Ying Tsao Fa Shih* of 1103 A.D.

13*a*–*c*. SWASTIKA ROTORS

a. Temple, one day northwest of Chengtu, Szechwan, 1900 A.D. *b*. Chengtu, Szechwan, 1800 A.D. *c*. Sintu, one-half day northeast of Chengtu, Szechwan, 1875 A.D. *b* is only a variation of the waves of 9*b*.

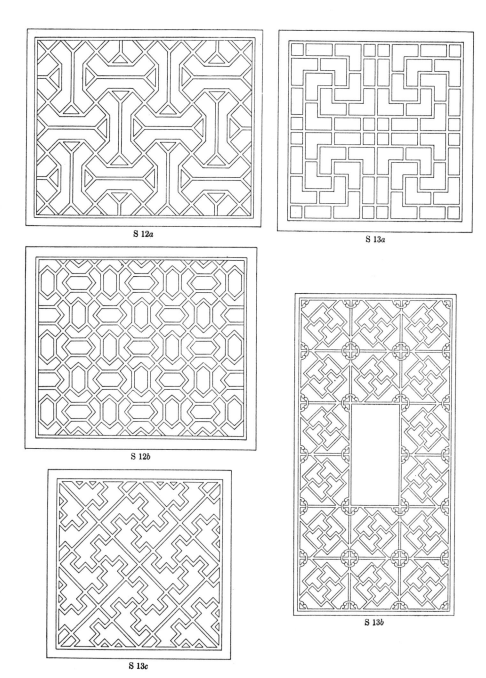

S 12a

S 13a

S 12b

S 13c

S 13b

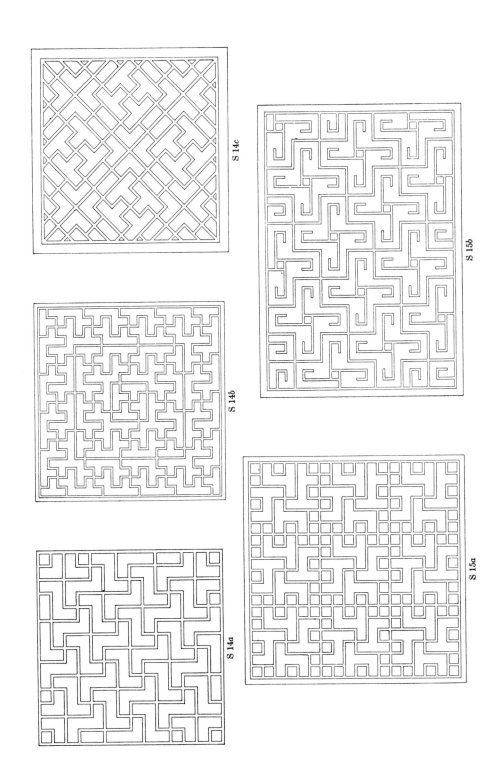

S 14c

S 15b

S 14b

S 15a

S 14a

S. UNLIKE SWASTIKAS (*continued*)

14*a–c*. Squared and Centered Swastikas

a. Chinese silk design, 1920 A.D. *b*. God of war temple, Chengtu, Szechwan, 1875 A.D. *c*. Residence, Chengtu, Szechwan, 1750 A.D.

The Chinese call the design in *a* large-adding-small-swastika characters. It is the analogue of the crosslet. The concentered frames of *b* are unique.

15*a, b*. Opposed Swastikas of Two Systems

a. Residence, Manchu city, Chengtu, 1900 A.D. *b*. Chinese silk design, 1927 A.D.

S. UNLIKE SWASTIKAS (*continued*)

16*a, b*. PAIRED SWASTIKAS OF CROSSED THUNDER–CLOUDS

a. Canton, Kwangtung, 1850 A.D. *b*. Wên-shu monastery, Chengtu, Szechwan, 1825 A.D.

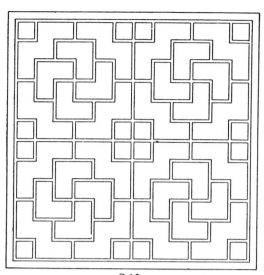

S 16a

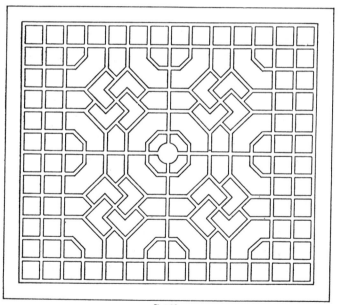

S 16b

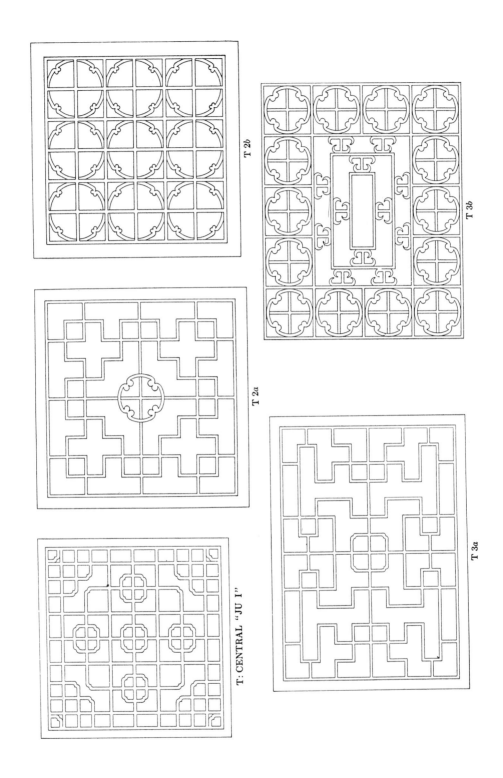

T 2b

T 3b

T 2a

T 3a

T: CENTRAL "JU I"

T. CENTRAL JU I

One method of treating of line is to continue it until it becomes endless. Another is to keep it within control and then end it. It is easier to control line on the vertical and especially on the horizontal than it is on the diagonal, but the Chinese manage the latter successfully in roofs with upturned eaves. This group of plates illustrates some of the methods of line ending. The purpose is to give pause and concentration at the center of interest. The Ju I scepterends tend to bring the attention back and focus it at the center of the pattern or patterns; the artistic treatment of the line end is as significant as its meaning: "May things be as you desire." It is used as a symbol in Taoism.

2*a, b*. CENTRAL JU I SCEPTERS

a. City temple, one day northwest of Chengtu, Szechwan, 1850 A.D.
b. Chengtu, Szechwan, 1825 A.D.

The recurrence in *a* of the ten-character in the light spots, as in the four corners of this plate, may be attributed to the working out of the design as much as to symbolic intent. *b* is one of the early and more poorly drawn plates, but it represents an open pattern in Ju I which was very common during the early part of the 19th century. It seems to show Cantonese influence of the 17th and 18th centuries.

T. CENTRAL JU I (*continued*)

3*a*. RECTANGULAR JU I

Chengtu, Szechwan, 1875 A.D.

This is not notable, but is typical of many windows with mixed motifs at the end of the 19th century.

3*b*. CONCENTERED FRAMES WITH JU I BORDER

Residence, Chengtu, Szechwan, 1825 A.D.

4. BIFOCAL JU I

Residence, Chengtu, Szechwan, 1825 A.D.

5, 6. INTERLOCKED JU I

5. Three days north of Paoning, Szechwan, 1825 A.D. 6. Two days northeast of Chengtu, Szechwan, 1825 A.D.

These two windows are probably rectangularized Ju I; they are decidedly pleasing. The small square toggles and the carved flowers were popular a century ago.

7*a*. CROSSED AND CONCENTERED JU I

Temple, Chengtu, Szechwan, 1825 A.D.

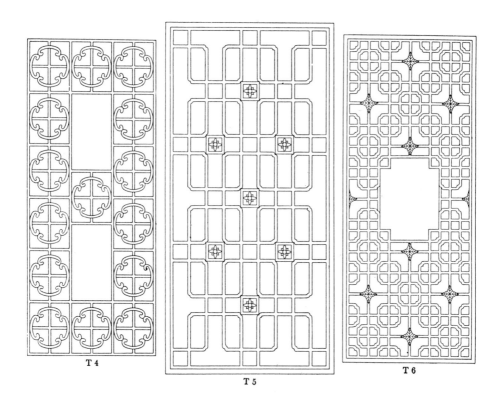

T 4

T 5

T 6

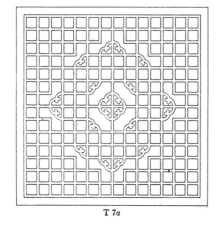

T 7a

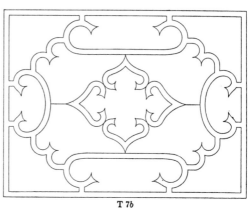

T 7b

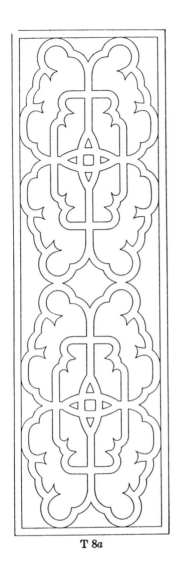

T 8a

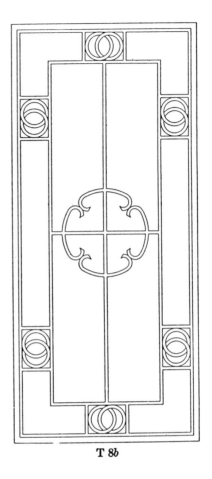

T 8b

T. CENTRAL JU I (*continued*)

7b–8a. ELABORATED JU I

Etching, coastal China (as in U 2*a* below), 1750 A.D.

This probably came from Foochow or Canton in the 18th century. Chippendale had access to some such motif. In 1932 I found in Canton close parallels to these in grilles of 1800 A.D., and later I obtained rubbings from old official homes of Foochow which are artistically related.

8b. ENFRAMED AND CENTERED JU I

Shop, Chengtu, Szechwan, 1825 A.D.

Often a grille over the front door survives longer than more substantial windows nearer the ground. This is a rare type that needs little comment. All features point toward the early years of the 19th century, or before. It would not have been novel in 1625.

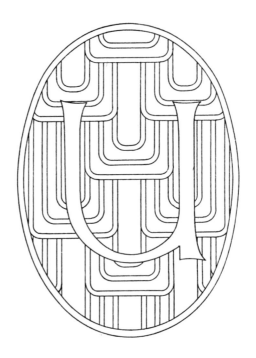

U. ALLOVER JU I

The distinction between the allover Ju I and the central Ju I is the same as that between the allover parallelogram of Group A and the single focus frames of Group D. Some of the specimens are exceedingly rare, and distinctly enhance the value of this collection.

2*a*. BACK–TO–BACK JU I

Etching, Chinese seaboard, 1750 A.D.(?)

The etching from which this detail was enlarged was probably drawn in Canton about the middle of the 18th century. The central light spots are outlined as many such spaces were in Canton at that time. In 1932 the writer saw there an overhead grille almost devoid of visible means of support.

2*b, c.* JU I ON CROSSES

b. Village near Shihfang, two days northwest of Chengtu, Szechwan, 1775 A.D.

c. Provenance uncertain, but Tze liu tsing, six days to the southeast of Chengtu, Szechwan, has this pattern without the supporting bars, 1775 A.D.

U 2c

U 2a

U: ALLOVER "JU I"

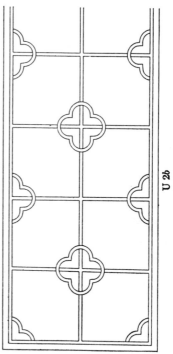

U 2b

[283]

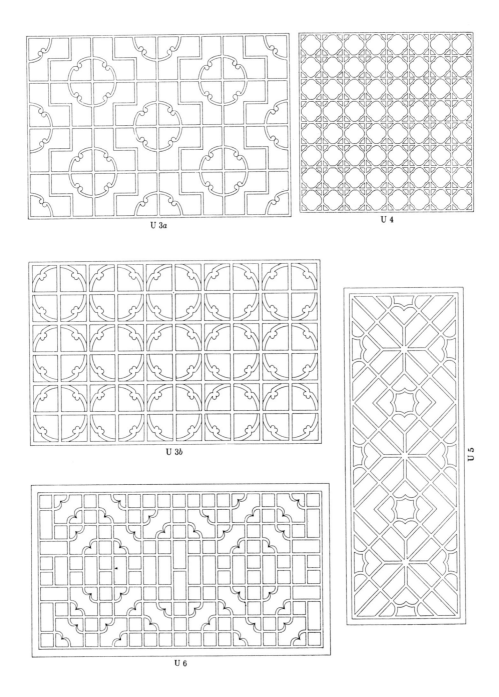

U 3a

U 4

U 3b

U 5

U 6

U. ALLOVER JU I (*continued*)

3a. Ju I Framed by Waves
Over street doorways, Chengtu, Szechwan, 1850 A.D.

3b. Allover Back–to–Back Ju I
Residence, Chengtu, Szechwan, 1875 A.D.

This is a very common lattice in Chengtu. The openness of the window suggests that it is a copy of one made about 1800 A.D. Other windows of this type have the Ju I dividing the squares into two approximately equal light spots.

4. Back–to–Back Ju I at Middle of Bars
Residence, Chengtu, Szechwan, 1775 A.D.

This is an unusual and pleasing variation of the Ju I. The void within the square takes the form of the prunus bloom.

5. Ju I Interlocked with Squares and Waves
Ch'ang-yüan, Wuchang, Hupeh(?), 1650 A.D.(?)

One of the features is the general shape of the three frames through the center, with rounded sides and indented corners, as in some porcelain plates of that period. The shapes of the two light spots within the two small squares are similar to those between Ju I in 2a and 2c. The crossed waves from end to end of the frame are reminiscent of 1750 and before. This design is artistically related to W 4a in curve, in light spots between units, and in double use of elements.

6. Interlocked Ju I
Chengtu, Szechwan, 1850 A.D.

The tips of the Ju I merely touch, but need little support from each other as they all cross two bars. The general arrangement is suggestive of special features of the Han line of Group M.

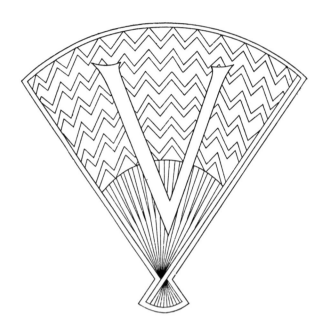

V. S–SCROLL

The S-scroll, or thunder-scroll, and the U-scroll, or cloud-band, are perhaps the oldest designs to be found in this collection, although their use in lattice windows is of recent date. What the real significance of these shapes was in the early days, I do not attempt to establish; I am convinced that it was far more than merely pictorial or geometric. The forms connote fertilizing clouds, rain, and lightning, they imply intoxicating incense, buoyant forces supporting and levitating sages and saints. This list does not exhaust their content, but may account for the persistence with which the Chinese have employed them. It is safe to maintain that the Chinese have been exploring the possibilities of these patterns for three thousand years; they have used them in bronze, in stone, in jade, in woodblock printing, in paint on porcelain, in wood lattice, and in wood carving.

2a. Crossed and Knuckled Thunder–Scroll

Foothill village, Mount Omei, Szechwan, 1850 A.D.

The balancing of the adjacent ends of the crossed thunder-scrolls excludes this specimen from the compound swastika group. The window may be as early as 1750 A.D.

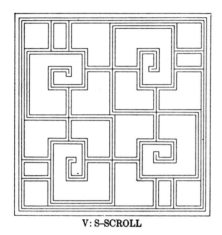

V: S–SCROLL

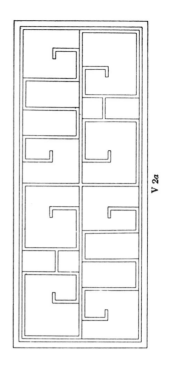

V 2a

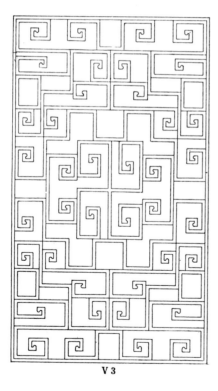

V 3

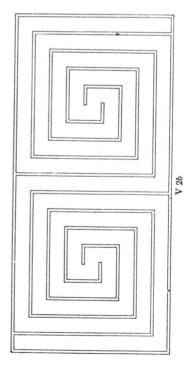

V 2b

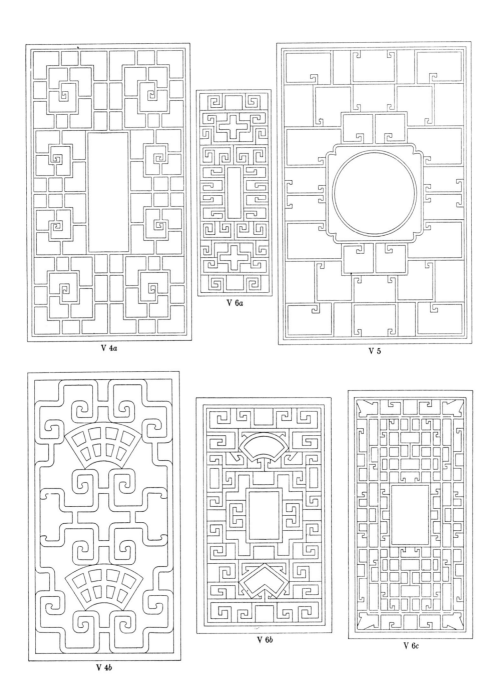

V 4a

V 6a

V 5

V 4b

V 6b

V 6c

V. S–SCROLL (*continued*)

2*b*. INTER–ROLLED SCROLLS

Residence of official, Sintu, one half-day northeast of Chengtu, Szechwan, 1850 A.D.

Such scrolls must be supported by a wooden back (cf. W 2*a*).

3. KNUCKLED CLOUDS AND THUNDER–SCROLLS

Chengtu, Szechwan, 1825 A.D.

4*a*. EXAGGERATED THUNDER–SCROLL

Two days northeast of Chengtu, Szechwan, 1825 A.D.

The scroll ends are not all equal, and the convolutions are admirably graduated. This design has companion pieces in Chengtu.

4*b*. HEAVY CLOUDS, THUNDER–SCROLLS, AND FANS

Ch'ang-yüan, Wuchang, Hupeh(?), 1650 A.D.(?)

These can hardly be matched in Szechwan, even by W 2*b* and W 3*a* (cf. W 4*a–c*). The heavy grille fans give vertical orientation.

5. COMPOUND THUNDER–SCROLLS

Chengtu, Szechwan, 1775 A.D.

This rare window speaks for itself; possibly it is the best in this group. Between the circle and the indented corner frame there is thin board, marked by the absence of superfluous ornamentation.

6*a–c*. INTERLOCKED OR KNUCKLED THUNDER–SCROLL. (Also given as W 7*c*.)

Chengtu, Szechwan, 1850 A.D.

Such designs as these were common in Chengtu during the middle of the 19th century. *a* is the only plate that is repeated in this book.

V. S–SCROLL (*continued*)

7*a*–8*c*. Diagonal Grille in Thunder–Scroll and Cloud–Band

Han dynasty brick in University of Pennsylvania Museum, 206 B.C.–220 A.D. Provenance uncertain.

In these five plates the bars should be slightly heavier. Although these designs are taken from brick, I believe that they represent wood lattice of the Han dynasty.

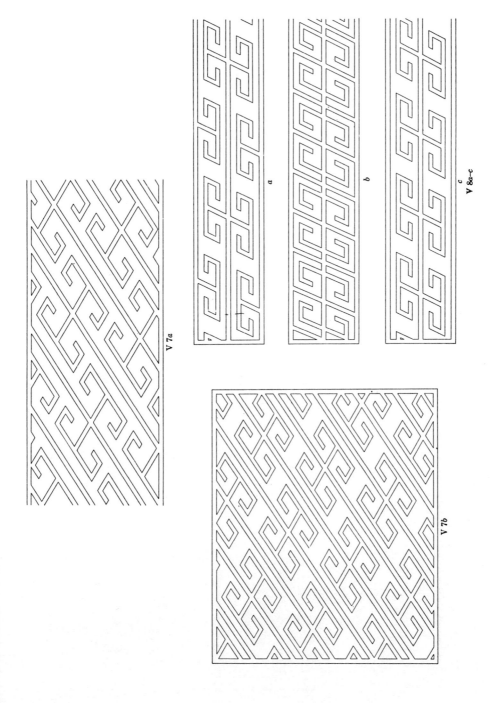

V 7a

V 7b

V 8a–c

a

b

c

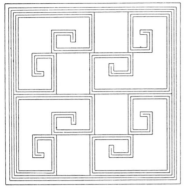

W: U-SCROLL

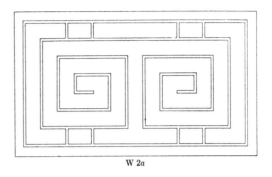

W 2a

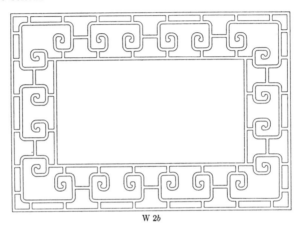

W 2b

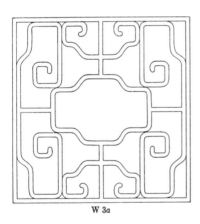

W 3a

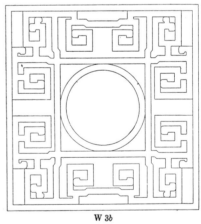

W 3b

W. U–SCROLL

The name applied to this group is cloud-band. There is some lack of consistency in the use of the terms cloud-band and thunder-scroll, in both Chinese and English. The usual form of the cloud-band (with connecting bar above and ends curling under) is a conventionalization of the cumulus cloud as it floats over hot plains, bulging upwards and curling inward from the outer and lower surfaces. The pairing of the cloud-bands in these plates allows them to be placed on the two sides of a window, or at the top and at the bottom facing each other, but the latter is not the usual position.

The U-scroll was used and exploited later than the S-scroll, but it was being developed in the early Han period.

2a. SINGLE CLOUD–BAND

Residence of official, Sintu, one half-day northeast of Chengtu, Szechwan, 1850 A.D.

This window is not structurally strong, and can be constructed only in wood in a protected place or with a wood back.

2b. CENTRAL FRAME SUPPORTED ON CLOUDS

Ancestral temple, Kienwei, on river two days below Kiating, Szechwan, 1800 A.D.

This is one of the finest windows in the collection. I have seen a few examples of this design west of Yachow, Szechwan, but in almost no other place.

W. U–SCROLL (continued)

3a. CLOUDS AND HEAVY GRILLE
Temple, Wenchuan, three days northwest of Chengtu, Szechwan, 1775 A.D.

3b. COMPOUND CLOUDS CROSSED
Provenance uncertain, probably 1775 A.D.

This heavy grille window with slightly offset line is exceedingly well executed. There is much carving within the central circle, but this is not reproduced in our drawing. The symbolism suggests the circle of heaven, the square of earth, and the cloud-bands.

4a. KNUCKLED CLOUDS
Ch'ang-yüan, Wuchang, Hupeh(?), 1650 A.D.(?)

In almost every group there is a window which illustrates how a principle may be carried to the extreme limit. This design appears to be made up of four cloud-bands with the incurls toward each other. I have seen two or three similar examples in Chengtu and Canton, dated about 1800 A.D.

4b. CLOUDS AND VARIATIONS
Ch'ang-yüan, Wuchang, Hupeh(?), 1650 A.D.(?)

The clouds with their peculiar variations seem more related to the Wu-Han work of the 19th century than to any other place. The peach of immortality and the Buddha's hand of longevity (a citrus fruit) are well carved.

4c. CLOUDS SUPPORTING CLOUDS
Ch'ang-yüan, Wuchang, Hupeh(?), 1650 A.D.(?)

5a. KNUCKLED CLOUD–BANDS
Chengtu, Szechwan, 1750 A.D.

5b. CLOUD–KNUCKLED CENTRAL FRAMING
Temple, six days northeast of Chengtu, Szechwan, 1750 A.D.

The cloud-band endings are very different from those of 5a. The writer believes that 5a was developed earlier than 5b, notwithstanding the dates given, which are those of manufacture, as nearly as the writer can determine them. The apparent discrepancy is due to oscillations in development and use of patterns and styles. 5b has not been generally reproduced in Chengtu since 1890 A.D.

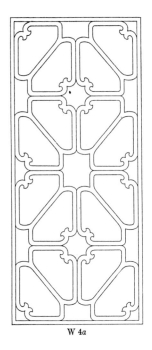

W 4a

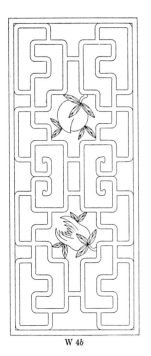

W 4b

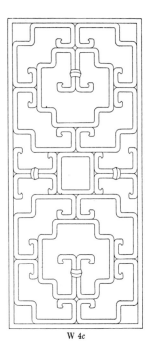

W 4c

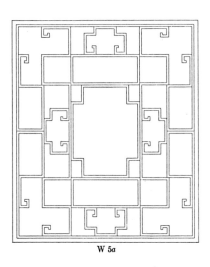

W 5a

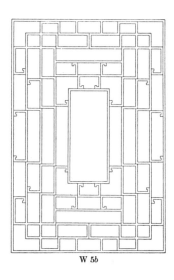

W 5b

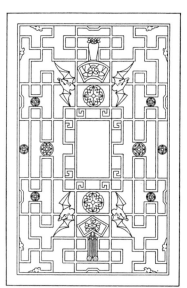

W 6a

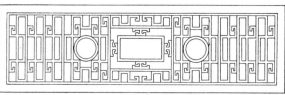

W 6b

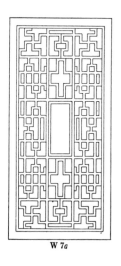

W 7a

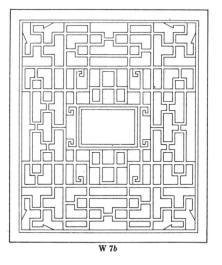

W 7b

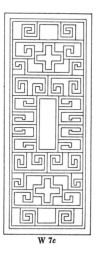

W 7c

W. U–SCROLL (*continued*)

6*a*. CROSSED CLOUDS

Woodyard, North Gate suburb, Chengtu, Szechwan, 1775 A.D.

6*b*. NINE FRAMES WEDGED AND LOCKED BY CLOUDS

City temple, Chengtu, Szechwan, 1850 A.D.

This window is a characteristic example of the knuckling of frames during the middle of the 19th century. It would seem that these were as general in 1850 as the swastika was in 1875.

7*a–c*. INTERLOCKED OR KNUCKLED WINDOWS

a, b. Chengtu, Szechwan, 1875 A.D. *c.* Same, 1850 A.D.

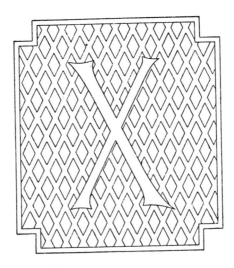

X. RUSTIC ICE–RAY

To appreciate the designs in this division, one needs to see ice forming on quiet water on a cold night. Straight lines meet longer lines, making unique and beautiful patterns. The Chinese term this *ice-line* (cf. &u 2*w'*), or lines formed by cracking ice; I have described it as the result of a molecular strain in shrinking or breaking, but more recent observations and photographs seem to prove that it is a conventionalization of ice-formation which has become traditional.

This group includes those ice-ray patterns which are not symmetrical, and will not fold upon themselves either vertically or horizontally. There is balance, but not involute balance. This type of window has been used since before the Christian era.

2*a*. Irregular Triangular Ice–Ray

Temple, Tachienlu, Szechwan, 1900 A.D.

This reproduction is from memory, but is approximately correct.

2*b*. Centered Circular Ice–Ray

Manchuria, 1900 A.D.

The irregularity of ice-ray is attained in this design, yet a certain amount of circularity is also achieved.

3*a*. Rectangular Ice–Ray

Shop, Chengtu, Szechwan, 1850 A.D.·

The bars of this window are so oriented as to give a sense of the horizontal. I call this "polarized ice-ray."

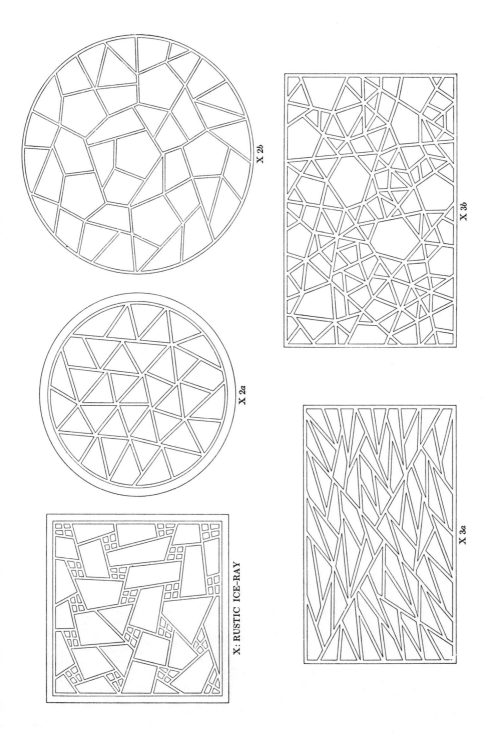

X 2b

X 3b

X 2a

X: RUSTIC ICE-RAY

X 3a

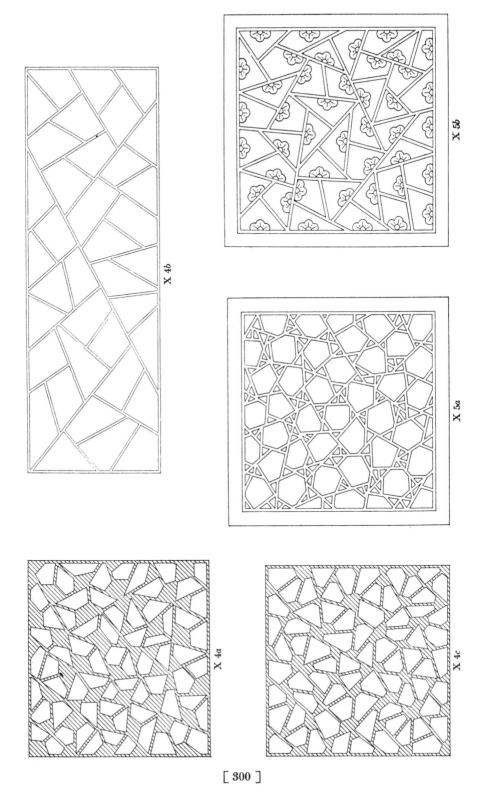

X 4b

X 5b

X 5a

X 4a

X 4c

X. RUSTIC ICE–RAY (continued)

3b. Unequal Light Spot Ice–Ray

Clay funerary furnishings from near Chengtu, Szechwan, 150 B.C.

This is a rather poor expansion of &f 40c, which was copied from a clay summer house of a Han student. The pattern was etched in clay, and then baked. This is not a good type of ice-ray, but is highly important as showing the early period when the design was employed.

4a, c. Nucleated Ice–Ray

Ginger jars, 1750 A.D.

This ice-ray is more highly conventionalized than most. It is not like the real nucleation in natural ice, but is pleasing. Patterns such as these are commonly seen on porcelains, but are rarely used in windows.

4b. Z–Shaped Ice–Ray

Residence, Chengtu, Szechwan, 1800 A.D.

Structural strength is provided by three bars somewhat in the shape of a Z. The other bars are shorter and more or less parallel the main bars which determine the plan of the window. The building in which this was found is an old one with several rare windows in it. This particular one has been repaired after the original design, but another which was made in 1922 by a carpenter to match this one failed to equal the original.

5a. Evenly Distributed Unequal Light Spots in Ice–Ray

Ginger jar, 1700 A.D.

This fine design has exceeded the conventional limits in wood construction. It is somewhat like &f 40c.

5b. Prunus Ice–Ray

Residence, Chengtu, Szechwan, 1875 A.D.

The prunus blossom covers the end of the mortise and tenon, where the workmanship leaves something to be desired. This type of design appears to be confined to Szechwan. It was probably developed about 1800 A.D. as a lattice pattern. During the time of Kang-hsi, 1662–1723 A.D., it was much affected in porcelain, where sprays of prunus appear on, or reflected in, conventional ice-ray. I believe that the lattice design was taken from the porcelain, but the discovery of new material might alter this view.

X. RUSTIC ICE–RAY (*continued*)

6*a*. BAMBOO AND PRUNUS ICE–RAY

Window paper, Chengtu, Szechwan, 1916 A.D.

There is very little structural strength here, as the pattern is block-printed upon paper which is to be pasted upon lattice windows.

6*b*. SEMI–ROTATIONAL ICE–RAY

South street-shop, Chengtu, Szechwan, 1850 A.D.

It requires careful designing to mass thirty-two scalene triangles of equal areas and avoid horizontal and perpendicular lines and rotational effects.

7*a*, *b*. MAN–CHARACTER ICE–RAY

a. East Road, Yachow sector, Szechwan, 1850 A.D. *b*. Residence, Chengtu, 1875 A.D.

a shows a central frame, with internal outline found in a tray from Canton of 1750 A.D. and external outline of rectangle, enframed in a lozenge shape. *b* is a variation of *a*, but equally good. It should be remembered that the characters for "man" and for "to enter" exchange positions when the observer goes into the room and looks out through the window (cf. &u 2*m*, *h*).

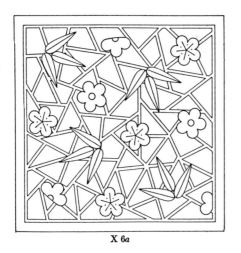

X 6a

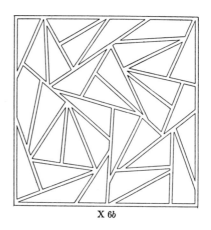

X 6b

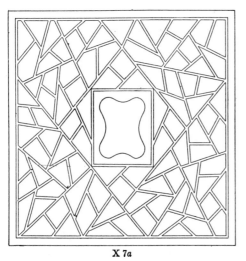

X 7a

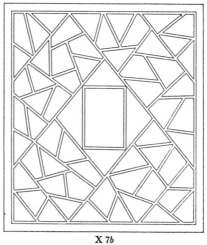

X 7b

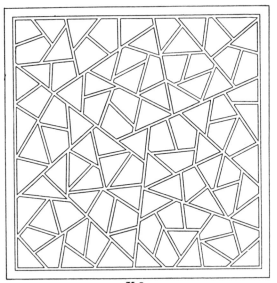

X 8*a*

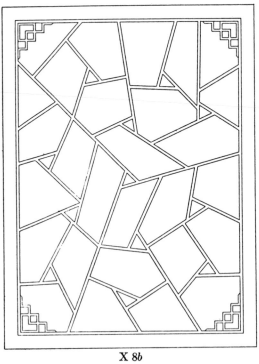

X 8*b*

X. RUSTIC ICE–RAY *(continued)*

8a. IRREGULAR ICE–RAY

Chengtu, Szechwan, 1880 A.D.

8b. COMPLEX THREE–VANED WINDWHEEL ICE–RAY

Jungking, Szechwan, on a road that connects Burma, Yunnan, Tibet, as well as south and west Szechwan, with the imperial highway of Yachow-Chengtu-Hanchung-Peking, about 1725 A.D.

This is almost the choicest design in our collection, and is the best rustic work that I have seen. It has been carefully planned, though not obtrusively so. It is true that this was found in a sweet-meat stall of straw thatch outside the city wall, but the window was much older than the stall, and had come from a building of some preten-sions. The materials and general state of repair, as well as the design, suggest our dating. Many monuments in the environment, as well as the local historical gazetteers, testify to a past culture superior to that of the present.

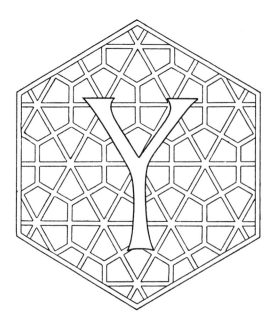

Y. SYMMETRICAL ICE–RAY

This group includes symmetrical patterns made up of short bars, rather than those which stress line. These suggest the somewhat irregular ice-ray of the X group, but even more the regular crystalline structure. Many examples approach the formal lattice of other groups. In many ways it is the finest, richest, and most chaste group of Chinese lattice we have seen.

2a. REINFORCED ICE–RAY

Window in street-vender's case, Chengtu, Szechwan, 1916 A.D.

These are simple bamboo weave patterns done in well-joined wood.

2b. HEXAGON–AND–TRIANGLE ICE–RAY

Residence, Penghsien, Szechwan; Yünnan guild hall, Suifu, Szechwan; Buddhist temple, Ningpo, Chekiang. All 1800–1900 A.D.

This type is common in the Yangtse valley region and in South China, but is rarely found in North China. Like the hexagonal snowflake, this appears in various variations and proportions, but those given here are the most frequent.

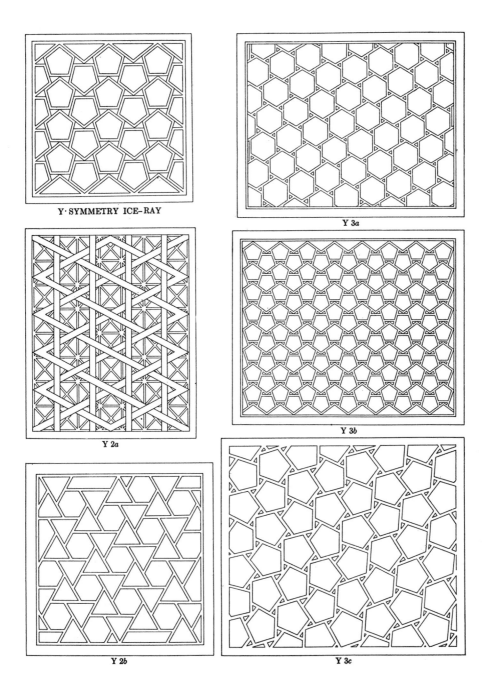

Y·SYMMETRY ICE–RAY

Y 3a

Y 2a

Y 3b

Y 2b

Y 3c

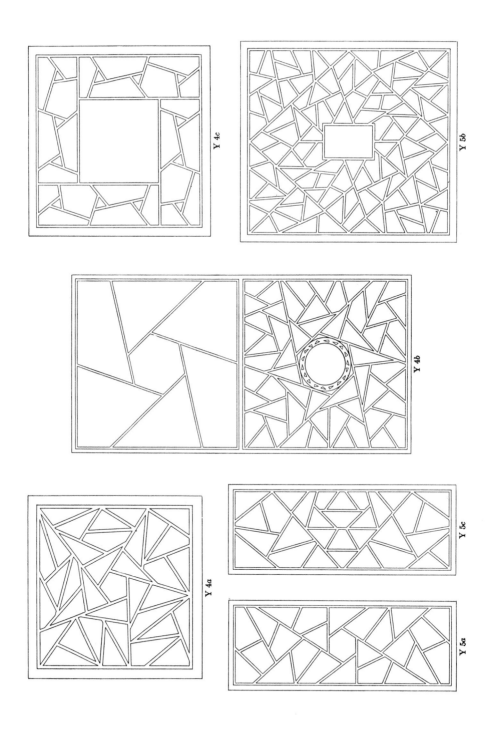

Y 4c

Y 5b

Y 4b

Y 4a

Y 5c

Y 5a

Y. SYMMETRICAL ICE–RAY (*continued*)

3*a*. SIX–SIDED ICE–RAY
Near Hanchow, Szechwan, 1900 A.D.

This is a variation of the preceding design, but diverges so much that it appears quite different.

3*b*. PENTAGONAL ICE–RAY
Yamen and Arsenal, Chengtu, Szechwan, 1900 A.D.

Unlike the preceeding plate, this one is bilaterally symmetrical. The example of this in the Chengtu arsenal has lanceolate half-blossoms of prunus at each end of every horizontal bar and at the upper and lower ends of the quasi-vertical bars. These flowers of the winter season are an additional feature, which also covers the mortise joints.

3*c*. PENTAGONS
Woodyard, Chengtu, Szechwan, 1900 A.D.

This is essentially the same design as the preceding one, but its appearance is quite different, through the change in orientation of the light spots, and the omission of the wave border just within the outer frame.

4*a*. CENTERED ICE–RAY
Shop, Chengtu, Szechwan, 1875 A.D.

4*b*. COMMON–BAR ICE–RAY
Shop, Kwanhsien, one day northwest of Chengtu, Szechwan, 1875 A.D.

Four windows in one section of the shop are thus oriented. Each is worked out in the same way.

4*c*. RECTANGULAR AND TRIANGULAR ICE–RAY
Jungking, one day southwest of Yachow, Szechwan, 1850 A.D.

5*a*. OBLONG CENTERED ICE–RAY
One half-day south of Chengtu, Szechwan, 1875 A.D.

5*b*. ROTATIONALLY SYMMETRICAL ICE–RAY
Sintsing, one day southwest of Chengtu, Szechwan, 1850 A.D.

A number of pleasing old window designs are found in this region.

Y. SYMMETRICAL ICE–RAY (*continued*)

5c. FOLD ICE–RAY
Residence, one half-day southwest of Chengtu, Szechwan, 1875 A.D.
This is involute lattice, save for one extra bar in the lower left-hand corner.

6a. THREE AND FOUR VANED ICE–RAY
Tea shop, West Gate, Chengtu, Szechwan, 1800 A.D.
This window has very few close analogies; 4c and X 8b are most akin.

6b. IRREGULAR ICE–RAY SYMMETRICAL BY ROTATION
Three hours from Chengtu, Szechwan, on southwest road, 1875 A.D.
This plate is slightly defective, as it was one of the first drawn.

7. TRIANGLE–CENTERED ICE–RAY
Woodyard, North Gate, Chengtu, Szechwan, 1800 A.D.
It is possible to produce three-fold symmetry in circular windows such as this. This design has its analogue in the Fu Lung Kwan, a temple at Kwanhsien connected with the ceremonies of opening the Chengtu irrigation project dam.

8a. PRUNUS ICE–RAY
Residence, Chengtu, Szechwan, 1800 A.D.
Structurally this is 6b executed in thin bars with the addition of half-blossoms of prunus. Flowers such as this were popular during the late years of the Ch'ing dynasty.

8b. PRUNUS ON WAVE ICE–RAY
Residence, Chengtu, Szechwan, 1850 A.D.
The structural background is like N 6c, which came from a stone sarcophagus of 150 B.C.

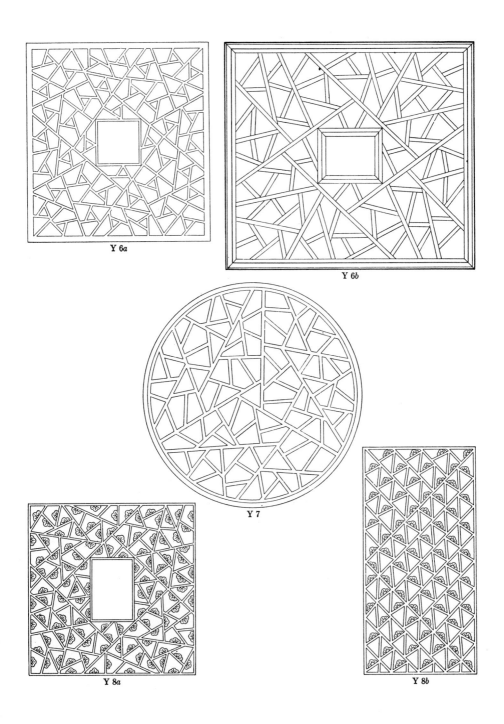

Y 6a

Y 6b

Y 7

Y 8a

Y 8b

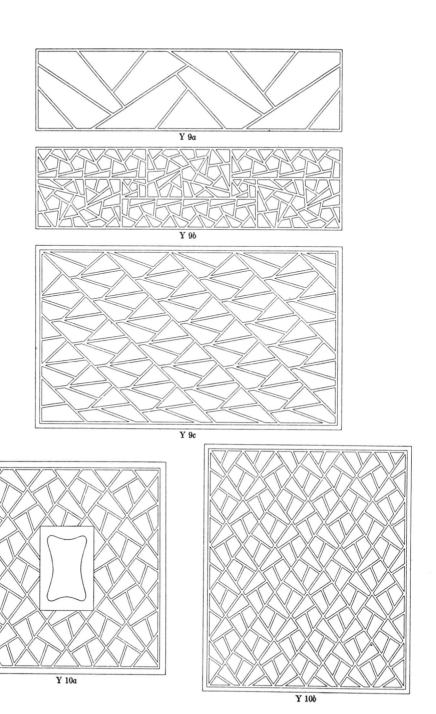

Y 9a

Y 9b

Y 9c

Y 10a

Y 10b

Y. SYMMETRICAL ICE–RAY (*continued*)

9*a*. ICE–RAY SYMMETRICAL BY TRANSLATION
Shop, Chengtu, Szechwan, 1900 A.D.

This openwork is placed above the shop boards, which close the shop at night, and permits ventilation.

9*b*. ICE–RAY SYMMETRICAL BY ROTATION AND TRANSLATION
Hsioh Tao Street, Chengtu, Szechwan, 1800 A.D.

9*c*. BAMBOO LEAF DESIGN
Shop window, Chengtu, Szechwan, 1875 A.D.

I have met but this one example of this unique pattern. This is another instance of how bamboo pervades Chinese life and art throughout the centuries.

10*a*. MAN–CHARACTER ICE–RAY
Kiungchow, on Chengtu-Yachow road, Szechwan, 1750 A.D.

The diagonal background bars engage into the frame differently from 10*b*, so that there is more individual than collective framing. The man-character has its mirror-image, the enter-character, for the sake of balance, as well as for observation from the other side of the window. Mr. Yang, who executed these drawings, insists that this is "head-first-piece" of all these designs. (Cf. man-character &u 2*m* and enter-character &u 2*h*).

10*b*. ENFRAMED MAN–CHARACTER ICE–RAY
Dye, after 10*a*, 1930 A.D.

It seems eminently worth while to repeat the former motif in an all-over. To form the central line of design and border is not simple. This window was designed (with a small opening at the bottom edge) for the West China Union University bursar's office.

Y. SYMMETRICAL ICE–RAY (*continued*)

11*a*. FAN AND ICE–RAY

Pao-kuang temple, Sintu, one half-day northeast of Chengtu, Szechwan, 1800 A.D.

The fan space is used for the inclusion of characters; the paper is changed at the Chinese New Year and pictures or characters are then replaced. Small decoration pieces are carved with flowers such as orchids and bamboo leaves, colored, gilded, and fastened in ten light spots: the two median ones, the large ones at the four corners of the fans, those in the two lower-pointed corners, and the two upper-end ones. These carvings were too difficult to execute properly, and were not included in this plate. There are no parallels, horizontals, verticals, or X-crosses among the bars, which is orthodox for ice-ray lattice. This lattice is well designed and executed.

11*b*. K'ANG-HSI VASE IN ICE–RAY

Tea shop, Kwanhsien, one day northwest of Chengtu, Szechwan, 1900 A.D.

This window obviously is bilaterally symmetrical. It exhibits a tendency that has crept into lattice, especially since 1850 A.D., to carry designs too far. Around 1800 A.D. porcelain vases were fired with designs of smaller vases including flowers in many colors.

12*a*. QUASI–BILATERALLY SYMMETRICAL ICE–RAY

Midway between Chengtu and Kwangyuan, Szechwan, 1850 A.D.

Such an exquisite sense of symmetry is more subtle than that revealed in involute balance. There was fine lattice, even in small places, along the old imperial highway from Paocheng, near Hanchung, to Kwangyüan, Chengtu, and Yachow, although it varied from locality to locality.

12*b*. BILATERALLY PAIRED AND X–CROSSED ICE–RAY

Kienchow Peh, six days from Chengtu toward Kwangyüan, Szechwan, imperial highway, 1800 A.D.

This type of lattice is unusual.

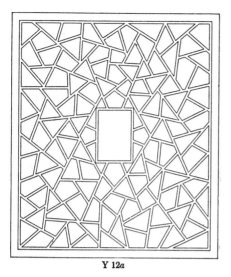

Y 12a

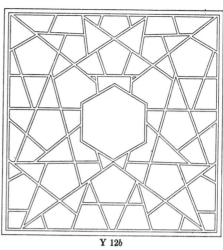

Y 12b

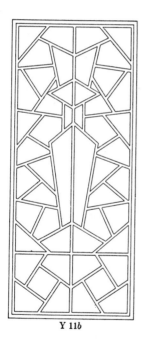

Y 11b

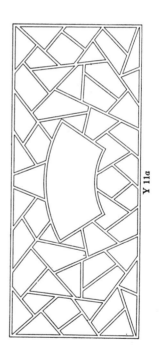

Y 11a

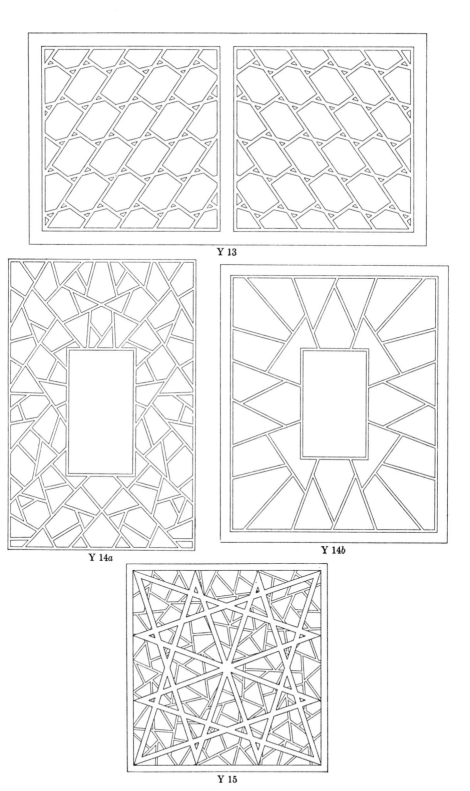

Y 13

Y 14a

Y 14b

Y 15

Y. SYMMETRICAL ICE–RAY (*continued*)

13. Paired Ice–Ray

Chinese painting of 1825 A.D.

This is taken from an old picture, which forms a legitimate source of lattice designs, but must be used with caution.

14*a*. Irregular Paired Ice–Ray

Lokiang, two days northeast of Chengtu, Szechwan, 1850 A.D.

14*b*. Open–Paired Ice–Ray

Buddhist temple, Tachienlu, Szechwan, 1900 A.D.

15. Reinforced Ice–Ray

Window of street-vender's case, Chengtu, Szechwan, 1900 A.D.

The interlacing of endless lines is habitual with the Chinese. This regular ice-ray is related to the endless-knot or fish-entrail designs. It forms a suitable closing piece for this group.

Z. SQUARE AND ROUND

The square and the round were early employed in patterns in China. It is difficult to say just when symbolic meaning was attached to them. Stone and jade examples date from Chou and pre-Chou days, as exhibits in the Field Museum, the Freer Art Gallery, and other museums show. During the Chou and Han Dynasties these shapes appeared on coins. The circle of heaven and the square of earth symbolized deities that were omnipresent. The compass and square are mentioned in Chinese ethical and classical literature (cf. Mencius, Bk. IV, Le Low, Part I, Chap. II, v. 1). The circle and the square, or rather the squared circle and the rounded square, form the first diagrams of the *Ying Tsao Fu Shih* of 1103 A.D., that classic of Chinese architectural literature (cf. &v 1*d–e*). The designs themselves are intrinsically beautiful, aside from their rich symbolism, so that this group of windows is one of the finest discovered. The designs run the gamut from the square to the circle.

2*a*. CROSSED SQUARES

Tea shop, Chengtu, Szechwan, 1900 A.D.

This plate might very well be considered as a companion to D 12*a*, but the square of earth predominates over the concentered frames. The pattern was woven into cheap windows of bamboo splints in Chengtu after the fire of 1916. It is one of the natural designs arising out of splint weave; a local or a national turn is given by its sym-

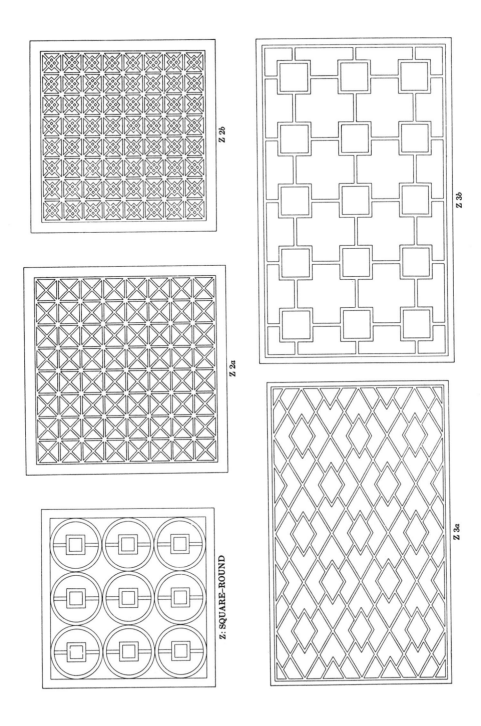

Z 2b

Z 2a

Z 3b

Z 3a

Z: SQUARE-ROUND

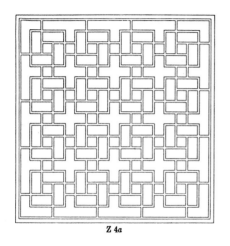

Z 4a

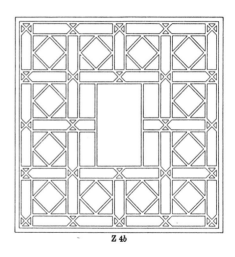

Z 4b

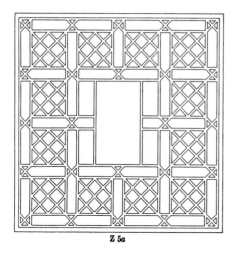

Z 5a

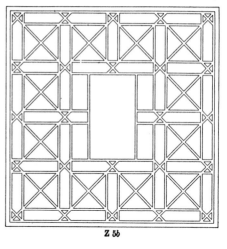

Z 5b

Z. SQUARE AND ROUND (*continued*)

bolism, by the variation in size of bars in the same piece, by its colors, and by the relation between the size of the bars and that of the light spots.

2b. SQUARE ON CROSS IN SQUARE

Temporary bamboo-woven window, Chengtu, Szechwan, 1916 A.D.

This is like the preceding window, but with the intersections tied together by a woven splint. I have seen this method used in Chinese splint work, but not in wood windows.

3a. SQUARE WITHIN SQUARE

Tomb carving, Kiating, Szechwan, Han Dynasty.

The square within a square is managed by supporting bars radiating to neighboring repetitions. The pattern is raked until the lozenge is produced, but the illusion of a square within a square is obtained. The grille is fairly strong. The plate is slightly more raked than is the case in the original design. The cartoon for this plate is an expansion from a drawing of a somewhat crude detail of a running grille. This fills up part of the framework in a building tooled on the stone wall of a Han dynasty cave-grave. The crossed and concentered frames formed by the cross-bars are in keeping with the details. Such grille as this indicates that a real technique and art in lattice existed in Szechwan under the Han dynasty (206 B.C.–220 A.D.). The same design in the rectangle is found in the *Ch'ang-yüan*, which may be ascribed to Wuchang (1650 A.D.).

3b. SQUARE AND CROSS

Yüan-yeh, Soochow, Kiangsu, 1635 A.D.

4a. IN-SQUARED WINDWHEEL

Shanghai, 1900 A.D.

4b–5b. WINDWHEEL, CROSS, AND SQUARE

Suifu, Szechwan, 1918 A.D.

This series of windows is unusual. The windwheel is well disguised.

Z. SQUARE AND ROUND (*continued*)

6a. CROSSED OCTAGONS, CIRCLES, AND SQUARES

Mount Omei, Szechwan, 1850 A.D.

6b. CIRCLES, SQUARES, AND OCTAGONS

Mount Omei, Szechwan, 1850 A.D.

Plates 6a and b are not outstanding, but they display patterns frequently found on Mount Omei.

7a. CIRCLE AND SQUARE

Midway between Chengtu and Kwangyüan, on imperial highway, Szechwan, 1750 A.D.

The oblong openings have bars through the middle which are slightly depressed. The bead of these bars is an inverted V (the inside, or paper side, is of course flat). This window is defective in transmitting light. I have seen only one similar to it, at Kwanhsien, Szechwan, but the latter was not its equal in artistry. It reveals strong Ming influence.

7b. SQUARE AND CIRCLE

Peking, Chihli, 1875 A.D.

This window is well joined in hard wood, so that the circles and the corners of the square frames persist. It is one of the finer windows which suggests the designs of the 18th century. The indented corners of the square frames resemble tea tray shapes in Canton of the first half of that century.

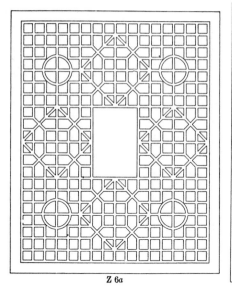

Z 6a

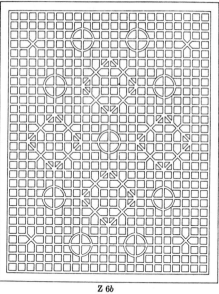

Z 6b

Z 7a

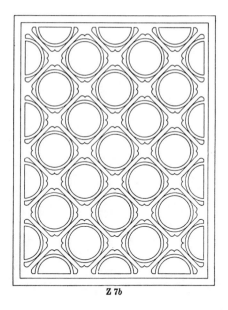

Z 7b

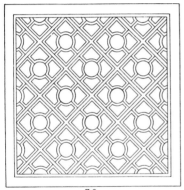

Z 8a

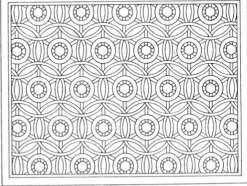

Z 9a

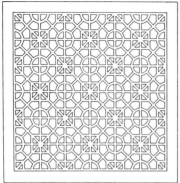

Z 8b

Z 9b

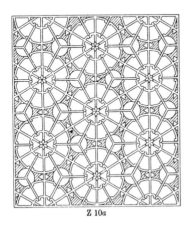

Z 10a

Z 10b

Z. SQUARE AND ROUND (*continued*)

8a. CIRCLE WITHIN SQUARE
Chengtu, Szechwan, 1850 A.D.

8b. CIRCLES, SQUARES, AND OCTAGONS
Mount Omei, Szechwan, 1850 A.D.

In this window one may see circles, or squares of about the same size, or circles within octagons or within squares, or a circle within a square, cornered by four squares or by four circles, etc. Windows such as this were more common a century ago than they are at present.

9a. OBLONG CASH PATTERN
Temple, Suifu, Szechwan, 1915 A.D.

9b. CIRCULAR CASH PATTERN
Canton, Kwangtung, 1750 A.D.

This splendid design needs no symbolism to perfect it. Rows of cash, without the connecting bars, are found on Han dynasty brick. The bars are added here to give strength.

10a. WHEEL OF LIFE
Buddhist temple, Chengtu, Szechwan, 1836 A.D.

The Buddhist wheels of life I have encountered in Chinese lattice always have six sections (cf. &a 19b). The Ju I scepter, which is a symbol of Taoism, is used in this Buddhist window! The hatched work in the diagram is of perforated board, but the main structure of the window is of joined work.

10b. HEXAGONALLY–LINKED CIRCLES
Residence, Chengtu, Szechwan, 1855 A.D.

This design is not so common as the rectangularly-linked circles (cf. 12b).

Z. SQUARE AND ROUND (*continued*)

11*a*. CIRCLE WITHIN SQUARE

Temple of city god, Chengtu, Szechwan, 1750 A.D.

Temples often have more elaborate carving in doors and windows than do residences. In the former, where tapers play a part of the ceremony, dim light is a desideratum. When more light is needed the doors are thrown open.

11*b*. RECTANGULARLY–LINKED CIRCLES

Chengtu, Szechwan, 1775 A.D.

12*a*. HEXAGONAL BROCADE OF CIRCLES

Village in foothills, one day and a half northwest of Chengtu, Szechwan, 1750 A.D. The *Ying Tsao Fa Shih* of 1103 A.D. calls this pattern the "Framework of six-repeat-ball pattern."

12*b*. INTERLOCKED CIRCLES

English etching of Chinese scene, Canton(?), 1750 A.D.(?); also in Wu Hou temple, one mile southwest of Chengtu, Szechwan, 1900 A.D.

The side or end view presents the gold coin pattern, which is peculiarly Chinese. Its diagonal use is seldom seen. The Chinese have used the design on small objects since the Han dynasty, when it appeared on mortuary brick.

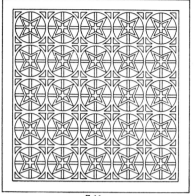

Z 11a

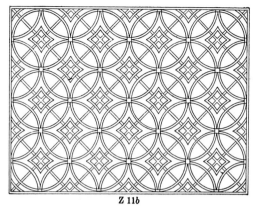

Z 11b

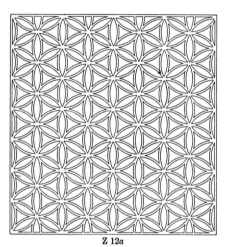

Z 12a

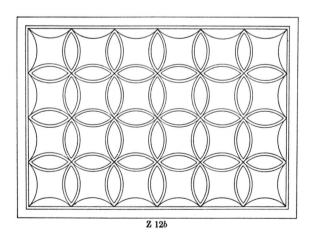

Z 12b

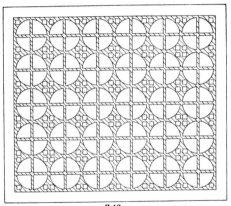

Z 13a

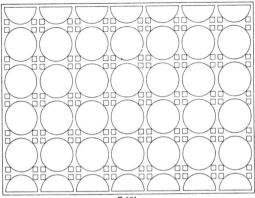

Z 13b

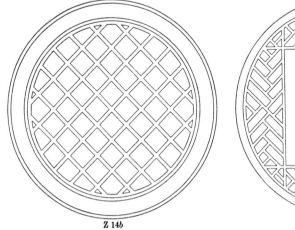

Z 14b Z 14a

Z. SQUARE AND ROUND (*continued*)

13*a*. CIRCLES AND SQUARES

City temple, Chengtu, Szechwan, 1850 A.D. or earlier.

This was a favorite design of the first half of the 19th century in Szechwan.

13*b*. CIRCLE AND SQUARE AND CROSS

Temple, North Gate suburb, Chengtu, Szechwan, 1750 A.D.

This is 13*a* without the cross-bars through the centers of the circles. Some designs seem to have numerous kindred, but the spread of this is limited. It is found in the city temple along with 11*a*.

14*a*. HEAVEN, EARTH, AND MAN

Dye after Yamen, Hanchong, Shensi of 1850 A.D.

Between the two frames, one exterior and one interior, is the man-character prop (&u 2*m*), simulating an ice-ray. The latter detail is inserted by the author. The original ice-ray may have been quite different, but the remainder of the window is very like the original. The arrangement may have existed in window lattice in the year 1700 A.D.; the crossed ends frame has come down approximately from that date.

14*b*. CIRCLE–FRAMED SQUARES

Buddhist temple, Ningpo, Chekiang, 1825 A.D.

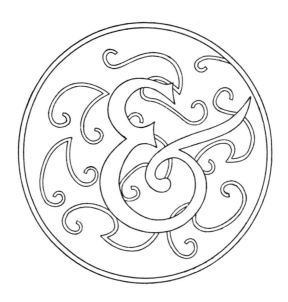

SUPPLEMENT

Even a hasty survey of the lattice window plates from A to Z leaves one with the realization that other factors should be included in a study of lattice: lattice windows must have a setting. Some of this background material which seems relevant is included in this supplement. In this section the writer has purposely omitted extensive comments. Cross-references might have been given in more detail, and much additional comment regarding artistic cross-currents, but this would detract from the main purpose of the book. A few of the plates have no provenance noted. Some of the borders have been taken from windows in this book, and adapted.

&a. TAIL PIECES

The collection of lattice and grille under &a called *Tail Pieces* might have been distributed under appropriate groups from A to Z; but because of the special frames as well as the unusual designs it seems appropriate to present them in this way.

1a. JADE PI SHAPE

Buddhist temple, Ningpo, Chekiang, 1825 A.D.

The shape of the frame is an imitation of the Chou and pre-Chou *Pi* signifying Deity of Heaven (cf. C 10*b* and Y 2*b*). The inner frame

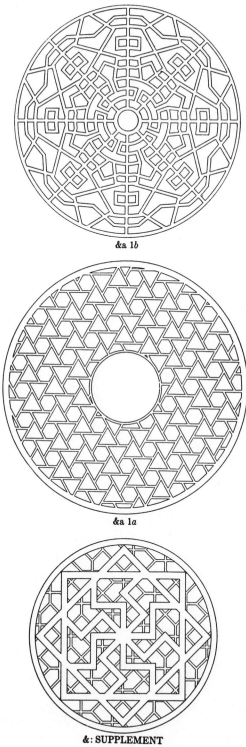

&a 1*b*

&a 1*a*

&: SUPPLEMENT

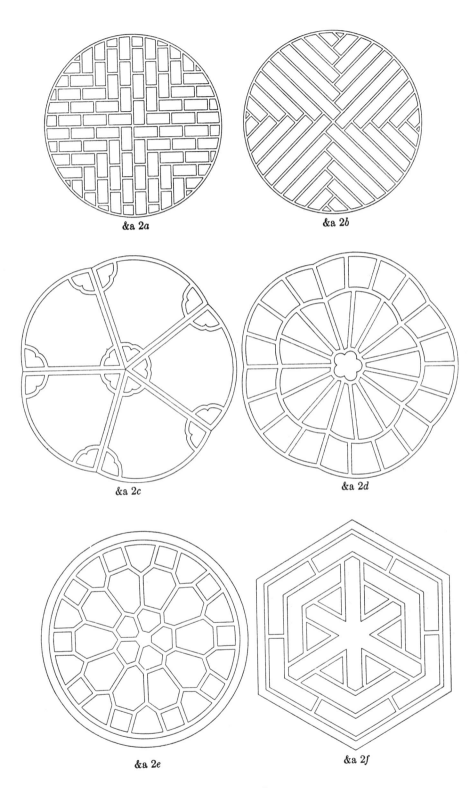

&a 2a

&a 2b

&a 2c

&a 2d

&a 2e

&a 2f

is too narrow exactly to reproduce the original. A somewhat similar pattern is found in the Chinese book *Yüan-yeh,* of Soochow, 1635 A.D. This window is about 4 feet 6 inches, or 150 centimeters, across, being larger than most; it is one of a pair across the front and central section of the building.

1*b*. MANIFOLD LONGEVITY WINDOW

Ts'ao T'ang monastery, outside South Gate, Chengtu, Szechwan, 1875 A.D.

This comes from the temple which especially commemorates the T'ang dynasty poet Tu Fu. It was the fine lattice in this temple that influenced me to start collecting lattice patterns.

2*a, b*. CENTRAL SWASTIKA AND MAN–CHARACTER PROP

Mohammedan mosque, Chengtu, Szechwan, 1900 A.D.

Patterns similar to these are found in Group K. In Chengtu the few mosques, each with its Mecca niche, are simple. They use Chinese lattice windows, but without symbolic significance.

2*c–f*. DESIGNS FROM SOOCHOW

Yüan-yeh, Soochow, Kiangsu, 1635 A.D.

These designs were used in windows. *e* is an almost exact replica of a window shown in a book of prints from Japan.

&a. TAIL PIECES (*continued*)

3a–d. OCTAGONAL AND HEXAGONAL SHAPES

a. Fire god temple, Chengtu, Szechwan, 1775 A.D. *b*. Ch'ing-yang temple, South Gate, Chengtu, Szechwan, 1662 A.D. *c*. Theater platform, Shansi guild hall, Chengtu, Szechwan, 1850 A.D. *d*. Chengtu, Szechwan, 1825 A.D.

Multiple framing is exhibited in all these designs. *a* and *b* are centered by the T'ai Chi, the Illimitable or Great Ultimate, whence all things have come. These two interlocked commas also represent the Yin-Yang, the male and female principles, and so do the long and short bars of *b*. This combination of long and short bars, known as the *pa kua*, or eight trigrams, is of great significance in Chinese cosmogony and philosophy.

&a 3a

&a 3b

&a 3c

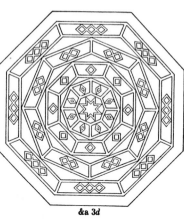

&a 3d

[335]

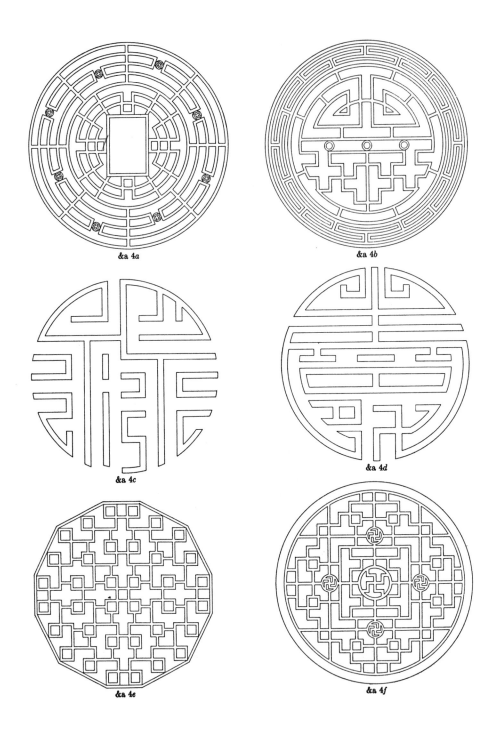

&a 4a &a 4b

&a 4c

&a 4d

&a 4e &a 4f

&a. TAIL PIECES (*continued*)

4a–d. LONG LIFE PLAQUES

a. Chengtu, Szechwan, 1775 A.D. *b.* Kweichow guild hall, Chengtu, Szechwan, 1775 A.D. *c.* Embroidery, Chengtu, Szechwan, 1920 A.D. *d.* Same as *c.*

4e–5b. ENDLESS LINES IN CIRCLES

4e. Residence, North Gate suburb, Chengtu, Szechwan, 1850 A.D.

4f. Temple of literature, Chengtu, Szechwan, 1850 A.D. *5a.* Chengtu, Szechwan, 1850 A.D. *5b.* City temple, Chengtu, Szechwan, 1850 A.D.

4e is an extension of the knuckle-wedge of Group I. *4f* is found in the main Confucian temple in Chengtu. The swastika is not avoided in Confucian and Taoist temples. In the statelier temples the details of windows are seldom overdone by crowding the field. It was in the Confucian temple during the Manchu days that the Szechwan viceroy twice a year, in the presence of his retinue and the students of the capital before dawn, made the three genuflections and the nine prostrations to the tablet of Confucius. The reinforced windows *5a* and *5b* represent a small group; the writer has seen not more than two dozen of these. The background of *5b* would be called "Grouped Hexagon Pattern" in the *Yüan-yeh.*

&a. TAIL PIECES (*continued*)

6a, b. Circles

Interpretations and adaptations of Han period motifs from funeral bricks and caves; Dye, 1931 A.D.

a represents a window which might have existed in Han dynasty days. *b* is the formalization of a millstone dentation of Chengtu of 1931 (cf. N 6c).

7a, b. Centered Octagons and Variations

Chengtu, Szechwan, 1875 A.D.

These are symmetrical along eight axes, an arrangement which is very unusual. Such complex windows as these can only be constructed where funds are available, as in fine temples in wealthy communities, or guild halls, or the residences of chief officials or salt-well or white-wax barons.

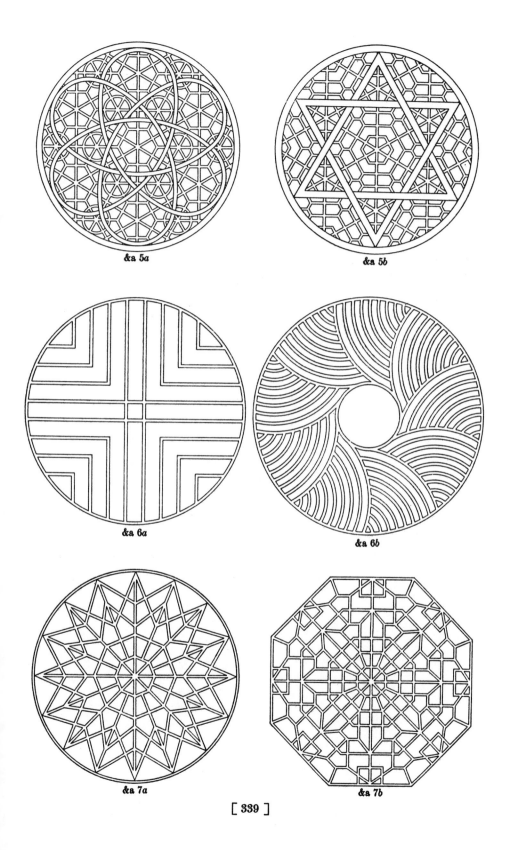

&a 5a

&a 5b

&a 6a

&a 6b

&a 7a

&a 7b

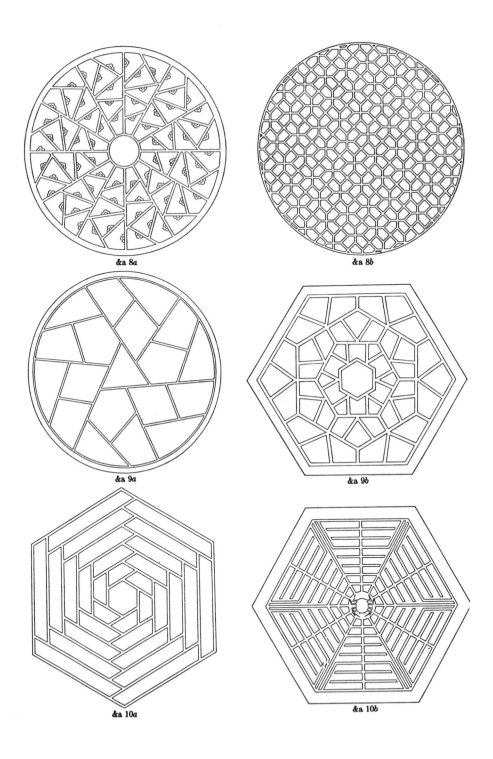

&a 8a

&a 8b

&a 9a

&a 9b

&a 10a

&a 10b

&a. TAIL PIECES (*continued*)

8a. Ice–Ray Table Foot–Rest

Foot-rest under circular table, Chengtu, Szechwan, 1931 A.D.

This is a rare design that scarcely suggests repetition, but in reality the twelve segments are all alike. Each light spot is marked by half a prunus flower. These flowers give circularity in keeping with the whole.

8b. Maze of Hexagons and X's

Chengtu, Szechwan, 1850 A.D.

This very unusual mosaic is most striking. It would be better as a tile pattern than as a wooden lattice. It may be analyzed in several ways, depending upon what component elements are picked out of the pattern.

9a. Man–Character Ice–Ray

Chengtu, Szechwan, 1875 A.D.

The ice-ray pattern is centered by the heaven-earth-man triangle.

9b. Concentered and Stepped Octagon Frames

Chengtu, Szechwan, 1875 A.D.

10a. Concentered Hexagonal Windwheel

East Gate suburb, Chengtu, Szechwan, 1800 A.D.

This unusual window belongs with Group K, external engagement.

10b. Longevity and Spider Pattern

Residence, Chengtu, Szechwan, 1825 A.D.

The long, balanced, geometrical form of the longevity character is not used in writing and printing today, but is reserved for decorative use in stucco, paint, thread, porcelain, and wood. Its decorative qualities as a lattice motif are seldom seen in better light than in this sixfold pattern surrounding the spider and helping to form the web. This might be called the "lettered spider pattern."

&a. TAIL PIECES *(continued)*

11*a, b.* FISH–ENTRAIL WINDOWS

a. Chengtu, Szechwan, 1900 A.D. *b.* Urga(?), Manchuria, 1875 A.D.

The mortise of the frame is carefully done to suggest the in-and-out weaving of the bars. The design symbolizes happiness. It is much used in lattice windows in Peking and Manchuria, but is not so common in Szechwan.

12*a, b.* MODIFIED SQUARES AND OCTAGONS

Chengtu, Szechwan, 1875 A.D.

12*c.* SIMULATED BAMBOO GRILLE

Etching, Canton, Kwangtung(?), 1750 A.D.(?).

This is done in brick, covered with mortar so as to simulate bamboo joints.

12*d.* FRAME KNUCKLED WITHIN AND WITHOUT

Residence, Chengtu, Szechwan, 1775 A.D.

This window the writer obtained from an old residence that was being dismantled. It is splendidly designed, and is typical of many windows of that time. Chengtu, Paoning, and Sintientsi (one half-day north of Paoning) have windows which are akin to this.

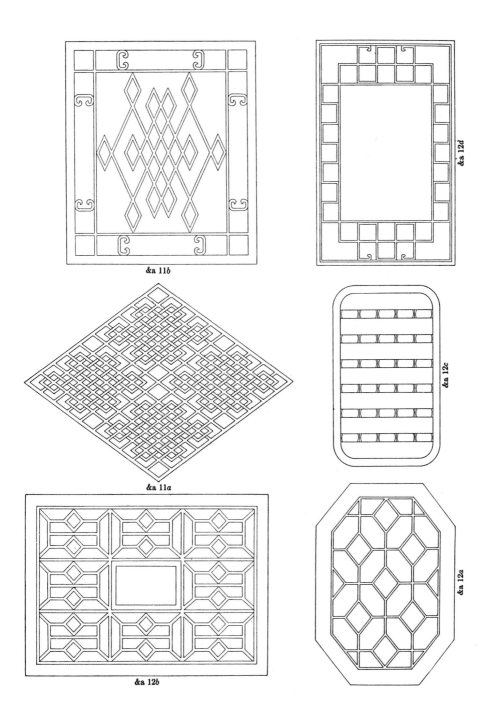

&a 11b

&a 12d

&a 11a

&a 12c

&a 12b

&a 12a

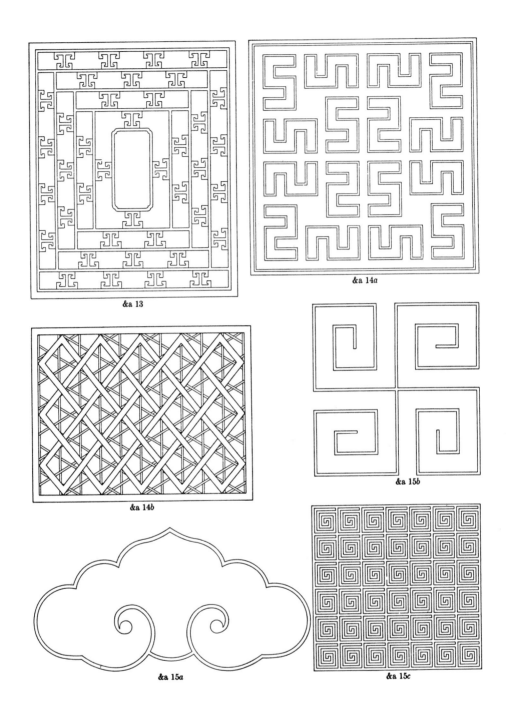

&a 13

&a 14a

&a 14b

&a 15b

&a 15a

&a 15c

&a. TAIL PIECES (*continued*)

13. Concentered Frames

Residence on watershed between Kwangyüan, Szechwan, and Han-chung, Shensi, 1800 A.D.

This is a good example of a window that is commoner in Szechwan than in any other of the Eighteen Provinces. This supporting of the uprights from near the ends of the cross-bars is like that of the roof-framing of Chinese buildings (in lieu of the conventional trusses of Occidental construction).

14a–15c. Sundry Designs

14a. Design in silk gown, Hangchow, Chekiang, 1927 A.D. 14b. Street-vender's stall, Chengtu, Szechwan, 1918 A.D. 15a. Êrh Lang temple of irrigation system at Kwanhsien, Szechwan (burned down about 1926 A.D.), 1875 A.D. 15b. Wooden strips on board back-ground, Chengtu, Szechwan, 1920 A.D. 15c. Adaptation of old Chinese design; Dye, 1917 A.D.

These illustrate the reappearance of old designs under various guises today. Compare &a 22a with &a 15a.

&a. TAIL PIECES (*continued*)

16*a*, *b*. Swastikas in Unusual Frames

Residence, Chengtu, Szechwan, 1775 A.D.

The fine swastikas appear in rare frames, along a covered way by the side of the compound, extending from the front to the garden, pavilion and rock garden.

17*a*. Complex of Bats and Lines and Endings

City god temple, Hwa-yang prefecture, Chengtu, Szechwan, 1875 A.D.

This complicated window is surrounded by patterns of like merit. The five geometrical bats suggest the five happinesses. The two swastikas and the general configuration suggest longevity.

17*b*–18*b*. Ju I in Various Frames

Location and date, same as &a 16*a*, *b*.

These Taoist Ju I symbols are fittingly framed, especially the latter two. The first of these has the Ju I shape in the frame, and the second the Taoist peach of longevity. The various fine frames and windows from the same compound are found in a corridor that leads back to the buildings and the garden behind the main buildings.

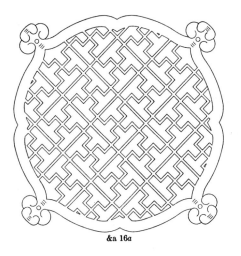

&a 16a

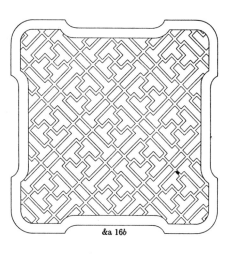

&a 16b

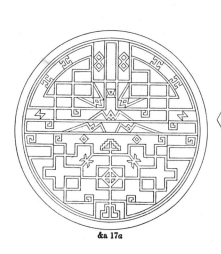

&a 17a

&a 17b

&a 18a

&a 18b

&a 19a

&a 19b

&a 20a

&a 20b

&a. TAIL PIECES (*continued*)

19a, b. WHEEL OF LIFE

Wên-shu Yüan, Chengtu, Szechwan, 1834 A.D.

These fine examples of the transmigration wheel are in one of the best-known temples of Chengtu. Here each fall are held the initiation ceremonies during which the initiates have spots burned into their scalps. All of the Chinese wheels of life have six spokes or divisions (cf. &x 1e). Rarely found after 1800.

20a, b. CIRCLES AND SQUARES

a. Adaptation of stone carving in Han tomb in connection with building timber designs, Kiating, Szechwan, 206 B.C.–220 A.D.; Dye, 1932. *b.* On imperial highway seven days northeast of Chengtu, Szechwan, 1825 A.D.

a. The cash design on brick of the Han days is to be found in almost every direction from Kiating, at Hanchow, at Kwangyüan, and around Hanchung, Shensi; it was a favorite one of the period. This particular design was found on the wall, but has been adapted by the author to a window frame, as he believes that it was undoubtedly so used at that time.

b. This is a common design depicted in a square frame at Omei, Kiating, Chengtu, and elsewhere in Szechwan. Most of these designs are old, but some dating from 1875 A.D. or possibly later have been observed.

&a. TAIL PIECES (*continued*)

21*a, b.* HEAVEN–AND–EARTH SYMBOLS

a. Table foot-rest, Chengtu, Szechwan, 1900 A.D. *b.* Dye, 1932 A.D.

22*a.* RECTANGULAR CLOUD

Erh Lang temple of irrigation system at Kwanhsien, Szechwan (burned down about 1926 A.D.), 1875 A.D.

22*b.* THE ALTAR OF HEAVEN OF THE LATE MANCHU DYNASTY

Outside of walls, south of the Imperial Palaces, Peking, 1402-1424 A.D.

This seems a fitting plate with which to close this group. It epitomizes much. From antiquity these forms have been associated with heaven and earth. It was on this altar of heaven, with its east-west, north-south, and center orientation, that the Son of Heaven, facing south, the cardinal direction, interceded on behalf of his people at the solstices.

&a 21b

&a 22b

&a 21a

&a 22a

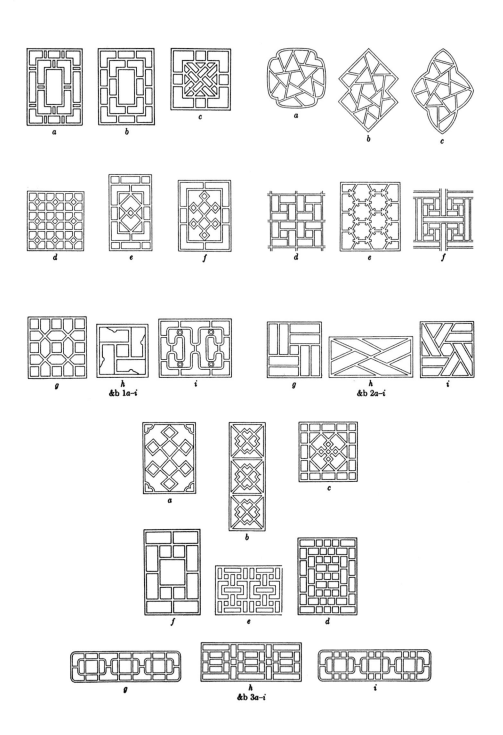

&b. MINIATURE WINDOWS

A few small windows not needing full space are given here. Some come from important cities and buildings, and others from sedan chairs and the stands of travelling venders.

1a. A Yangtse city, three days below Chungking, Szechwan, 1850 A.D. This is a Ming type of window.

1b, c. Shop, Chungking, Szechwan, 1875 A.D.

1d. God of Medicine temple, Hankow, Hupeh, 1850 A.D.

1e, f. Peking, Chihli, and Mukden, Manchuria, 1900 A.D.

1g–i. Suifu, Szechwan, 1875 A.D.

2a–c. Temple of Agriculture, Peking, Chihli, c. 1520 A.D.

2d, f. Anking, Anhwei, 1900 A.D.

2e. Shops in Mukden, Manchuria, and Seoul, Korea: much used in Japan, 1923 A.D.

2g. Chengtu, 1922 A.D.

2h. A very open grille, common in many parts of China, 1775–1825 A.D.

2i. Provenance uncertain.

3a, b, i. Peking, Chihli, 1900 A.D.

3c, d. Mukden, Manchuria, 1900 A.D.

3e. Shensi Guild Hall, Chungking, Szechwan, 1875 A.D.

3f. Museum, Seoul, Korea, probably before 1800 A.D.

3g, h. Mukden, Manchuria, 1825 A.D.

Doors do not, as a rule, present open lattice patterns, but samples of a few which do are shown herewith. Even the heavy solid lacquered doors are frequently decorated quite artistically. Any proper residence in China has an outer and an inner gate at the front entrance, with a gateman's lodge in conjunction. The outer gate opens directly on to the street, and stands open through the day. In case there is open lattice work, it appears here. The inner or "screen" door is always solid, but may be decorated quite artistically, as in &c 2a, b. It is usually kept closed, hiding the interior from passers-by. On either side are small, narrow doors which serve for the passage of servants or members of the family on ordinary occasions.

1a. Street-side gate, Shansi guild hall, Chengtu, Szechwan, 1875 A.D.

One does not often find a door so openly constructed as this one, but in such a situation the inner door is more substantially built than usual. Frequently such a pattern merely stands out from a solid wooden background. The bars in this diagram are drawn too thin. There should also be a line down the center, as the gate is composed of two leaves. When the gates are closed the central bars combine to simulate one square bar diagonally placed (cf. &z 1g).

1b. Street gate, Confucian temple, Chengtu, Szechwan, 1875 A.D.

The circle-and-square symbolism is included in this gate. The bars are rectangular and set on the diagonal (cf. &z 1g). This arrangement conserves light for most angles, and the artistry is far superior to square bars set flat to the face of the gate. The central bar is in reality a double bar on the inside of the gate, which the porter opens when necessary. The outsider cannot reach around the circular plaque of boards just within the bars.

2a, b. Bats and longevity characters on screen doors, Chengtu, Szechwan, 1900 A.D.

b shows the shape and usual method of division. The bat and longevity design is frequently done in gilt upon a black lacquered background. The five bats in rebus fashion spell the five happinesses. The bat motif seems to have come into general use in design during the last two centuries.

3a, b. Doors, Ch'ang-yüan, Wuchang, Hupeh(?), 1650 A.D.(?)

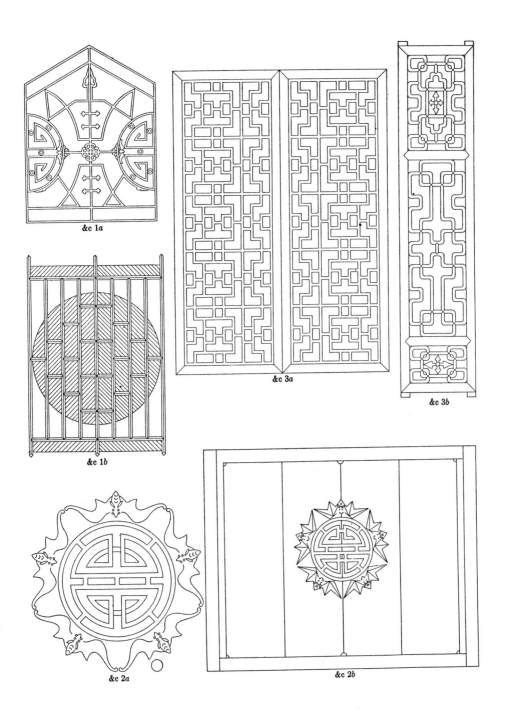

&c 1a

&c 3a

&c 3b

&c 1b

&c 2a

&c 2b

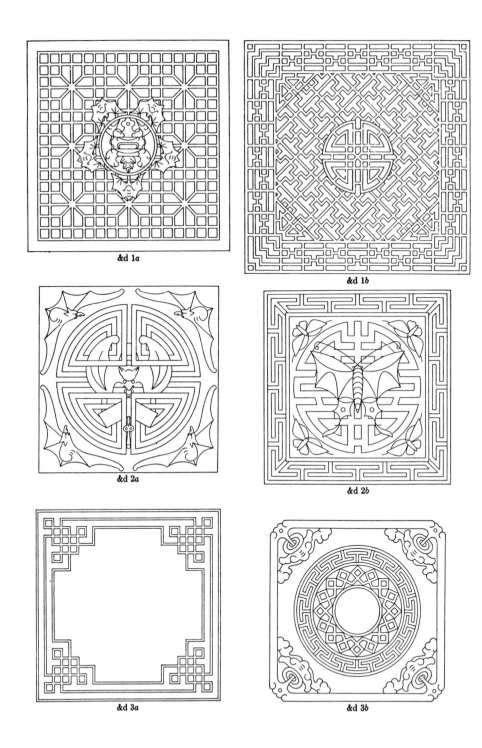

&d 1a

&d 1b

&d 2a

&d 2b

&d 3a

&d 3b

Screens to obstruct the view of the curious are placed sometimes outside the street door, sometimes within the compound, and sometimes in passageways within the building. Some are backed by boards, while others are merely open lattice.

1*a*. Residence, Chengtu, Szechwan, 1875 A.D.

The five-fold bats of happiness are different from the usual forms.

1*b*. Provincial mint, Chengtu, Szechwan, 1910 A.D.

A longevity character forms the center of the screen.

2*a*. Residence, Chengtu, Szechwan, 1875 A.D.

The fifth bat holds the jade musical instrument (cf. &s 1*f*).

2*b*. Residence, Chengtu, Szechwan, 1900 A.D.

The fifth butterfly poises upon the longevity character. Its rebus significance is the same as that of the bats.

3*a*. One day northwest of Chengtu, Szechwan, 1900 A.D.

3*b*. Residence, Chengtu, Szechwan, 1900 A.D.

Temples, residences, and large medicine shops often have heavy railings that belong to lattice art. They must be in keeping with the type of lattice chosen. Some of these railings have been included with Groups A–Z.

1a–2a. Luchow, Szechwan, 1800 A.D.

2a shows affinity with J 3c of Paoning, Szechwan.

2b. Modification of railing at Union University, Chengtu, Szech-wan, 1917 A.D.

This is probably derived from &e 3a, by many steps.

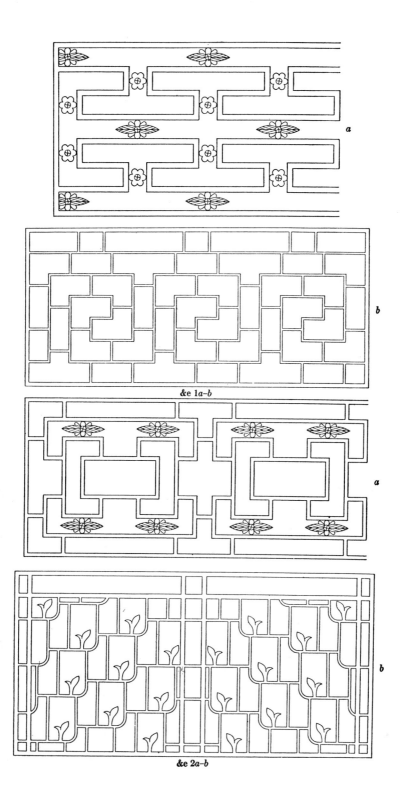

&e 1a–b

&e 2a–b

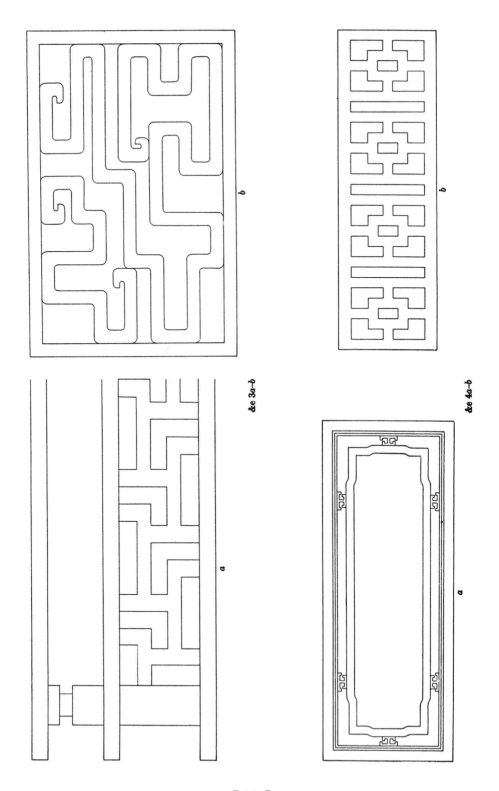

&c 3a–b

&c 4a–b

&e. BALUSTRADES (*continued*)

3*a*. Cave, Tatung, Shansi, Northern Wei dynasty, 5th century A.D.

This comes from Sir Aurel Stein's epoch-making discoveries. The railing is unique. It is a sort of extrusive cantilever of andiron support.

3*b*. Etching, Coastal China, 1750 A.D.(?).

4*a*. Heavy rail in open entrance building to temple, two days northwest of Chengtu, 1700 A.D.

4*b*. West Lake, Hangchow, Chekiang, 1900 A.D.

&e. BALUSTRADES (*continued*)

5*a*. Overhead grille in Yü Wang temple, near Shaohing, Chekiang, possibly 1700 A.D.

These complex cloud-bands are particularly fine. The temple was erected to the memory of the Great Irrigator.

5*b*. Embroidery pattern on Szechwan woman's garment, 1875 A.D.

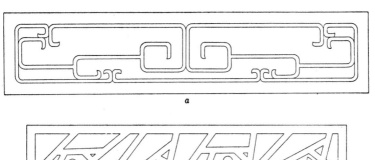

a

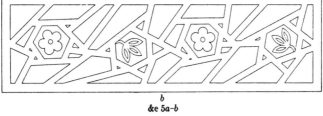

b
&e 5a–b

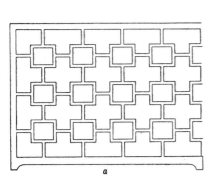

a

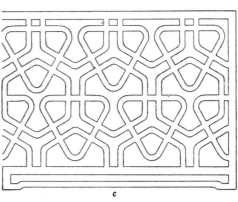

c

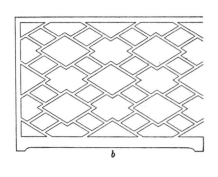

b

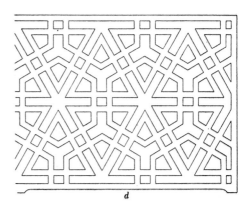

d

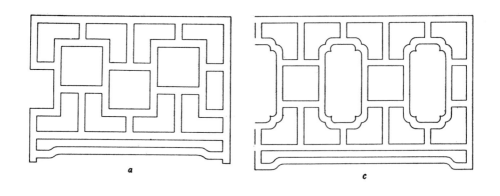

a

c

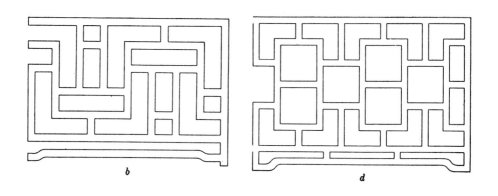

b

d

&e 7a–d

&e. BALUSTRADES (*continued*)

6*a*–7*d*. Railings, *Yüan-yeh*, Soochow, Kiangsu, 1635 A.D.

This is one of the finest collections of such screen balustrades that the writer has ever found.

&f. BORDERS

This group is made up of running borders, and some of the grille that may be used for borders. Some have been taken from the plates in Groups A–Z and adapted by the writer and the draughtsman. Most of the examples come from grille very much as they are presented. Provenance has been given for many of the plates but not for all. Comments have been eliminated in most cases, as the main ideas concerning such designs have already been expressed. The numbering does not correspond exactly to that of the A–Z groups, for certain border designs are not practicable in grille, and there are certain forms of window-grille which do not satisfy the requirements for running borders. But in general the order followed is the same.

1*a*, *b*. From Chinese wood-block cut, in Chinese compendium.

1*c*. Yü Wang temple, near Shaohing, Chekiang, 1700 A.D. or earlier.

All of these five patterns would have been in keeping with Ming dynasty traditions.

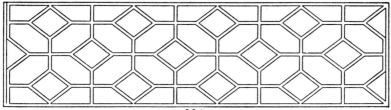

&f 1*a*

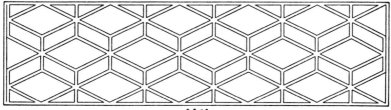

&f 1*b*

&f 1*c*

&f 1*d*

&f 1*e*

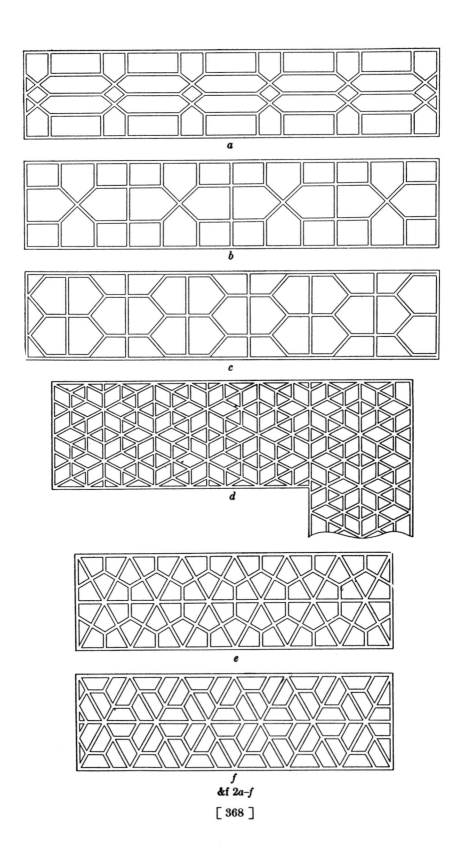

a

b

c

d

e

f
&f 2a–f

2*a–d*. Shops, Chengtu, Szechwan, 1850 A.D. *b* comes from the Manchu city, Chengtu, but has also been seen without cross-bar in a K'ang-hsi rug.

2*e, f*. *Ch'ang-yüan*, Wuchang, Hupeh(?), 1650 A.D.(?)

&f. BORDERS (*continued*)

3*a*, *b*. *a*. God of Plague temple. *b*. East Gate suburb, Goddess of Mercy temple, Chengtu, Szechwan, 1850 A.D.

3*c*, *d*. Shensi guild hall, Chengtu, Szechwan, 1850 A.D.

These patterns were perfected by the beginning of the seventeenth century.

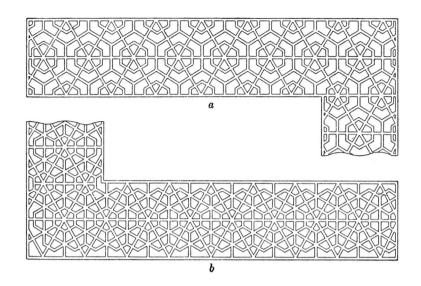

a

b

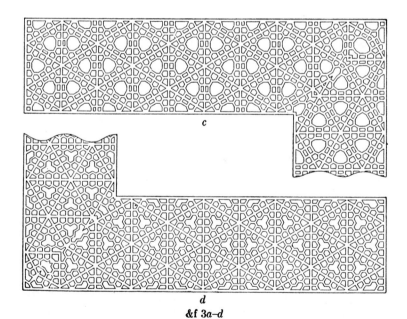

c

d

&f 3a–d

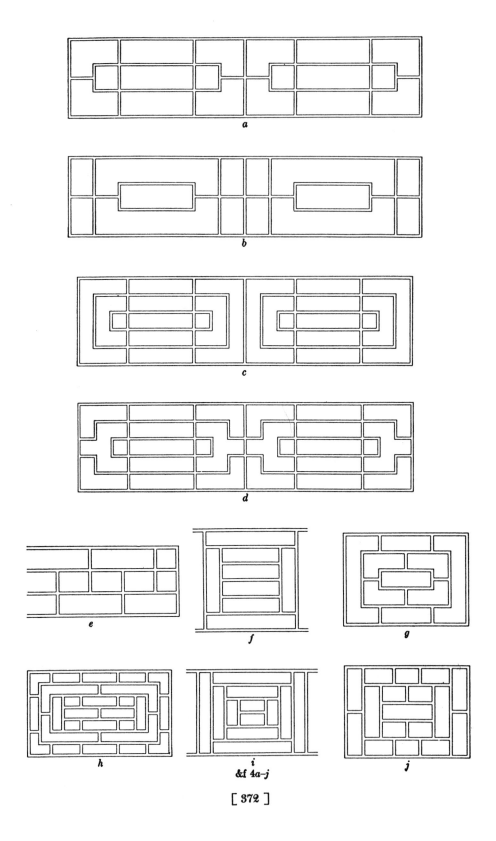

a

b

c

d

e f g

h i
&f 4a–j j

4a–c. Chengtu, Szechwan, 1850 A.D.

4d. Sintu, one half-day northeast of Chengtu, Szechwan, 1850 A.D.

4e–j. Yachow and environs, Szechwan, 1850 A.D.

These patterns have changed but little since the end of the Ming dynasty.

&f. BORDERS (*continued*)

5*b*, *c*. *Chung-kuo Tsung-lun*, or Chinese compendium.

5*d*–*f*. Chengtu, Szechwan, 1825 A.D.

These overhead grilles could have been designed in 1725 A.D.

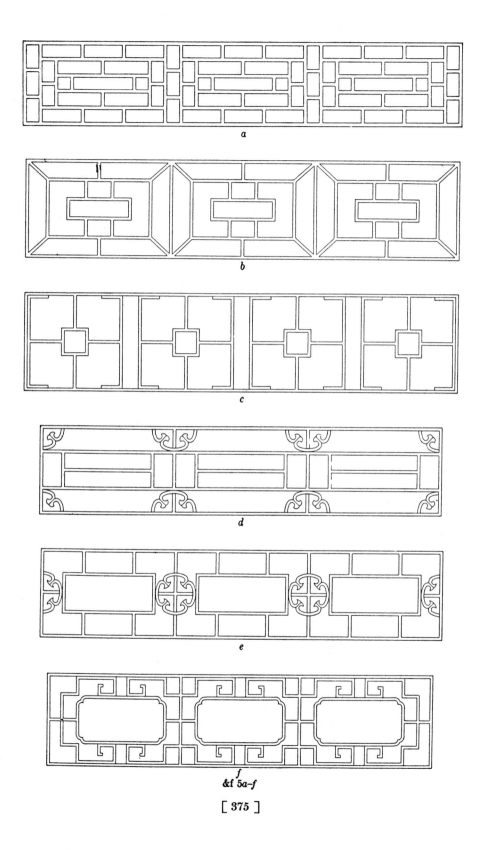

a

b

c

d

e

f
&f 5a-f

a

b

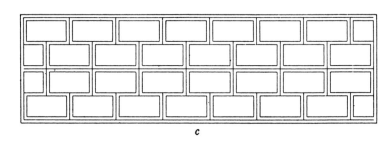

c

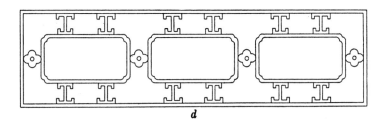

d

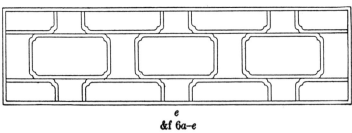

e
&f 6a–e

&f. BORDERS (*continued*)

6*c*. Chengtu, Szechwan, 1825 A.D.

6*d, e*. One day and a half northeast of Chengtu in the hills, Szechwan, 1750 A.D.

The knuckled and wedged patterns of 6*c, d, e* were not new creations in 1700 A.D.

&f. BORDERS (*continued*)

7*a*, *b*. Yachow, Szechwan, 1700 A.D.

7*c*. Same as 6*d*, *e*.

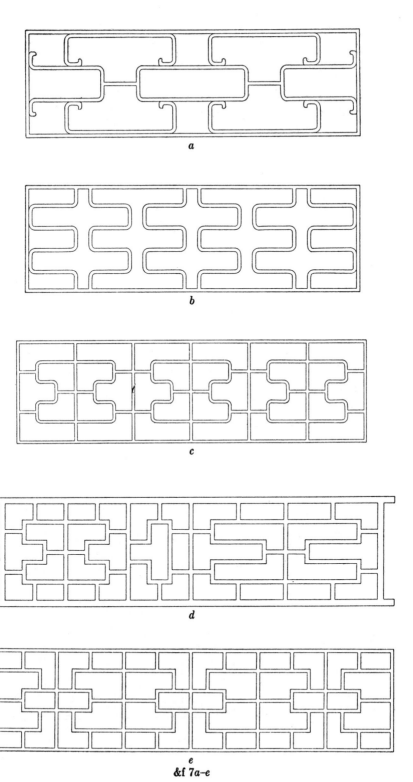

a

b

c

d

e
&f 7a–e

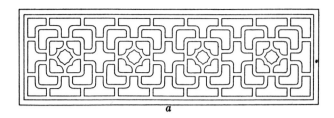

a

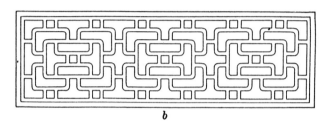

b

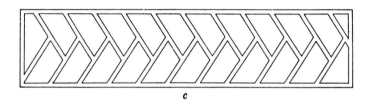

c

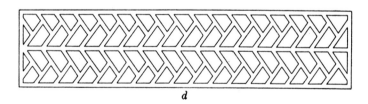

d

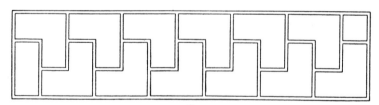

e

&f 8a–e

&f. BORDERS (*continued*)

8*a*. Cf. M 3*a*.

8*b*. Cf. M group.

8*c, d*. Chengtu, Szechwan, 1875 A.D.

8*e*. Shanghai-made movie film.

&f. BORDERS (*continued*)

9*a–d*. One day southwest of Chengtu, Szechwan, 1800 A.D.

9*e*. Tachienlu, Szechwan, 1875 A.D.

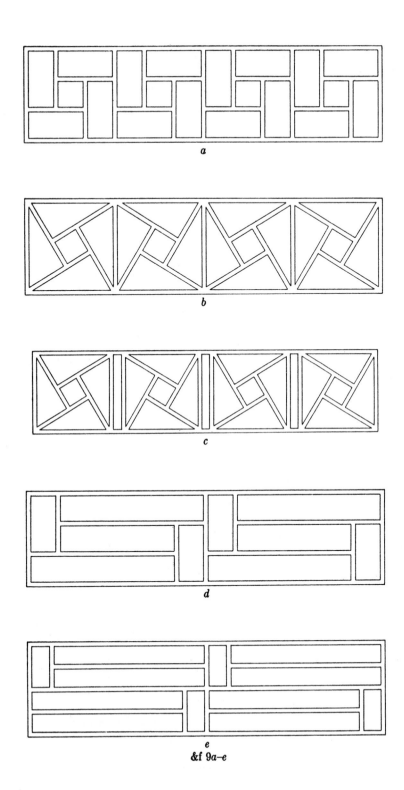

a

b

c

d

e
&f 9a–e

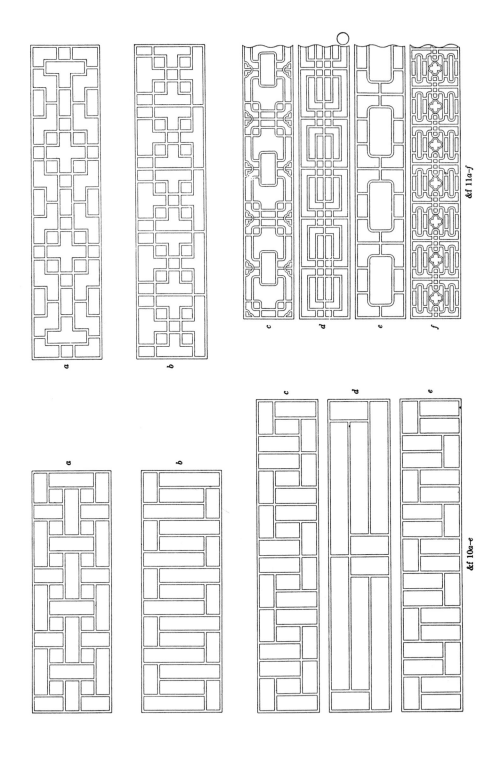

&f 11a-f

&f 10a-e

&f. BORDERS *(continued)*

10*a–b*. Foochow, Fukien, and across Szechwan from Yachow-Cheng-tu-Kwangyüan to Hanchung, Shensi, 1850–1900 A.D.

10*c–e*. Tea shop, Chengtu, Szechwan, 1875 A.D.

These designs have been common in Szechwan from 1600 A.D. on.

11*c, e*. Chengtu, Szechwan, 1750 A.D.

11*d, f*. Confucian temple, Kienwei, forty miles southeast of Kiating, Szechwan, 1750 A.D.

The four borders 11*c–f* were not new in 1650. I call them beaded frames or catenary frames, as the borders are made of small frames threaded somewhat as beads are.

&f. BORDERS (*continued*)

12*a–d*. Over entrance gates, Chengtu, Szechwan, 1875 A.D.

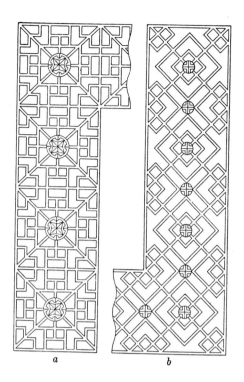

a b

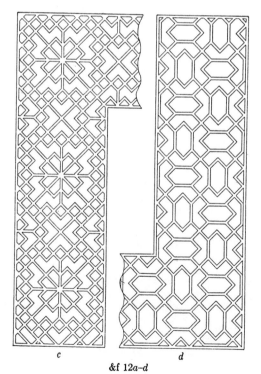

c d

&f 12a–d

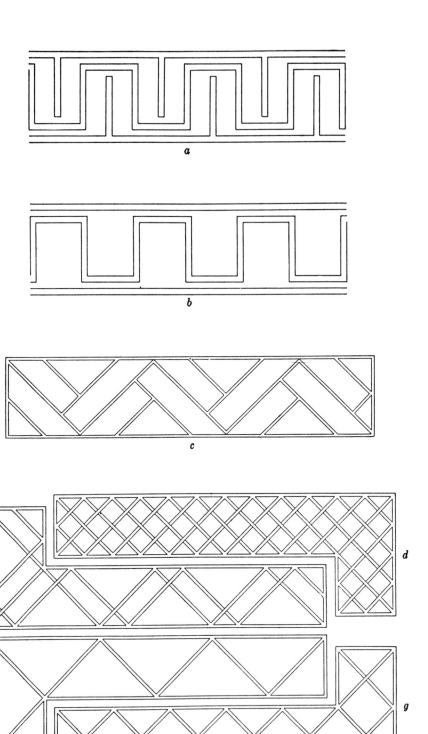

a

b

c

e *d*

f *g*

&f 13a–g

&f. BORDERS (*continued*)

13*a*–*g*. Chengtu, Szechwan, 1850–1900 A.D.

These patterns are either applied upon board backgrounds, or in wood bars overhead along the street side of buildings to allow of light and ventilation.

&f. BORDERS (*continued*)

14*c*. Very common design before and after 1800 A.D. Found in woodcuts and paintings.

14*d–g*. Yünnan guild hall, Suifu, Szechwan; designs and lines common since 1800 A.D. These four patterns are frequently found in needlework.

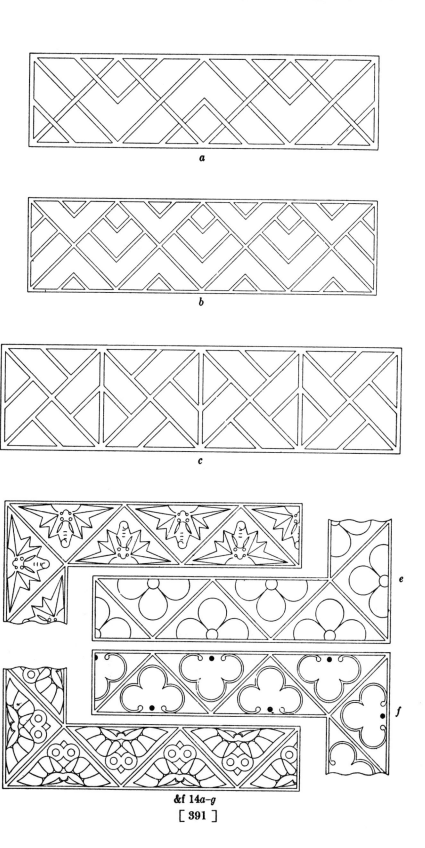

a

b

c

d

e

f

g

&f 14*a–g*

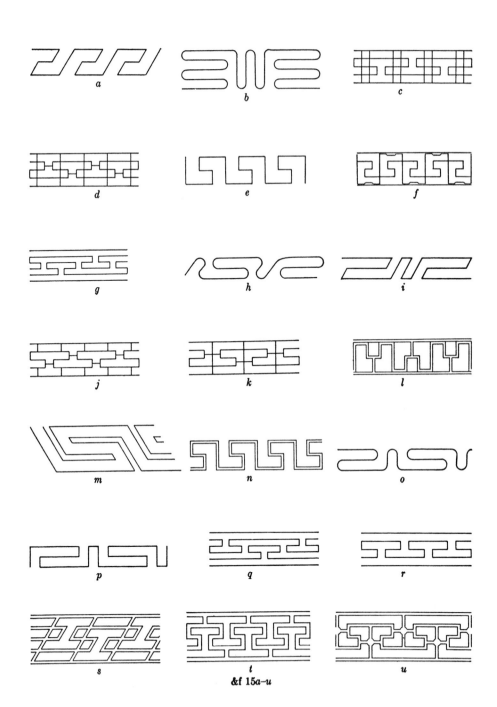

&f 15a–u

&f. BORDERS (*continued*)

15*b, g–i, o–r*. Kiating, Szechwan, 1900 A.D.

15*e*. Greek Attic vase.

15*c, d, f, j, k*. Chengtu, Szechwan, 1825–1900 A.D.

15*m*. Seoul, Korea; 10th–14th century.

15*t*. Hangchow, Chekiang, 1900 A.D.

15*u*. Nanking, Kiangsu, 1850 A.D.

Most of these running borders have been used since the Ming dynasty. Some like *a, m*, and *t* are imprinted on brick and used as the ridge of a roof. This design and its variations may be used in dating buildings in parts of Szechwan.

&f. BORDERS (*continued*)

16*d*, *e*. Kiating, Szechwan, 1875 A.D.
16*g*. Pattern on silk, 1927 A.D.

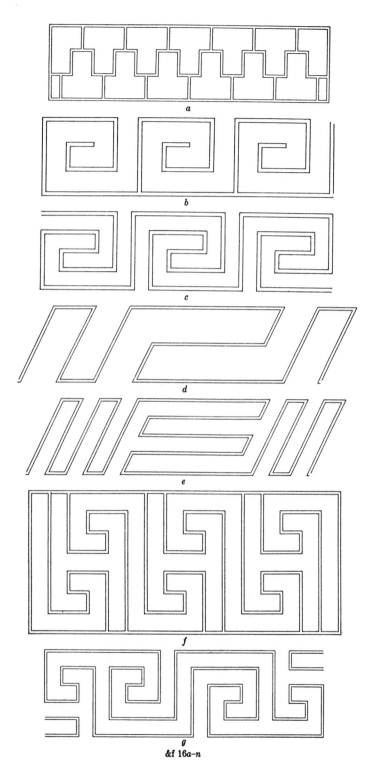

a

b

c

d

e

f

g

&f 16a–n

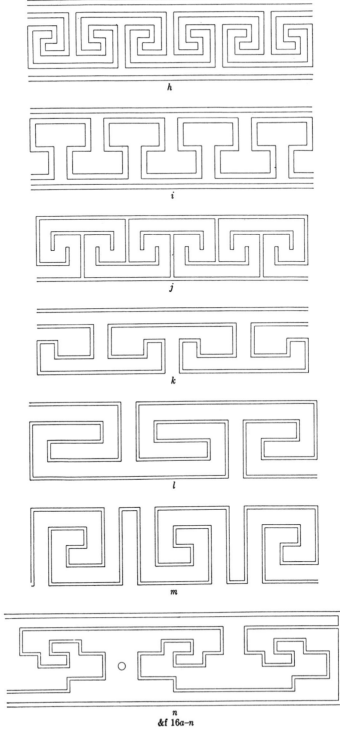

h

i

j

k

l

m

n
&f 16a–n

&f. BORDERS (*continued*)

16*h–i*. Chengtu, Szechwan, 1650–1850 A.D.

16*l, m*. Pao-kuang Buddhist monastery, Sintu, one half-day northeast of Chengtu, Szechwan, 1875 A.D.

16*n*. Curio-table carving, Chengtu, Szechwan, 1875 A.D.

&f. BORDERS (*continued*)

17*a*. Same as &f 11*d*.

17*b*. Same as &f 14*d–g*.

17*c, d. c.* Manchu city. *d.* Residence, Chengtu, Szechwan, 1895 A.D.

18*a, b.* Ten Thousand Years temple, Luchow, Szechwan, 1850 A.D.

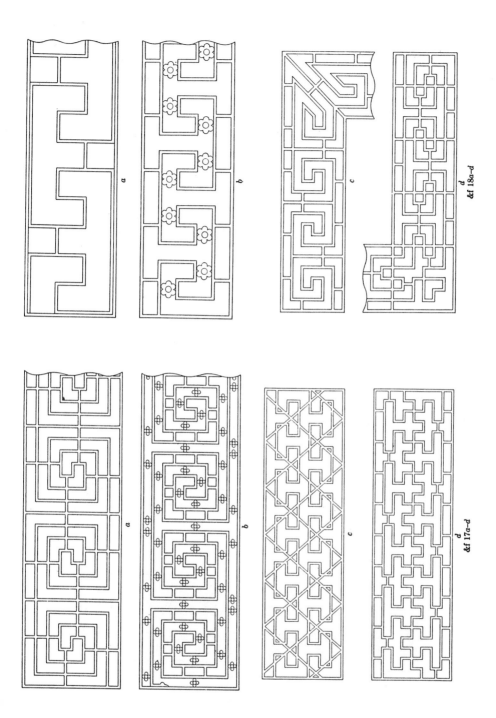

&f 18a–d

&f 17a–d

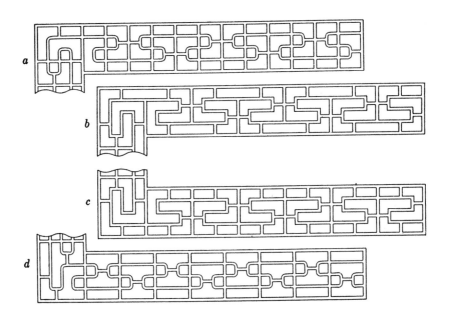

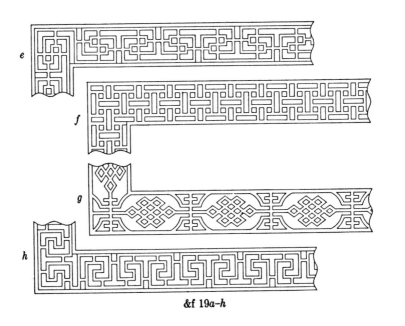

&f 19a–h

&f. BORDERS (*continued*)

19*a*. Same as &f 14*d–g*.

19*b–d*. Chengtu, Szechwan, 1850 A.D.

19*e–h*. Chengtu, Szechwan, 1875 A.D.

The borders listed above have come down from the Ming dynasty with slight modifications. In fact 15*a*–19*e* are merely variations of the so-called Greek fret. 15*r* was used on a gold band ring during the Han dynasty in East China.

19*f*. Chengtu, Szechwan, 1850 A.D.

19*g*. Chengtu, Szechwan, 1900 A.D.

&f. BORDERS (*continued*)

20*a, b.* Adapted from cast bells in Szechwan temples of 1750 to 1900 A.D.

20*c.* Adapted from Shanghai, Kiangsu grille, 1900 A.D.

20*d* Chengtu, Szechwan, 1775 A D. This fine border is artistically related to V5.

20*e.* Chengtu, Szechwan, 1850 A.D.

20*f.* Heavy balustrade in Buddhist temple in mountains, two days northeast of Chengtu, Szechwan, 1700 A.D.

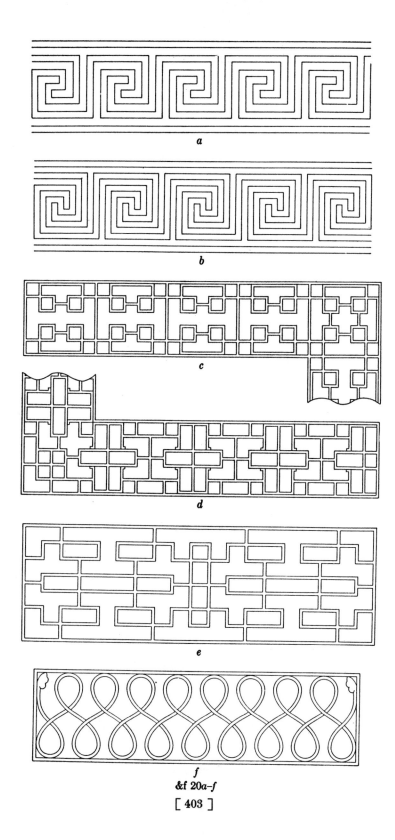

a

b

c

d

e

f

&f 20a–f

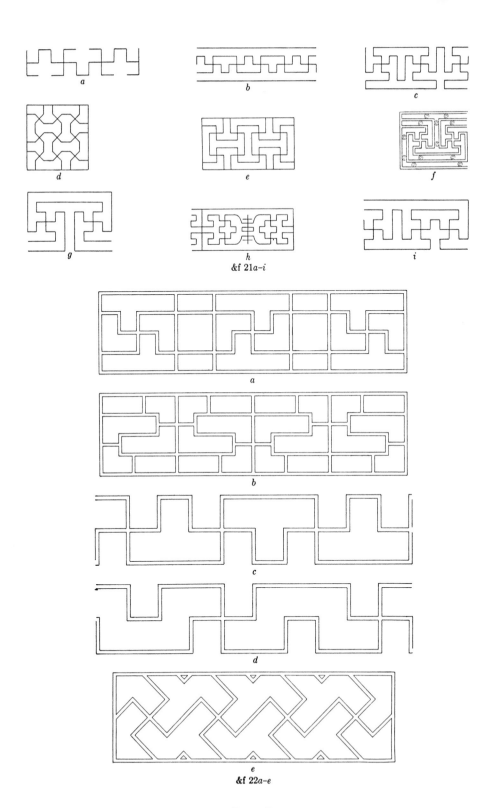

a

b

c

d

e

f

g

h

&f 21a–i

i

a

b

c

d

e

&f 22a–e

21*b–d, g, i.* Kiating, Szechwan, 1900 A.D.

21*f.* Chengtu, Szechwan, 1825 A.D.

21*h.* Ch'ing-yang temple, Chengtu, Szechwan, 1875 A.D.

22*a, b.* Same as &f 16*l, m.*

22*c, d.* Sintu, one half-day northeast of Chengtu, Szechwan, 1875 A.D.

&f. BORDERS (*continued*)

22e–23d. Chengtu, Szechwan, 1900 A.D.

24a, b. *a.* God of War and *b*, God of Fire temples, Luchow, Szechwan, 1875 A.D. *b* in its use of the floral toggles follows styles of 1825 A.D. The interlocking of the so-called Greek frets merely carries into the border field what is constantly practiced in window grille; i.e., superposition of allover designs. I believe the swastikas are incidental to the crossing of the frets.

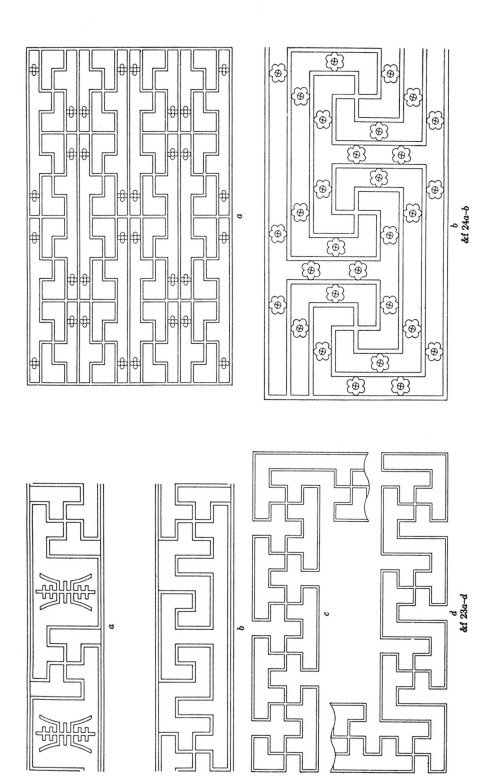

&f 24a-b

&f 23a-d

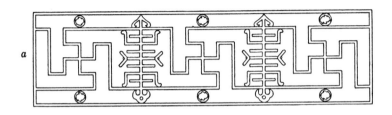

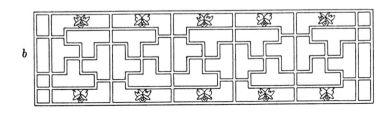

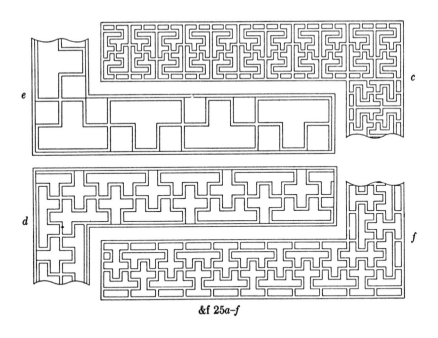

&f 25a–f

&f. BORDERS (*continued*)

25*a*, *b*, *e*, *f*. Chengtu, Szechwan, 1875 A.D.

25*c*. Hangchow, Chekiang, 1900 A.D.

25*d*. Suifu, Szechwan, 1900 A.D.

&f. BORDERS (*continued*)

26*a–d*. Chengtu, Szechwan, 1900 A.D. *b* is also found on a Grecian cup of 500 B.C.

27*a*. Shop, Luchow, Szechwan, 1900 A.D.

27*b*–28*d*. Chengtu, Szechwan, 1800 to 1900 A.D.

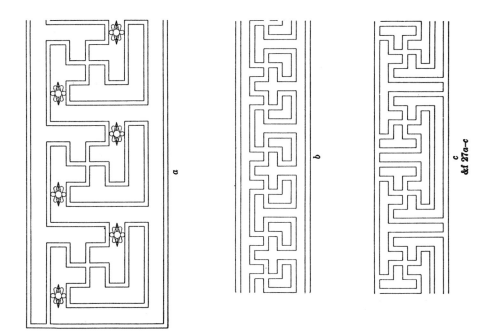

a

b

c

&f 27a–c

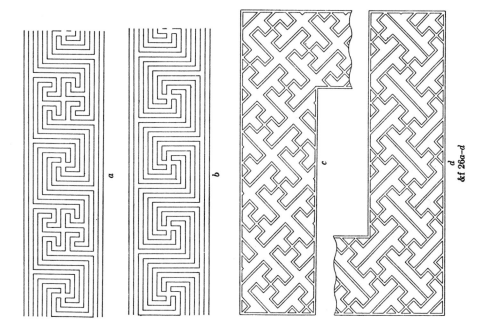

a

b

c

d

&f 26a–d

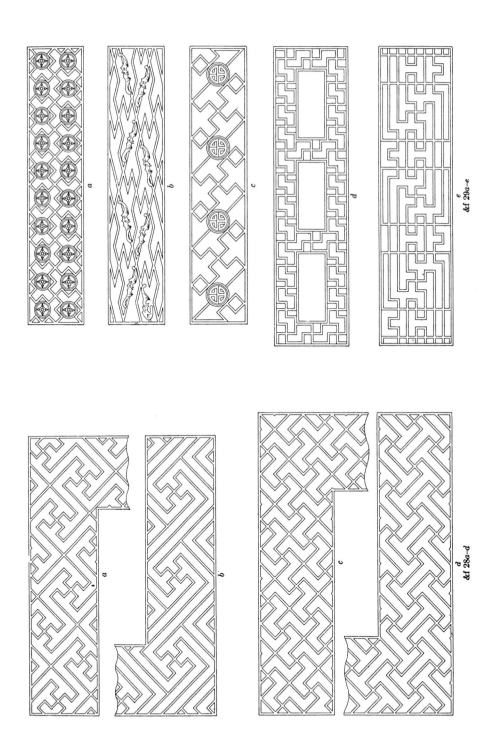

a

b

c

d

e
&f 29a–e

a

b

c

d
&f 28a–d

&f. BORDERS (*continued*)

29*a*–30*b*. Chengtu, Szechwan, 1875 A.D.

Note endless lines and waves in & 29*a*, *c–e*. In 29*b*, *c* are represented "Many blessings and long life." The knuckled frames in 29*d*, *e* are noteworthy.

30*c–e*. *Ch'ang-yüan*, Wuchang, Hupeh(?), 1650(?)

&f. BORDERS (*continued*)

31*a*, *b*. Chengtu, Szechwan; (*a*) 1875 A.D., (*b*) 1900 A.D.

31*c*. Szechwan-Shensi border, 1850 A.D.

31*d*. Imperial city, Chengtu, Szechwan, 1850 A.D.

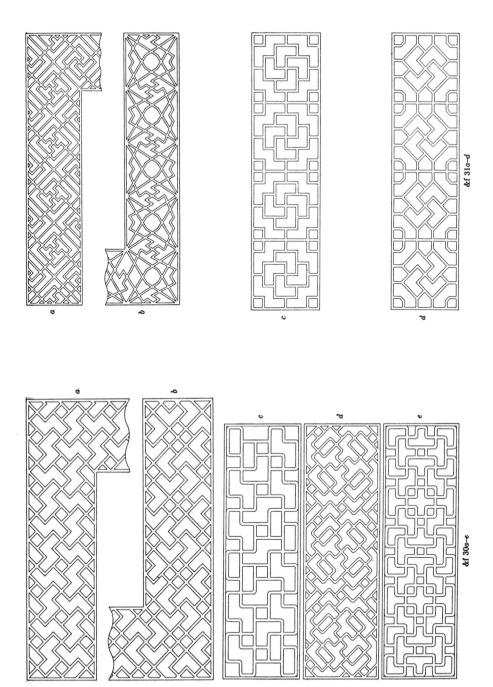

&f 31a–d

&f 30a–e

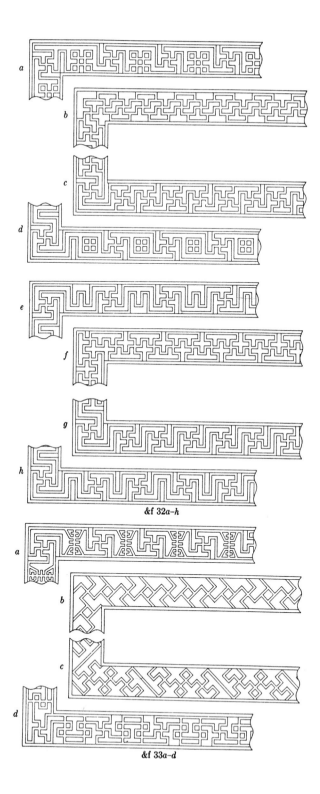

&f 32a–h

&f 33a–d

&f. BORDERS (*continued*)

32*a*–34*l*. Chengtu, Szechwan, 1800–1900 A.D.

&f. BORDERS (*continued*)

35*a*–*l*. Dye, 1930. Thunder-scrolls and cloud-bands and some analyses in dotted lines.

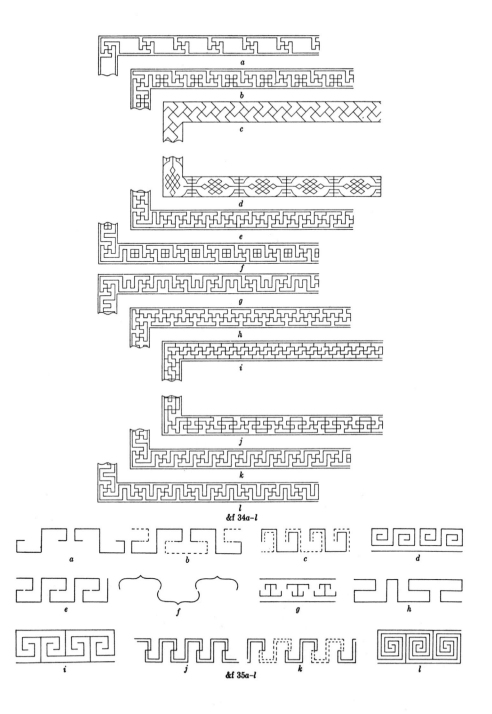

&f 34a-l

&f 35a-l

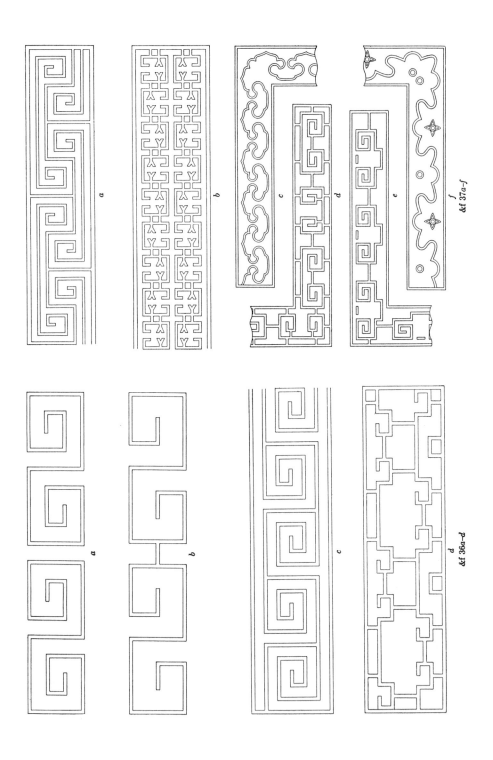

&f 37a–f

&f 36a–d

&f. BORDERS (*continued*)

36*a, b.* Chengtu, Szechwan, 1850 A.D.

36*c, d.* From old Chinese books seen in book shop in Chengtu; probably antedating 1800 A.D.

37*a, b.* Patterns from Ch'ien-lung's *Catalogue of Ancient Bronzes*; Chou and Han dynasties.

37*c.* Summer Palace, Peking, Chihli.

37*d–f.* Suifu, Szechwan, 1825–1850 A.D.

&f. BORDERS (*continued*)

38*a*. Pagoda, Shanghai, Kiangsu, 1825 A.D.(?)

38*b*. Shanghai, Kiangsu, 1900 A.D., and Szechwan-Shensi border, 1875 A.D.

38*c*. Ch'ing-yang temple, Chengtu, Szechwan, 1662 A.D.

39*a–d*. *Ch'ang-yüan*, Wuchang, Hupeh(?), 1650 A.D.(?)

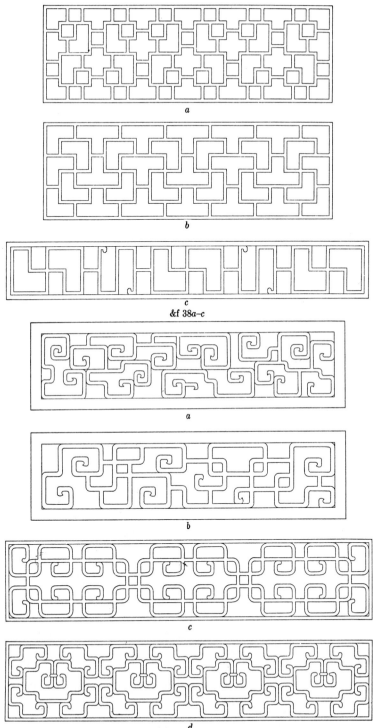

a

b

c

&f 38a–c

a

b

c

d

&f 39a–d

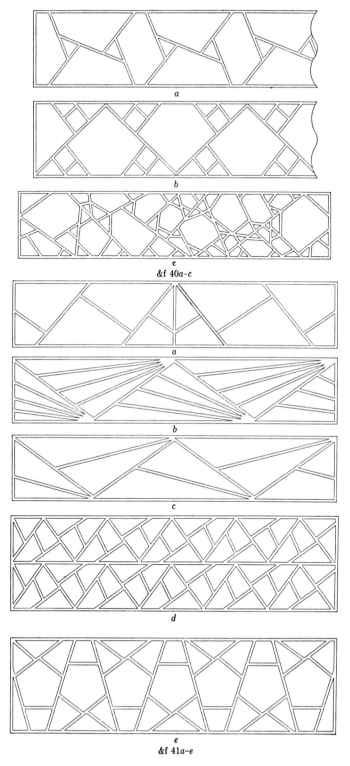

a

b

c

&f 40*a–c*

a

b

c

d

e

&f 41*a–e*

&f. BORDERS (*continued*)

40*a, b.* Day west of Yachow, Szechwan, 1725 A.D. (cf. X 8*b*).

40*c.* Summer-house in funerary clay goods exhibit, Union University, Chengtu, Han dynasty, 206 B.C.–220 A.D.

This general design in irregular ice-ray of unequal light spots has reappeared during each dynasty since the Han.

41*a, c–e.* Chengtu, Szechwan, 1900 A.D.

41*b.* Dye: modification of a companion of *c.*

&f. BORDERS (*continued*)

42*a*, *b*. Etching, coast provinces, 1750 A.D.(?)

42*c*, *d*. Tile ends on wall cover, Yü Wang temple, outside of Shao-hing, Chekiang, 1800 A.D.

43*a–d*. Chengtu, Szechwan, 1900 A.D.

These four grille are found above street side gates near the South Gate of the city.

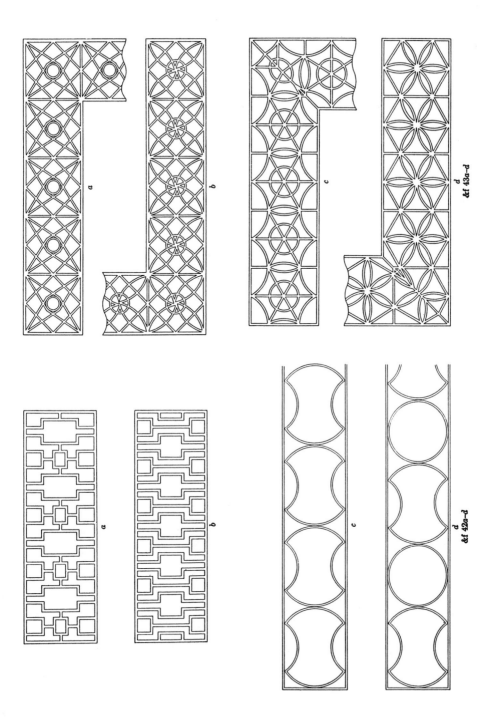

&f 43a-d

&f 42a-d

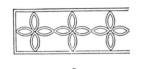

a

b

c

d

e

f

g

h

i

j

k

l

&*g* 1*a–l*

Basic designs and ornamental motifs have diffused themselves throughout China. Recurrent stabilization under successive dynasties has fostered interconnection among the various branches of the arts, and has tended to evoke harmonious milieus.

The Chinese use of tile for roofing is distinctive. The small bucket-made tile has prevailed over the large flat tile with crimped edges of Chou and Han times. This is partly due to their enhancing the fine lines of the roof, for repetition and reiteration are favorite devices. There is something unusually fine about the curved roof lines, which are strengthened by the rows of tiles running up and down, and the small stepped lines produced by the shingle-step in the small overlapping tiles. They add running lines and supplementary borders along the edges to outline the buildings. It is in such a setting that the lattice window is suitable.

These individual tiles also blend into designs in walls and wall tops. It is partly to discourage thieves but also for artistic reasons that the ornaments worked out in tile are added to the walls around Chinese houses. The width of the tiles is from 5 to 8 inches. These are sometimes piled up without the use of lime, but are more often cemented together and covered with two or three layers of brick. Occasionally a tile roof covers the wall, with miniature ridge and projecting eaves; such a wall may last for half a century if well built.

Some of these patterns have been noted in books on China, and three tile patterns have been given in H 2a–c.

1a, b, g, h, k, l. Residence courtyards, Peking, 1900 A.D.

Peking has the finest selection of designs in tile wall tops that China knows; but Hangchow in Chekiang excels Peking in wall shapes, wall windows in brick, and wall window outlines. Chungkingchou, a day southwest of Chengtu, in 1935 had more and finer tile flowers in walls than any other city in Szechwan.

1c, d. Carved wave designs on board, Chengtu, Szechwan, 1850 A.D.

These two designs in carved wood are added to demonstrate that the Chinese have transferred designs from lattice to carving and *vice versa*. These are not very different from the pure lattice patterns in this book.

1e, f, i. Wall tops, Chengtu, Szechwan, 1900 A.D.

1j. Wall and house ridge, Shaohing, Chekiang, 1850 A.D.

&k. OVERHEAD GRILLE

In connection with the entrance hall to the finest of buildings there is almost always a close grille overhead between the bents in the front central section. This should be in keeping with the wood decorations and lattice grille of the buildings in the group. These grilles change a barnlike structure into one of artistic merit. The illustrations give a selection of the finer examples, but the list is not exhaustive.

1*a*. Shop, Chengtu, Szechwan, 1825 A.D., or earlier.

1*b*. Kwanhsien, one day northwest of Chengtu, Szechwan, 1825 A.D., or earlier.

1*c*. One day southwest of Chengtu, Szechwan, 1825 A.D.

1*d*. Chengtu, Szechwan, 1850 A.D.

2*a*. Chengtu, Szechwan, 1875 A.D.

2*b*. Residence, Chengtu, Szechwan, 1825 A.D., or earlier.

2*c*. Sintsing, one day southwest of Chengtu, Szechwan, 1826 A.D.

2*d*. Shanghai, Kiangsu, 1910 A.D., in the fashion of 1825 A.D.

3*a*. City temple, Chengtu, Szechwan, 1875 A.D.

3*b*. Chengtu, Szechwan, 1875 A.D.

3*c*. Residence, Chengtu, Szechwan, 1900 A.D.

4*a, b, d*. *Ch'ang-yüan* designs, Wuchang, Hupeh(?), 1650 A.D.(?)

4*c*. City Moat temple, north suburb, Chengtu, Szechwan, 1825 A.D.

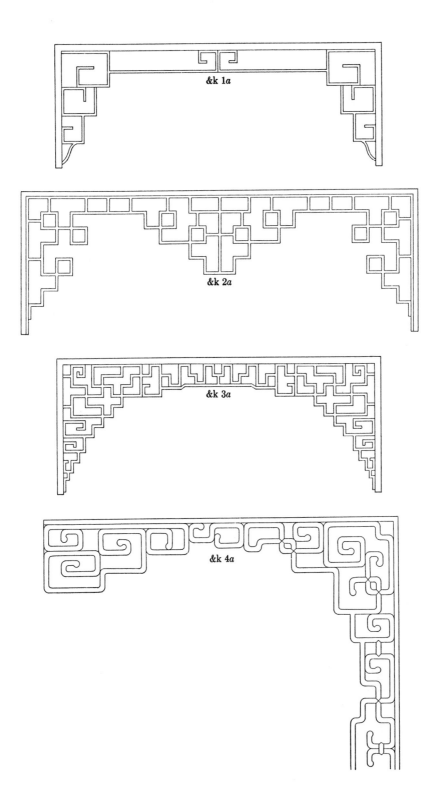

&k 1a

&k 2a

&k 3a

&k 4a

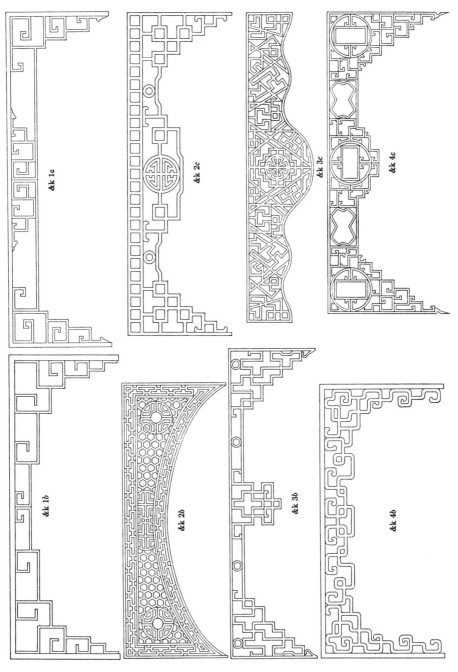

&k 1c

&k 2c

&k 3c

&k 4c

&k 1b

&k 2b

&k 3b

&k 4b

[432]

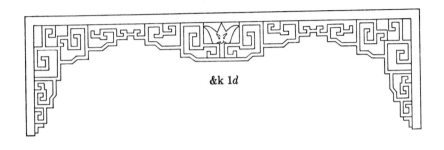

&k 1*d*

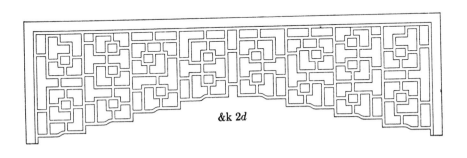

&k 2*d*

&k 4*d*

&11i

&12c

&12a

&12b

&11e

&11f

&11g

&11h

&11a

&11b

&11c

&11d

The Chinese are masters in modifying corners and emphasizing them. These may be finished in a most stately manner without grille, but in such cases there must be heavy posts, squared and symmetrical or else rounded and tapered. Many builders effectively use brackets of divers types, which must be chosen carefully to harmonize with the lattice, balustrade, and the overhead grille.

1a, b. Chengtu, Szechwan, 1825 A.D.

1c, d. Chengtu, Szechwan, 1850 A.D.

1e, f, i. Érh Lang temple, Kwanhsien, Szechwan, 1850 A.D.(?)

1g, h, 2a, b. *Ch'ang-yüan* designs, Wuchang, Hupeh(?), 1650 A.D.(?)

2c. Ten Thousand Years monastery, Mount Omei, Szechwan, 1775 A.D.(?)

This is an unusual bracket. The three-focus grille of F 6*a, b* is in the temple section immediately adjacent. The writer has not had access to the temple history, but concludes from the state of preservation of the bracket, and from the carving and the style, that it antedates 1800 A.D. It is probably much older than the tentative date assigned, and is the finest bracket he has ever observed. Designs on Chou Dynasty bronzes underlie it. The George Eumorfopoulos Collection in London and the Ch'ien-lung *Catalogue of Bronzes* have prototypes of this design. The dragon design is called the Unipede (or one-legged) Dragon. I found an old door with this design that is certainly a Ch'ien-lung (1736–1796).

A few doors and walls are given here as typical surroundings of elaborate lattice.

1a, b. Temple ends, two days below Suifu on Yangtse, Szechwan, 1800 A.D.

The temple proper is supported on wooden posts and sets snug to the wall. The latter, of an odd number of steps, is well done, and the cloud-bands are outlined in white on grey brick. The second end is less gracefully carried out than usual. This motif seems to have been derived from Canton, where winds and fires are common; fire-ends and even fire-walls from street to street are frequent.

1c. Stone gateway in brick wall on street, Yangtse gorge town, Szechwan, 1900 A.D.

1d. Stone gateway, Luchow, Szechwan, 1875 A.D.

1e. Doorway, Seoul, Korea, 1900 A.D.

1f. Wooden door inside temple and entrance to priest's room, Mount Omei, Szechwan, 1850 A.D.

1g, h. Wooden doors and entrance to priest's room, Nine Peaks temple, three days northwest of Chengtu, Szechwan, 1850 A.D.

1i. Temple, Hanchow, Szechwan, 1800 A.D.

This door presents the man who appears there in a frame setting, hence the raised sill. It is closed by tightly fitted boards, but the bolts are not visible from the outside. When the two leaves are wide open they are invisible from the outside.

a

b

c

d

e

f

g

h

&m 1a-i

i

&m 2a

&m 2b

&m 2c

&m. WALLS AND DOORWAYS (*continued*)

2*a–c.* Guest-room doorways, Chengtu, Szechwan, 1850 A.D.

Latticed window-frames and shapes can be observed in conjunction with other window-like vents, which always remain open. Ofttimes they lie within buildings, but more often are set at right angles to the length of the street. They are called "fish-hole gates," but their purpose is to enframe the shop front as the passerby approaches. Some of the shapes are indeed pleasing, and remind one of tea trays and table-shapes of the Colonial period in America, and in Chippendale's *The Director*.

1a. Yachow, Szechwan, 1850 A.D.

b–d. Chengtu, Szechwan, 1850–1875 A.D.

&n 1a

&n 1b

&n 1c

&n 1d

a

b

c

d

e

f

&o 1*a–f*

a

d

g

j

b

e

h

k

c

f

i

l

&o 2*a–l*

&o. PLAQUES AND VENTS IN MASONRY

The Chinese are never satisfied until they have worked out a given idea in different media. A design in painting finds its way into porcelain, wood-work, and masonry. These vents in ornamental walls in some cases are plastered up to form plaques. Some are worked out with frames; others are merely indicated.

1*a–f.* Frames in wall filled with wattle, private residence, Chengtu, Szechwan, 1850 A.D.

2*a–l.* Peking, Chihli, 1875 A.D.

&p. FRAMES

Framing is one of the characteristics of Chinese art and design. Certain frames that one sees are chaste, while others are very much overdone. Not all the illustrations given in this volume are complete, since the wood-carved flowers and ornamentations have been occasionally omitted. Some are taken from panels of old doors.

1*a*. Door with wooden back, Chengtu, Szechwan, 1825 A.D., or earlier.

1*b–e*. Door panel designs, Yachow, Szechwan, 1825 A.D.

1*f*. Mount Omei, Szechwan, 1850 A.D.

1*g, h*. Chao-chüeh monastery, Chengtu, Szechwan, 1662 A.D.

&p 1a

&p 1b

&p 1c

&p 1d

&p 1e

&p 1g

&p 1f

&p 1h

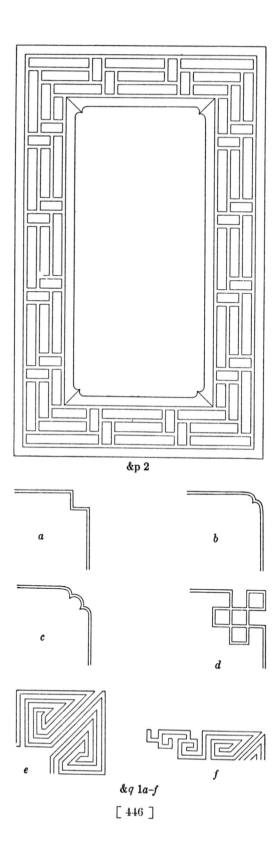

&p 2

a

b

c

d

e

f

&q 1a–f

&p. FRAMES (*continued*)

2. Hanchow, Szechwan, 1850 A.D.

&q. CORNERS

If the Chinese are past masters at modifying or emphasizing corners, as has been stated under &l, they are even more adept at turning corners. The eye does not readily skirt an acute corner, and it must even be induced to turn a right-angled one. The Chinese have studied this problem for many years and in many arts.

1*a–d*. Mukden, Manchuria, 1875 A.D.

1*d*. Summer palace, Peking, Chihli, 1872 A.D.

1*e*. Corner of border on stone tablet, Chengtu, Szechwan, 1825 A.D.

1*f*. Carving on wood, Chengtu, Szechwan, 1875 A.D.

The skill acquired in designing lattice windows appears also in furniture. The carpenter does not change his methods when he turns from one to the other.

1*a*. Bric-a-brac case or cupboard, Chengtu, Szechwan, 1850 A.D

This is only a fairly satisfactory instance, but I did not have the opportunity of getting a better one. Books are sometimes put in such cases, but more often porcelain cups, mirrors, and *objets d'art* are displayed to good advantage.

1*b*. Side of large chair, Pao Kwang monastery, Sintu, one half-day northwest of Chengtu, Szechwan, 1850 A.D.

2*a–c*. From Chippendale's *The Director*, 1753 A.D.

Note the symmetrical completion of the designs across the closed doors. This is often overlooked in Chippendale imitations. The proportions of *c* are very poor; the whole is entirely too heavy. The V mortise is drawn to show the angle made by the Chinese: the single and double frames are each enclosed as one (a second line should have been dotted in at the angle of the V to suggest this). The westerner tries to teach the Chinese carpenter to put in corners in the western way, until he comes to understand that the Chinese are really framing when they use the V-mortise.

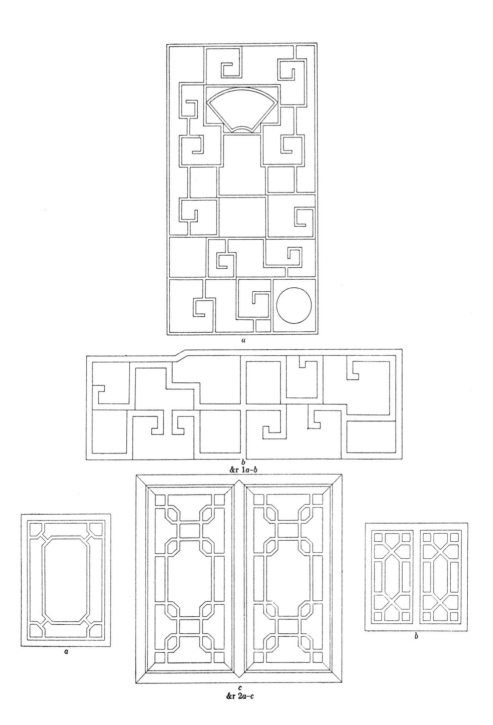

a

b

&r 1*a–b*

a

c

&r 2*a–c*

b

a

b

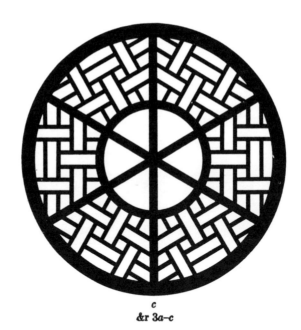

c
&r 3*a–c*

&r 4a–l

a

b

c

d

&r 5*a–d*

&r. FURNITURE (*continued*)

3*a, b.* Dye, in 1700 A.D. Chengtu style, Szechwan, 1931 A.D.

These were designed to meet definite needs. *b* is the carving on the end of the support for a large screen, and is better designed than *a*.

3*c.* Table foot-rest, Chengtu, Szechwan, 1900 A.D.

4*a–l.* Some details of Chinese tables of 1750–1825 A.D.

The line, ending, and angles or corners are noteworthy.

5*a–d.* Windows for ventilation, *Yüan-yeh*, Soochow, Kiangsu, 1635 A.D.

Designs for lattice are drawn from many fields — painting, weaving, jade, and the like. Examples of these sources follow:

1*a*. Bamboo. This is carved on plaques; it is added as detail in the form of leaves, and is imitated in bars.

1*b*. The tide, the sun, and the five bats. The five bats of happiness are frequently used as decoration because of their beauty and symbolic significance.

1*c*. The flower in full bloom or the half-opened blossom is often used in the ice-ray to symbolize winter.

1*d*. Weave in bamboo. This appears in the man-character bar.

1*e*. Weave in bamboo. This shows in the opposed windwheels.

1*f*. Jade musical instrument known as cloud-board, often used in decoration.

1*g*. Fish entrail. This is a sign of good omen.

1*h*. Ju I scepter. The head of this is often used in modified form in lattice.

1*i*. Gathered half-clouds. These are carved on lattice in various forms.

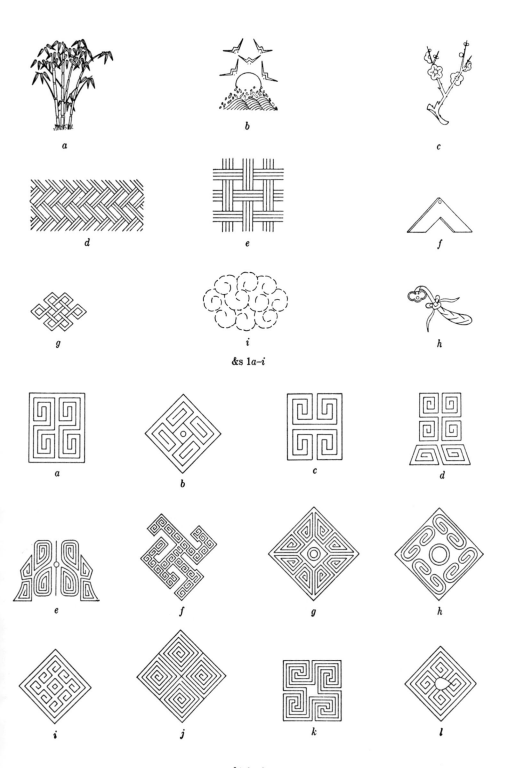

a

b

c

d

e

f

g

i

h

&s 1*a–i*

a

b

c

d

e

f

g

h

i

j

k

l

&t 1*a–l*

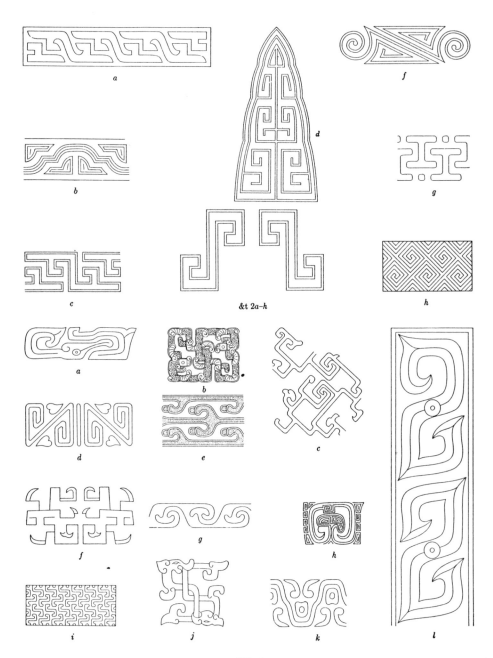

a

b

c

d

&t 2a–h

f

g

h

a

b

c

d

e

f

g

h

i

j

k

l

&t 3a–l

&t. SOME DESIGNS FROM ANCIENT BRONZE SOURCES
USED IN LATTICE

Chinese lattice is rooted in the ornamentation of the ancient bronzes, whence the inspiration of much of their design comes. Many of the designs themselves occur on the bronzes of pre-Christian times. These assume new angles, lines, and line-endings with each strong dynasty, but the underlying pattern is to be found in the permanent bronzes, which are often sacrificial vessels.

1*a–l*. Thunder-scroll and cloud-band designs from the *Po Ku T'u*.

1*c–e, g, j, l*. Ascribed to Shang, 1700–1100 B.C. *b, h, i*. Ascribed to Chou, 1100–255 B.C. *f*. Ascribed to Han, 206 B.C.–220 A.D. *k*. Ascribed to T'ang, 618–907 A.D.

2*a–h*. Designs from museum pieces.

a. Ascribed to Han. *c, e, h*. Ascribed to Chou. *d*. Ascribed to Ch'in, 255–209 B.C.

3*a–l*. Designs from the *Hsi-ch'ing Ku-chien*. *h* is ascribed to the Shang dynasty, all the others to Chou.

&u. CHINESE CHARACTERS AND OLD GRAPHIES

The study of lattice must touch upon the connection of writing with it. The brush used by the Chinese in writing characters has exercised a pervasive influence; moreover, certain ideographs have been worked into lattice, and the evolution of certain characters explains some patterns; one of the earliest examples of lattice is seen in 2*u, v*.

1*a*. One of the forms of longevity inserted in lattice and carvings, 1900 A.D.

1*b*. Double happiness character, 1900 A.D.

1*c*. Happiness character in ordinary, rectangular, formal woodcarving, 1900 A.D.

1*d*. Swastika, ten-thousand, or myriad character in one of its forms. The more common type omits the four extremities given here.

1*e–i*. Old graphies from the *Hsi-ch'ing Ku-chien.*

These five drawings, taken from sacrificial vessels attributed to the Shang and Chou dynasties, fall between 1700 B.C. and 255 B.C. Their form, as well as the shape of the vessels on which they are found, puts them nearer the earlier than the later date. The *Catalogue* attributes *f, g,* and *i* to Chou, and *e* and *h* to Shang. The borders around *g, h,* and *i* are not in the original bronze, but those in *e* and *f* are copied from the book itself. These pictographs represent a series of ideas, rather than single words: they show episodes, if not epochs, in family history. The setting is the ancestral temple, which is represented by the square with indented corners. In the three pictographs which the artist enclosed in border-lines are shown ancestral temple gates or temples. In *f* the father is presenting the newborn before the gates in hopes that the grandfather will vouchsafe his presence and blessing. In *g* the ancestor is seen in person beyond the gates. In *h* the ancestor has left the desired footprint within the temple, which is conventionalized by a gammadion. In *i* the ancestral eye appears within the temple at the upper right-hand corner. In both *f* and *i* there is a hand, represented by three fingers attached to a forearm, offering libation or incense, which is represented by a flame-shape or oblong drop.

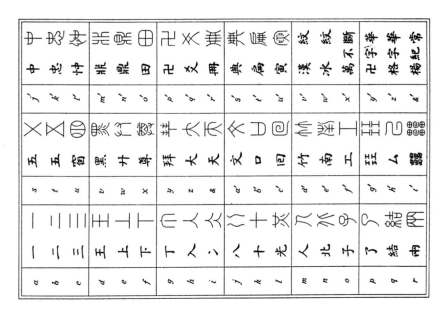

&u 2a-&

f

h

i

e

g

d

&u 1e-i

a

b

c

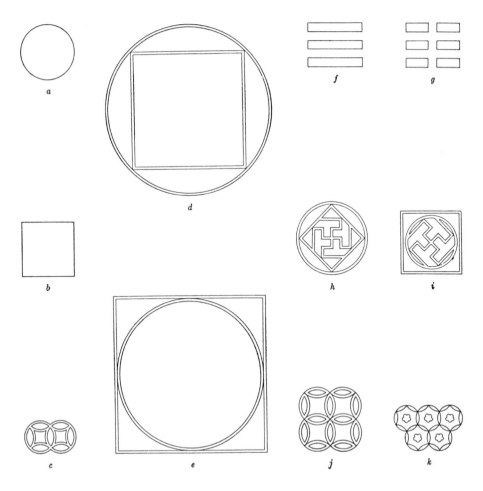

&v 1a–k

&v. SOME COMMON BUT IMPORTANT DESIGNS

Certain items may be overlooked because they so frequently occur. Some designs which are common, but highly symbolic, are collected here.

1*a*. The circle, representing the deity of heaven.

1*b*. The square, representing the deity of earth.

1*c*. The "gold coin," design of good luck.

1*d*. Yüan Fang, or the Circle-Square, is the first diagram in the *Ying Tsao Fa Shih* of 1103 A.D.

1*e*. Fang Yüan, or the Square-Circle, is the second diagram in the same work on architecture.

1*f*. The Ch'ien Kua of the eight trigrams. It has the meaning of male, light, strength.

1*g*. The K'un Kua of the eight trigrams. It signifies female, darkness, weakness.

1*h*. The circle, square, and swastika. In common use during the 18th and 19th centuries.

1*i*. The same as the preceding, but with the order changed.

1*j*. The hollow brocaded ball. This is an allover of the interlocked circle of heaven, where the hollow square simulates the square of earth.

1*k*. The brocaded ball of six sides. This works out in a hexagonal system.

In preparing this alphabet I have tried to evolve a set of initial letters which would harmonize with this Grammar. The design follows the basic principles. The alphabet is composed of three elements:

(1) The fundamental capitals are from Trajan's Column, Rome, executed when the Han dynasty ruled in China, while the supplementary capitals are adapted from *Essentials of Lettering*, by T. E. French and R. Meiklejohn.

(2) The backgrounds are mainly from Chinese latticed windows of the eighteenth century as seen in this book.

(3) The frames and borders are taken from precious stones, bronzes, metal mirrors, porcelains, stonework, brickwork, wood, and bamboo as used from the Chou to the Manchu dynasties, inclusive.

Two fundamental conceptions in Chinese design are the center and the frame. Something worthy of framing should be properly framed. The background is but a corollary of framing. Centrality and framing are strictly observed in these initials.

A approximates the triangular form, and so it is framed in the triangle of heaven-earth-man. This is usually placed with the horizontal sign for heaven above.

B is framed as porcelain plates are sometimes shaped.

C stands out from a background of miniature frames, enclosed in one of similar pattern. Not uncommon.

D stands forth from a background of alternating D's made by bars and waves. The octagonal frame is copied from a bronze mirror of the Ming dynasty.

E is on a field of cloud-bands widely used before 1 A.D. The U with inturned stems may be varied, but it is always a cloud-band. It is found in relief on well designed door panels, *ca.* 1800 A.D.

F is on a background that is closely related to that of the initial E. This thunder-scroll design is often found along with the cloud-band; in fact the names are sometimes used interchangeably. Rotating one half of either the cloud-band or the thunder-scroll on the midstem converts the one design into the other. The endless inlooped border-frame is akin to that of initial *E*.

G is backed by a design of tiles from Peking wall-copings. The Chinese penchant for bilateral symmetry is displayed here. The shield-shaped border is shaped from tile, turned on a potter's wheel.

&w. THE ENGLISH ALPHABET IN A CHINESE
SETTING (*continued*)

H is displayed upon an allover fret. The lines cross at right angles in
such a way as to connect the two systems of lines. The frame
is in the shape of an old shield.

I is a surface where waves cross on the horizontal and on the vertical.
There is a right angle in the frame corner, which is somewhat
unusual, but the incusp of the inner corner offsets it. This
frame is taken from a temple door pattern in the mountains
near Chengtu, Szechwan.

J is placed on a surface of echelon waves, from a porcelain ginger jar
of the Manchu dynasty.

K stands upon the broken-backed ice-ray where no horizontal, verti-
cal, parallel, or crossed lines may be used. Even the frame is
nearly broken-backed. Such frames are executed in brick and
lime in walls around the West Lake at Hangchow.

L is enmeshed in maze lines. This is adapted from a piece of yellow
silk from a Chengtu grave. The design was woven in silks in
the latter half of the 19th century, but it comes down from
Chou bronzes.

M is associated with the man-character-pile-up. The design is taken
from a bricklayer's pattern and named by its resemblance to
the ideogram for man. The frame is the outline of a ginger jar
cartouche.

N is supported on waves which are on the point of breaking. The
border is a scroll design. It is sometimes done in the wood of
windows, but more frequently in wall masonry.

O is in the midst of intersecting heaven-circles. The frame is a near-
circle taken from a picture fan mounted on a scroll.

P appears among what are almost Sung dynasty spirals and vines.
The background is like the running thunder-scroll. The
border is the leaf of one type of Chinese fan.

Q floats upon highly conventionalized clouds. The border is from a
Ming dynasty mirror.

R is seen on a coat-of-mail design which is really a honeycomb of
three units with the three central partitions omitted. The
border is the same motif on a larger scale. The door gods
often display this design on their armor.

S is fittingly enframed in a threefold border, the middle one of which
is composed of the strictly classical thunder-scrolls of the
sigmoid form

T is raised upon a thunder-scroll and cloud-band design from a
bronze vase of late date, but the design is genetically related
to bronzes antedating the Christian era.

U is superimposed upon an imbricated pattern from a Han dynasty
bronze. The background suggests the lotus leaves of Egyptian
architecture. This motif was widely used during the Ming
dynasty. The frame is from a Chinese picture outline.

V is fitted into a fan frame on a series of concentric and parallel
waves. Something similar is found upon a Szechwan sar-
cophagus of the Han dynasty.

W is on a cross-wave background. The fan frame is common today
in scrolls, painting, porcelain, and architecture.

X is in the elephant-nostril or lozenge lattice, which has been used
in China for at least two thousand years.

Y is imposed on the hexagonal turtle-shell, which would be called
honeycomb in the Occident.

Z is surrounded by a series of swastikas raked to conform to the
slope of the *Z* itself. The frame is copied from the outline
of a metal mirror of the Manchu dynasty.

& is supported upon peculiar conventional clouds that are carved
upon an old jade circle. The ampersand is enclosed by the
circle of heaven.

SUPPLEMENT TO ALPHABET

; is surrounded by the great limit symbols, with the male and female
 principles, which underlie Chinese cosmology. The circle of
 heaven encloses the nested T'ai Chi or great limit. There are
 paired Yin Yang symbols in cartouches around the border.
 The interior and exterior framing is copied from a bronze
 platter of 1700 A.D.

, is framed in the outline of a copper cash of the T'ang Dynasty when
 coinage was at its best in China. The kua in the border
 simulate the split bamboo roots which are used in connection
 with prayer in temple worship. These are superimposed
 upon the cash design, as their shape is analogous to that of
 the comma.

. is the outline of the circular upper platform of the Altar of Heaven
 at Peking of the Ming dynasty. This represents a birdseye
 view, with the three concentric marble balustrades of the
 altar, the circular blue-tiled wall surrounding it, and the
 square enclosure outside it. The gates and steps mark the
 cardinal points.

Some details in floral ornament and in carving are difficult to show on drawings of the scale of the lattice windows, so it is necessary to present them on a larger scale.

1a–c. Details of hexagonal lattice carvings, 1850–1900 A.D. These are favorites in Chihli palaces and temples and in Szechwan.

1d–f. Details of splendidly carved windows of 1775 A.D. or earlier, found by the Rev. T. Torrance at points off the beaten track which have retained Ming influence in marked degree.

1g–i. Floral details from Suifu, Szechwan, 1850 A.D.

1j–l. Details from *Ying Tsao Fa Shih* windows and doors, 1103 A.D.

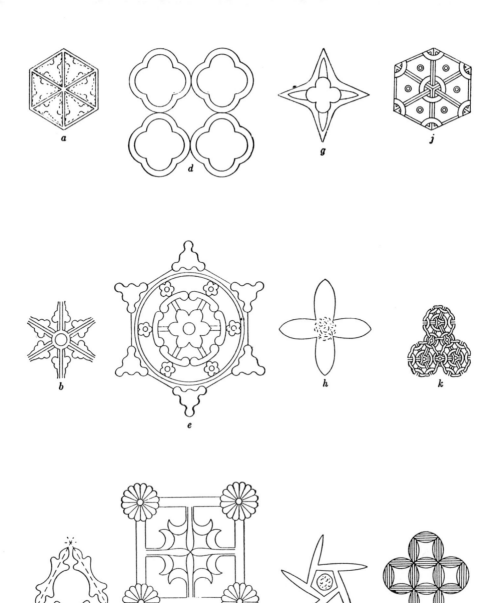

&y 1a–l

&z 1a–j

&z 2a–d

The plates do not give the beads which are used in each case; as a matter of fact the style of bead may be important, and enhance or mar the effect of the whole.

1*a–j*. Beads as used from 1800 to 1900 A.D.

These are the favorite beads for lattice. The back of the bar where the paper is pasted is at the bottom of the plate. This faces inside the room. The top of the diagram is the bead, which faces toward the outside. *a* is generally used with Mount Omei windows and also with Group A. *c* and *e* are commonly used with elephant-nostril or lozenge lattice. During the Sung dynasty there were occasionally flutings in bead, but these are not often seen today (cf. *f*). *g* is used in vertical bars as in &c 1*b*. *h* and *i* are used in such open balustrades as the M group.

2*a–c*. Mortise as used from pre-Han to the Republic.

a. "Backed" bars from Honan grave clay house of pre-Han times. The horizontal bar is behind and in contact with the vertical bars.

b. Threaded bars from Szechwan, late Ming or early Ch'ing dynasty. I have only seen a half dozen windows in Szechwan so reinforced. I have seen this method used in a Ming pagoda in Soochow. It is common in Japan.

c. Half-mortise, everywhere in China, Ch'ing dynasty. The vertical bars are cut in half from the back, and the horizontal bars are cut in half from the front, so that when fitted together they form a window with bar faces in one and with all backs in another plane.

d. Perforated Board, two days northwest of Chengtu, Szechwan, 1650 A.D. A very few windows and doors have been found in out-of-the-way corners in Szechwan where wide boards have been used and perforations have made mortise, threading, and backing unnecessary. Sometimes the outside has been beautifully finished and the inside has been but crudely carved. It is very suggestive of the ramma of Japan. The half dozen examples discovered in 1935 may be survivals of what was customary practice in earlier times.

A CATALOG OF SELECTED
DOVER BOOKS
IN ALL FIELDS OF INTEREST

DRAWINGS OF REMBRANDT, edited by Seymour Slive. Updated Lippmann, Hofstede de Groot edition, with definitive scholarly apparatus. All portraits, biblical sketches, landscapes, nudes. Oriental figures, classical studies, together with selection of work by followers. 550 illustrations. Total of 630pp. 9⅛ × 12¼.
21485-0, 21486-9 Pa., Two-vol. set $29.90

GHOST AND HORROR STORIES OF AMBROSE BIERCE, Ambrose Bierce. 24 tales vividly imagined, strangely prophetic, and decades ahead of their time in technical skill: "The Damned Thing," "An Inhabitant of Carcosa," "The Eyes of the Panther," "Moxon's Master," and 20 more. 199pp. 5⅜ × 8½. 20767-6 Pa. $4.95

ETHICAL WRITINGS OF MAIMONIDES, Maimonides. Most significant ethical works of great medieval sage, newly translated for utmost precision, readability. Laws Concerning Character Traits, Eight Chapters, more. 192pp. 5⅜ × 8½.
24522-5 Pa. $5.95

THE EXPLORATION OF THE COLORADO RIVER AND ITS CANYONS, J. W. Powell. Full text of Powell's 1,000-mile expedition down the fabled Colorado in 1869. Superb account of terrain, geology, vegetation, Indians, famine, mutiny, treacherous rapids, mighty canyons, during exploration of last unknown part of continental U.S. 400pp. 5⅜ × 8½. 20094-9 Pa. $8.95

HISTORY OF PHILOSOPHY, Julián Marías. Clearest one-volume history on the market. Every major philosopher and dozens of others, to Existentialism and later. 505pp. 5⅜ × 8½. 21739-6 Pa. $9.95

ALL ABOUT LIGHTNING, Martin A. Uman. Highly readable nontechnical survey of nature and causes of lightning, thunderstorms, ball lightning, St. Elmo's Fire, much more. Illustrated. 192pp. 5⅜ × 8½. 25237-X Pa. $5.95

SAILING ALONE AROUND THE WORLD, Captain Joshua Slocum. First man to sail around the world, alone, in small boat. One of great feats of seamanship told in delightful manner. 67 illustrations. 294pp. 5⅜ × 8½. 20326-3 Pa. $4.95

LETTERS AND NOTES ON THE MANNERS, CUSTOMS AND CONDITIONS OF THE NORTH AMERICAN INDIANS, George Catlin. Classic account of life among Plains Indians: ceremonies, hunt, warfare, etc. 312 plates. 572pp. of text. 6⅛ × 9¼. 22118-0, 22119-9, Pa., Two-vol. set $17.90

THE SECRET LIFE OF SALVADOR DALÍ, Salvador Dalí. Outrageous but fascinating autobiography through Dalí's thirties with scores of drawings and sketches and 80 photographs. A must for lovers of 20th-century art. 432pp. 6½ × 9¼. (Available in U.S. only) 27454-3 Pa. $9.95

THE ART NOUVEAU STYLE BOOK OF ALPHONSE MUCHA: All 72 Plates from "Documents Decoratifs" in Original Color, Alphonse Mucha. Rare copyright-free design portfolio by high priest of Art Nouveau. Jewelry, wallpaper, stained glass, furniture, figure studies, plant and animal motifs, etc. Only complete one-volume edition. 80pp. 9⅜ × 12¼. 24044-4 Pa. $10.95

ANIMALS: 1,419 Copyright-Free Illustrations of Mammals, Birds, Fish, Insects, Etc., edited by Jim Harter. Clear wood engravings present, in extremely lifelike poses, over 1,000 species of animals. One of the most extensive pictorial source-books of its kind. Captions. Index. 284pp. 9 × 12. 23766-4 Pa. $10.95

OBELISTS FLY HIGH, C. Daly King. Masterpiece of American detective fiction, long out of print, involves murder on a 1935 transcontinental flight—"a very thrilling story"—*NY Times*. Unabridged and unaltered republication of the edition published by William Collins Sons & Co. Ltd., London, 1935. 288pp. 5⅜ × 8½. (Available in U.S. only) 25036-9 Pa. $5.95

VICTORIAN AND EDWARDIAN FASHION: A Photographic Survey, Alison Gernsheim. First fashion history completely illustrated by contemporary photographs. Full text plus 235 photos, 1840–1914, in which many celebrities appear. 240pp. 6½ × 9¼. 24205-6 Pa. $8.95

THE ART OF THE FRENCH ILLUSTRATED BOOK, 1700–1914, Gordon N. Ray. Over 630 superb book illustrations by Fragonard, Delacroix, Daumier, Doré, Grandville, Manet, Mucha, Steinlen, Toulouse-Lautrec and many others. Preface. Introduction. 633 halftones. Indices of artists, authors & titles, binders and provenances. Appendices. Bibliography. 608pp. 8⅜ × 11¼. 25086-5 Pa. $24.95

THE WONDERFUL WIZARD OF OZ, L. Frank Baum. Facsimile in full color of America's finest children's classic. 143 illustrations by W. W. Denslow. 267pp. 5⅜ × 8½. 20691-2 Pa. $7.95

FOLLOWING THE EQUATOR: A Journey Around the World, Mark Twain. Great writer's 1897 account of circumnavigating the globe by steamship. Ironic humor, keen observations, vivid and fascinating descriptions of exotic places. 197 illustrations. 720pp. 5⅜ × 8½. 26113-1 Pa. $15.95

THE FRIENDLY STARS, Martha Evans Martin & Donald Howard Menzel. Classic text marshalls the stars together in an engaging, nontechnical survey, presenting them as sources of beauty in night sky. 23 illustrations. Foreword. 2 star charts. Index. 147pp. 5⅜ × 8½. 21099-5 Pa. $3.95

FADS AND FALLACIES IN THE NAME OF SCIENCE, Martin Gardner. Fair, witty appraisal of cranks, quacks, and quackeries of science and pseudoscience: hollow earth, Velikovsky, orgone energy, Dianetics, flying saucers, Bridey Murphy, food and medical fads, etc. Revised, expanded In the Name of Science. "A very able and even-tempered presentation."—*The New Yorker*. 363pp. 5⅜ × 8. 20394-8 Pa. $6.95

ANCIENT EGYPT: Its Culture and History, J. E. Manchip White. From predynastics through Ptolemies: society, history, political structure, religion, daily life, literature, cultural heritage. 48 plates. 217pp. 5⅜ × 8½. 22548-8 Pa. $5.95

SIR HARRY HOTSPUR OF HUMBLETHWAITE, Anthony Trollope. Incisive, unconventional psychological study of a conflict between a wealthy baronet, his idealistic daughter, and their scapegrace cousin. The 1870 novel in its first inexpensive edition in years. 250pp. 5⅜ × 8½. 24953-0 Pa. $6.95

LASERS AND HOLOGRAPHY, Winston E. Kock. Sound introduction to burgeoning field, expanded (1981) for second edition. Wave patterns, coherence, lasers, diffraction, zone plates, properties of holograms, recent advances. 84 illustrations. 160pp. 5⅜ × 8¼. (Except in United Kingdom) 24041-X Pa. $4.95

INTRODUCTION TO ARTIFICIAL INTELLIGENCE: Second, Enlarged Edition, Philip C. Jackson, Jr. Comprehensive survey of artificial intelligence—the study of how machines (computers) can be made to act intelligently. Includes introductory and advanced material. Extensive notes updating the main text. 132 black-and-white illustrations. 512pp. 5⅜ × 8½. 24864-X Pa. $10.95

HISTORY OF INDIAN AND INDONESIAN ART, Ananda K. Coomaraswamy. Over 400 illustrations illuminate classic study of Indian art from earliest Harappa finds to early 20th century. Provides philosophical, religious and social insights. 304pp. 6⅜ × 9⅜. 25005-9 Pa. $11.95

THE GOLEM, Gustav Meyrink. Most famous supernatural novel in modern European literature, set in Ghetto of Old Prague around 1890. Compelling story of mystical experiences, strange transformations, profound terror. 13 black-and-white illustrations. 224pp. 5⅜ × 8½. 25025-3 Pa. $7.95

PICTORIAL ENCYCLOPEDIA OF HISTORIC ARCHITECTURAL PLANS, DETAILS AND ELEMENTS: With 1,880 Line Drawings of Arches, Domes, Doorways, Facades, Gables, Windows, etc., John Theodore Haneman. Sourcebook of inspiration for architects, designers, others. Bibliography. Captions. 141pp. 9 × 12. 24605-1 Pa. $8.95

BENCHLEY LOST AND FOUND, Robert Benchley. Finest humor from early 30s, about pet peeves, child psychologists, post office and others. Mostly unavailable elsewhere. 73 illustrations by Peter Arno and others. 183pp. 5⅜ × 8½. 22410-4 Pa. $4.95

ERTÉ GRAPHICS, Erté. Collection of striking color graphics: *Seasons, Alphabet, Numerals, Aces* and *Precious Stones*. 50 plates, including 4 on covers. 48pp. 9⅜ × 12¼. 23580-7 Pa. $7.95

THE JOURNAL OF HENRY D. THOREAU, edited by Bradford Torrey, F. H. Allen. Complete reprinting of 14 volumes, 1837–61, over two million words; the sourcebooks for *Walden*, etc. Definitive. All original sketches, plus 75 photographs. 1,804pp. 8½ × 12¼. 20312-3, 20313-1 Cloth., Two-vol. set $130.00

CASTLES: Their Construction and History, Sidney Toy. Traces castle development from ancient roots. Nearly 200 photographs and drawings illustrate moats, keeps, baileys, many other features. Caernarvon, Dover Castles, Hadrian's Wall, Tower of London, dozens more. 256pp. 5⅜ × 8¼. 24898-4 Pa. $7.95

CATALOG OF DOVER BOOKS

AMERICAN CLIPPER SHIPS: 1833–1858, Octavius T. Howe & Frederick C. Matthews. Fully-illustrated, encyclopedic review of 352 clipper ships from the period of America's greatest maritime supremacy. Introduction. 109 halftones. 5 black-and-white line illustrations. Index. Total of 928pp. 5⅜ × 8½.
25115-2, 25116-0 Pa., Two-vol. set $21.90

TOWARDS A NEW ARCHITECTURE, Le Corbusier. Pioneering manifesto by great architect, near legendary founder of "International School." Technical and aesthetic theories, views on industry, economics, relation of form to function, "mass-production spirit," much more. Profusely illustrated. Unabridged translation of 13th French edition. Introduction by Frederick Etchells. 320pp. 6⅛ × 9¼. (Available in U.S. only)
25023-7 Pa. $8.95

THE BOOK OF KELLS, edited by Blanche Cirker. Inexpensive collection of 32 full-color, full-page plates from the greatest illuminated manuscript of the Middle Ages, painstakingly reproduced from rare facsimile edition. Publisher's Note. Captions. 32pp. 9⅜ × 12¼. (Available in U.S. only)
24345-1 Pa. $5.95

BEST SCIENCE FICTION STORIES OF H. G. WELLS, H. G. Wells. Full novel *The Invisible Man*, plus 17 short stories: "The Crystal Egg," "Aepyornis Island," "The Strange Orchid," etc. 303pp. 5⅜ × 8½. (Available in U.S. only)
21531-8 Pa. $6.95

AMERICAN SAILING SHIPS: Their Plans and History, Charles G. Davis. Photos, construction details of schooners, frigates, clippers, other sailcraft of 18th to early 20th centuries—plus entertaining discourse on design, rigging, nautical lore, much more. 137 black-and-white illustrations. 240pp. 6⅛ × 9¼.
24658-2 Pa. $6.95

ENTERTAINING MATHEMATICAL PUZZLES, Martin Gardner. Selection of author's favorite conundrums involving arithmetic, money, speed, etc., with lively commentary. Complete solutions. 112pp. 5⅜ × 8½.
25211-6 Pa. $3.95

THE WILL TO BELIEVE, HUMAN IMMORTALITY, William James. Two books bound together. Effect of irrational on logical, and arguments for human immortality. 402pp. 5⅜ × 8½.
20291-7 Pa. $8.95

THE HAUNTED MONASTERY and THE CHINESE MAZE MURDERS, Robert Van Gulik. 2 full novels by Van Gulik continue adventures of Judge Dee and his companions. An evil Taoist monastery, seemingly supernatural events; overgrown topiary maze that hides strange crimes. Set in 7th-century China. 27 illustrations. 328pp. 5⅜ × 8½.
23502-5 Pa. $6.95

CELEBRATED CASES OF JUDGE DEE (DEE GOONG AN), translated by Robert Van Gulik. Authentic 18th-century Chinese detective novel; Dee and associates solve three interlocked cases. Led to Van Gulik's own stories with same characters. Extensive introduction. 9 illustrations. 237pp. 5⅜ × 8½.
23337-5 Pa. $5.95

Prices subject to change without notice.

Available at your book dealer or write for free catalog to Dept. GI, Dover Publications, Inc., 31 East 2nd St., Mineola, N.Y. 11501. Dover publishes more than 400 books each year on science, elementary and advanced mathematics, biology, music, art, literary history, social sciences and other areas.